INTERPRETING CONTEMPORARY ART

Edited by Stephen Bann *and*
William Allen

REAKTION BOOKS

Published by Reaktion Books Ltd
1–5 Midford Place, Tottenham Court Road
London WIP 9HH, UK

First Published 1991

Designed by Humphrey Stone

Photoset by Wilmaset, Birkenhead, Wirral
Colour printed in Great Britain by
Balding and Mansell plc, Wisbech, Cambridgeshire
Printed and bound in Great Britain by
Redwood Press Ltd, Melksham, Wiltshire

British Library Cataloguing in Publication Data
Interpreting contemporary art.
1. Visual arts, 1970–
I. Bann, Stephen II. Allen, William 1967–
709.047
ISBN 0–948462–15–9
ISBN 0–948462–14–0 pbk

1001283163

Contents

Photographic Acknowledgements

Alinari p. 78 bottom, Richard Deacon pp. 198, 199, 200, Ruth Kaiser p. 59, Lisson Gallery, London pp. 188, 196, Massimo Audiello Gallery, New York pp. xiii, 96 top and bottom, 97, 98, Sue Ormerod/Whitechapel Art Gallery p. 182, Richard Stoner p. 144.

Notes on the Artists

ROBERT MOTHERWELL was born in 1915 in Aberdeen, Washington, USA. After studying literature, philosophy and aesthetics at Stanford and Harvard Universities, he began to paint in 1940. Through the encouragement of Meyer Schapiro he met many European exiles in New York, and his own first one-man show was presented by Peggy Guggenheim at the Art of This Century Gallery in 1944. Since then he has exhibited regularly in the United States and Europe. A retrospective exhibition of his work opened at the Albright-Knox Art Gallery, Buffalo, in 1983 and subsequently travelled to Los Angeles, San Francisco, Seattle, Washington and New York. This confirmed his stature as one of the most imaginative and productive painters of the second half of the twentieth century.

COLIN MCCAHON was born in Timaru in 1919 and died in Auckland in 1987, having lived in New Zealand all his life apart from visits to Australia (1951) and the United States (1958). Always a painter of powerful images, these were sometimes abstract, landscape or of text, and later a combination of all three. Death and the problem of belief were his abiding subjects.

JANNIS KOUNELLIS was born in 1936 in Piraeus, Greece. In 1956 he moved to Rome where he still lives. In the last two decades he has exhibited widely. International institutions that have produced catalogues accompanying their one-man shows of the artist include ARC/Musée d'Art de la Ville de Pa.ïs (1980); Stedelijk Van Abbemuseum, Amsterdam (1980–1, travelled); Museum of Contemporary Art, Chicago (1986).

DAVID REED, who has lived for twenty years in Tribeca, New York, continues to paint through various 'deaths of painting'. Before moving to New York, he painted the landscapes of the American southwest. Inspired by the space and light of the desert, he thought the Grand Canyon 'the source and home of American painting'. More recently he has travelled extensively in Italy, tracing the influences on and of the Carracci.

JONATHAN LASKER was born in Jersey City, New Jersey, in 1948. He studied at the School of Visual Arts, New York, and the California Institute of the Arts (1975–7). In the last decade his work has been shown in a number of galleries in Europe and America: he has held solo exhibitions, most recently in the Massimo

Audiello Gallery, New York (1988, 1989), the Gian Enzo Sperone Gallery, Rome (1988), and Michael Werner, Cologne (1980). He is represented in a number of public collections including the Museum Ludwig, Cologne, and the Hirshhorn Museum, Washington.

SUSAN SMITH was born in Greensberg, Pennsylvania, and lives and works in New York. She has had solo exhibitions at a number of New York galleries, including most recently the Margarete Roeder Gallery (1989). Her pictorial work has always dealt with architecture – as site, as construction and as memory. She has been involved with the type of assemblages discussed here, which take their starting point in found demolition material, since the mid-1980s.

HELMUT NEWTON was born in Berlin in 1920. He emigrated to Australia and worked as a freelance photographer in Sydney in the mid-1940s. Later he settled in Paris and Monaco. His photographs have appeared regularly in the German magazine *Stern* and the French and American editions of *Vogue* in recent years. Among his books of photographs are *Sleepless Nights* (1978), *47 Nudes* (1982) and *World without Men* (1986).

DAVID SALLE was born in Norman, Oklahoma, in 1952 and lives and works in New York. His one-man shows have been seen at the Addison Gallery of American Art, Phillips Academy, Andover, Massachusetts, the Museum Boymans-van Beuningen, Rotterdam (in 1983) and the Museum of Contemporary Art, Los Angeles (in 1988).

ANNETTE LEMIEUX was born in Norfolk, Virginia, in 1957, studied at Hartford Art School, Connecticut (BFA, 1980) and now lives and works in New York. She has exhibited in the Cash/Newhouse Gallery, New York (1984 and 1986), and in Holly Solomon Gallery's group show '57 St. Between A & D' (1985, New York). *Homecoming*, 1985, was exhibited in the 1987 Whitney Museum of American Art Biennial, New York.

HAMISH FULTON was born in 1946 and lives near Canterbury in Kent, England. *Hamish Fulton: Selected Walks 1969–89* (1990) (with essays by Michael Auping and David Reason) was recently published on the occasion of an exhibition organized by the Albright-Knox Art Gallery, Buffalo, New York. The exhibition travelled to the National Gallery of Canada, Ottawa, and the Centro Cultural Arte Contemporaneo, Mexico City.

RICHARD DEACON was born in 1949 in Bangor, Wales, and lives and works in London. He is represented by the Lisson Gallery, London, and the Marian Goodman Gallery, New York. Among his one-man exhibitions were the Fruitmarket Gallery, Edinburgh (1984, travelled), Tate and Serpentine Gallery, London (1985), Carnegie Museum of Art, Pittsburgh, and Museum of Contemporary Art, Los Angeles (1988), Whitechapel Art Gallery (1988–9), Kunstnirnes Hus, Oslo, and Saatchi Collection (1990). In 1987 he was awarded the Turner Prize.

Robert Motherwell, *Riverrun*, 1972, acrylic on canvas, 152.4 cm × 381.0 cm.
Private collection.

David Reed, *No. 273*, 1988–9, oil and Alkyd on linen, 284.5 cm × 71.1 cm.
Max Protetch Gallery, New York.

Colin McCahon, *Te Tangi o te Pipiwhararua*
(The song of the shining cuckoo; a poem by Tangirau Hotere),
1974, oil on unstretched canvas (five panels), 175.0 cm × 451.4 cm (assembled).
Hocken Library, University of Otago, New Zealand.

Susan Smith, *White Metal with Red and Gray,* 1987–88, oil on canvas
with found metal and construction board, 120.0 cm × 137.7 cm.
Margarete Roeder Gallery, New York.

Jonathan Lasker, *Double-Play*, 1987, oil on linen, 116.8 cm × 254 cm, Rubell Collection, New York.

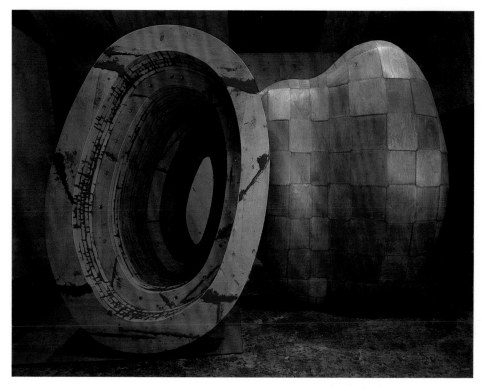

Richard Deacon, *Kiss and Tell*, 1989, epoxy, timber, plywood and steel, 175 cm × 233 cm × 162 cm. Collection Arts Council of Great Britain.

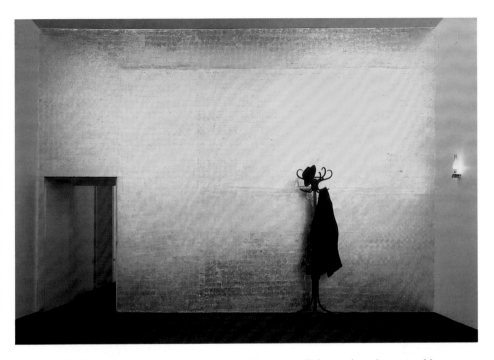

Jannis Kounellis, *Civil Tragedy*, 1975, gold leaf on wall, hat-rack with coat and hat, and oil lamp, 478 cm × 541 cm. Collection of Karsten Greve, Cologne, and the artist. Installed at the Modern Art Agency, Naples, 1975.

OVERLEAF Hamish Fulton, *ROCK FALL ECHO DUST*, 1988.

ROCK

FALL

ECHO

DUST

A TWELVE AND A HALF DAY WALK ON BAFFIN ISLAND ARCTIC CANADA SUMMER 1988

Notes on the Editors and Contributors

STEPHEN BANN was born in Manchester in 1942. Since 1967 he has taught at the University of Kent, where he is Professor of Modern Cultural Studies and Chairman of the Board of Studies in History and Theory of Art. His books include *Concrete Poetry – An International Anthology* (editor, 1967), *Experimental Painting* (1970), *The Tradition of Constructivism* (editor, 1974), *The Clothing of Clio* (1984), *The True Vine* (1989) and *The Inventions of History* (1990). He has also written numerous catalogue essays and published articles in journals such as *Studio International* and *Art Monthly*.

WILLIAM ALLEN was born in London in 1967. He studied History and Theory of Art and graduated with a First Class degree in Visual and Performed Arts from the University of Kent in 1988, his final-year dissertation being on the Saatchi Collection. He has held internships at the Brooklyn Museum and the Whitney Museum of American Art, New York, and is now doing freelance work, including projects for the Victoria Miro Gallery and Coracle Press. Among his recent publications is 'Jean Fautrier's path to abstraction', *Kunst & Museumjournaal* (April 1990).

MARCELIN PLEYNET was born in 1933 in Lyon. He was *secrétaire de redaction* of the French magazine *Tel Quel* (now *L'Infini*) and has published numerous books of poetry, in addition to his critical writings. The works on art by him which are available in English include *Painting and System* (trans. Sima N. Godfrey, University of Chicago Press, 1984) and *Robert Motherwell* (trans. Mary Ann Caws, Paris, Editions Daniel Papierski, 1989). His study, *The Moderns and Tradition*, is forthcoming. He holds the Chair of Aesthetics at the Ecole Nationale Supérieure des Beaux-Arts, Paris.

WYSTAN CURNOW was born in 1939 and educated at the universities of Auckland and Pennsylvania. Currently Associate Professor of English at the University of Auckland, he teaches contemporary poetry and image–text relations. He has curated a number of exhibitions in recent years, including *I Will Need Words, Colin McCahon's Word and Number Paintings*, National Art Gallery, 1984, and *Putting the Land on the Map, Art and Cartography in New Zealand, 1840 to the Present*, Govett-Brewster Art Gallery, 1989. The author of two collections of poetry, he co-edited the writings of the New Zealand pioneer

film-maker and kinetic sculptor, Len Lye, *Figures of Motion* (Auckland University Press, 1984).

DAVID CARRIER is a contributing editor for *Arts Magazine* and Professor of Philosophy at Carnegie-Mellon University, Pittsburgh. His books include *Artwriting* (Amherst, 1987), a history of recent American art history; *Principles of Art History Writing* (University Park and London, 1991), a study of the philosophy of art history; and *Poussin's Paintings* (University Park and London, 1992). He publishes art criticism in *Arts Magazine* and *ArtInternational*.

RAINER CRONE studied at the Universities of Berlin, Freiberg and Bonn. Prior to the completion of his doctoral dissertation, he published the first major monograph on the work of Andy Warhol in 1970. Since 1984 he has been Associate Professor of Art History at Columbia University, and since 1987 he has also occupied the post of Chief Curator and Vice-Director of the Kunsthalle, Düsseldorf. He has organized exhibitions in Europe and America since the 1970s and published a wide variety of catalogue essays and articles, most recently with David Moos, *Object/Objectif* (Paris, 1989) and *Painting Alone* (New York, 1990). Among his recent books are *Francesco Clemente* (Munich, Prestel, 1984), *Paul Klee: Legends of the Sign* (with Joseph Koerner; Columbia University Press, 1991), and *Kasimir Malevich: The Climax of Disclosure* (with David Moos; London, Reaktion Books, 1991). He has recently accepted the chair for Twentieth-Century Art at the University of Munich.

DAVID MOOS was born in Toronto, Canada, in 1965. He studied History of Art and modern American Literature at McGill University, Montreal, and completed his Master of Arts degree at Columbia University, where he is now working towards a doctorate and co-teaching (with Rainer Crone) a graduate seminar in contemporary art. He has co-authored a number of publications with Rainer Crone, including *Objet/Objectif* (Paris, 1989), *Painting Alone* (New York, 1990) and most recently *Kasimir Malevich: The Climax of Disclosure* (London, Reaktion Books, 1991).

YVE-ALAIN BOIS was born in Constantine, Algeria, in 1952. He studied in Paris at the Ecole Pratique des Hautes Etudes, where he obtained a doctorate in 1977 for a thesis on the conception of space in Malevich and Lissitsky, with Roland Barthes as his advisor. Since 1984 he has held a teaching post at the Johns Hopkins University, Baltimore, where he is now Professor in the Department of History of Art. He was co-founder and co-director of the journal *Macula* (1976–9) and the book series of the same name. He has published widely in journals in France and the United States, and his most recent book is *Painting as Model*, an anthology of his essays on modern painting (MIT Press, 1990).

VICTOR BURGIN was born in Sheffield, England, in 1941 and studied at the Royal College of Art, London, and Yale University. He is now Professor of Art History at the University of California, Santa Cruz, where he teaches in the Art History and History of Consciousness programs. Burgin's visual work has been

exhibited in such museums as: Tate Gallery, Victoria and Albert Museum, London; Centre Georges Pompidou, Paris; Guggenheim Museum, Museum of Modern Art, New York. His critical and theoretical writings have appeared in many journals, including: *Artforum, Screen, 20th Century Studies, New Formations, Architectural Design, AA Files*. Burgin's books include: *Work and Commentary* (1973), *Thinking Photography* (editor, 1982), *Between* (1986), *The End of Art Theory: Criticism and Postmodernity* (1986).

PAUL SMITH studied English at the University of Cambridge and completed a PhD at the University of Kent at Canterbury. He has taught at various American universities and is at present Associate Professor in the Department of English at the Carnegie-Mellon University, Pittsburgh. He has published *Pound Revised* (1983) and edited, with Alice Jardine, *Men in Feminism* (1987). His art criticism has appeared in *Art in America*, and he is currently completing a critical edition and translation of the writings of the French art theorist Jean-Louis Schefer.

DAVID REASON teaches social and cultural theory at the University of Kent at Canterbury. He has also taught at the Universities of Cambridge and Essex and at the Institute of Sociology of the Bulgarian Academy of Sciences. Recent research has concerned the nature and consequences of 'restructuring' (*perestroika*) in Eastern Europe. Interests in the social and aesthetic theory of the Frankfurt 'Critical Theorists' and in the determinations and consequences of discourses of 'nature' have found expression in a continuing series of studies of British land art, including several essays on the work of Hamish Fulton. A major contributor to *The Unpainted Landscape* (1987), he is currently preparing a book on 'land/scape arts since 1960'.

MICHAEL NEWMAN took his BA in English at Oxford and has done research in art history at the Courtauld Institute, London, and in philosophy at the University of Essex. Since 1980 he has worked as a freelance art critic, lecturer and exhibitions curator. He has written extensively on sculpture and on artists' use of photography. His publications include 'Revising Modernism, Representing Postmodernism' in *Postmodernism* (ed. Lisa Appignanesi, London, Free Association Books, 1989) and the exhibition catalogues for *The Mirror and the Lamp* (Fruitmarket Gallery, Edinburgh, and ICA, London) and *The Analytical Theatre* (Independent Curators Inc., New York).

Introduction

STEPHEN BANN AND WILLIAM ALLEN

This volume of specially commissioned essays on contemporary art is intended to open doors and not to close them. By the editors' decision, it does not take its stand on any particular critical ideology. None the less, it could be said to have a clear and discernible unity. This is in part because of the particular brief which was given to our contributors, as a result of our own conviction that the time was ripe for a volume which would approach a select number of contemporary works with adequate seriousness and comprehensiveness. Of course, it is also, very largely, because of the way in which our contributors responded to their brief, reinforcing our sense that the criticism of the present day is well equipped to deal with a period in which outstanding works of art continue to be produced on all sides – even though the art world itself often appears to be terminally afflicted. It can be said of all these essayists, we feel, that they are enthusiasts for their chosen subject. That is a far from insignificant fact, if we measure it against the carping and dogmatic criticism that was all too often the rule no more than a decade ago.

The brief which we offered was that contributors should write about one work in particular (though this need not exclude a group of related works or a set of contrasted examples) and that the work (which could be in any medium whatsoever) should date from after 1970. As it has turned out, the range of works selected has extended over the last two decades with a reasonable regularity: Robert Motherwell's *Riverrun* (1972) is the first in date, while Michael Newman's survey of the sculpture of Richard Deacon includes one example from 1990 and concentrates on a work from the previous year. Our definition of the contemporary was certainly not intended to be a prescriptive one. The important thing was that the work would not have to be contextualized historically (although it might have to be contextualized in other ways) before the critic attempted to come to terms with it. Or to put it in a more positive way, it was to be the challenge of looking at something new – which was, thus, likely to pose

special problems of interpretation – that grounded the critical enterprise. An incidental point here is that we made no special attempt to achieve a balance between genres of work or to distribute the featured artists across various geographical categories (except in so far as this was implied in the choice of contributors). We have ended up with more essays on contemporary painters – indeed, more essays on contemporary American painters – than on all the rest combined. But this in itself may be significant, since in fact the balance of contributors was distinctly toward the non-American. And one of the interesting possibilities which emerges from such a range is the ability to compare the various modes of discussing contemporary painting with those of interpreting the other genres: relief, sculpture, installation and photography.

The other part of the brief was deliberately open. We were well aware that our contributors would differ quite widely in their approaches or (to use a term which already perhaps prejudices the outcome) in their choice of methodologies. We were aware that the very exercise of writing for a collection of this kind would inevitably force the issue of method to the forefront, but we wished to leave it to the discretion of each essayist as to how far he chose to make this element explicit. In the event, this has produced an interesting result. As might have been predicted, no one takes the opportunity to present the reader with an 'open sesame' which will instantly dissolve the problems of interpreting contemporary art. The stage at which it was possible to write within the terms of a method which offered quasi-scientific certainty – structuralism, psychoanalysis, Marxism, etc. – is clearly long past. But equally there has been no relapse, for our contributors, into a vague and belle-lettristic type of commentary or a superficial formalism.

What many of these essays hold in common is a sober revisionism, in terms of method, which does not in any way impugn (in effect, considerably enhances) the vitality of the work under discussion. Thus, for example, Victor Burgin constructs his discussion of a striking photograph by Helmut Newton as a commentary on Laura Mulvey's celebrated article on the male gaze: he argues that Mulvey's argument has been vulgarized in such a way that it has become a mere caricature of psychoanalytic theory, and his retrieval of Mulvey's original insights also becomes a plea for giving serious attention to the complex investments of the photographic image, rather than hastily proscribing them. In a very different register, David Carrier looks again at the type of analysis which has been pejoratively described as formalist; while he is in no doubt that the formalism of both Roger Fry and Clement Greenberg is highly

problematic, this does not stop him from looking at the paintings of David Reed in terms of the 'implicit' or 'secondary' narratives which can be found there, in much the same way as they can be found in the great figurative paintings of the Renaissance tradition. For both Burgin and Carrier, therefore, the approach to the work is through a revision, and refinement, of theoretical concepts which have been contaminated by crude dogmatism, but remain, none the less, accessible for use.

This comparison brings out at the same time the widely differing stances which our contributors have adopted, in relation to the author as well as the work. Burgin's biographical interest in the photograph by Helmut Newton is strictly limited – although the autobiographical resonance of his discussion of the male gaze is something to which he freely admits. Carrier writes as a person who has shared his perceptions of the link between contemporary abstract art and the old masters with the artist himself – and he is not diffident about raising the question of how far these connections can be said to be publicly accessible. Obviously, there is a spectrum across the whole range of contributors, as regards the immediacy and directness of their dialogue with the artist. Marcelin Pleynet writes not only as the author of the most recent comprehensive work on the paintings of Motherwell, and a friend of long standing, but also as a poet whose work Motherwell has recently illustrated (this kinship does not prevent him from ostensibly violating in an unmistakeable way the painter's advice not to look too closely into his titles!). David Reason writes specifically about the need for personal experience of, and identification with, the work and castigates the habit of much criticism to lose itself in a thicket of supposed connections and allusions. At the same time, his validation of personal response passes by way of, and is enriched by, the references which he makes to the German philosophical tradition. As will be noted later, he is not alone in seeing German thought as a means of clarifying, and giving due weight to, the subject's engagement with the object.

Equally, there are those among our contributors who would see their critical activity as belonging within a particular institutional bracket and, therefore, to some extent dissociated from such issues of subjectivity. Thus, Paul Smith reasonably situates his exploration of the 'Salle/ Lemieux' duo within the province of cultural studies where the texts selected can already be taken as implicated in a 'social and cultural narrative'. Here, it can be mentioned that no one raises in an explicit way a point which, as editors, we took to be of special importance. This is the relationship of the institution of art criticism, at the present day, to the

institution of art history. Any casual reader of our list of contributors will notice that, in effect, virtually all of them work in the academic world (the marginal cases of Pleynet, as a poet who is also the occupant of a Chair of Aesthetics at the Ecole des Beaux-Arts, and Burgin, an artist who also teaches art theory at an American university, hardly prove the rule). The fact that there is no one who is known exclusively as an art critic, writing chiefly for newspapers or art magazines, is not a conscious decision of policy (we did originally have such contributors in mind). At the same time, it is no mere accident. For it is our firm conviction that much of the best writing on contemporary art comes from within the academic world. This is not only because of the considerable pressures, of all kinds, which the art critic has to undergo; it is also, more positively, a feature of the way in which art history, as the hegemonic discipline concerned with the evaluation and criticism of visual images, has developed over the last few years. Since this development is crucial to the way this collection of essays has turned out, it will need a little attention on its own terms.

 In the introduction to his selection of 'Essays in New Art History from France', *Calligram*, Norman Bryson draws attention to the odd fact that, in the English-speaking world, art history and art criticism (or 'writing about contemporary art') 'take place in two different worlds, with different personnel, modes of funding, journals, and conventions of writing'.[1] This is still largely true. And Bryson is right to underline the irony that 'official art history', which characteristically insists on discussion of the work within a defined historical context, is thus engaged in denying a critical context to the art of the contemporary period – or at least not seeking to provide one. Richard Wollheim has also pointed out the curious divergence, in this respect, from other modes of discourse on art, which do not so exclusively cultivate the historical paradigm:

Standardly we do not call the objective study of an art the history of that art. We call it criticism. We talk of literary criticism, of musical criticism, of dance criticism. What then is a special feature of the visual arts, something which must be over and above the general way in which all the arts are connected with a tradition, and which has, allegedly, the consequence that, if we are to understand painting, or sculpture, or graphic art, we must reach an historical understanding of them? I do not know, and, given the small progress that art-history has made in explaining the visual arts, I am inclined to think that the belief that there is such a feature is itself something that needs historical explanation: it is an historical accident.[2]

Of course, both these comments, written in pursuit of quite different arguments, amount at the same time to a reopening of the question of

what art history can contribute to contemporary criticism. Wollheim, who is discussing not only Giovanni Bellini and Ingres but also De Kooning in his lectures on 'Painting as an Art', takes the view that we can discover things about a work by looking long and hard at it, and the transcription of these findings into words is not an essentially different process whether the work dates from a few years ago, or a few centuries. Bryson, in his editorial remarks, points to a culture in which the different modes of writing about the visual arts are not so rigidly compartmentalized by institutional protocol. The French critic, whether or not he considers himself a historian, participates in a 'broader intellectual horizon' than his Anglo-Saxon counterpart.

A distinction of this kind can appear too absolute. The case of Michael Fried is relevant, perhaps, as a counter-example. Here is a writer and academic who began as a distinguished critic of contemporary art, in the tradition of Greenberg, and progressively deepened his historical knowledge and his overall grasp of the theory of visual representation until Manet, David, Chardin, Courbet and many others were incorporated in a macro-historical argument which still maintained its relevance to the crucial critical distinctions of the early writings. A parallel case in France would be Hubert Damisch, whose systematic control of the notion of perspective in its process of historical transformation informs his contemporary criticism of Pollock and François Rouan, as well as his studies of the Italian Renaissance. For both Fried and Damisch, one senses, the vivid response to the art of their own period is not in any way a dispensable luxury or a distraction from sober scholarship. It is a way of focusing on the genealogy of the present, since the contemporary work (properly anatomized and scrutinized) broadcasts its history no less surely than a living cell reveals the genetic code to an attentive scientist.

Yet in spite of the case of Fried, Bryson is right in giving the French phenomenon its due weight. It would be hard indeed to find in the English-speaking world the equivalent of a young art historian like Georges Didi-Huberman, whose remarkable and sustained work on the Christian tradition of representation has generated, by a process which seems only too gracefully appropriate, a special interest in some of the most rewarding of contemporary artists and an ability to demonstrate his creative ideas as a curator of exhibitions. In this collection, however, Yve-Alain Bois is able to demonstrate brilliantly that the investigation of the work of a contemporary artist is at the same time a deconstruction and a reconstruction of a complex historical process. Bois does not deny that it would have been possible to discuss the reliefs of Susan Smith in a

more conventional fashion, for example by relating them to the colour studies of Albers, or the experience of tactility which has been repressed in the discussion of contemporary art since Cubism. But he prefers to consider them as initiating a 'dialogue between the sphere of art and the world at large'. Like Damisch and Didi-Huberman (both his colleagues, at one stage, in the group around the French magazine *Macula*), Bois recognizes that the criticism of art, at the present day, inevitably brings with it the history not merely of art, but of the history of art. What he calls the 'crisis of the modernist paradigm' entails a fresh look at the dialectical relationship between the art work and the discourses which have been used to validate it historically. The work itself can be envisaged, pre-eminently, as a testing of the limits of 'museability'.

So the French critical mode, as Bryson identifies it in *Calligram*, is an important paradigm for many of the contributors to this volume. But it would be a mistake to conclude that Paris has simply recovered, in the realm of writing on art, the hegemony which it once possessed as the pre-eminent centre of modernist painting. For one thing, the French approach (if we may generalize in this way for a moment) has already been integrated to a certain extent in the historical development of other critical schools. In Britain, for example, the immensely influential aesthetic criticism of Ruskin and Pater, whose effect can be gauged in the all-encompassing prose of Proust, met with a temporary reversal when critics of the next generation like Fry and Bell tried to purify their perceptions and strip them of any element extraneous to the recognition of pure form. Fry and Bell were accused of judging all art, and particularly that of their native country, by the standards of French Modernism. Their successor, Adrian Stokes, can be seen as having effected an ambitious synthesis between the formalist approach, with its minute attention to painterly values and its cult of Cézanne, and an aesthetic criticism revivified and given new exegetic power by the incorporation of the concepts of Kleinian psychoanalysis. Richard Wollheim, whose questioning of the division between art history and criticism has already been endorsed here, owes much of the confidence with which he pursues a psychoanalytically based art criticism to the example of Stokes. The same could be said for our contributor David Carrier, who has not abandoned Stokes's cherished project of finding a resonant accord between the best contemporary work and the great paintings of the Renaissance tradition.

Art criticism in the United States has had to rely, no doubt, on more shallow roots. But it would be ridiculous to ignore the vitality of the

critical interchange which helped to fuel the development of the Abstract Expressionist movement. The reason why none of our contributors would align themselves with the critical positions of Clement Greenberg or Harold Rosenberg is probably a simple one. Both of these critics, in spite of their deep divergences of theory and tone, are inevitably spokesmen for the New York School at the time when it was laying claim to the same primacy in the world of contemporary art as Paris had effectively possessed from the 1860s until the 1920s. Yet, criticism now has to be written – as all our contributors would surely agree – from a position where neither Paris nor New York can be seen as the unquestioned centre. This does not mean that centres, in the plural, no longer exist: the cultural world of Jannis Kounellis (as explored here) involves the implicit dialogue between centres, Rome and Byzantium, Rome and Vienna, as well as the effects of the artist's practical decision to make his home in the old imperial capital. But it does mean that some of the most interesting challenges for the contemporary critic emerge not at the centre, or centres, but at the margin. Wystan Curnow's essay on Colin McCahon, the New Zealand painter, is a comprehensive investigation of the issue of marginality, in its different nuances of significance, and it convincingly establishes McCahon's claim to be a modernist artist of real importance, rather than a provincial seen through the eyes of the 'New York viewer'.

To confine this discussion to the competing claims of Paris and New York, or indeed to the reaction of the 'margins' against the 'centre', would, however, be a further mistake. As it happens, only one of these essays focuses on a European, that is to say non-British, artist: the Greek-born, Italian by adoption Jannis Kounellis. The significant development of German art in the last two decades is not directly noted. But what is noteworthy – and what forms another modification of the French paradigm – is the importance which German aesthetics and the German philosophical tradition have come to occupy in the critical approaches of a number of our contributors. It is perhaps no accident that, in the period when such artists as Beuys, Richter and Baselitz were acquiring their reputation, German writing on art was also being restored to a place which it had temporarily lost in the postwar period. Significant pointers from the 1980s would be a series of translations, such as Rilke's essay on Rodin (with an introduction by the British sculptor William Tucker), which was published in 1986, and Gadamer's collected essays, *The Relevance of the Beautiful*, which appeared in the same year. Of course, the way in which German philosophers of our century, in particular

Heidegger, were reflected and refracted in the aesthetic writings of Jacques Derrida is no less significant, and argues against any facile polarization between the German and the French schools. Nevertheless, it is worth noting that not a few of our contributors have felt the need to return to German ideas at their source: David Reason invokes Hegel and Nietzsche as well as the Frankfurt School in his characterization of the critic's role, while Michael Newman brings Heidegger as well as Wittgenstein into his assessment of the place of the art work in the world. Yve-Alain Bois uses Nietzsche's ideas on history, as well as the persuasive views of the art historian Alois Riegl on the cult of the monument, to explain how the abstract relief achieves a critical distance from the contemporary scene.

These brief references will be enough to show that our contributors do not minimize the critic's task. Their aim is to integrate the art object within the wider horizons of historical and philosophical discourse. At the same time, David Reason is quite right to insist that criticism should be seen as 'a kind of tactical diversion whose goal is to exhaust words'. So a lot depends on the tactics; a lot depends on precisely where the diversion goes. It would be fair to say that most of these essays exhibit the structure, if not of a diversion, at least of a digression. The very incommensurability of a single work (or group of works) and a single piece of writing on that work comes starkly home to us – how could we ever expect to pay attention to a visual work for the same time as we take to read the piece of writing, and with the same mode of attention? Consequently, the strategy must be to organize our means of departing from the work, with the proviso that we are likely to be brought back to it, perhaps suddenly, so that we see its unexpected side. But this is not just an arbitrary process of defamiliarization. The point is that the work is always, already, implicated in the discourses which have constituted it. It is part of the discursive formation which is history of art and which comprises the lengthy evolution of the detached, framed picture from its original architectural placement (or a comparable process in the case of sculpture, as Michael Newman points out in relation to Rilke's comments on Rodin). It is part of the discursive formation which is history of philosophy, in so far as the very process of perception has been mediated by philosophical categories, from Kant and Hegel to the phenomenologists. The individual work is the thread which can elicit a whole structure of thought and feeling: the trick is to work such a slender connection without overloading it.

It is up to the reader to judge how far this aim has been successful. As

we noted at the beginning, this is not a collection of essays which takes its stand on any particular position, except for the implicit point that such a volume is timely, as we are launched into the last decade of the twentieth century. It signals, as we have noted, a convergence between the concerns of art history and contemporary criticism which is not an isolated or unimportant phenomenon. And, perhaps as an inevitable result of this broader historical perspective, it betrays a certain irritation with the critical strategies which have most vociferously competed for attention over the last few years. David Carrier cites the fashionable view that 'art in the 1980s [was] involved in a kind of endlessly prolonged Postmodernist end-game' and detects a certain complacency that lies behind this apparently bleak and radical view. Paul Smith refers to the tendency of Postmodern artists to offer not so much 'a hermeneutic puzzle to be solved' as 'a reified process of labour whose meaning might not exist at all as an object to be deciphered for its statement or message or position, but only as a set of relations'. His comparison between Salle and Lemieux, however, implies a rupture in this practice, with Lemieux returning to the 'specificity of the look' – 'bringing back the possibility of reverie and meditation to the spectator's experience of the art work'. In a similar way, Yve-Alain Bois excoriates the 'yuppie punk artists' of the last decade and the cynical ideology which supported them, putting forward Susan Smith's work as a 'guerilla archaeology' to combat the mindless slogans of apocalypse.

All this amounts, if not to a programme, at least to a shared orientation. It can also be found in those contributors who are less centrally concerned with deflating the bubble of Postmodernism but whose choice of artist itself demonstrates a kindred stance: Marcelin Pleynet examining the career of one of the most long-lived and productive of American modernist painters and, moreover, giving special attention to his encounter with the 'otherness' of modernist writing; David Moos and Rainer Crone making a plea for the ontological self-sufficiency of painting, in connection with an American artist who has defied the repeated warnings of the 'death' of the genre (David Carrier's chosen painter has had a similar ability to survive the repeated tolling of the funeral bell). To stand apart from all the frantic fuss of the accelerating art world is a liberty which artists have to fight for, and critics also should be concerned to defend. It is a liberty which we hope to have made possible for our readers through this volume of essays.

Art and Literature: Robert Motherwell's Riverrun

MARCELIN PLEYNET

'Why, why, why! Weh, O weh! I'se so
silly to be flowing but I no canna stay!'

James Joyce, *Finnegans Wake*

By what title?

Take this painting: *Riverrun* (p. ix), acrylic on canvas, 152.4 cm by 381 cm, completed in 1972 by Robert Motherwell. With no immediately identifiable elements of definition, it offers itself to us as a vast chromatic field in its breadth; quantitatively it is dominated by the arrangement of transparent areas of a grey-blue, with a pale green – itself also playing on the effect of transparency – constituting an event in suggesting at the same time the establishment and the dissolution of a vertical partition in the overall plane of the painting. Off centre a little to the left, a fine, clear line implies the structural development of the arrangement of colours. Meanwhile, a little to the right of centre a figure composed of three black semi-verticals, underlined by a horizontal of the same colour, appears at the top of the painting to constitute an event which will determine the phenomenological effect of the work as a whole.

Apart from the complexity of the chromatic and graphic elements which it displays, this painting offers us none of the other customary signs of recognition which might capture our attention. As a painting (a picture) we naturally associate it with the history of painting, and the complexity of the elements which constitute it incites us to ask questions about the way in which they operate within the framework of this history. But how could we not be suspicious of the seductive power exercised upon us by this vast picture plane which seems to have no normative element to appeal to our judgement? Are we to think that these patches of colour play the same role in the history of art as the ink blots of the Rorschach test play in the history of psychology? Would that not be in fact a way of excluding

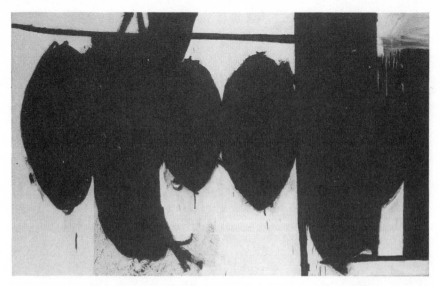

Robert Motherwell, *Elegy to the Spanish Republic No. 70*, 1961, oil on composition board, 175.3 cm × 289.6 cm. The Metropolitan Museum of Art, New York.

such pictures from the history of art and assimilating them more essentially to the history of psychology? So what kind of a statement is embodied in this picture which Robert Motherwell painted in 1972? How do we come to terms with it? By what title are we to understand and judge it? What criteria should we use to support our judgement?

Engaged in such a process of analysis (from which the element of psychological projection cannot be excluded), we will obviously, at an initial stage, situate this particular work within the framework of the artist's work in general and conclude that it draws on a set of signs which can easily be detected in the paintings which precede it. Division of a rectangle on its side into vertical planes occurs in the work of Motherwell from 1943 onwards (with *Pancho Villa, dead and alive*); it appears in a clear and significant way in *La Résistance* (1945), and no doubt it is *The Voyage* (1949) which for the first time provides it with the function which it is to perform in so spectacular a way in the *Elegy to the Spanish Republic* series, which had already gone past a hundred when Motherwell completed *Riverrun*. The predominantly horizontal planes of the vast *Open* series were also to be constructed in vertical sequences, especially with *Open No. 11* (1968). Another constant element in the artist's work, one that obviously plays a different sort of role according to the overall organization of the painting, can be detected in the placing of the graphic element which most frequently comes towards the top, if it is not actually

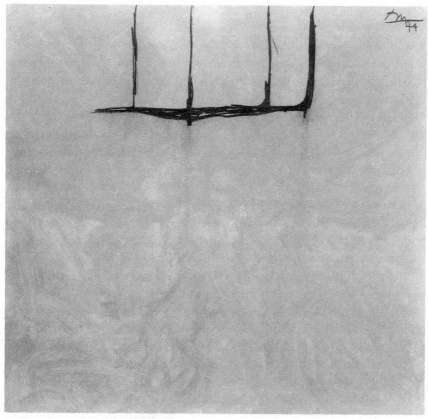

Robert Motherwell, *A La Pintura No. 7*, 1974, acrylic on canvas, 203.2 cm × 215.9 cm.

attached to the upper edge of the canvas, as in the very famous *Elegy to the Spanish Republic No. 70*, now in the Metropolitan Museum of Art, New York. The graphic element of a sort of trident which appears in *Riverrun* can be found in subsequent works, but it seems to establish its function in this great painting from 1972. Certainly a three-toothed figure can be picked out in a number of other pieces: as early as 1941 high on the right of *Spanish Picture with Window*, in 1959 at the bottom of a collage (*Greek Collage*), in 1970 as a specifically structural element in *White on Tan*. But there can be no doubt that *Riverrun* is the first work to present it in all its dynamism, even though it seems to have been invented within a sequence of works, extending from the two parallel series of the *Open* pictures (*Open No. 1* dates from 1967) and the prints which accompany Rafael Alberti's poem, 'A la pintura', giving rise to the paintings of the same title, such as *A la Pintura No. 7* of 1974.

I will come back to the way in which these three different moments in the work of Robert Motherwell are interlinked. For the moment, what I would like to stress, without going any further into the interpretation of the system of signs which constitutes the work, is the way in which a painting like *Riverrun* shares in (and is formed within) the logic of a certain number of signs which are the painter's own, with the effect that they create a resonance, they tend to establish a meaning which is the artist's own meaning. It remains to be seen how far his own meaning can possibly be communicated and to what extent the participation in which it involves us can be made intelligible. If we recognize in the work a system of signs which are coherent as far as the work is concerned, we already have a basis for judgement in this internal coherence. Given that any psychological structure has, in itself and for itself, a coherence of its own, we are also obliged to investigate what may be the structure of this system of signs and discover to what extent it goes any further than a more or less complex psychological feature which we would only be able to make contact with in an episodic way.

We can without any doubt locate Robert Motherwell's own attitude within the specific context of what is called 'modern' art. This is a context to which he lays claim, like the majority of the painters of his generation and those which follow, in an explicit fashion. Thus we can see that the set of signs which constitutes and establishes his work both acknowledges and transforms a vocabulary and a syntax which are generally held in common by a certain number of artists. Numerous studies have been done of this formal (formalist) community, and it has become established as a dogmatic principle under the symptomatic title of modernist 're-duction': that is to say, the constitution of groups of forms reduced to nothing but themselves. This merely constrains any judgement within the limits imposed by the notion of a specific system, closed in upon itself, and so does nothing but generalize, under the label of the 'modern', the problem posed by any form of singular psychological experience. The closed system of modernism displaces onto the level of the school, the group or the movement the impenetrability of a discourse which has only its own problematic for an object and is thus caught up in the unending race of a process without a subject. As a significant attempt to conceive of the constitution of vocabularies of signs whose relationships do not immediately imply a conventional type of communication, modern formalism displaces the critical focus from the individual symptom (a language which would only make sense for a single speaker) to the

cultural and semi-collective symptom (a society or a social group which would not wish to know what goes on inside it).

If we move on from the question of the greater or less degree of opacity in a system of singular signs (that specific to Robert Motherwell, for example) to the way that system functions within a theory which restricts the operation of groups of forms to nothing but themselves, we are abandoning for some curious reason any chance of discovering what title the work has to claim our attention. We are abandoning the chance of discovering the subject in the work which claims our attention. The most we can hope for is to be a little more careful in our appreciation of the way in which the signs put in front of us are ordered and arranged.

The title

'Title: borrowed from the Latin *titulus*, expressing a distinction of rank, a dignity – inscription, honorary title. Designation of a proportion: "ingot of a certain title". Designation of a subject: name given to a work by its author.'

In the phenomenological description of pictures, just as in their formal analysis, it is usual to take no account at all of one element: the title. Generally the artist exhibits a degree of embarrassment in referring to the titles which he gives to his pictures; the critic rarely sees the title of a work as being anything more than a handy way of designating a picture which would otherwise be hard to identify. Robert Motherwell himself has often told me that he would rather people did not spend too much time on the titles which he gives to his works. He has, moreover, insisted on a number of occasions on the randomness of his choice of titles. With regard to *Mallarmé's Swan* (1944) he has published the following note: 'This work was first titled *Mallarmé's Dream*. Joseph Cornell, with whom I shared in those days a lonely preoccupation among American painters with French Symbolism, misremembered the title as *Mallarmé's Swan*, which along with white or blackness was the symbol for Mallarmé of purity. I preferred Cornell's misremembrance, and the picture has been so named ever since.' And apropos of *The Homely Protestant* (1947–8): 'I could not find a title for possibly my most important "figure" painting. Then I remembered a Surrealist custom, viz. to take a favorite book and place one's finger at random in it. In *Ulysses* or *Finnegans Wake*, I forgot which, my finger rested on the words "homely protestant", and I thought, "Of course, it is a self-portrait".' A similar influence from Surrealism can be found in Arshile Gorky who, like André Breton, drew the title for some of his pictures out of a hat. Together with the custom of

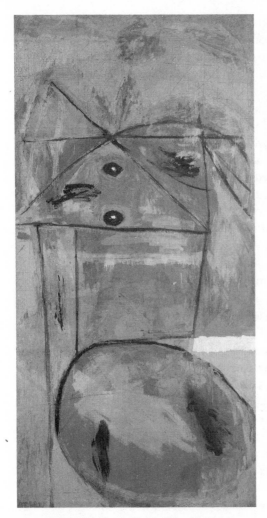 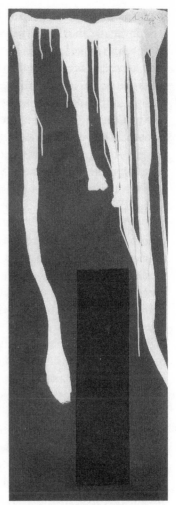

LEFT Robert Motherwell, *The Homely Protestant*, 1947–8, oil on composition board, 243.8 cm × 122.6 cm. The Metropolitan Museum of Art, New York.

RIGHT Robert Motherwell, *River Liffey (Dublin)*, 1975, acrylic and collage on canvasboard, 182.9 cm × 61.0 cm.

reducing the work's title simply to the process of creation, as with an abstract painter like Mondrian who began in 1912 to make more and more systematic use of the generic title 'Composition' followed by a number and date, it impelled Jackson Pollock to confine the titles of his paintings to a simple number (thus emphasizing the quantity produced during a single year). This has a certain significance, bearing in mind the

situation of art in the United States at the end of the 1940s and the way in which the art market has subsequently developed. In any case, it should be noted that these attempts to exclude titles of a more essentially literary type never succeeded in gaining a complete hegemony, that some of Gorky's titles have nothing to do with the Surrealist game, and that Pollock expands his titles by keeping the number relating to his annual production and adding a qualifying term which may even be naturalistic, as with *Number 30: Autumn Rhythm*. In the same way, Motherwell uses for the title of a series painted in 1962 the indication of the place where it was completed: *Beside the Sea*.

What has not been sufficiently noted is the fact that, however reduced it may be (with regard to the process of realization: Mondrian, *Composition with Red, Yellow and Blue*, 1939–42, or the number of the work within the year's production: Pollock, *Number 32, 1950*), the title can in no case be pictorial. Since it cannot in any way be a pictorial effect, it is inevitably confined to description (even if it only describes its place in the career of the artist); it is literary and, to the extent that describing is the opposite of defining, belongs to a literature which is more or less legendary.

The titles of the vast majority of the works making up what is commonly called the history of art are borrowed from religious literature (the Bible) and classical literature (Greek and Latin), usually with a mythological basis. But we should also take account of the spontaneous development which nowadays impels us to classify as works of art a large number of objects which were at first only considered as cult objects and have acquired their measure of formal inventiveness through invoking some legend or other (this goes for what we call nowadays 'African art' or 'Aztec art'). Even if we look at the forms of representation which were specific to the development of bourgeois societies, we still find that they involve a more or less legendary and metaphysical story of the way in which the goods and property of a particular social class, group of individuals, family or single exemplary figure have been constituted. Courbet well recognized this fact when he gave the dimensions of the history painting to the two works which explicitly celebrated his own personal adventure: *Tableau de figures humaines, historique d'un enterrement à Ornans* and *L'atelier du peintre, allégorie réelle déterminant une phase de sept années de ma vie artistique*. And as I suggested above, it is no accident that Pollock's system of numbering forms the legendary foundation of the market in modern art in the United States.

So the attitude of modern and contemporary artists to the titling of

their works is most often the sign of a malaise (or at best an ambivalence) with regard to the symbolic system in which their imaginary life, to a greater or lesser degree, structures and deploys its creative potential. We should note that, in such a context, the practice of Motherwell forms a surprising exception. It is indeed worth asking oneself if the care which he takes in establishing, little by little, a series of extra-pictorial references which are exclusive to his own work is not a precise measure of the wholly individual character of his working procedure. The system of references in Robert Motherwell's work is extremely complex and rarely permits the attribution of univocal meanings. I have already emphasized the interdependence of the references to painting, biography and political and social life in works like *The Little Spanish Prison* (1941–4), *La Résistance* (1945) and the series *Je t'aime* (1955).[1] This type of interpretation could be extended, and I am convinced that virtually all Motherwell's work could be assessed in these terms. These references, however well integrated they may be in the process of painting, would at the same time become embarrassing because of their very anecdotal precision if they were not, at the same time, woven into the texture of a much larger cultural whole. And since they consist inevitably of anecdotes, discursive events, literary references and legends which are capable of determining the act of painting, it is literature itself which finds itself charged with the task of effecting a metamorphosis. The particular event – historical, political or biographical – realizes itself as painting (pictorial language) within the dimension of a fiction which can take charge of it, by incorporating it within a group of symbolic structures which are as far-reaching as they can be. And in fact it does seem as though literature has been charged with playing this role. There can be few bodies of work like that of Motherwell, if indeed there are any others, in which the number of references to works of literature is so high. There is Baudelaire (*The Voyage*, 1949); Mallarmé has already been cited. One group of collages is actually in a sense dedicated to a great French publishing house (the NRF collages, 1959–60). Motherwell makes no secret of his interest as a young man in French literature 'from Baudelaire to Symbolism and from Proust to the writers of the NRF'. This must obviously have been a good introduction to the authors who were subsequently to find themselves associated with his work: among others, Rimbaud, Joyce, Federico García Lorca, Rafael Alberti, Octavio Paz, T. S. Eliot, Robert Frost, etc. In this connection it is worth noting not only the presence of the great French poets but also the presence of the French language in the titles of his works (*La Belle Mexicaine*, 1941; *La Danse*, 1952; *La Résistance*,

1945; *Histoire d'un peintre*, 1956; *Je t'aime*, 1955; *Guillotine*, 1966; *Gauloises bleu*, 1968; *L'art vivant*, 1972; *Pierre Bérès*, 1974; etc.). Indeed, the French language also occurs within the work itself in a sequence of paintings (*Je t'aime*) of which the artist has said that they are an affirmation of his capacity to love 'in painting'.

It is clear that the link between Motherwell's art and a work of literature became established in quantitative terms first of all with the *Elegy to the Spanish Republic* collection, which already consisted of more than 167 pictures by 1985. We know that the decisive inspiration for this series of works passes from a poem by Harold Rosenberg to a poem by Lorca ('Llentos per Ignacio Sanchez Mejias'), whose very first line ('At five in the afternoon') will serve as a title, in 1949, for one of the studies which may be regarded as the formal matrix for the *Elegy to the Spanish Republic* works. But it should be noted that already in 1955, when Motherwell had painted nearly fifty of the *Elegy* series, the ovoid forms of these works and the vertical division of the plane of the canvas can be identified with *Je t'aime No. 2*, one of the finest in that group, and that there is consequently a large body of paintings which have a tendency to express (to communicate) *in French* the artist's affirmation in which he declares and claims for himself the constant real possibility of being able to love in painting (with painting), even if all the rest were to abandon him. Motherwell has declared apropos of the *Je t'aime* series: 'When Rothko first saw these paintings, he loved them. He understood that they were an assertion that I can love, a desperate assertion.'

However, the matter cannot rest there. The artist's affirmation that he has recourse to French language and literature because his tastes and his scholastic studies impelled him to read and more or less devote himself to a certain number of writers and poets remains a little short as an explanation. However familiar Robert Motherwell may be with French literature, it remains inevitable that French should be a foreign language for him: an 'other' language, just as literature always remains an 'other' language for the painter – a language other than the one in which he expresses himself, that is, the language of painting. By the same token, this gives a particular character to the function of literary reference within the domain of painting: it forms part of plastic creation in the same measure as it is 'the other' of painting (not being homogenous with, but heterogeneous to plastic creation). Motherwell's use of French, a language other than English, the painter's mother tongue, bears witness not only to the fact that the painter is capable of using a tongue other than his own but also that he is concerned with exploiting the dynamism of his

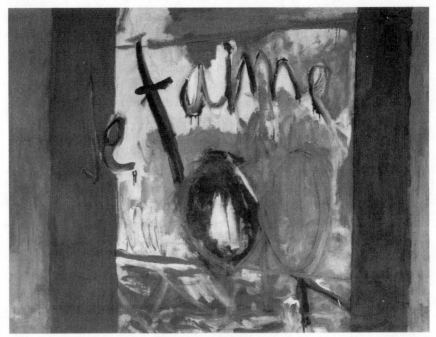

Robert Motherwell, *Je T'aime No. 2*, 1955, oil on canvas,
137.2 cm × 182.9 cm. Private collection.

own tongue's specific qualities by confronting it with forms which are
foreign to it. The French language thus also has the function of conveying
that literary reference can function as the 'other' of painting, as the
'other' of a type of painting which is capable of carrying out the singular
logic of its encounters – encounters which are assumed by the artist in
their heterogeneity and lived, in just the same way, under the declarative
logic of the 'Je t'aime', an affirmation of love.

The way in which such a process works itself out can only be complex
in the extreme. In order that the French language should fulfil in
Motherwell's work the function that I am attributing to it, it must
absolutely necessarily be confronted with the artist's language of origin.
For French to offer itself as an 'other' language (and for literature to be
the 'other' of painting) there has to be the English language and its
literature. Here Motherwell's genius is to have known spontaneously
how to choose within his own language the linguistic event which serves
most effectively to make art and literature operate in this way. We should
note in effect that, if Motherwell frequently refers to Surrealism, to
automatic writing, to his collaboration with *VVV*, to his meetings with

the Surrealist writers and painters in exile in New York, there is absolutely no trace in his work of explicit quotation from Surrealist literature. And even if the process by which he entitled *The Homely Protestant* in 1947–8 can be called Surrealist, the title chosen in fact refers back to a body of work which we cannot possibly suspect of belonging to the Surrealist movement, even remotely. As we noted before, in writing about *The Homely Protestant,* Motherwell supplies us with the following details: 'I could not find a title for possibly my single most important "figure" painting. Then I remembered a Surrealist custom viz., to take a favorite book and place one's finger at random in it. In *Ulysses* or *Finnegans Wake*, I forget which, my finger rested on the words "homely protestant", and I thought, "Of course, it is a self-portrait".' Motherwell not only gives us the information that, by 1947–8, he was already interested in Joyce ('a favorite book') but also, following the objective order of chance, attributes the recognition of the '*self*-portrait' to a confrontation with the fact of literature.

More than one title
Robert Motherwell's interest in Joyce's work goes back a long way beyond *The Homely Protestant*; he has confided to David Hayman that it was on his first journey to Europe in 1935, when he was twenty years old, that he bought and read *Ulysses*. In the essay which he has written on the recent illustrations completed by Motherwell for the Arion Press edition of *Ulysses*, David Hayman establishes that the book which in 1947–8 gave its title to *The Homely Protestant* was in fact *Finnegans Wake*. It would appear that after its baptism in *The Homely Protestant* in 1947–8 (to coin a phrase) Joyce's presence in Motherwell's work becomes less explicit for a number of years. But is it not worth taking into account the fact that during these years the painter's work is establishing its own order and logic with regard to the symbolic system which is Motherwell's own and offers itself for decipherment today? *Elegy to the Spanish Republic No. 1* dates from 1948; *At Five in the Afternoon* (another matrix for the *Elegies*) dates from 1949, *Je t'aime No. 2* (with the French word intruding into the painting) from 1955, the group *Beside the Sea* from 1962; the *Open* series begins in 1967 and develops around 1971–2 with the completion of *A la Pintura*. It is in accordance with the logic of this semantic accumulation – and more especially with the gesture which combines the quasi-theoretical radicality of the *Open* series with *A la Pintura* – that the Joyce text makes its return explicitly as the presence of the 'other' language: that it manifests itself as the indispensable foreign

Robert Motherwell, *Open No. 35 (Raw Umber)*, 1968, acrylic and charcoal on canvas,
193.0 cm × 289.6 cm. The Metropolitan Museum of Art, New York.

body, heterogeneous to the language of painting, as the indispensable
element in the intelligence of the creative process.

Riverrun, painted in 1972, displays in monumental fashion (152.4 cm
by 381 cm) and with sumptuous effect the possibilities which painting
possesses of holding a discourse on itself which is not limited to pure
formal variation. We should approach a work like *Riverrun* bearing in
mind the radical strictness of the *Open* series. In these works, Robert
Motherwell demonstrates yet again and with unprecedented rigour the
fact that in painting rhetoric is capable of producing a great pictorial art.
With the *Open* series, the simple formal operation engages with a
complex discourse, if only to the extent that it takes up (in the artist's
own words) 'a subtle but real reference to one of the most classical themes
of modern art: that of the window, or of the French window'. In so doing,
it also involves one of the oldest of pictorial metaphors, which brings
together the gaze, sight and the picture in identity with the eye, itself
conceived as a window on the world. There can be no doubt that
Motherwell knew of Alberti's work and Leonardo's *Trattato della
pittura*, and the strength of the *Open* series derives in the first place from

the way in which a form which traverses the whole history of Western painting is put into play rhetorically and finds itself reanimated in an astonishing way by this American artist at the very moment when minimal art had almost made people forget that painting could have a history. However this may be, can we fail to mention Leonardo's *Trattato della pittura* when we note that Motherwell addressed himself to completing a number of works from the basis of a poem which had as its title *A la Pintura*? This has to be said with due regard to Motherwell's modesty and the reservations which are imposed by the poverty of the surrounding culture.

So it is impossible to consider the *Open* series, and the way it is employed in *A la Pintura*, without taking account of the discourse which is explicitly put before us. This discourse, although essentially pictorial, is also of a high degree of theoretical rigour, a rigour precisely capable of taking in what the art of the second half of the twentieth century has studiously tried to forget: that rhetorical mastery is a major condition of the disposition of discourse. Again it is necessary to understand this and, with the *Open* series passing by way of *A la Pintura*, to provide pictorial discourse with the challenge of an encounter on equal terms with *Riverrun* . . . in other words with what is by no means accidentally the first word of *Finnegans Wake*. The revelation of painting as an 'other' language and of literature as the 'other' of pictorial language goes to the very heart of the theoretical instrument. This literary language, the English of Joyce, plays in relation to the whole of the body of Motherwell's work the same role as is marked (in French, a foreign language) by the *Je t'aime* series: it invokes the amorous impulse, the erotic drive, the eroticization of the act of painting through treating it to a chance encounter with the 'other' (compare again the game as a result of which the 'self-portrait' of 1947–8 came to be entitled *The Homely Protestant*). We should recognize that the *Je t'aime* series is conditioned by a relationship to painting ('a la pintura') which is its main feature, but that it also involves a situation which is more intimate; and one can follow the role of French and English in lending themselves to the spontaneity of inspiration and the gesture of painting by having regard to the distinction drawn by Motherwell between the process which led him to complete an engraving for my collection of poems, *L'Amour Vénitien*, and the process involved in his recent plates for Joyce's *Ulysses*. David Hayman writes: 'Motherwell ascribes the difference between the Pleynet and the Joyce images to his own sense of what is appropriate for a French as opposed to an American eye.' And he quotes Motherwell as saying:

'Deep in my unconscious and maybe somewhat consciously, too, I knew from the beginning that in Pleynet's case I was doing something appropriate to a modern French poet, something that had to be appropriate for "French art" . . . The Pleynet image is fine and subtle and slightly erotic. With the Joyce I often did the opposite. I used heavy almost coarse and brutal lines.'

Although I am quite aware of the incongruity in comparing my volume of poems with *Ulysses*, I am quoting Motherwell's words, none the less, in the conviction that he has never declared in such explicit terms the form of organization which enables him to assume the reality of the 'other' language in pictorial terms. For the first time, as far as I can see, Robert Motherwell allows it to be understood that the role played in his work by the specific activity which is the encounter with 'the other' (the other of painting, the other of the English language) is not completely unconscious for him ('Deep in my unconscious *and maybe somewhat consciously, too*'). If we are to believe the statement made by David Hayman, ('Motherwell ascribes the difference between the Pleynet and the Joyce images to his own sense of what is appropriate for a French as opposed to an American eye'), the painter is identifying the 'American eye' with Joyce's English. Taking into account all the statements which David Hayman has published, it would appear that French is indeed the 'other' language and the English of Joyce the language of Motherwell, a language which in accordance with a singular process (unconscious and conscious) contributes to creating a particular pictorial language, with the artist's 'American eye'.

From *Riverrun* (1972) to the illustrations for *Ulysses* (Arion Press, 1989), Motherwell makes more and more references to Joyce, as if he wished to be especially insistent on an aspect of his work which had previously passed almost without notice. He paints the *River Liffey*, dedicated to James Joyce ('For James Joyce') in 1975, *Stephen's Gate* in 1981; he devotes a part of 1972 to two sketchbooks inspired by Stephen Dedalus, *The Dedalus Sketchbooks* (one of the drawings is based on the graphic form of the French words, 'Je t'aime'). It is worth asking if *The Sirens*, from 1985–8, does not refer back to *Ulysses*, since in the same year Motherwell realized (at the age of 73) in his *A Rose for James Joyce* an iconographic achievement which could be regarded as having the same degree of importance in his work as that of *At Five in the Afternoon* in 1949. *The Feminine II*, in 1989, is yet another confirmation of the inventive force and the inspiration which appeared in *A Rose for James*

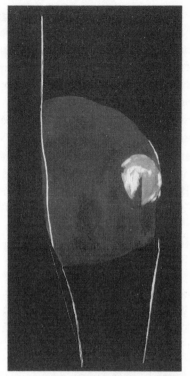

Robert Motherwell, *A Rose for James Joyce*, 1988, acrylic on canvas,
198.1 cm × 96.5 cm. Private collection.

Robert Motherwell, *The Feminine II*, 1989, acrylic on canvas, 223.5 cm × 304.8 cm.

Joyce, which I personally consider to have been inspired by the figure of Molly.

Beyond any doubt, from *Riverrun* to *The Feminine II* and the plates of the Arion edition of *Ulysses*, Motherwell is not simply placing the accent on one of the most influential of the elements which inspired his paintings, but he also seems to be profiting from this emphasis on Joyce to give his work a fabulous new impulsion. Let us remember that the *Open* series and *A la Pintura* are the splendid reactivation of one of the elements of pictorial rhetoric (the identification between the eye and the window), and similarly the reference to Joyce (*Ulysses* and *Finnegans Wake*) confirms the place of classicism and tradition within the lively, dynamic thinking of modern art. With *Riverrun*, Motherwell is not choosing for the title of his painting the first word of *Finnegans Wake*; he is choosing the current (*run*) which brings back the last sentence of Joyce's work ('A way a lone a last a loved a long the') into the first ('riverrun, past Eve and Adam's, from swerve of shore to bend of bay, brings us by a commodius vicus of recirculation back to Howth Castle and Environs'). Thus it comes as no surprise that the next painting bears the title, the *River Liffey*. The *Open* series and *A la Pintura* (see especially *A la Pintura No. 7*, 1974), which make manifest most explicitly the declaration of the painter's art, find in *Riverrun* the current, the pictorial flux whereby the ancient, returning eternally in the new, generates an opening by curling back on itself and returns always as the other and never comes to an end: 'Why, why, why! Weh, O weh! I'se so silly to be flowing but I no canna stay!' What can be thought, painted, written, always lives, art or literature, by more than one title.

Translated by Stephen Bann

2

The Shining Cuckoo

WYSTAN CURNOW

I

Passages through which the thought of superseding a focus might move.
Arakawa and Gins, *The Mechanism of Meaning*

Like most members of the order, the Shining Cuckoo is parasitic, its
principal host being the Grey Warbler and the Chatham Island Warbler.
W. R. B. Oliver, *New Zealand Birds*

This essay is about a painting by a remarkable yet not well-known artist.
Colin McCahon lived and worked at the margins or, as I will sometimes
want to put it, outside the limits of the art world. He painted *The Shining
Cuckoo* in his studio at Muriwai Beach outside of Auckland, on the
Pacific coast of the North Island of New Zealand, in October 1974.
October in this hemisphere is late winter/early spring, about the time that
most of the Shining Cuckoos have arrived from the Solomon Islands,
some two thousand miles to the north, and the beginning of the artist's
painting year.

First exhibited the following month in Wellington at the Peter
McLeavey Gallery, it was three years later presented by the artist to the
Hocken Library of the University of Otago, in Dunedin.[1] McCahon grew
up in this small South Island city, and it is a feature of the Hocken's
splendid collection of New Zealand art that it contains so many of his
works. No sooner had this painting found a home there, however, than it
was dispatched on its first national tour – as part of 'McCahon's
Necessary Protection', a selection of works from the 1970s. In 1984 it
was included in 'I Will Need Words', a show of his text paintings
assembled for the Sydney Biennale and the Edinburgh Festival of that
year. In 1990, *The Shining Cuckoo* returned to the United Kingdom, to
the ICA in London, and flew again to Australia, as part of the exhibition,
'Colin McCahon, The Language of Practical Religion'.

The Shining Cuckoo (p. xi) is by now a well-travelled painting. A migratory bird of a work. And travels change a painting. Of course, paintings change all the time; they seem to expand or contract, taking up or abandoning this or that discursive space. And, as here, such changes may correspond to, or be prompted by, literal movements, may reflect 'overseas experience'. *The Shining Cuckoo*, I have said, has its home and does belong, as New Zealand itself belongs, outside what we call the art world. What has been written already about McCahon, and there is a quantity of it, tends to disregard, if it does not actually precede, the passage of his work across the border with this art world.[2] And commentary consequent upon its arrival there, such as Kiron Khosla's *Artscribe* review of the ICA show, also disregards it, as if to speak of its home is to introduce an irrelevancy that somehow reduces its authority as art. The task of this essay, then, is discursively to re-enact that passage and to enlarge on the space taken by his work on the farther side of that border.

Like the Grey and Chatham Island Warblers who play host to the Shining Cuckoo, there are painters whose work hosts McCahon's works and serves as a carrier or vehicle of sorts for their transportation and translation. John Walker for one. A painter who has been variously based in Britain, the United States and Australia, he visited New Zealand in 1981 and acquainted himself with McCahon's works at the Auckland City and the National Art Galleries. Among the paintings Walker saw was *A Grain of Wheat* (1970) which, like many McCahons, is dominated by a biblical text, in this instance beginning: 'In truth, in very truth, I tell you, a grain of wheat . . .' (John 12, 24–5). Shortly after his visit, Walker began putting hand-written phrases in his own paintings, favouring especially one from St John's account of the parable of the good shepherd: 'In truth, in very truth, I tell you, I am the door' which appears on *In Truth II* (1981), the triptych *Oceania IV* (1982) and *Oceania, My Dilemma* (1983), among others. These were shown in New York and London. When Paul Brach, the New York critic, attributed these inscriptions to Walker's 'dialogue' with the New York painter, Robert Motherwell, he aptly illustrated the art world border at work.[3] McCahon thus crosses over unnoticed and, along with other stowaways, joins the ranks of countless unidentified influences at loose on the streets of New York.

Walker painted those paintings in Australia. Since the mid-1980s, McCahon's reputation there has grown immensely, so that many Australians regard him as without equal in that country, and his influence on practising artists seems greater there now than it is in New Zealand.[4] But does Australia belong to the art world? The question

occupies Imants Tillers, who has also developed a consuming interest in Colin McCahon. In Australia, he once claimed, 'the experience of works of art through mechanical reproduction always precedes their direct experience.' However, given that this is increasingly the case within the art world itself and that the mark of the Postmodern is an acknowledgement of such a situation and the 'mimicry and deconstruction of the codes and signs of consumerism', Australian artists should, Tillers urges, 'emphasize rather than hide [their] provincialism, even bathe ostentatiously in it'.[5] We may note that the reproduction which precedes, and supersedes, the original presents itself here as a border effect. Like the unidentified influence, the influence without a source. Either way we see how one territory – the 'art world' – works to maintain itself by not recognizing sources beyond its boundaries.

Tillers appropriates other artists' work. He is that sort of bird. He devotes himself to the quixotic task of recovering, from photographic reproduction, not so much the original as its aura. Exhibited on either side of the art world border, his paintings represent one or more crossings of it and an interrogation of its politics. Mostly Tillers mimics established art world figures; the few fellow provincials that receive his hospitality have special strategic importance for him. Since 1987, this Australian painter has produced no fewer than twenty Tillers/McCahons. They so dominate his current output that he seems at present more hostage than host to the New Zealander. They have been exhibited in places where McCahon is hardly known, if at all (London, New York) and where he is best known (Wellington, Sydney).[6] Well aware of the 'Walker factor', Tillers sets out both to exploit and to confound it:

It would be foolish to imagine that I could confront the chauvinism of a provincial New York art scene by presenting totally unfamiliar appropriated images from New Zealand – no matter how powerful McCahon's work may be, it cannot speak in a void. However, I hope that this audience which understands me as an artist whose modus operandi is appropriation will wonder *where* the unfamiliar power and raison d'être of this body of work springs from.[7]

Which is to say, the New York viewer of a Tillers/McCahon is put in the position of the provincial, an exile from the world of art. Ironically, he receives his information not from photographic reproductions but from painted simulations. The tables are turned; the processes of art world dissemination slyly mocked.

Tillers's works are ordinarily hybrids; other favoured artists such as Arakawa, Baselitz, Bleckner are paired with McCahon and the borders between them opened. These, and many other crossbreeds, together

make up a version of the art world, the eccentricity of which is vouched for by the central position occupied by the uncanonized McCahon:

Other artists whose work has some resonance with McCahon's are inexorably drawn into his and our orbit. McCahon's opus becomes an index to the elaboration of other texts. For example, his work has given the Italian artist, Enzo Cucchi, the painter of black Mediterranean landscapes and the modern apocalypse, a new lease of life within my canon.[8]

Hence Tillers's work provides a concrete example of the kind of space we might ourselves envisage McCahon occupying. It offers a range of intertextual connections rich in suggestions of structure and content.

Tillers admires McCahon for having 'the courage to quote from God', while he, dedicated quotationalist though he is, may only quote from McCahon; 'my painting,' he claims, 'is about whole-heartedly giving in to authority.' The position of *authority* in his work is one he seeks to relinquish but never can, one he desires to repudiate and whose loss he either mourns or cannot fully accept. Thus, 'the constant tension' he finds in McCahon's work 'between the search for meaning, the desire for transcendence and a pervasive unmovable skepticism' speaks for a similar tension in his own work, problematizing his relation to the Postmodern, as it problematized McCahon's to the modern.[9]

Thomas McEvilley suggests that the 'Modern/Postmodern antinomy has grown into a new kind of dualism: either Neo-Expressionists are right and the appropriators are wrong, or vice versa . . . What is needed is . . . a flexible continuum on which Modernism and Postmodernism may approach one another.'[10] A Tillers/McCahon belongs near the centre of such a continuum.

II

The immobility of grey is desolate. The darker the grey the more preponderant becomes this feeling of desolation, and strangulation. When it is made lighter, the colour seems to breathe again, as if invested with new hope.

Wassily Kandinsky, *Concerning the Spiritual in Art*

I used grey to avoid the color situation. The encaustic paintings were done in grey because to me this suggested a kind of literal quality that was unmoved and unmovable by coloration and thus avoided all the emotional and dramatic quality of color. Black and white is very leading. It tells you what to say or do.

Jasper Johns, in *Art International* (September 1969)

The Shining Cuckoo, 1987, the Tillers one, looks to be a McCahon in name only. The title provides a lyrical tag to a 'powderpuff' Carl André

Imants Tillers, *The Shining Cuckoo*, 1987, vitreous enamel on 240 steel panels
(each 15.2 cm × 15.2 cm), 182.9 cm × 304.8 cm.

floor piece. Whatever attracts Tillers to André or McCahon has little to
do with the earnest puritanism of either of them. The bright shiny
delicacy of material and colour in this work is as much at odds with the
luminous greynesses of McCahon's canvases as with the deep tones and
dull surfaces of André's metal plates.[11]

Every tile of the Tillers has a different colour, and the whole is organized
as a full spectrum, with light/dark gradations. Curiously enough, taken
together, the two *The Shining Cuckoos* are paradigmatic of the situation
of painting in the early 1970s, at least as far as colour is concerned. With
the retreat of colour-field painting and the emerging dominance of
sculpture in the later 1960s, colour became a side issue. Work was either
black, white or grey, and colour was admitted only so long as it functioned
chiefly as a kind of code. Jasper Johns was perhaps the first to spell this out,
with the grey *Jubilee*, and its coloured companion, *False Start* (both 1959),
and *By the Sea* (1961). And he stuck quite faithfully to this paradigm at
least through *Voice 2* (1971). Barnett Newman's late series, *Who's Afraid
of Red, Yellow, Blue* (1966–70), explicitly challenges it, while the late
work of Mark Rothko and Ad Reinhardt appears to acquiesce. That in the
early 1970s a young Gerhardt Richter should be working on a series of
grey monotone canvases and, at the same time, on a series based on colour
charts, is not a surprise. Similarly, that the major international exhibition
to be seen in Australia and New Zealand at this time, 'Some Recent
American Art', should be virtually colourless is also unsurprising. Brice
Marden, Agnes Martin and Robert Ryman were the only painters in this
Minimalist/Conceptualist exhibition which, coincidentally, appeared at

the Auckland City Art Gallery the same month McCahon painted *The Shining Cuckoo*.

McCahon began giving up colour in the 1960s, burying it deep in the recesses of the glossy blacks and creamy whites of his abstract *Gate* series. The odd yellow-cum-orange or dark green aside, black and white – telling you what to say or do, like Johns says – increasingly dominate his output from the mid-1960s until the end of his career. So *The Shining Cuckoo*, along with other works originally exhibited with it, *Poem* and *Blind*, are untypical in their overall greyness yet consistent in their lack of colour. The exhibition they made up complemented a group of paintings begun more than a year previously, the so-called *Beach Walk* series (A, B, C and D series), both in setting, the Muriwai littoral, and in their elegiac tone. A note accompanying the first exhibition of the series C and D paintings makes reference to the death of a friend, and series C, *Walk*, bears numeral reference to the fourteen Stations of the Cross.[12] As a result, we might say, of combining Kandinsky's and Johns's concepts of grey, McCahon's grey speaks of a desolation experienced also as a crisis of vision.

Each of *The Shining Cuckoo*'s five separate canvases depicts a quite similar scene. It has been suggested that, like the canvases of *Walk* and the much earlier *Six Days in Nelson and Canterbury* (1950), each represents a pause taken in the course of a walk or a journey, during which light conditions, topography and so on change. And that is an acceptable reading. However, it makes little allowance for the apparently arbitrary black borders, for how they point up the physical separateness of the five parts and so literally hem in an already partitioned view, blocking the panoramic flow of the image from canvas to canvas, a flow which with *Walk* makes sense of its title and twelve-metre length. These borders significantly influence how we perceive the grey areas they enclose.

It might be argued that these are five versions of the same view. Repetition amounts to an insistence that we do look, and perhaps that we look at our looking. But at *what* do we look? It is an empty beach. At the breaker line (is it?) there in the fourth canvas? At the flight of the solitary bird? Despite suggestions of a break in the weather, the light is either failing or it has that ugly glare it gets. The air is chilly and heavy with rain. Nothing is happening. We are placed, like figures in a Caspar David Friedrich landscape, not so much viewing as gazing at a scene which should offer us all the satisfactions of immensity, of access to the depths of infinite space. Instead it seems intent on frustrating the gaze at every turn. The flat greys of cloud, sky and sand are often identical and may seem to occupy the same plane, parallel to and not far from the picture

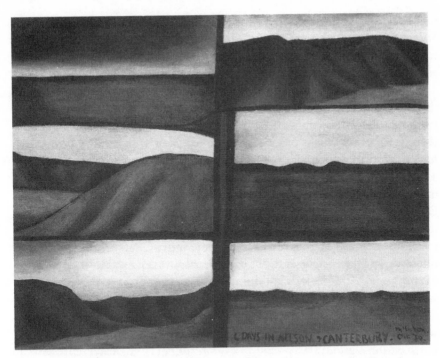

Colin McCahon, *Six Days in Nelson and Canterbury*, 1950, oil on board, 88.5 cm × 116.5 cm. Auckland City Art Gallery.

plane. They threaten to close off the view, to wall in the gaze. The horizon lines link up with the borders, and taken together, they look like sash window frames; cloud banks or patches of sky look like blinds, half-drawn. The viewer is by this account indoors – not out on a beach walk – sometimes seated, sometimes standing at a window looking out, waiting for something to happen.

Blind consummates what is a process of reframing, progressively distancing us from that view, first within the terms of depiction itself but eventually within the terms of the material facts of the painting as well. What we take to be rain-washed or blind-covered window-panes more or less obliterate any view. These are not 'windows on the world'. As with the canvases of *The Shining Cuckoo*, *Blind*'s five parts have sewn borders top and bottom, and red selvage stitching down either side of what are literally lengths of awning canvas. The grey blinds the viewer by blocking off – emotionally, illusionistically and literally – the prospect, leaving the viewer contemplating, and the painter confessing (with the one-word inscription *Blind*) the loss of vision.

Where do the numbers figure in all of this? The numbers count; that is, they offer the eye an alternative course of action, that of reading. To take it up is to find that what previously were borders or barriers are now road signs, punctuation marks indicating the way of the text down the centre of each canvas and demarcating one number from the next, a process of differentiation which is assisted by the (non)colour changes of the rectangles from grey to white to darker grey and so on. The flatness of these areas suggests surfaces – paper, clay tablet, gravestone – suitable for inscription. McCahon's choice of Roman numerals seems an appropriate one, for they are less 'arbitrary' than Arabic; '2' compared to 'II' has only an arbitrary relation to the concept *two*. Thus we see that counting is figured within the sign for each number, as well as without it in the sequence of number signs, and that the Roman system is more evidently a code – only three marks (I, V, X) are used to produce fourteen different signs. Reading thus begins as simple movement, the following of a set of signs *for* sequence, counting from one to fourteen. This measured and measuring act provides a kind of ritualized release from the desolation of grey; it is the movement of elegy and of epitaph.

According to Yve-Alain Bois, 'mourning has been the activity of painting throughout this century. "To be modern is to know *that which is not possible any more*", Roland Barthes once wrote.'[13] These numbers, 1–14, are a code within a code, reductions to number form for the purposes of devotional meditation, of episodes in the narrative of Christ's journey to his cross, his crucifixion and entombment. To read, to count the numbers, is to walk in the mind the Via Dolorosa. Also, assuredly, to walk the beach at Muriwai. But, as already noted, to try to conflate these readings is to encounter ambiguities which require us at the same time to keep them distinct. The Way ends with the entombment, not the resurrection; its closure there, on the threshold of the Absolute, is one reason why a number of modern painters who are not Christian have used it as a subject. Number XIV is half-bathed in the yellow light of dawn, or is it heaven? God is dead; will he return? But what do we make then of dawnlight at VII (or VII–VIII is it?) when Jesus fell a second time and the women of Jerusalem mourned for him? Ambiguity produces continuity and discontinuity in more or less equal proportions. Meaning accumulates on either side of what is neither one thing nor another but rather the conjunction, the border and gap, between one code and another, and reaches no conclusion. Thus *The Shining Cuckoo* eases, and suppresses, its own pathos and that of *Blind* through its sublation of loss in the problematics of coding.

III

Just as I had confronted other dogmatic positions of the purists, neo-platonists and other formalists, I was now in confrontation with their dogma which had reduced red, yellow and blue into an idea-didact, . . . I had, therefore, the double incentive of making these colors expressive rather than didactic, and of freeing them from the mortgage. Why should anybody be afraid of red, yellow, blue?

Barnett Newman, *Art Now: New York* (March 1969)

The mourning process must begin with the recognition of an ever-present fear, which is always the fear of death. . . . Once I have recognized that I am afraid of red, yellow, and blue, . . . Newman's challenge raises a paradox. Of the two questions extending from there, one belongs to the dawn of modernism, the other to its twilight. The first was, does abstract painting still have a past?; the second, does painting after abstraction still have a future? Both are dictated by fear. . . . the future of painting addresses its demand for legitimization to the modernist past.

Thierry de Duve, 'Who's Afraid of Red, Yellow, Blue?' *Artforum* (September 1983)

The Shining Cuckoo and *Blind* associate non-colours (black, white, grey) with the blockage, the frustration and the loss of vision and death. We have seen that at this time colour is a side issue, as is painting. 'For at least five years,' wrote Max Kozloff in 1975, 'a whole mode, painting, has been dropped gradually from avant-garde writing, without so much as a sigh of regret.'[14] We may be grateful for Tillers's suggestion that we compare *The Shining Cuckoo* to an André floor piece and his attitudes to his materials at this time to Arte Povera. We may notice how colour co-ordinated it is with Minimalist work and how its numbers and words contribute to the contemporary proliferation of language in, around and on the art work. Yet, these connections must remain somewhat incidental to our reading of the work. McCahon never doubted that painting in general, and his in particular, faced a crisis, but it had nothing to do with painting's problems under Minimalism *per se*.

One way to characterize his sense of crisis is to look at his attitude to Mondrian. His feelings were undoubtedly mixed and complex. He wrote that Mondrian 'came up in this century as a great barrier – the painting to END all painting.'[15] McCahon approved of Mondrian's desire for the transcendental: 'I see the angels he saw.' And yet he was in a sense appalled by the art, by the whole reductive programme of work which stemmed from it. Two polemical paintings 'after' Mondrian make this clear.

Of the first, *Mondrian's Chrysanthemum of 1908* (1971) he said, 'it refers back to my lasting feeling for Mondrian and his work', and it is

inscribed 'Greetings to Mondrian's Chrysanthemum'. He further com-
mented that it 'is perhaps a chrysanthemum, perhaps a sunset: quite
possibly a bomb dropped on Muriwai'.[16] Why, we wonder, would
McCahon want to extend his greetings to a flower whose monstrous
blossoming would lay waste his home, perhaps? It is to be noted that
Mondrian's many studies of this flower between 1906 and 1908
immediately precede his systematic retreat, as it appears in retrospect,
from mimesis. McCahon makes of them a prophetic image of that retreat,
compressing its lengthy history into a moment of destructive violence.

The second painting, McCahon's red, yellow, blue painting, is titled
Mondrian's Last Chrysanthemum (1976), and it belongs, as if in answer
to Newman's question, to a series called *I am scared*. A yellow line
separates a red sky from a blue/black land below, one half of which has
been over-painted with white (and so is grey) and the word 'ash' – that
which, it may be supposed, the flower has been reduced to. Again the
rendering down, the reduction of the visible world is treated as a
metaphor for holocaust, the end of painting as a metaphor for the end of
history. The fire to red, yellow, blue turned to grey ash. What are we to
make, then, of McCahon's choice of *Mondrian's Chrysanthemum of
1908* as the final work in his 1972 retrospective? Of course, McCahon is
saying the Bomb threatens all our futures. But also, through the back-
handed homage to the great Dutch modernist, confessing his complicity
in this threat of apocalypse.

Thierry de Duve's essay, 'Who's Afraid of Red, Yellow, Blue', expands
Neuman's 'fear' to a point where it engages a view of the history of
abstraction couched in terms of the sublime, and so permits us to suggest
that McCahon's difficulty with Mondrian, like Newman's, can be
explained by reference to the sublime, which springs, after all, from a
dialectic of crisis. According to Jean-François Lyotard, 'The sublime may
well be the single artistic sensibility to characterize the Modern.'[17] The
avant-garde statement consists, he suggests, of a combination of 'an
openness to the "Is it happening?"', the indeterminate and a profound
fear that 'nothing further might happen'. Such a contradictory feeling is
constitutive of the sublime:

Terrors are linked to privation: privation of light, terror of darkness; privation of
others, terror of solitude; privation of language, terror of silence; privation of
objects, terror of emptiness; privation of life, terror of death. . . . Burke wrote
that for this terror to mingle with pleasure and with it produce a sublime
sensation, it is also necessary that the terror-causing threat be suspended, kept at
bay, held back. This suspense, this lessening of the threat or danger, provokes a

kind of pleasure which is hardly positive satisfaction, but is rather more like relief. This still qualifies as privation, but it is privation in the second degree: the spirit is deprived of the threat of being deprived of light, language, life.

Lyotard took Newman's 1948 essay, 'The Sublime is Now', as his starting point and went on to argue that in Newman's painting, the 'Is it happening?' is colour. The American's version of the avant-garde sublime sprang from his rejection of the work of the first generation of abstract painters, and his terms were no less extreme than McCahon's. When he attacked 'the geometry principles of World War I', he too insinuated a necessary association between abstraction and war. The geometry of those painters was a 'death image'.[18] In their hands colour had become an 'idea-didact'. Their dogma represented, in sum, the profound threat that 'nothing further might happen'. The vehemence of Newman and McCahon derives from the fact that their own work contained this very danger, was driven by this same fear. By the late 1970s it was being argued that there was a necessary association between Abstract Expressionism and the Cold War.

All the privations Lyotard enumerates are intimated in *The Shining Cuckoo*, except for that of language. *Te Tangi*, it says: The Song; *o te Pipiwhararua*, of the Shining Cuckoo. Indeed, it is the appearance of language in McCahon's work which gives rise to the avant-garde question: Is it happening? From the 1950s, when he first painted 'all word' paintings, this is what has always provoked viewers. It disturbs what many take a picture to be. It suspends the terror, or the 'suffocation' which is Kandinsky's word, and its appearance and movement are what provide the action, the relief. The danger that language will too readily answer its own question, that it, for example, purports merely to gloss what is depicted, is thus more imagined than real.

The double coding not only of the numbers but also of the flight of the cuckoo, of the text which is in a language (Maori) foreign to the vast majority of its readers, of the writing itself, sees to that. Many of McCahon's major works, such as *The Lark's Song* (1969), consist of large expanses of black, often readable (barely) as night landscapes overlain with white handwriting. The mere trace of the writing hand on the picture plane suffices to keep the terror at bay, the appearance of the linguistic code reduces a threatening immensity to the dimensions and function of an albeit rather large notepad.

When painting regained some art world authority in the early 1980s, it brought with it from beyond the borders some new versions of the avant-garde sublime, among them those of Imants Tillers and Anselm

Kiefer. Theirs intersect with McCahon's at the level of the landscape subject, at least initially. Commenting on his *Hiatus* (1988), a work hybridizing Eugene von Guerard's *Milford Sound* (1879) and McCahon's *Victory Over Death* 2 (1970), Tillers said that that 'combining of the two images effectively collapsed (encapsulated) the romantic tradition of the "sublime" from its origins as found in the landscape of Caspar David Friedrich (as embodied in von Guerard) and its culmination in the pure abstraction of Newman and Rothko (embodied in McCahon).'[19] Kiefer's apocalyptic landscapes, described here by Mark Rosenthal, have an effect similar to that of McCahon's beach scene in *The Shining Cuckoo*:

the earth was often dark in tonality, the event or scene seemed to occur at night, the horizon was almost always too high to allow for escape, and there was usually a reference placing the landscape in Germany. In these works, we experience the earth as if our faces were pushed close to the soil and, at the same time, as if we were flying above the ground but close to it.[20]

But perhaps the Kiefer to consider here is not a painting but an artist's book, *Piet Mondrian – Operation Sea Lion* (1975). It comprises thirty-four double-page photographs. Once again Mondrian is linked to war. The title proposes a connection between his abstract grid and the window frames which feature in the opening and closing images of the book. Ice and frost cake the glass; snow is heaped on the sills. Light shines from an interior; outside all is dark. Inside, on a bare concrete floor sits a tin bath, floating in it a toy battleship and an iceberg. *Operation Sea Lion* was the code name for Hitler's aborted plan for a sea invasion of Britain. Having viewed, photographed, this strange studio scene from various angles, we approach the windows again, this time from the inside. Close up, but quite unable to penetrate the blank white panes and the black frames. This is a cold cousin to *The Shining Cuckoo*. A frozen play of images in which Kiefer and his reader, Hitler and, yes, Mondrian, too, are apportioned distinct and yet also interchangeable parts. Three generations of artists have pressed Mondrian into service to stand for what, in modernity, the avant-garde sublime finds it has most to fear.

IV

'Working the frame' is, thus, Derrida's strategy for breaking with the sterile alternatives that both aestheticists and historical-philosophical systems have imposed on the question of art – a way of using the question of aesthetic specificity to develop alternative theoretical possibilities.

David Carroll, *Paraesthetics* (1987)

The frame, the reading of which produces Derrida's 'borderline aesthetics', is 'distinguished from two grounds, but in relation to each of these, it disappears into the other. In relation to the work, which may function as its ground, it disappears into the walls and, then, by degrees, into the general context. In relation to the general context it disappears into the work.[21] Reading the frame, as against either the inside or the outside, or a combination of the two, forestalls its disappearance, drawing it to the centre of any interpretation.

Before going into the question of the frame in *The Shining Cuckoo* and its relation to McCahon's modernism, I wish to elaborate briefly on a point which is perhaps already apparent: the previous discussion has deployed a figure which is clearly somewhat akin to that of the frame.[22] The art world 'border' frames contemporary art practice and its reception and distinguishes a centre from provinces beyond its margins. Imants Tillers's painting, by hybridizing artists like McCahon, Arakawa and André, works the border from the outside in and from the inside out, constructing an opus *of* the margin. And we have seen that McCahon is to be associated with Newman and Kiefer in their resistance to Mondrian's art, a kind of modernism which seemed to them to have 'framed' painting itself and obliged them to pose once again the question, 'What is Painting?'

Derrida's essay on the frame, 'The Parergon', re-reads Kant's *Third Critique* and finds there, where American formalism had found success, a failure to realize a theory of aesthetic purity or autonomy. Modern art, Clement Greenberg proposed, was framed by the progressive 'elimination from the effects of each art of any and every effect that might conceivably be borrowed from or by the medium of any other art. Thereby each art would be rendered "pure" and in its "purity" find the guarantee of its standards of quality as well as independence.'[23] From the 1950s McCahon's painting, by contrast, became increasingly contaminated by literature. The texts which came to figure more and more prominently in his *oeuvre*, which he sited there, were almost exclusively literary.

The Shining Cuckoo may be thought of as a book, a sort of loose-leaf book of five pages.[24] It is useful to do so, if only because the intrusion of the text is variously implicated in its 'support' or frame. This painting's prototype, the artist's first text-bearing work composed of a number of similarly sized unstretched canvases installed in a row, was *The Wake* (1958), a large-scale 'illumination' of a poem by John Caselberg, clearly influenced by Blake's books. It begins, extreme left, with a title page. *The*

Shining Cuckoo, on the other hand, has a title, or rather the Maori text has its title and author, on page three.[25] Like pages one and five, it features the outline of a headstone and a dash of sunshine. Centrally placed between the two framing pages, it establishes a tension between left and right as measures of progression or balance, between the painting as book or picture, as literature or art. The literary frame has been installed in the centre of the picture, provoking a crucial ambiguity that the artist has no intention of removing.

If McCahon was, as he claimed to be, 'finished with frames and all they imply', why then did he compose this painting almost entirely of framing devices? What way was this to finish with them? The first such device (we might call it the 'cut' of the 'page') is the edge which remains when stretchers and/or material surrounds have been dispensed with. Even this, hemmed top and bottom, does more than just mark its conceptual function as frame, for the cut splits the work open, in four places, interpolating not merely the frame but the wall as well. Those four strips of wall thus become elements of a new frame which putatively surrounds the outer cut of the entire work. Instead of disappearing, the frame appears to extend its territory, laying claim to the 'general context'.[26] The frame also expands, gains substance, by virtue of the traffic which moves across it. We theorize a single length of awning canvas, from which five roughly equal pieces have been cut and then distributed sideways, so that a previously continuous reading, here inscribed as a column of figures, 1–14, has become a series of shorter columns with forced exits and entrances (II–III, VI–VII, VIII–IX, XI–XII) across or through the frames. Each canvas, furthermore, tends to read either as a top or a bottom of a headstone, a reading which again unsettles confidence in the side-by-side disposition of the parts, reiterating the radical effect of the cut on the unity of the work.

In these matters *The Shining Cuckoo* is very reminiscent of Johns's slightly earlier work, the triptych called *Voice 2* (1971). The letters V, I and E are split between canvases. The division of the V between the left-hand edge of the leftmost canvas and the right-hand edge of the rightmost raises the possibility of rearranging the elements of the triptych so that canvases A, B, C may read B, C, A or C, A, B. Just as McCahon's painting resists the regime of reading's left-to-right scan with his 'column' of figures, so Johns's finds three ways of acceding to it. We may think of his triptych as a cylinder and the reading of it as a continuous anti-clockwise movement. Johns's canvases are on stretchers whose edges are colour-coded: each sports a small tab which wraps round the stretcher edge half-

way down each side, a tab whose colour matches that of the adjacent canvas. Thus, the right-hand tab of canvas A matches the left-hand tab of canvas B. But the reason for the tab's particular colour – this one is purple – emerges only if the stretcher edge is visible and the stretchers some distance apart. Johns usually bolts together his multi-panel works. Again, we have a work split open, one which draws the wall into itself. Purple results from 'mixing' the otherwise blue edge of canvas A with the otherwise red edge of canvas B; it is the colour 'in between' blue and red. *Voice 2*'s coloured edges function much like the black borders around *The Shining Cuckoo*'s canvases, with the matched tabs of the one corresponding to the (sometimes) matched gaps in the other and the indicated bisectioning of A (vertical), B (horizontal) and C (diagonal) paralleling the further internal sectioning of McCahon's work. In both paintings the over-coding of the frame leaves distinctions between inside and out provisional and ambiguous and extends the territory of the frame not only *out* to the general context but *in* as well, to a point where a question arises as to whether anything remains to be read apart from it.

In so far as the 'cut' has the gallery wall as its ground, the painted border has the work itself, so it can be observed variously 'disappearing' into it. Now a window frame, now an obstacle which, cartographically and allegorically, punctuates the flight-path of the cuckoo, now a portion of beach. Further, it describes the edges of a third set of frames composed of the repeated figure of the headstone. For the most part, the painted border is drawn into the sign space of the work down the internal cuts separating the canvases. As the conventional site for such 'outside' information such as the artist's signature, the date of composition and so forth, this painted border seems over-burdened. For it also carries numbers to indicate – this hardly seems necessary – the order in which the canvases are to be arranged, as well as much of the Maori text.[27] The remainder of this text is inscribed on the area surrounding the headstones, an area between frames. Completing this interlocking nest of frames are the lines which serve to separate the numbers one from another.

The complex frame-work of *The Shining Cuckoo* constitutes a kind of diagram or grid which, in sharp contrast to the classic modernist grid, thoroughly subverts the autonomy of the work. Reading this frame, we find what we are looking for: a text, two texts, numbers, words, narrative, literature. Paradoxically, if the frame is a figure which disappears into either of its grounds, then its appearance, the claim it has to being a major organizing figure, is clear evidence of its being 'finished

with'. And it takes with it theories of the painting derived from those grounds.

Voice 2, like its precursors, Voice (1964–7) and the lithograph Voice (1966–7), seems to want to present what painting cannot: the sound of human utterance. If the full title of McCahon's painting is, as some would have it, The Song of The Shining Cuckoo, then it has a like ambition. Voice 2 perhaps does the next best thing: by so working the written element of the signifier to painting's limits – by dividing, folding, piercing and opening in good part through over-coding the frame – it seems to mime the spoken element as well, giving voice to 'voice'. The lithograph Voice bears the imprint of a human throat; perhaps we are to consider the putative cylinder, formed by linking canvas A to canvas C, as throat-like? In any event, this work is characteristic of Johns's interest in the effects of the media of other arts which, in combination with a preference for indexical modes of signification, produces his wilfully impure art. With Johns, representation is so often a matter of the next best thing.

McCahon and Johns are both artists whose formal 'playfulness' derives from confrontation with the unpresentable; for neither of them, then, is it in that sense a choice. Yet, to say the art of each was equally an art of mourning would be to obscure obvious differences between what Lyotard has described as two modes of modernity. Unlike McCahon (or Newman or Tillers), Johns evinces no nostalgia for a lost absolute; he may not (in Lyotard's words) be 'jubilant with the results of the invention of new rules of the game', but there is no question that he is profoundly amused by them. McCahon, however, is compelled by 'the loss of presence felt by the human subject and the obscure and futile will which inhabits him in spite of everything'.

V

Einst dem Grau der Nacht enttaucht (Klee)
Il n'y va pas seulement de l'integrité des dents (Pougny)
Xikrin, Cayapo, Xuracare, Taulipang, Jivara (Baumgarten)
I don't relish my position, sir, but I've stumbled on something (Rauschenberg)
Tuia tui, Tuia tui, Tahia, tahia (McCahon)

A text weaves its way across the territory of the frame to become, with numerals, colours and the framing devices themselves, one of the painting's signifying textures. 'Tuia tui', the first words of the text, in fact call upon us to 'weave', to 'bind together' as with a texture, a call reiterated on the hemmed and painted border immediately below. What

language *is* this? The truth is that the words on this painting are incomprehensible to its viewers, to all those beyond the shores of New Zealand who will not recognize the language, as well as to the vast majority of those within them whose comprehension of Maori extends no further than place names and a few phrases. Maori is the language of those Polynesian people who migrated to New Zealand perhaps a thousand years ago from a homeland in the north, named Hawaiki, to which they expected to return on their deaths. The Shining Cuckoo, *Te Pipiwhararua* (or *Pipiwharauoa*, as it is more commonly spelt) is native to Hawaiki; flying north it embodies a human spirit headed home.

In the 1970s, estimates were that only 10 per cent of the Maori population under the age of fifteen – and they amounted to 50 per cent of that population – were speakers of the language. McCahon first used Maori in his paintings in 1962, and from then on it has recurred regularly in his work. He was an admirer of Maori culture, and while such usage is commonplace in New Zealand art today, twenty years ago it was almost unheard of. Some significance may be attached to the fact that McCahon's son-in-law was Maori. Concerning his 1969 show at the Peter McLeavey Gallery, McCahon wrote: 'this is a personal and "family" exhibition. The paintings 1–5, and 9, are all for Matui Carr, our grandson (No. 5 for his first birthday). His birth and the discovery of Matire Kereama's book (*The Tail of the Fish, Maori Memories of Northland*, 1968) . . . has made these paintings happen.'[28] Three years later McCahon was commissioned to produce a painting for an exhibition commemorating the great nineteenth-century Maori chief and prophet, Te Whiti-o-Rongomai, who preached and practised non-violent resistance to European plunder of Maori land. The Parihaka triptych was subsequently gifted to Te Whiti's descendants in Taranaki. Among several inscriptions, one comes from Kereama's book: 'Einga atu ana he tetekura. E ana mai ana he tetekura' (One chief falls, another rises and takes his place). That same year, 1972, he used the same words on another painting, *Tui Carr Celebrates Muriwai Beach*, as if to say: this grandson of mine is heir to the greatness of Te Whiti.

McCahon knew little of the Maori language; but he was very attracted to the sound of it. Concerning the text of *The Lark's Song*, also from the Kereama book, he had this to say: 'I loved it, I read the poem out loud while I painted . . . The words must be read for their sound, they are signs for the lark's song. . . . Please don't give yourself the pain of worrying out a translation of the words, but try for the sound of the painting. But never forget that these are the words of a poet too. Some people can read

Colin McCahon, *The Lark's Song (a poem by Matire Kereama)*, 1969, PVA on two
wooden doors, 81.0 cm × 198.0 cm. Auckland City Art Gallery.

them.'[29] By not offering an English translation, the artist reminds us that
the lark, like the Shining Cuckoo, has been translated already, from bird
to human 'song'. So simply to utter the Maori, to give it voice, suffices to
intimate the sublime of which both birds are the avatars. In both
paintings McCahon erected a language barrier he himself faced, and
which he wanted his viewers to recognize and deal with. His concern was
more with having us engage with what is to be translated than with its
removal by translation.

Te Tangi o te Pipiwhararua is a traditional chant passed by Tangirau
Hotere to his painter son, Ralph Hotere, who, in his turn, sent it to his
friend Colin McCahon: 'It's called *The Song of the Shining Cuckoo* and
refers to the spirit en route to Te Reinga and resting for a bit in the
Hokianga harbour.' And it is this aspect of the text which interests
McCahon. The weight of it falls more upon the social purpose of the song
or chant, as a statement of welcome to travellers visiting *marae*, or tribal
meeting places.[30] 'Tuia tui, tahia: bind us together, let us be one.' And

'Tau mai: rest *here.*' The reference to the bird in the line 'Kotahi te manu i tau ki te tahuna' (one bird rested on the beach) serves both to endorse the *marae* and to allegorize the visitor's journey.

What might be described as a further thread in the painting's weave of signification supplements the text by charting a portion of the cuckoo's flight. As with the chair-seat outline on the third canvas of Johns's *Voice 2*, this dotted line re-positions the viewer 'above' the painting, as though it were a map or, as those gaps in the frame suggest, some kind of board-game. On the other hand, the dots are less schematic than elsewhere in McCahon's work. More like small crosses, one arm grey the other white, summarizing the movement of wings and the white flash or shine of the breast, they quite probably reflect McCahon's interest in Harold Edgerton's stop-time photographic sectioning of bird flight.[31] In their double coding as indexical and iconic signs supplementing linguistic and numerical signs they are entirely typical of the semiotic mix which makes McCahon's work such a challenging instance of 'impure' modernism.

As we have seen already, the frames function in a similar way. Together the dots and the frames structure the painting's double narrative. Both stories concern themselves with death – that final barrier – and the possibility of life after death, of passage across the border separating this world from 'the next'. Significantly, each is but an episode or sequence of events belonging to a larger story and, far from bringing either of them to a conclusion, McCahon's account serves to defer it indefinitely. His repeated return to such episodes in the many other 'stations' paintings, in groups of works concerning the spirit's departure from Cape Reinga (the northernmost tip of New Zealand, threshold of 'this world') and those concerning the raising of Lazarus, confirms his fascination with the larger stories as well as the conviction that he cannot properly bring them to conclusions.

One of the narratives is Maori, the other European. The fact that they have their origins in vastly different times and places (all of which precede the existence of New Zealand as a place of human culture) registers their deep separateness, as well as universalizing and relativizing the belief structures to which each belongs. Neither narrative is privileged; for while visually the Stations do dominate, the painting as a whole is named after the Maori narrative. To that extent, McCahon rejects a history in which the structures of the 'civilized' West have repressed those of its Other, and continue to do so in present-day New Zealand. Each narrative has its own reading regime, distinguishing clearly the elements proper to it in the weave of the painting. At the same time, interruptions,

cross-purposes, ambiguities flourish and seem somehow the unavoidable consequence of the coded character of both narratives, a character implicating them equally in the larger project of human culture. *Tuia tui, Tuia tui.*

3

Jannis Kounellis and the Question of High Art

STEPHEN BANN AND WILLIAM ALLEN

The end wall of the room is covered in gold leaf. In front of it, somewhat to the right of centre, there is a bent-wood hat-stand reminiscent of the early years of the century. On the branching hooks at its summit, there perches a black hat, on the lower hooks, a black overcoat. From the adjoining wall, at the extreme right-hand side, a small lamp creates a blaze of light and, incidentally, ensures that the coat, hat and hat-stand cast a shadow on the golden surface. Thereupon, a particular set of associations forces its way in and contrives to give a context to this work by Jannis Kounellis, installed for the first time at the Modern Art Agency, Naples, in 1975. Such a shadow, at once reproducing and distorting the biomorphic curves of the bizarre yet functional object, is reminiscent of another shadow painted in *trompe-l'oeil* on the work in which Marcel Duchamp celebrated his farewell to the painter's craft: *Tu m'*, completed in 1917, which borrows its elongated form from the specific proportions of Katherine Dreier's library, just as Kounellis's *Civil Tragedy* (p. xv) covers this room's end wall.

We can make a small catalogue of features which suggest that Duchamp is the patron of this work. The hat-stand embodies, in its purest form, the principle of the ready-made: taken out of its original location (but where, precisely, was that?), it acquires aesthetic value through its very effect of displacement. Hat and coat constitute together a kind of uniform, metonymic substitute for a certain kind of male functionary, like the 'malic moulds' which hang in alert suspension to the left-hand side of the bottom panel of Duchamp's *Large Glass*. No paint is involved. The permissive medium which Duchamp so cordially detested is replaced, here as well, by the neutrality of the ready-made (and yet, are these elements so neutral?) and the metallic facture of the gold leaf. The lamp which casts the shadow seems almost a replica of the lamp that illuminates the spectacle of a sylvan transgression (Diana espied by Actaeon?) in the culminating installation of Duchamp's career, *Etant*

donnés, which was revealed to his astonished public after his death in 1968.

Yet to list, one after another, the apparent affiliations of *Civil Tragedy* with the work of the grand master of conceptual art is to infiltrate at the same time an argument about the character and direction of modernism which has become especially influential since Duchamp's death. Arthur Danto summed it up when he wrote, in his commentary on Hans Belting's *The End of the History of Art*: 'The history of modernism is in fact the story of experiments in self-definition, an endeavour on the part of art to determine what its own nature is from within.'[1] If this is indeed the case, the artistic career of Duchamp is exemplary, but the fate of his disciples is an unenviable one. The destiny of conceptualism is to become ever more self-referential in its dogged refusal to admit being sullied by content or perhaps ever more strident in its claim for a gross materiality which will offset the abstract premiss: in other terms, either Daniel Buren or Jeff Koons. *Civil Tragedy* does not appear to have embarked on that particular journey to Scylla, or Charybdis.

In beginning all over again the search for an adequate interpretation of *Civil Tragedy*, we might be tempted to make a traditional iconographic interpretation. Where are the figures? What public meaning are we to attribute to them? Panofsky undertook his well-known exercise in the demonstration of the iconographic method with the aid of an illustration from everyday life. We are walking along the street. Out of the unresolved blur of colours and forms, the figure of a man materializes. He lifts his hat, and immediately his action belongs within the framework of the conventions of politeness accepted by Western society. If the greeting is taken further, we may reach a more profound understanding with our well-dressed acquaintance. Here is an analogy for the successive stages whereby a decoding of figurative elements can lead to an illumination, not merely of a particular work of art, but of the 'essential tendencies of the human mind'.[2]

Yet the hat and coat of *Civil Tragedy* are not so easily correlated with a social convention. They are not there to 'greet' us on our way. They hang, one to the top left, and the other to the bottom right, of the egregious stand. (In a subsequent installation of the work at the Castello di Rivoli, Turin, in 1988–9, the positions of the two objects are reversed, but the stand has also been repositioned to the left, to allow for a doorway on the right. *Mutatis mutandis*, the same equilibrium is achieved, while the effect of the gold leaf is intensified by the faded grandeur of the eighteenth-century decor of the castle.)[3] This black coat and hat (why do

we presume that they belong together?) are in a state of having been left. They speak of an absence.

Yet again, Svetlana Alpers has warned us that Panofsky's little story is deceptive in that it elides the dimension of representation.[4] What we see in a painting is not directly analogous to what we observe when an acquaintance crosses our path. If the coat and hat are mute signs of an absence, this is only at the price of isolating them from the other elements of the work considered as a whole: the carefully positioned lamp and the effulgent golden wall. Panofsky's analogy suggests a purely negative value for the ground of representation: it is the chaos out of which a meaningful configuration of elements will, as a first necessary stage, emerge. Here the ground is far from negative, far from chaotic, in its relation to the figures which stand in sharp profile against it. Who ever saw a wall covered in gold leaf before? Who ever saw such an extensive display of what can hardly be called a colour at all, but a manifestation of an element (one might almost say, the most quintessential of elements) in its purity?

The gold-leaf ground in itself is not original in the annals of contemporary painting. Yves Klein covered canvases with gold leaf, just as he stained them with uniform grounds of blue pigment which drew attention to the substance of the material, and not simply to its idealized effect. In the European movements that had matured by 1970, 'Nouveau Réalisme' in France and 'Arte Povera' in Italy, there was a reversal of the cherished Albertian principle that the painter gained more merit by representing a material through what it was not than by using it directly. Alberti had scorned the gold-leaf backgrounds which established a monetary value for late Gothic altarpieces and encouraged the Renaissance painter to monetarize his talent through the deft working of yellow pigment. An artist like Klein, or Burri and Manzoni in Italy, was dedicated to restoring not only the phenomenological appearance but the symbolic richness of elemental materials. Klein indeed seems to have held the belief, however difficult to recuperate from his paintings, in the periodic recurrence of the 'Golden Age'.[5]

Civil Tragedy, however, is not a uniform field of gold applied to a canvas, let alone a statement of belief in the 'Golden Age'. It is an installation piece, but for all that, it works pictorially. It works through a particularly vivid articulation of the plastic principle of figure and ground. Yet the relationship of the hat-stand with its appurtenances to the golden ground is not, quite obviously, that of the traditional, Albertian space in which objects are defined within a perspectival,

receding system of linear coordinates. It suggests the exemplary demon-
stration of the principle of the plane in the works of Malevich, beginning
with the *Black Square*: as Hubert Damisch has argued, Malevich
expressed the difference between figure and ground not as a positive/
negative relationship but as superimposition of one plane upon another.
If Suprematism functions as a 'limit', to use Malevich's own term, this is
because the plane aspires to become homogeneous with the ground and
thus to negate itself. As Damisch puts it, 'the "infinite" white plane of
Malevich [is] a prelude to the historical production of a new structure, a
structure that this time is truly *dialectical*, unlike representational
structure which was founded upon the "annihilation" of the support and
not upon its negation'.[6]

Civil Tragedy achieves a dialectical effect which is parallel to, though
not of course identical with, the achievement of Malevich's 'white on
white'. The gold ground is both a surface and a substance; the laden hat-
stand is both a figure and an object. To the 'infinity' of the golden light
corresponds the finitude of the profiled elements, which are, none the
less, caught up in the luminous space: hat and coat levitate in the glow. A
further connection with Malevich, not immediately apparent in the
faktura of his oil-painted canvases, lies in the antecedent example of the
Byzantine icon which led him to place the works in the same type of
physical location – high up on walls and across the corners of a room – as
an icon was traditionally placed in the Russian household. This connec-
tion, which involves not simply the precedent of the icon but also the
physical context of its location, leads us to ask once again the question
which was only deferred with the invocation of examples of Western art.
Who ever saw a wall covered in gold leaf before?

One thinks of a way of modifying this question and at the same time
making it more significant. The point is not that this wall is covered in
gold leaf but that it indexes the effect of gold, both as substance and as
surface. And it is not strictly 'a wall covered in gold leaf' but a
representational ground on which the figure is superimposed. The
essence of the work lies in this relationship, but it is bound up all the same
with the fact that the ground fills the end wall, apart from the solitary
doorway. It is not framed; it does not (like the canvases of Yves Klein) sit
proud of the wall surface. It is (and it is not) that surface.

Let us make those points the basis of a comparison with one of the
architectural works which the Byzantine Empire left as a legacy in
Ravenna shortly before its final and ill-fated attempt to reconquer the
Empire of the West. The sixth-century chapel in the Archbishop's Palace

Christ the Warrior, mosaic in the vestibule of the 6th c.
Cappella Arcivescovile, Ravenna.

is ablaze with golden mosaic; on the golden ground of the barrel-shaped vault, birds are picked out within a network of rosettes, while the two side walls show golden texts contrasting with parallel stripes of blue. On the end wall, the figure of Christ the Warrior rises against a uniform golden sky, a red cross slung nonchalantly over his shoulder and a book in his left hand reading: EGO SUM VIA VERITAS ET VITA (I am the way, the truth and the life).

To have a figure picked out on a golden ground is to invite certain consequences, from the purely visual and plastic point of view, as well as to imply certain symbolic values. To call that golden ground a 'sky' is to court visual paradox, for nothing could be more unlike the naturalistic infinity (if it may be so called) of the blue sky, as coded by a succession of Western artists which may have reached its peak in Turner, as Hubert Damisch suggests.[7] When Giotto painted the great blue vault of the Arena Chapel and filled the west wall with a vision of the Last Judgement, he allowed just a chink of the gold light of Paradise to appear, as the angel

begins to fold up the blue vault of heaven like a scroll.[8] Blue, as Julia Kristeva has argued in an essay devoted precisely to Giotto's use of the colour in the Arena Chapel, is the tonality which lends itself least to the differentiation of outlines. Hence the all-over, merging effect of Giotto's sky; hence, also, the decision of Cézanne to restore the vibrancy of natural light in the landscape by bounding objects with blue outlines.[9] To fix a figure against a golden ground is, by contrast, to intensify the presence of both figure and ground: instead of receding to infinity, the golden surface draws attention to itself and to its light-reflecting properties. It is both absent, as space, and present, as substance.

Christ the Warrior starts from this ground with a shock of irrepressible presence: presence of the Word (since we read it in the open book) and also presence of the body in its plasticity (the sharp outline of the Cross, passing behind Christ's back, asserts the separation of superimposed planes as surely as the comparable cruciform shapes in Malevich). Vasari poured scorn on the primitive visual skills of the Byzantine artists of Ravenna, who could not supposedly register the solidity of bodies in space and presented them as if 'on tiptoe'. Christ the Warrior observes this convention, but its particular efficacity is stressed as we note the force with which he appears to tread upon the heads of the lion and the serpent. He does not stand on the earth, any more than he can be said to stand against a sky. The implied weight of his body on the subservient heads is transferred into an act of levitation – a stress equal and opposite to the downward force, which lifts him upwards and outwards.

It might be over-fastidious to list the features of *Civil Tragedy* which correspond to this brief description. They include, at any rate, the effect of the gravitational force upon the hat-stand as a physical object (accentuated no doubt by the deliberate structure of the splaying bent-wood feet) and its counteraction by the broad surface of the dark overcoat, which appears to defy gravity as it becomes manifest against the golden ground. The hat floats even more freely, perched as it is on an invisible hook and gaining depth relative to the picture plane from the sharp intervening lines of the remaining wooden members. Christ's halo starts from the surface on which the twisted cross is superimposed with an equivalent vigour, though *Civil Tragedy* veils its address to the spectator: no face confronts us and no enunciation of the Word.

Kounellis himself has, however, not been reluctant to talk about the cultural resonance of his own creations. His comments on *Civil Tragedy* are highly specific and, in the context which has already been sketched out, highly illuminating. Even if we had not been aware of them, the title

given by Kounellis would set up some initial expectations, especially as the vast majority of his works have to be content with the uniform description of *Untitled*. *Civil Tragedy*, therefore, establishes two definite expectations: it is 'tragic' and the tragedy is of a communal nature, pertaining to 'civilization' perhaps, rather than a purely individual situation. An extensive quotation will bring out the further ramifications of this authorized reading (so we may suppose, as it appears in the most substantial catalogue of his work published to this date):

In Byzantine art there are human figures on the gold ground – figures either royal or divine which are eternalized by the gold; the relationship of figure to ground in that case asserted the eternality of the human soul or, put slightly differently, of a certain measure, the measure of a culture that saw itself as founded on eternal verities and thus more or less unchanging. But the figure has fled from Kounellis's piece, leaving an empty hat and coat as lonely traces of its vanished presence, and pointing to the theme of the loss of the measure and the fragmentation of the self in a society where synthesis has been lost. Kounellis associates the hat-rack with hat and coat on it with Middle European café scenes, especially those of Vienna. For him the hat-rack in between the viewer and the golden wall signifies the culture of Vienna which, he says, is a bridge to Byzantium. By the culture of Vienna, he means the work of Gustav Mahler, Franz Kafka and other authors whose theme was the lack of wholeness in modern selfhood . . . after the First World War.[10]

This says it all. And yet, if we look more carefully, what does it say? 'The culture of Vienna' as 'a bridge to Byzantium'? At one stroke we have resolved what might be called the stylistic incongruity of the installation. The hat-rack or stand is indeed, now that we come to notice it, not only constructed of bent wood but very probably of Austrian provenance; the hat and coat are reminiscent of the turn of the century. Yet imperial Vienna, as a traditional outpost against the Turkish infidel, also takes on the mantle of that earlier, Eastern Empire which perpetuated the rule of Rome at the other end of the Mediterranean long after the rise of Islam and only fell finally at the period of the Italian Renaissance. Vienna as a golden wall, the echo and displacement of Byzantium – why not?

The only answer to this question is perhaps to ask another. Who speaks, from what vantage point, and with what authority? We need not always assume that what artists tell us about their works is true, let alone the whole truth. If they tell us anything at all, we have to regard it with suspicion, until we have tested it against our experience of the actual work. But there is another way of being assured that what the artist chooses to tell us is worth listening to. This is to experience the authority of the work in its muteness, its 'untitled' form. There is a sense in which a

body of work can establish not so much a specific communication as an impression of complete seriousness, so that whatever the artist may say gains credence in advance, by a kind of blank cheque. This is what we felt in front of the *Untitled* installation in the 1988 Venice Biennale: twenty-one elements occupying a space comparable to that of an indoor tennis court; twenty-one steel panels, each one bearing the trace of human hands on its unsealed and vulnerable surface and loaded down with six sacks of coal secured by two double iron bars. This array of elements was set, it should be noted, at a uniformly high level along all four walls of the room – an achievement of High Art?

Who speaks, from what vantage point, and with what authority? It is the artist, evidently, who gives us this gloss on the interpretation of *Civil Tragedy*. But what kind of an artist is he? What *persona* authorizes him to speak in this way about the wider cultural significance of his work? In the case of the quotation which has just been given, his discourse is filtered through the impersonal medium of a critical introduction ('Kounellis associates . . . For him . . . he says . . . he means'.) But he has also spoken out in his own person, so it would seem, in that most intimate of all literary forms, the journal. In the extracts which were published in 1981 – in a catalogue dedicated by Kounellis himself to the legendary Russian icon painter Andrei Rublev – he mixes up the mythic past of contemporary art with its turbulent present: Joyce, De Chirico and Kandinsky with Fabro and Weiner. Under the pretext of talking to, and receiving letters from, 'a would-be politician', he can register the shock of plural events in imaginary simultaneity:

I learned with distress that Mayakovsky is dead, and also Blok is dead, and also Malevich . . . I want to tell you a golden secret; here, in Russia, to my surprise I discovered the sense of colour. Ideology of perspective in the painting of Masaccio. Ideology of colour in German expressionist painting . . . Yesterday, I met an old lady who was playing the violin . . . Who would have thought that she could be the wife of the young avant-garde painter Arshile Gorky?[11]

In this kaleidoscope of images and experiences from the history of culture and art, Kounellis seems to search for points of identification no less energetically than the exiled Armenian, Arshile Gorky, with his two borrowed names, and his unremitting early commitment to the two exemplars of contemporary painting, Cézanne and Picasso. Yet out of the welter of references and evocations, a clear artistic and political direction seems to emerge (the extracts are from a publication originally dated

1976): 'There, now I have at my fingertips all the terms and conditions in the world. I shall go to America, to Chile, I'll meet Weiner and tell him why I can't agree to contribute to his conceptual publication.'[12]

Ten years later, we find Kounellis speaking no less forthrightly, this time in a recorded interview with his colleagues, Joseph Beuys, Enzo Cucchi and Anselm Kiefer. It is rare enough, in the permissive world of the discourses of contemporary art, to find a spokesman with the assertiveness and rigour of Kounellis, who here directs his attack not on conceptualism but on the pervasive threat of cultural relativism. To Beuys who repeats the litanies of Utopianism, Kounellis replies with the strikingly concrete example: 'Yes, but Cologne Cathedral indicates a centralization, encompasses a culture and points to the future. Otherwise we would run the risk of becoming nomads.' The instance of cathedral building as an emblem of human culture, which is indeed the pre-established theme of this discussion, leads Beuys into further speculation about the national diversity of the European peoples and Kounellis to a timely rejoinder: 'But in order to build a cathedral you need a method and an understanding of the past. Otherwise you can't construct.'[13]

Kounellis's insistence on the concepts of centralization and under-standing of the past as preconditions for contemporary art earn him the reproof from Beuys of being 'a bit backward'. And Kounellis replies: 'Just because we've spoken about identity, is that supposed to be an old and common thing after the catastrophe which resulted from the Second World War?' It is a fascinating confrontation – and one which makes the other participants seem merely onlookers – between the European artist of the postwar period whose work most comprehensively embodies a social and economic critique of the forms of contemporary social organization and an artist of the following generation, growing to maturity after the war, who is not reluctant to court the accusation of conservatism in his refusal of 'this excess of rejecting culture'. His apostasy reaches its climax in his repudiation of what Beuys defends as the 'ironical' position of Andy Warhol.

Who is the artist speaking here? The catalogue which includes the extracts from a supposed 'journal' also publishes a biography which is admirable in its concision: 'Jannis Kounellis was born in 1936 in Piraeus. In 1956 he moved to Rome where he still lives. From 1960 he has exhibited widely.' It is the 'movement' from Piraeus (the ancient port of Athens) to Rome which seems the essential point, coupled with the fact that Kounellis indeed remained there. This was not a mere 'nomadic' movement of a rootless artist but a journey from the periphery to the

centre, as a result of which Kounellis was able to discover his capacities as an artist and allow his work to radiate out from that centre. The name of Arshile Gorky occurs enigmatically in the journals, which are concerned above all with fixing a certain notion of the Russian (and Byzantine) tradition as a crucial point of identification for the contemporary artist. Gorky himself, of course, made the journey from the periphery to the centre, from Armenia to New York; and yet, in that process, he rediscovered the mythic centrality of his homeland, drawing on its ancient religion and folklore, its deep-dyed Byzantine identity. The journey of Kounellis from Piraeus to Rome may reflect a similar drama of identity in process.

Yet an objection will easily be raised at this point. Gorky was right to bet on the chance that New York, after the fall of Paris, would be the centre of the contemporary art world. His own importance as an artist is guaranteed by the vigour of the activity that took place around him and survived his death. What comparable significance could a journey from Piraeus to Rome in 1956 embody? The point is that the relationship between 'centre' and 'periphery' is a constantly evolving one, and the diversity of the Western tradition would appear to imply that more than one such 'centre' is invariably involved. What is constant is a kind of cultural topology, a distribution of points which can be related only by the purposive activity of the artists (writers, intellectuals) themselves. Pier Paolo Pasolini planned to make a film of the life of Saint Paul in the last years of his life. However, he had decided to change the three centres of the apostle's activity in accordance with the cultural balance of the contemporary world. In his script, the religious capital of Jerusalem was to be replaced by Rome, the intellectually questing city of Athens by Paris and the imperial centre of Rome by New York. In moving to Rome in 1956 from the vicinity of Athens, Kounellis was no doubt obeying a different logic from the one presupposed by Pasolini. What if the new Rome were – after all – Rome?

The possibility can be illustrated further by the example of one American artist who made the move in the opposite direction. Cy Twombly was born in Virginia in 1928 and studied at a number of places, including the Art Students League in New York and Black Mountain College in North Carolina, itself a displaced European institution whose members included John Cage and Robert Rauschenberg. Between 1951 and 1953 he travelled (nomadically?) in North Africa, Spain and Italy; in 1957 'he moved to Rome where he still lives'. Twombly's repossession, as it were, of the culture of the Mediterranean world has since proved to be

one of the most absorbing adventures of contemporary painting and can only be juxtaposed with the spectacular atrophy of his colleague Rauschenberg's art after so promising an outset. Where Kounellis rejects Warhol's 'irony' — the cause of offence was Warhol's refusal to name a favourite Italian artist because his knowledge of Italy was confined to spaghetti! — his strategy seems curiously similar to that of such an un-American American painter as Twombly. Like Twombly, Kounellis placed his bets on a cultural empire not so obviously in evidence at the height of the Cold War.

This judgement may appear to reduce the multifarious cultural issues of contemporary art to a kind of crude geographical determinism. Worse still, it could be seen as championing the cause of a cultural imperialism whose political underpinnings have almost disappeared (and rightly so) from the contemporary Western world. But this would surely be a mistake. When Pierre Restany writes of the 'Holy Roman Empire' — stretching from the Low Countries and the Rhineland down through Switzerland to Italy — as the forum for a particular kind of advanced consciousness in contemporary art, he is implying the existence of a symbolic community whose historical roots reach very far back. It could be argued, however, that this powerful myth of a Western Empire, successor to Rome, is one-sided if it does not take into account the split between West and East — between latter-day Rome and Byzantium. The remarkable thing about the art of Twombly and Kounellis is that, from a base in Rome, it seeks continuously to establish an alternative base, so that the appropriate figure for describing its symbolic universe would not be a circle with a central point but an ellipse with two focuses, each connected to the other by a process of dynamic aspiration. This perhaps is the *Andersstreben* of contemporary art, to use Pater's term: art aspiring not to the condition of music but to the condition of an East beyond the West.

In spite of this comparison, it needs to be stressed that these two artists explore the Eastern dimension in wholly different ways. Twombly extends his explorations into an Orient where sexual identity becomes blurred and confused: *Nike*, the androgynous figure of Victory, presides as the *Anabasis* of the Greek soldiers into Persia results in defeat and death. *Wilder Shores of Love* indicates the myth of the Amazonian Western woman, merging finally with the oriental masculine culture. To the hard, clear figure of the Greek Apollo corresponds the disguised and subversive image of the Lycian Apollo, clothed in a wolf's skin and sharing the dubious attractions of Dionysus or Pan. This is of course a

telegraphic version of a complex imaginative world, manifested in the successive stages of Twombly's art. But the general message is clear. Twombly enacts an eastward movement, in the course of which stable, rational, Classical values are metamorphosed and transcended.[14]

In Twombly's art, Western identity is subverted, almost to the point of dissolution. The East represents its perilous 'other side'. By contrast, the art of Kounellis has a notable stability and strength. It transacts between its two poles – East and West, Byzantium and Rome – with undiminished verve. *Civil Tragedy* is a case in point. 'The culture of Vienna' becomes 'a bridge to Byzantium'. Although the title of the work speaks of tragedy and its iconography of absence, the imaginative realization is remarkably rich and full. Here the West is glimpsed, as it were, against the gleaming prospect of mythic East, whose lustre is all the more bright in proportion to its lack of correspondence with the contemporary political scene. Twombly's art is, in the last resort, a drama of individual identity against the vivid backdrop of Classical culture, which results in the achievement of an inimitable style. Kounellis (as Rudi Fuchs has remarked) is essentially an artist without style. His work is, in comparison with Twombly's, a demonstration of remarkable objectivity. And as history itself joins in the exhilarating process of toppling the frontiers between West and East, it seems to achieve at the same time a renewed status and authority.

Why should this be so? Rather than resting the case on *Civil Tragedy* alone, it is worth looking, however briefly, at the full range of Kounellis's career since his movement to Rome in 1956 and showing, if not the major achievements and the most well-known, at least the exemplary stages of his development. These will suggest a logic of interconnection which helps to explain, as far as anything will, the special authority of Kounellis's work.

Pictures which testify to an apprenticeship form the first phase: Kounellis completed a series of austere white canvases with heavy block-characters outlined against the amorphous ground. In *Untitled* (1959), the repetitive letter forms (S E / S E E) rock gently against a white mass which is inflected with thin ruled lines and emergent squares. Kounellis's own childhood and upbringing in the port of Piraeus has been evoked in connection with this series involving the equivalent of stencilled letters, and the motif of maritime travel manifestly comes across as if these signs denoted the destination of some figmentary cargo. But it is also worth recalling the Cubist precedent. These deceptively simple paintings could provoke a restatement of the phrase dedicated to Picasso by Apollinaire

Jannis Kounellis, *Untitled*, 1959, enamel on canvas, 138 cm × 245 cm.
Städtisches Museum Abteiberg Mönchengladbach.

in 1913: 'Surprise laughs wildly in the purity of the light, and numbers and block letters insistently appear as pictorial elements – new in art but long imbued with humanity.'[15]

Apprenticeship leads to the act of assuming a vocation. It is perhaps hazardous to try to pin down the evidence of this crucial psychological process. Yet Harold Rosenberg, among others, has pointed the way in the exemplary case of Arshile Gorky, whose search for identity as an artist so clearly appears not only in the working through of a relationship to Cézanne and Picasso but also in the long period spent conjuring up the Armenia of his forebears in *The Artist and his Mother*. Rosenberg has suggested an intimate connection between the 'polished surface of the double portrait' and 'the transcendence of self into art which is the content of the work'.[16] Similarly, we might wish to see in Kounellis's *L'Arcobaleno* (The Rainbow) evidence of just the same careful attention to surface over a lengthy period of time. Kounellis abandons the chalk-white ground of his earlier works and spreads the gloss of a creamy pigment over a large canvas, veiling the 'rainbow' of colours in the process and yet allowing its traces to stay like veins below the skin-tight surface. The period during which he worked on this painting extended from 1961 to 1964. We may suppose that it was not a technical so much as a psychological difficulty which kept him close to the grindstone.

Rosenberg's equation between the 'polished surface' and the 'transcen-

dence of self into art' deserves to be set in a wider cultural context if it is to acquire its full significance. As Julia Kristeva has shown, the Neoplatonic philosopher Plotinus chooses the metaphor of polishing and 'working on your statue' as an illustration of the way in which the individual soul can avoid the blandishments of narcissistic self-adoration. The reference occurs in a discussion of the development of 'Western interiority' which Kristeva naturally has to cast in the widest possible terms.[17] But it is also open to interpretation from the strictly selective point of view of the Western artist and the intermingling of philosophical and religious strains in the whole concept of the artistic vocation. Even without the aid of any special biographical information, we can see the signs of dedicated work in *L'Arcobaleno* as the self-scrutiny of a Western artist at a crucial juncture of his career.

How then can we judge the success of this process? And what does it amount to? At the very stage when Kounellis receives his official consecration as an artist, within the critical grouping of 'Arte Povera', his individuality seems to assert itself without compromise. The first exhibition involving the name 'Arte Povera' was held in Genoa in 1967, and the links of all the artists concerned with masters of the previous generation like Fontana, Manzoni and Burri were all too evident, Kounellis being no exception. His resourceful use of diverse materials, including the element of fire, from this stage onwards was, on one level, an intensification of the process which these artists had already begun. But such a connection, however necessary it may be as an explanation of how Kounellis's work took the form that it did, largely bypasses the more crucial issue. It is necessary to ask at this stage precisely how he secured an identification with the traditions of Western art which few of his contemporaries, or his Italian predecessors, had managed to achieve.

Once again, Julia Kristeva provides a valuable source of insight. In her brief but remarkably suggestive essay on Jackson Pollock, she entirely revises the customary strategies of interpreting his mature work, whether as 'action painting' or as the working through of a relationship with Jungian archetypes. For Kristeva, the course which Pollock took is undeniably specific. He enacts the search of 'the Western individual . . . for his own image, an image which is always entwined with that of his mother'. But he does so particularly through the iconography, and the psychological pattern, of crucifixion. 'The male body that Pollock paints in his youth, and especially in the psychoanalytic drawings, is Christ crucified. And the body of Christ crucified suffers because it cannot disperse itself to the cardinal points of space assigned to it by the cross.'

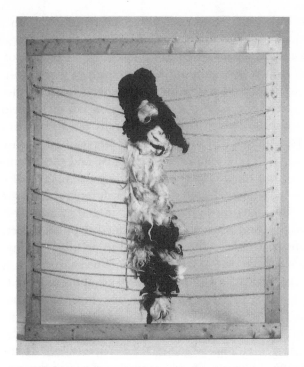

Jannis Kounellis, *Untitled*, 1968, black and white wool on wooden frame,
250 cm × 200 cm. Galerie Karsten Greve, Cologne.

For Kristeva, therefore, the tension implicit in Pollock's greatest work is
between a 'successful incest', transposing 'the Cross into a visible burst of
glory which can never become an object', and a more forceful mode in
which 'the cross tears apart this successful incest; its presence can be read
in the sculptural projections of *Blue Poles*'.[18]

This analysis is cited, despite the obvious danger of wrenching so dense
a commentary out of context, because of the exceptional prominence
which is given to the achievement of Pollock's *Blue Poles* (1953). This is
the very painting which Kounellis has acknowledged as the 'central
inspiration' of a decisive work from the early stages of 'Arte Povera': his
Untitled (1968), consisting of five wooden poles covered with wool,
which are designed to lean up against the wall. As Thomas McEvilley has
expressed it: 'Pollock's painted poles which seemed to lean in flat, allover
space were converted to sculpture and leaned against the wall of a real
room . . . Going well beyond Manzoni's use of wool, Kounellis's homage
to Pollock converted the allover space of painting into an allover space
for sculpture.'[19] Yet such a relentlessly formalist account of Kounellis's

procedure misses the point which Kristeva's reference to *Blue Poles* brings to the fore. Was Kounellis drawn to the work simply because of the possibility of 'converting' painting to sculpture and 'going well beyond Manzoni'? Surely not. The distinctiveness which Kristeva identifies in *Blue Poles* – as an insistence of the Cross – is likely to have contributed no less powerfully to the attraction which Kounellis felt to this particular painting.

Seen from this point of view, the interpretation of Kounellis's work from this period in terms of the imagery of crucifixion seems not inappropriate. *Untitled* (1968) suspends locks of black and white wool from a wooden frame which holds them in place yet allows the sagging tension to make its effect. Obviously this work is closely related to the previously described environmental piece of the same name and date. Kristeva names as the visible motif of Pollock's early drawings the agony of the crucifixion transplanted into plastic terms: 'the body of Christ crucified suffers because it cannot disperse itself to the cardinal points of space assigned to it by the cross'.[20] The second *Untitled* (1968) expresses just the same tensions, to an extraordinary degree, and it seems legitimate to argue that it demands a similar interpretation.

This reading may appear over-precise for a work which resolutely claims its 'untitled' status. But it is important to be clear about what is involved in such an interpretative move. The prevalence of the crucifixion motif is not offered here as a 'key' to the life's work of Kounellis, still less as an indication of a covert confessional belief. Comparatively few of the sculptures and installations from an extremely active middle career have been discussed here – essentially those that might form a chain of connections with the enigmatic *Civil Tragedy* – and it would be quite artificial to present them as offering the creed of the 'true' Kounellis. None the less, it is surely clear that the reiterated references to crucifixion have a resonance which goes beyond their mere utilization as a 'motif'. In discussing *Untitled* (1972), one of several works which suggest a truncated Latin cross, Thomas McEvilley makes a worthy attempt to resolve the issue: 'The cross in Kounellis's work signifies an attitude toward history. Though he is not a Christian believer, the cross is a part of his cultural history and appears in his work as an inherited element that must be accepted by one who realizes that he belongs to history.'[21]

This formulation may, however, succeed in pitching the stakes too low. 'An attitude to history' – surely this must be described as a special identification with a particular view of the Western past, broadly with the

Jannis Kounellis, *Untitled*, 1978, object, 125 cm × 40 cm × 40 cm.
Galerie Karsten Greve, Cologne.

bifurcation of empire which has already been mentioned here? 'The cross is a part of his cultural history' – surely not just a part, like the wheel or the plough, but a special vehicle for the assumption of a mode of subjectivity traditionally developed by the Western artist, in the tradition of the 'imitation of Christ'? McEvilley draws attention to the cast gold replicas of his baby son's shoes which stand on the foot support of the truncated cross in *Untitled* (1972): 'The work is a kind of testament, as if the father were leaving history to his son, or a kind of allegory of the onrushing riverine process by which each generation leaves to the next its crucifixion upon a certain intersection of time and space.'[22] The conceit is a subtle one and, undoubtedly, illuminating. But the primary reference in the work must at the same time be to the Son on the Cross, metonymically reduced to this emphatic sign. As with Yves Klein's *Triptych* (1960), the distribution of roles within the Trinity involves the artist at the level of the profoundest identity, and in this respect he speaks for the whole tradition of Western subjectivity in the Post-Classical era.

We have returned, by a reasonably direct route, to *Civil Tragedy*. It is

neither accurate nor useful to claim that this work is, in any simple sense, a crucifixion. Yet Kounellis's evident claim to mobilize, for our benefit, a certain view of history brings with it the requirement that we should investigate his stake (and at the same time, our own stake) in the European past. Kounellis might well refer, as Barthes did in his final autobiographical essay, to 'the religious stuff from which I am kneaded'.[23] At any rate, he willingly assents to the idea of building a modern cathedral, and he knows precisely what that implies, from the artist's point of view. 'The construction of the cathedral', as he explained in his discussion with a recalcitrant Beuys, 'is the construction of a visible language.'[24]

Agostino di Duccio, *Apostle* (fragment). Galleria Nazionale, Perugia.

Of the metamorphoses of Kounellis's 'visible language' since *Civil Tragedy*, there is much to be said and little space to say it here. Suffice it to remark that, in his rich repertoire as a Roman artist, he has evidently grasped the irreducible difference between identification with the Classical tradition and identification with the Christian past. Like Clemente, who is one of the few contemporary artists to be imbued with the same sense of history, he understands the difference in terms of Freud's subtle exegesis of the possibilities of identification: the artist can 'have' the Classical past in its fragmentary form, whereas the Christian affiliation requires the more strenuous effort of 'being like'.[25] Muteness is the overwhelming characteristic of the fragmented Classical busts which he

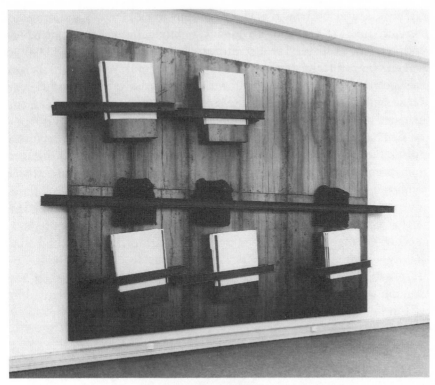

Jannis Kounellis, *Untitled*, 1988, steel plates, iron, jute, coal, paper,
400 cm × 650 cm × 60 cm. Christian Stein Gallery, Turin.

orders in sequence, or dramatically isolates, in a number of works dating
from around 1978. Their expressivity is frozen, their capacity for gesture
interrupted. Precariously shelved, or perched on pedestals, they often
exhibit a crude polychromy, as if satirizing the historical discovery that,
when such figures as these were cult objects, they were not gleaming
white but daubed with earthy colours. Now they have taken on the night-
shades of purple and black.

Yet this fundamental separation of the Classical and Christian strains
in Kounellis's work ignores the dialectical force in his 'construction of a
visible language' and his consequent ability (virtually unique among his
peers) to fuse the disparate elements in a new synthesis. The upward-
pointing finger in *Untitled* (1978) is bound to the fragmented head with
cord which serves at the same time to gag and to silence the god's power
of utterance. The work does not speak, but in its interruption of gesture it
seems as if it has fallen from a great height. A fragment (that is to say, an

authentic fragment) from the *Maestà* of Agostino di Duccio, preserved in Perugia, shows the hand of an apostle, lightly gathering the folds of his clothing, while the scroll that symbolizes his message to the world hangs broken, but still recognizable through the high gloss of its polished surface, from the absent other hand. Detached as it is from the great Renaissance composition that was its original home, this fragment levitates, buoyed up by the flurry of insubstantial garments, the gesture of the slender fingers and the precious message of the polished scroll. The *Untitled* installation of twenty-one repeated elements which Kounellis contributed to the 1988 Venice Biennale partakes not of the mute, abject condition of the classicizing work from ten years before but of the effective dematerialization achieved by Agostino's fragment. In the single-element *Untitled* (1988), coal in jute sacks and quires of thick paper are caught against a textured steel surface by horizontal and slightly elevated iron bars. All of this seems to operate not as an affirmation but as a negation of weight – the weight of history, no less than the weight of the physical world. The paper surfaces are blank, but we can imagine what might be written upon them.

4
David Reed: An Abstract Painter in the Age of 'Postmodernism'

DAVID CARRIER

What, exactly, can an abstract artist working in the late 1980s learn from the old masters? That question is not easy to answer.[1] Any art critic knows that most artists have postcard reproductions of many beloved old master art works in the studio next to their own paintings. The colours of those images will be suggestive to the artist, and certainly it is nice to think in a safely vague way that new art relates to older work. But since old master works usually present story-telling narratives and are always figurative pictures, it is hard to see how, exactly, they could really be very similar to the images of an abstract painter.

A few decades ago this question was easy to answer. Roger Fry thought that Cézanne was redoing Poussin's compositions, leaving out those story-telling elements which that great formalist critic found so distracting.[2] More recently, another formalist, Clement Greenberg, the greatest American art critic, has written of the relation between modernist painting and the old masters in strangely Ruskinian terms. Someday 'connoisseurs of the future may . . . say that nature was worth imitating because it offered . . . a wealth of colours and shapes, and . . . of intricacies of colour and shape, such as no painter, in isolation with his art, could ever have invented.'[3] For Greenberg, there is necessarily a continuity between the concerns of modernists and the old masters. 'Modernist art develops out of the past without gap or break, and wherever it ends up it will never stop being intelligible in terms of the continuity of art.'[4]

Today, in our 'Postmodernist' era, neither Fry's nor Greenberg's views of art and its history inspire conviction. Most of us can no longer believe that the formal parallels which Fry saw between a Poussin and a Cézanne composition are convincing.[5] Nor do we believe in the kind of continuity between contemporary and old master art that Greenberg finds. Fry links Cézanne to Poussin only by denying that the old master was concerned to use his compositions to tell stories. Greenberg establishes a genealogy for

Abstract Expressionism, relating it immediately to old master art, only at the price of what now seems a very selective reading of the sources of that movement. Nowadays all such claims of formalist critics seem highly problematic.

A function of what Arthur Danto has called deep interpretations is to show that two seemingly unconnected things, such as two paintings which are visually very different, do in fact have some real relationship.[6] A deep interpretation shows that we must look beyond appearances to identify the order of things. In their different ways, Fry and Greenberg offer deep interpretations. When Fry argues that Poussin and Cézanne are really involved in the same artistic goals and Greenberg claims that 'Pollock's 1946–1950 manner really took up Analytic Cubism from the point at which Picasso and Braque had left it . . .', they ask us to see an intimate connection between seemingly dissimilar art works.[7] These deep interpretations depend upon a formal analysis, or a Hegelian view of history, which is now hard even to understand, much less accept. And so what has happened is that once those theories are abandoned, these pictures no longer appear connected in the ways that Fry or Greenberg would have us understand. Their deep interpretations have now become all but incomprehensible.

According to the most fashionable theorizing, art in the 1980s is involved in a kind of endlessly prolonged Postmodernist end-game, unable either to continue the tradition or to establish a living relation with the masters. Art, the most influential theorists say, may appropriate from that old master tradition, which it is powerless either to contribute to or to continue. This issue has been much discussed in the now somewhat academic accounts of Postmodernism. As I have indicated elsewhere, I do not and cannot accept this vision of contemporary art, whose seeming bleakness and would-be political radicality hides, in truth, a certain complacency.[8] But I have not indicated how a constructive alternative account is possible. In particular, the Postmodernists usually make the very notion of abstract art seem highly problematic. How, if these Postmodernist accounts be rejected, may we understand the concept of abstract art? And how can an abstract artist build upon the traditions of painting?[9]

An analysis of David Reed's work provides a good way to answer these questions, for he, an abstract artist who has become a well-known figure in the 1980s, is concerned with exactly such problems. While commentators have been willing to accept the claim, which Reed has repeatedly made in interviews, that he is deeply interested in some late Renaissance

and Baroque painters, none of them have indicated exactly how a painter working in the 1980s may learn from that art.[10] This is understandable, for most art criticism tends to adopt a short-range historical perspective. Critics have been more interested in sorting out Reed's relation to American art of the 1960s and the 1980s than in dealing with these larger-scale problems. But now that these concerns have been much discussed, the time has come to take seriously his claim that art such as his may draw on old master tradition.[11] That claim is important both because it tells us about Reed's art and because it helps us to understand the old masters better. Here I focus on historical problems, leaving for another occasion an extended analysis of the development of Reed's own art.

Once we reject the older accounts, what kind of connection may be found between abstract painting and old master art? The best approach, I want to suggest, is to look not for formal parallels between the use of space in abstract and old master works, which will always lead to an ahistorical and so reductionist view of old master art, but for relationships between the narratives, implicit and explicit, of the old masters and the implicit narratives in Reed's painting.

Consider the narrative implicit in the colour relationships of Andrea del Sarto's Borgherini *Holy Family with the Infant St John*, as described in the majestic prose of Sydney Freedberg:

the three chief hues in the picture approximate a colour triad. But these relations, though perceptible, remain approximate: they do not mesh like the conjunctions of a classical colour system but, instead, make a slight dissonance. . . . The colour . . . has been given an unnormative complexion . . . not quite consistent with our expectation of natural experience.[12]

Such colour relations reappear in many Reeds. As he himself has noted, the central drapery of this painting, Christ's loincloth, is modelled with hue rather than value, even though the rest of the painting uses strong value contrast. This painting is an old master example of the use of colour from which Reed borrows.

Juxtaposing hues is a technique which is suggestive for the abstract painter, if only because it provides a way to use different types, or even levels, of colour relations. Value gradations suggest descriptions of volumes in the physical world while complementary hues suggest video and movie images, which usually provide a more unnatural or artificial description of what they depict. When I say they are unnaturalistic, something more than mere conventions of representation are involved.

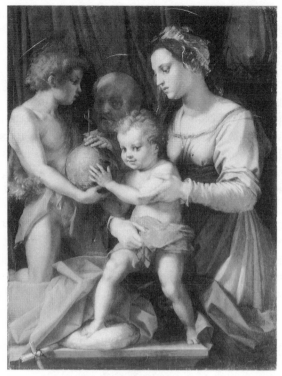

Andrea del Sarto, *Holy Family with the Infant St John*, oil on wood,
135.1 cm × 100.4 cm. Metropolitan Museum of Art, New York.

On the screen of a television or a cinema things which are far away and
near appear as if all at the same distance, projected onto that surface.

One weakness of much art history, and most especially of formalist art
criticism, is its focus upon the spatial structures of paintings, rather than
upon the structure of colour relationships. In Greenberg's criticism, for
example, the movement from the old masters to early modernism to
Abstract Expressionism is defined, first and foremost, by changing uses of
space *per se*. In his account, little is said about the different ways in which
Manet's paintings, and those of the Cubists and Pollock, use colour. As
Stephen Bann has accurately pointed out, the weak point in Greenberg's
account comes in that critic's conception of colour in Manet's art.[13]
Ideally, 'even primary hues, used pure, are compelled to reveal something
of their constituent colours at the evocative call of other colours in a
picture . . .'[14] Any imaginative abstract painter would be inspired by the
colour relations in old master art. But in so far as that art is used just by
dismantling it in piecemeal fashion, the result is merely a deconstruction

of tradition, using elements from works whose story-telling concerns are, unavoidably, inaccessible to an abstract artist or, indeed, to any painter working in the 1980s.

And so, the content of this older work must also be considered, for identifying it explains why these colour relations are of especial interest for Reed. Unlike a formalist critic, he is interested in the content as well as the formal relations of the painting, a concern which is fostered, I want to suggest, by his especial interest in the colour. In *Holy Family with the Infant St John*, del Sarto's Christ-child is playing with the globe as His mother holds His genitals in the loin cloth.[15] Freedberg identifies the primary narrative: 'The Child . . . accepts the sphere as if it were a toy, and shows his pleasure to the spectator.' He recognizes the burden He will shoulder, as from behind 'Joseph looks out at us . . . like ourselves he is a spectator . . .' Joseph is very much in the background, an effect reinforced by the dark colour of that portion of the picture, which also involves Christ's right hand. The implicit narrative of the erotic relation of mother and child, whose exact meaning is hard to understand, appears to have no connection with this otherwise straightforward story.

The colours of the drapery below Christ on the left and right are synthesized in the colour of his loincloth, reminding us that He is man incarnate. What is odd and complicated in relation to this central area of the picture is the arrangement of hands. The Virgin's curiously long right arm extends around her son, who reaches backward to grasp the globe. Part of the implicit story is told, then, by these colour relations, which thus cannot be appreciated merely abstractly, as a formalist would seek to appreciate the spatial relations. Colour carries narrative meaning in part because it is always identified as colour of form. We cannot disassociate the meaning of the colour relationships here from the meaning of the represented forms.

This del Sarto has influenced the colour in Reed's recent art. The other old master paintings I consider have a more general influence on the implicit narrative of his compositions. It is no accident, we will see, that all of these examples also involve, in one way or another, images of eroticism. Artemisia Gentileschi's Detroit *Judith and her Maidservant with the Head of Holofernes* shows an unusual moment in the story. It differs dramatically from Caravaggio's and Gentileschi's earlier *Judith Slaying Holofernes*, which show the violence itself. Here, standing in the tent Judith holds her hand over the candle, putting her eyes into shade so that she can see beyond the light of the tent. She and the servant are frozen, as if waiting to be discovered. The 'artist avoids . . . the bloody

Artemisia Gentileschi, *Judith and her Maidservant with the Head of Holofernes*,
oil on canvas, 184.15 cm × 141.61 cm. Detroit Institute of Arts.

moment of the slaying . . . choosing to focus . . . upon the moment just
after the decapitation. The women are still in Holofernes's tent . . . and as
Abra gathers up the head from the floor, Judith . . . turns from the act
completed to face an implied intruder.'[16]

Here, as in the del Sarto, we find a secondary narrative. Ostensibly the
picture is about the triumph of Judith over her enemy, the man whose head
lies on the floor. The pictures depicting Judith beheading Holofernes focus
on the moment of physical violence, which it is natural to relate to the
sexual violation of the artist herself when she was raped by a pupil of her
father. The subsequent trial was a traumatic experience for the young
artist which, it is natural to believe, was reflected in her choice of images.
In this picture we see a different Judith than the figure most male artists
depict: neither the sexually attractive figure of Rubens and many other
artists who present this theme nor the actor who does the violence, as in
the earlier Gentileschi, but a calculating warrior who looks ahead to the

Bernardo Cavallino, *Judith with the Head of Holofernes.*
National Swedish Art Museums, Stockholm.

next moment of the story, which is not yet completed. This picture is worth comparing with the Sarasota Mattia Preti, *Herodias with the Head of John the Baptist*, in which Salome's mother shows the head of the prophet, another picture which asks us to look forward in the ongoing action and to imagine what will happen.[17] In their different ways, both of these pictures treat the violence as one inevitable stage within the ongoing story.

In a related picture, Bernardo Cavallino's Stockholm *Judith with the Head of Holofernes*, Judith is holding the sword, which would previously have been held by Holofernes. In a strange way she appears to gain strength through him. They are seemingly united, becoming one in an almost sexual way. Judith cradles his head in the way that a lover might hold her beloved. She does not hold the sword by the hilt but by the blade. That sword is signed on the hilt, as if a reminder or an image of their intercourse. And her face is flushed, as though the artist were showing her

in the aftermath of their sexual activity. As one sensitive art historian has recognized, there is something oddly erotic about her expression, 'her wide-eyed, unseeing gaze; slightly parted lips; and weary hands, one grasping the sword loosely and the other resting limply, almost caressingly, upon the severed head of Holofernes.'[18] As with the Gentileschi, here again the implicit narrative takes us back to an earlier stage of the action, a moment before that shown in the scene we see. Judith and Holofernes were lovers, and the idea that she loved him, we might think, has still not passed from her mind. She thinks back, while Gentileschi's Judith is concerned with the future, a difference which it is easy to understand in relation to the personalities of these artists. (It would be surprising to learn that Cavallino's picture had been painted by a woman.) Gentileschi's Judith is worried that she will be discovered. This implicit narrative is seemingly at odds with, or independent of, the explicit story, as hard to connect to it as it is hard to link the Madonna's hand gesture in the del Sarto to Christ's passion, or relate Judith's looking out of the tent to the just completed action in Gentileschi's picture.

What does it mean to claim that Reed's entirely abstract pictures also involve implicit narratives? These examples show that the narrative, explicit or implicit, in an old master painting may be identified as the part of that painting which relates it to something outside the picture. The narrative is that element of the painting which involves a temporal dimension. These two seemingly different ways of characterizing that implicit narrative are closely connected. It is by organizing our experience of the painting as a temporal experience that the narrative of what is depicted in a picture involves such stories. When I identified the above three implicit narratives, that was to recognize that one way of organizing our temporal experience of the painting can be at odds with another. The Madonna's erotic gesture in the del Sarto has nothing obvious to do with the primary message of that scene; the idea presented in Cavallino's picture that Judith loved Holofernes is at odds with the explicit moral of that image. In these cases, the implicit narrative apparently contradicts the primary story.

But such a secondary narrative may also supplement the primary story told in the painting. Comparing the Caravaggio *Repose on the Flight into Egypt* with his *Magdalen Repentant*, also in the Galleria Doria, Rome, Stephen Koch observes that they were painted in the same year and use 'the same woman as a model'. The Magdalen's 'arms are in precisely the position to rest the baby's head ... the emblem of the prostitute's simultaneous penance and redemption is an absent child, whom she

Caravaggio, *Magdalen Repentant*. Galleria Doria, Rome.

simultaneously embraces and grieves over'.[19] (This claim, he adds, not recorded in the earlier literature, appears to be Reed's discovery.) If the explicit story in *Magdalen Repentant* tells of her repentance, the implicit story is about this loss. And identifying this implicit story shows how these two seemingly very different scenes are in fact connected. Such an implicit narrative is, in one way, the converse of a deep interpretation. We discover that two works with ostensibly different subjects are in fact visually similar. The meaning of these paintings lies entirely on the surface when they are properly seen.

Such stories are found in all images, representational as well as abstract, in so far as all pictures demand to be experienced one part after another, in temporal succession. And when we turn from Cavallino's *Judith with the Head of Holofernes* to Reed's *No. 273* (p. x), we move from a work which has an explicit and obvious story, as well as the implicit one I have identified, to a painting which also engages us in a temporal experience, because it too is involved in story-telling. This notion that a story can be

implicit in an abstraction may explain why abstract art encounters resistance even among relatively sophisticated viewers. For when such a story is not 'in' the work, considered as an illustration, but depends upon the viewer's capacity to respond creatively to that image, then viewing becomes an active process. Of course the viewer is always active, but we may tend to forget that when, identifying the explicit narrative quickly, we fail to look closely. Properly seen, any complex composition, 'abstract' or 'figurative', contains such an implicit narrative. What we perhaps (re)discover here, in strange parody of Greenberg's definition of modernism, is that abstract painting involves a self-consciousness about its medium – a self-consciousness not about its formal use of space, as he thought, but about its capacity to use colour to create implicit narratives. But it may be true, also, that paintings like Reed's sensitize us to dimensions of old master painting which earlier generations of viewers had difficulty identifying, or even seeing.

In the work of an important artist, nothing, I believe, can be accidental. And so it is interesting that Reed's usual practice, unlike that of many younger abstract painters, is not to provide evocative titles but only numbers for his paintings. The omission of a title is his way of forestalling facile readings of the implicit stories in his pictures, of putting a small obstacle in the viewer's way in order that she or he may better be stimulated to seek out these stories. Apart from the relatively small works, Reed's recent pictures are mostly vertically or horizontally oriented rectangles in proportions of three or four to one. The dimensions of these works are significant, for these formats encourage us to read them as narratives, as stories proceeding, especially (but not only) in the horizontally oriented rectangles, from one side to the other. We see one part and are led to see another part which then is seen in a different way than when it was first viewed.

For example, No. 273 involves an implicit narrative when I move from looking at the emerald-green stroke extending downward at the left corner, in a seemingly spontaneous gesture, to the two inserts around the centre. In the upper half of the picture I see a complex subdivision of the space. The lower portion is homogeneous in colour, apart from that stroke and part of one insert which extends downward, unifying top and bottom. I see that my eye is to move from left to right, not from above to below, and even while it is hard to know how to describe, in so many words, that movement, I am aware that the very movement itself identifies and so implies a story, an implicit narrative.

In one obvious way, Reed's implicit narratives must differ radically

from those I identified in old master works. Within the paintings of del
Sarto, Gentileschi and Cavallino we see that the story is told by the
depicted figures. Reed's works contain no represented figures and so no
explicit stories. His narratives are always implicit. The story told in *No.
273* is not a narrative about life and death, like those of Gentileschi and
Cavallino. The story Reed tells us is about the process of making a
painting, though it can only be identified, I would argue, by relating it to
these narratives in old master works. The best way to understand how a
work of art can present such an implicit narrative in entirely abstract
terms is to consider another example, an old master work whose
narrative is in part about the medium of painting.

Guercino's *Samson Seized by the Philistines*, in the Metropolitan
Museum, New York, has both explicit and implicit narratives: 'Guercino
. . . gives massiveness to the figures by allowing them to occupy a high
proportion of the picture space . . . bringing them forward toward the
spectator. But . . . he attenuates that massiveness by suggestions of
vigorous movement . . .'[20] For a painter, or a viewer passionately
interested in painting, this story about blinding is sure to have an especial
emotional resonance. But if the explicit narrative is the story about
blinding, the implicit story is about the way in which Samson seems to
stand for the canvas as such, when he is pressed forward as if he were to
be projected into our space. Such an outwardly projecting figure appears
in many Baroque works, but here when we consider the identity of the
figure who is pressed forward, this device has particular significance. It is
as if the entire space in which the action takes place, that place in which
Samson is being blinded, extends outward to include the position where
we are standing. At the next moment of the ongoing action, if we envisage
such a painting, the picture space would extend to encompass our place
before the image. Just as it is hard for a male spectator to respond in a
neutral way to the acts shown by Gentileschi and Cavallino, so it is hard
to distance oneself from this scene – not just because the act of blinding a
man is terrifying, but because the space in which it is taking place extends
outward beyond the picture space.

We see an image of violence against Samson which thus also implies an
act of violence against what might be called the very nature of painting.
For since his figure cannot really extend into our space, by implying that
he might fall forward Guercino suggests to us that when the action
proceeds to its next inevitable stage, it will no longer be paintable. Like
Gentileschi and Cavallino, he presents a narrative about violence linked
to eroticism, a painting about the power of women.[21] Their pictures

Guercino, *Samson seized by the Philistines*, oil on canvas,
191.1 cm × 236.9 cm. Metropolitan Museum of Art, New York.

Correggio, *Lamentation*. Galleria Nazionale, Parma.

showed the revenge of a wronged woman, this one an act of violence on a once powerful man who later will regain his powers. That later moment is anticipated already in this narrative, for as Samson resists vainly, he is pushed down, as later he will bring down the temple. And that implicit story is told here in a way which makes complex reference to what I will call, in parody and/or acknowledgement of the formalist's vocabulary, the nature of painting.

Art historians are familiar with the question: '*where* is the depicted image?' This, of course, is the question which motivates formalist art criticism. Fry identifies the position in space of Poussin's depicted figures; Greenberg links the spaces of Manet, the Cubists and the Abstract Expressionists. Art historians often describe the spatial relation between a representation and its spectator. Another less frequently asked question is '*when* is the depicted image?' Answering this question leads us to think about the narrative implicit or explicit in a picture. An image which appeals to the immediate presence of the spectator, as do those which I have discussed, appears as if in the temporal present of the viewer. *When is* a painting which depicts a historical event? It is of the time, the distant past, of the depicted scene. But it is also of our immediate present. We see it as if it were taking place right before our eyes.[22] Of course this is only an illusion. But so too is seeing the pictures as presenting these terrifying scenes, as if these illusionistic images were real re-presentations of those events. The blinding of Samson and the beheading of Holofernes are terrifying because these happenings of the historically distant past are presented as if they were occurring right before us. It is our eyes which seem threatened when we view Guercino's picture of Samson.

Reed's brushstrokes are initially readable as spontaneous or 'free' gestures, akin to those of Abstract Expressionism. But when we study his works, it soon becomes clear that strokes cannot be made by gestures.[23] His brushstrokes appear as if they were not made by human hands. Of course this too is an illusion, but it is an illusion of central importance for understanding his work. Many commentators have called attention to the seeming artificiality of Reed's images. Understanding their parallels with old master art is the best way to explain this important and striking effect. There is a strange contrast between their initial appearance of spontaneity and the highly calculated effects of Reed's compositions. Considering, for example, in *No. 273* the green line I mentioned earlier at the far lower left running downward, what at first appears a spontaneous gesture is eventually seen as a carefully thought out way of linking the top and bottom panels.

Reed's paintings frequently include rectangular elements of colour within the larger field – 'mirrors', as I will call them – which are equivalents in his style to the pictures within pictures or the images which exemplify the making of the picture in some old master works. In his works these rectangles provide the starting point for his implicit narratives. We can best understand the function of the mirrors by considering another example from old master art. In Guercino's late *Saint Luke Displaying a Painting of the Virgin* (Kansas City) in which St Luke shows the Virgin her portrait on his easel, the painter has given her and her Son the same blue and red garments as he himself wears. As the painter has his inner blue and outer red, Christ in red is in the arms of His mother, her outer blue matched by the inner red which shows from her sleeve. The colour in the painting on St Luke's easel, we are meant to see, is used to relate it to the larger work by Guercino. That mirror is thus implicitly about the larger painting. Mirrors appear also in old master works which contain images explicitly about the making of the work. In Caravaggio's *Boy Bitten by a Lizard* (National Gallery, London) we see an image of his studio reflected in the vase.[24] In his Uffizi *Bacchus*, similarly, we see a reflection on top of the wine in the carafe which the pseudo-Bacchus has just set down. It is a reflection showing Caravaggio at his easel painting the very painting we see.[25]

In these paintings, as in Reed's works, the 'product', the finished picture, cannot be seen apart from, and so cannot be detached from, the painter's act of telling. Literary critics and historiographers note that a narrative may erase reference to its origin, pretending that it is told as if no one were telling it.[26] The viewer (or reader) is asked to treat the picture (or text) as if it were created by no one. Such impersonal seeming pictures and texts pretend to be objective, as if they were not made by an individual who brought to them her or his particular emotional concerns. Other texts and pictures, including these old master pictures and Reed's paintings, acknowledge the fact that they were created by a person whose subjectivity is in evidence in the finished work. The implicit narratives in such old master pictures and Reed's works are ways of calling attention to the spectator's presence. In prose, as in painting, drawing attention to the making of the text is one way of pulling the reader into that work. We the viewer (or reader) feel, momentarily, that the work of art is our creation.

A secondary narrative, as I understand it, is a story implied by and perhaps complementary to the main story which a picture tells. In each case, then, going beyond the story told, we find another story, defined by

the composition and the colour. No doubt our familiarity with abstract art makes it easier for us than critics or historians of an earlier generation to turn from the primary story to these implicit narratives. Whether it is because when the primary narrative is too obvious that we turn aside from it or because we see colour and spatial relations differently than critics trained within the formalist tradition or because the work of the Poststructuralists makes us more concerned with the importance of all narratives, implicit as well as explicit, or, as I am inclined to think, because recent art has influenced our ways of seeing the old masters: in any event we seem to be more sensitive to these aspects of paintings than earlier critics. Perhaps we now see pictures differently because our concept of the self has changed. Here, a historical perspective on the relation of Reed's work to the old master examples I have given is important. When Reed constructs his implicit narratives, he demands that they be understood by a different viewer, a different kind of spectator, than that figure Fry, Greenberg and most traditional art historians think of as standing before the painting. Another example makes it easier to understand this change in the nature of the self, which is of great historical importance.

Correggio's two panels *Lamentation* and *Martyrdom of Four Saints* (now in the Galleria Nazionale, Parma) were painted for the del Bono Chapel, San Giovanni Evangelista, Parma. The chapel contains three other works by or after designs by Correggio: two lateral works at the entrance and, above, a figure of Christ. All these works are site specific. In their original context, the two major panels were meant to be seen from the altar; Christ above the entrance is looking across to St Paul being converted.[27] The chapel, furthermore, is in the church whose cupola contains Correggio's earlier *Vision of St John on Patmos*. The spectator coming into that church sees first the subject of St John's vision, Christ suspended above. Only afterwards, when he steps to the main altar, is he in a position to turn and see, at the edge of the cupola facing the entrance, St John himself.[28]

There is a fascinating spatial relationship between the cupola painting and the works within this chapel. In the *Lamentation* the workman climbing down from the ladder is in the position which Correggio occupied when he climbed down from the scaffolding. In *Martyrdom of Four Saints* the diagonal thrust of the two weapons extends in the opposite direction, downward. Christ, who is shown above the chapel door, also appears on the cupola. The Cerasi chapel, S. Maria del Popolo, Rome, Leo Steinberg wrote in a now famous article, is 'a miniature Latin

cross church', Caravaggio's pictures 'composed as to promote in . . . [the spectator] a sense of potential intrusion among its elements'.[29] These earlier Correggios, I would suggest, achieve a similar effect. Standing at the altar of the chapel, the spectator is between two mournful scenes. Looking to the arch, one sees two miraculous images of divine intervention. Gazing upward, walking into the centre of the church, one sees the hovering figure of Christ. The del Bono chapel creates real spatial and temporal relations between what in isolation, when displayed in their present museum setting, appear to be merely panel paintings.

Such site-specific effects assume the presence of an embodied spectator who must see the relation of panels. Leo Steinberg, the first art historian to call attention to these effects, argued in his account of 'the flatbed' (published in 1972) that what soon came to be called Postmodernist art cannot appeal to such a spectator.[30] The idea that experience of art can depend upon this radical change in the very nature of the self is one reason why Steinberg's account is so important and also, I suspect, why his claims have so often been resisted by his fellow art historians, if not by art critics. (Steinberg is often said by art critics to be the founding father of 'Postmodernism', though he himself does not, I believe, use that word nor, to judge by his published writings, accept its implications.[31])

Because usually there is surprisingly little overlap between the concerns of present day art historians and critics, the connection between his view of this history and what he says about contemporary art has remained unexamined. Looking for implicit narratives in old master and abstract painting provides one way of connecting the concerns of art historians and critics. For Steinberg, the history of art is the history of changing ideas of the self. This is a pregnant idea which deserves development. To cite but one obvious and important example, television creates a new sense of the relation of self to image which viewers also surely bring to painting. Trained by such novel visual media, we now see Baroque painting differently than did the contemporaries of the Carracci. (Are we better able to identify their visual subtleties? Or do we project into them our modern concerns? These questions are hard to answer. Perhaps that is a distinction without a difference.) Present day anxieties about the power of painters to sustain the traditions of art, which are one source of the Postmodernists' belief that the tradition cannot be continued, reflect this awareness of changes in the identity of the self, albeit in a confused way. Recognizing that the spectator is as if scattered in many positions, illusionistically not present at any one single place before the work of art, is liberating for Reed. Freed from the need to place him or herself in a

rigid way, the viewer is open to a richer experience of a painting in which, within a single isolated panel we find imaginary spatial and temporal relations which are as rich as, though very different from, those produced by walking through the del Bono Chapel.

One natural question about these secondary narratives in old master art is whether identifying them is an entirely objective process. The primary narrative, as I am calling it, is what the traditional art historian seeks when she or he seeks to study the iconography of a picture, identifying that text which is its source. That pictures have such determinate sources which can be unambiguously identified is a basic presupposition of traditional art history.[32] The formalists reveal that they also accept this presupposition when they frequently speak in a misleading way of *we*. How, Fry asks, 'can *we* keep the attention . . .' fixed on both the story and formal relations?[33] Looking at the shallow space in a modernist painting, Greenberg writes, '*we* may feel a certain sense of loss'.[34] Who is that *we* of whom they speak? When *I* see Cézanne's pictures differently than Fry, or Pollock's in ways unlike Greenberg, I would observe that their 'we' is a fiction, a way of trying to pretend that their accounts are more objective than they really are, or could be. This is why my narrative, unlike theirs, tends to employ first-person pronouns. My interpretation of these pictures, which draws frequently upon my discussions with Reed, is, both he and I would admit, subjective. Another viewer might read these pictures by Andrea del Sarto, Artemisia Gentileschi, Mattia Preti and Bernardo Cavallino entirely differently than do we, though we hope that this viewer would be able to understand our analysis. Indeed, since these examples involve erotic images and scenes of violence, it is predictable that how a viewer responds will depend upon his or her individual, and so unavoidably subjective, sense of sexuality. Feminist art historians, in particular, have played an important role in reminding us of the importance of this fact. Focusing on these implicit narratives seems to open the way to subjective responses to art. I think this result is to be welcomed, for it provides a way of responding more fully to the highly subtle content of these works.[35] One important way in which the abstract painting by Reed (and some of his contemporaries) may come to influence our understanding of the old masters is by making it easier to recognize how, in these ways, our responses to all pictures are in part subjective.

In the recent rejection by almost all critics of Greenberg's (and Fry's) formalism, something has been lost and much has been gained. What has been lost is the possibility of understanding contemporary art in relation

to old master painting. What has been gained is the opportunity to understand in a richer way the differences and similarities between these seemingly different art forms. Ultimately, my present goal in interpreting Reed's paintings is to reconstruct what I take to be Greenberg's most important insight, in a way which is accessible to a 1990s sensibility: 'The connoisseurs of the future may be more sensitive than we to the imaginative dimensions and overtones of the literal, and find in the concreteness of colour and shape relations more "human interest" than in the extra-pictorial references of old time illusionistic art.'[36] In an odd way he could not have predicted, perhaps Greenberg's prediction is already coming true.

Art criticism involves, too often, a critic imposing an artificial, perhaps alien perspective upon the artist's work. And so here, for once, the artist himself should be allowed to have the last word about his own work. Reed has said:

Baroque artists introduced a lot of tactile qualities as a way of getting around the figures, to break them down and make them disappear as you look at the paint surface. Since I don't have the tradition of figuration hanging over me, I have the opposite problem: I need to bring back within the all-over structure a sense of variety of the parts . . . an effect I want in my paintings . . . [is] a sense that something has just happened, or is about to happen, and if you look carefully you'll be able to see it. . . . the changes that you notice in the paintings . . . will be that event. The viewer and the paintings are the event, together.[37]

5

Romance of the Real:
Jonathan Lasker's Double-Play

RAINER CRONE AND DAVID MOOS

Does this really read like this:

Already work on the undersea tunnel which will connect the Korean peninsula with Japan has substantially moved forward. We have completed the planning stage, and initial excavation has already started.

A couple of years ago, I conveyed this idea to officials of the People's Republic of China. They expressed positive interest in the project and are conducting a feasibility study. Of course this project will eventually have to involve the Soviet Union because of its key geographical position in both Europe and Asia. I hope that I can establish contact with representatives of your government.

At the present time, I am also helping to create an automobile production city in Southern China in order to enhance the People's Republic of China's export opportunities. It is an exciting challenge to help to create an exportable car . . .[1]

Page 11 of the *International Herald Tribune* (14 December 1989) is taken up by a lengthy newspaper interview with the Reverend Sun Myung Moon of South Korea. His first public interview in thirteen years, it has been translated and reprinted from *Za Rubezhom*, a Soviet weekly with a circulation of one million 'serving leading intellectuals and policy leaders throughout the Soviet Union'.[2] The headline proclaims that 'a spiritual revolution is needed', but it becomes clear that the interview is only linked to spiritual or religious values for tactical reasons.

The single most striking characteristic of the Reverend Moon's approach to global cultural unification is his brazen equating of spiritual and artistic advancement with refined capitalist economic production. Following the recent demise of dogmatic Communism, Moon's motive for the interview emerges as purely economic – an attempt to retract personal political prejudice and stimulate commercial interest. Beginning with the topic of the Kirov Ballet, he praises Gorbachev's economic initiatives, dreams of an International Peace Highway, critiques American society and concludes stating: 'I want to assure the people of the Soviet Union that the Reverend Moon is your friend.' 'New thinking',

individual spirituality and world peace are advertised as attainable objectives only through economic growth and cooperation – a clear example being noted in car manufacturing. Capitalism triumphs as the single viable means to personal fulfilment. As Moon himself praises his own industrial pursuits, it becomes clear that his single-minded objective is to court Soviet business. His pretext of reverend secures a certain social position which is exploited for economic purposes.

Such a figure as Moon, who freely interweaves formerly separate secular and sacred social spheres, signifies the complete breakdown of cultural distinctions that previously gave the appearance of autonomy and authenticity to the human existential endeavour. That a reverend of an international church can openly double as king of a self-made economic empire, and then also assume the role of international statesman, reveals a profound shift in the late twentieth-century social superstructure.

But such analysis of a character like Reverend Moon should not come as a surprise to the informed reader conversant with media manipulation in today's technologically oriented global society. Aside from scrutinizing the various pretexts Moon (purports to?) fulfil, in the above instance we can observe a most pernicious undermining of the real. By *real* we refer to any notion or context with a predetermined normative meaning and predefined signification.

Page 11 of the *Tribune* is not, as we have been led to believe by its appearance, an item of noteworthy news sanctioned by the editors. It is rather an advertisement for the Moon empire. One of the Reverend's many companies, the World Media Association, purchased the page to reprint this 'silence breaking interview', as the 'headline' proclaims. The design of the advertisement – yes, advertisement! – complete with a photo-portrait centred on the page, apparently takes the form of the original interview itself, with a scene-setting preface and postscript supposedly critically evaluating the Reverend's remarks. Wording in the postscript exudes an aura of uneasy translation, the faltering English of an apparent Russian journalist who attempts genuine expression in the English language he has not quite mastered. Indeed, the entire linguistic fabric of the interview is characterized by this cultural discrepancy (intentionally preserved, or perhaps fabricated for verisimilar ends) eliciting the involvement of English-speaking readers.

This, of course, is the first flaw in the facade of the real because the most important overseas American newspaper is certainly not constituted by journalists who write English as a second language. The

typeface is not identical with that of the actual newspaper but is arranged in wider columns, appearing to be a special section, or perhaps this new format is closer to Soviet newspaper design. If not for the word 'advertisement' printed quaintly at the top left and right margins of the page, the interview would pass as a major event, authentic critical journalism. Maybe the interview is unaltered, appearing in its original form, but we conclude that this is unlikely given the demands of advertising.

As advertising assumes the form of journalism, superseding itself by becoming journalism, the status of the newspaper itself is thrown into question. That a private media company can so heavily impinge upon a morally responsible publication reveals, above all, the primacy of economic power – which inserts itself between any concept of the real and an invented facsimile aberration governed by independent motives. The real becomes a vestige of the nostalgic past, a familiar acquaintance we are unable to befriend.

Three months previous to this abstraction of the *real*, in the exhibition catalogue, *Cultural Promiscuity*, which takes its title from thirteen studies of one major painting, *Cultural Promiscuity*, Jonathan Lasker speaks of the intimate relationship between economics and culture in the late 1980s:

The hyperreality of the culture is parallel to an economy that is basically running on hot air, or air, period, and on bogus manipulation. I don't think it is accidental that the culture is running parallel to that trajectory. Let's say the economy totally deflates itself; all of a sudden the bubble bursts, and we find ourselves in an entirely deflationary, depression-oriented position. I think that the culture we would get from that economic circumstance would be radically different from today's culture. *The irreality of contemporary culture is supported by and in complicity with the irreality of a bankrupt economy.* [our italics] A bankrupt, but superficially affluent, economy.[3]

That such concerns occupy the attention of a painter today attests to his awareness that painting, as a medium for expression, aspires to address a certain fundamental disorientation in culture. Either directly or circuitously, by order of its impact as an autonomous artifact, the painting may erect and affect a discourse governed by a value-oriented structure which is opposed to nihilism and superfluidity. In a situation where major concepts have been altered, instigating a 'hyperreality', let us begin by outlining a new criterion for cultural comprehension.

The term 'real', linked to a reality, pertains both to the work of art and its receptive context. The materiality of paint which is articulated onto

the unmanipulated canvas produces in Lasker's case a painterly 'reality' characterized by the simple phenomenological presence of different surface treatments; from smooth, effacing brushwork to impastoed, 'gestural' strokes. The real is initiated and manifest in the painting in so far as its defining criterion is internally contained and self-sufficient. The real can have no affiliation to external representations (either observable or symbolic) but is dependent upon and constituted through its own denotation. Through the suppression of external referents, the real begins to achieve its purest form. This dichotomy between referentiality and the real is observed by Lasker, traceable through a distinct historical context: '[Jacques Louis] David exercised the conceptual operation in painting as a form of moral propaganda, but a painting can also function as a self-analytical event.'[4]

When Lasker mentions David, it is the David who discussed specific issues in late eighteenth-century French society by retrieving themes from ancient Greek and Roman culture. This ideological discourse operated through implication to affect the contemporary social climate. Conceptually, David's paintings are significant in so far as their thematic representations fulfilled specific issues. The actual application of paint onto the canvas is subservient to the required clarity of narrative depiction. David's painting can be regarded as a representational simile but does not recognize itself as expansive metaphor; potential 'poetic' meaning has been subsumed by the literary dictates of narrative text.

Lasker's reference to David signifies two crucial concerns. The first pertains to his awareness of the now irreconcilable dichotomy in painting between representation (of a specific depicted event) and its non-representational obverse – in Lasker's words, the painting as an autonomous 'self-analytical event'. Thematic, historic and other qualities of traditional painting that constructed a definite relationship to the external world are of limited, if not entirely diminished, significance. The so-called 'external world' of today is not composed of myriad visions available for the artist to re-produce but is rather composed of ideas and perceived issues available for the artist to reflect upon in the selected medium. In this clearly defined non-tautological way Lasker's awareness of the social can be acute, its articulation succinct. His painting is detached from overt social implications, operating as an object from which discourse originates, rather than concludes with. Societal concerns are not reflected or mimicked in Lasker's work but nevertheless exist as instigating critical issues.

To trace the origin and first concrete formulation of these complex

ideas concerning the nature and being of painting, the recognition of the painting as an autonomous object in the world, Neo-Classicism and David must be abandoned and our attention focused on early German Romanticism. The profound Romantic understanding and positing of *mimesis* against *poesis* announces a conceptual stance in painting and poetry that today still has radical ramifications. And although Lasker is certainly not overtly engaged with Romantic notions, his painterly project can be summarily accessed through this historic movement which reoriented philosophical directions in Western art.

Observable nature, recognized in its complexity and grandeur, served as an essential source of inspiration and conflict to the German Romantic mind. Unlike in preceding eras, the Romantic endeavour strove to displace the correlative bond between the artist and the surrounding world. The Romantic work of art no longer maintained an ineluctable, direct relationship to nature.[5] Novalis asserted that poetry is 'the absolute real',[6] basing his philosophy on the fundamental tenet that 'the more poetic a work of art is, the more truthful it becomes'. The radical outcome of this approach was an understanding of truth in art that could only be fulfilled through increased degrees of artistic investment. The inception of an 'absolute truth' contained in art clearly links artistic creation to the real. The Romantic poem expressed why the infinity of empirical events, previously understood to be the real, assumed diminished importance, nature now functioning as merely one order of the real. Although the artist could still utilize and preserve a syntax derived from nature, the meaning of the artistic utterance was intractably and conceptually transformed.

Romanticism thus believed the work of art to possess and produce as infinite a number of characteristics as are found in nature. It was, however, liberated because, as Novalis phrased it, art assumed the 'dismissed tendency to *copy* nature'. Because of the multifaceted meanings of language in art, the Romantics asserted that the poem be inexhaustible in meaning. Poetic meaning could metaphorically present what is impossible for the actuality of direct representation. Novalis referred to this aspect of art as the reason for *transcendental subjectivity*.

The unpresaged essence of subjectivity is articulated always to exceed the expressed – and in this way the work of art distinguished itself from any other products of nature or man, drawing closer to our present conceptions and appreciations of the art work. Novalis presumed the work of art to reflect an exact yet expansive intention, the reason for subjectivity itself – the 'self-analytical event'. Because creative subject-

ivity is the motivation for what is created, 'Ins-Werk-Setzen', truth is produced by art itself. Subjectivity cannot be reproduced or anticipated and thus emerges as the unique meaningful core of the art work, its real truth that can generate a major event of historical significance in culture.

Assuming this position from German Romanticism, this line of thought culminates with Heidegger's refined definition of truth. Truthful creations are defined by expressions or interpretations. Heidegger asserted that interpretations are truthful if they reveal aspects of the world in their essence ('wie sie an ihnen selbst sind' from *Sein und Zeit*, para. no. 44, 217). Thus, according to Heidegger, only interpretation is true, and only true, if it explains to us beingness (Sein). In this context the subjective subsumes any objective counterpart or critique that could undermine it.

With the dismissal of representations of nature from the creative conflict and the ascension of transcendental subjectivity, the art work retains a self-defining criterion that can be approached through a suitably individual hermeneutic context.

From these brief comments about early German Romanticism our conception of the real as constituted and created through the artistic articulation of 'poetic' truth gains unequivocal resolution as a prime motivating definition of any artistic project. The complicated, yet concise union of these fundamental and epistemological concerns of man, understood as the transcendental subjective, established the potential for authentic creation to carry meaning. Even a cursory recollection of major contributions throughout the history of modern painting (Delacroix, Van Gogh, Malevich, Newman) evidences the validity of this criterion for assigning value.

Having recognized the necessity for a value structure and authenticity in painting, one can only regard the generation of artists surrounding Lasker as being confronted with a succession of culturally demanding occurrences that overwhelmed many artists' attempts to confront and recuperate the real. Unable to deny or genuinely supply the communal urge for newness, distinctions diminish as cultural systems close in on themselves, collapsing into unmediated mimicry. Our example of Reverend Moon serves as a paradigm for the abstruse warping of traditional cultural values into hybrid forms that are recognizable, but have no established significance. Over the past decade a majority of artists sought refuge from traditional means of creation by merely experimenting with curious media and perplexing techniques. The fracturing of the canvas

into parts, the addition of sculptural elements both on the canvas and off the wall, the dramatic rise of photographic (and video) techniques – all overtly hostile characteristics aimed at exorcising convention – signify a profound inability to fulfil tradition adequately. The rapid acceleration and proliferation of trends and styles is perfectly analogous to the decade's inflationary tendency to appropriate instantly and exhaust options purporting to reconcile technique with meaning coherently, and simultaneously to commune with history. At a time when cultural systems are so imperiled, what sense can we make of a technically traditional painter who aspires to contribute to the contemporary discourse and ultimately find a secure place in the history of art?

Double Play (1987, p. xiii) contains all of the basic traditional components of what a painting was understood to be. And simply because tradition has determined finite limits for a created planar object, as has the artist, we as viewers must not succumb to history and exclude the repositing and re-evaluating of those limits: such dictates as line, form, plane, space (depth) and surface articulation. Although this painting measures 116.8 cm × 254 cm, a scale that is physically overwhelming, an exact preceding miniature replicate – referred to by Lasker as a 'study' – exists as a fully conceived entirety. Except for size, comparison with any of the studies reveals a high degree of preconceived composition, as well as the artist's thoughtful ability to anticipate how the effect of paint will change on an altered scale. The decision to 'enlarge a study' is purely subjective, governed by no apparent or empirical formula. Lasker's major paintings vary in size, from larger than *Double Play* to less than one-quarter its size. This disparate range is not manifest in the design of the studies, which are all the same size. Conceived in miniature the painting only becomes a painting through the process of transition from idea to entity.

The most prominent features of *Double Play* are the horizontal pink bars, floating against the mauve ground, which diminish in a consistently proportionate and symmetrical fashion toward the bottom. Imposed upon by the left-side painterly form, they dominate and cancel out portions of the right-side linear form. But indeed, how can we define form, if the two congruent shapes are so differently constructed; the left one built up from painterly strokes and the right through black line alone. The two forms mirror each other in outline, definitively determined by the vertical centre of the painting, but resemble each other only in shape.

The right shape is articulated through the simple act of drawing – painting? – a black line, synonymous with outline, against the homo-

geneous ground. The combination of these basic visual elements generates a form which defines itself through its constituent elements. This can be the spectator's only conclusion when regarding the right side by itself. If, however, the eyes move to compare to the left side of the painting, containing a more complicated configuration, attention focuses less on outline than on the painterly values which function as the constituent elements of this form. Outline is effaced by the free application of paint. This form is built up first from a blue understructure, then a succeeding smooth layer of intermittent umber, followed by the dense imposition of webbed yellow lines. These yellow lines are discontinuous, running randomly in an unrestrained weave. These lines show liquid traces of the blue and umber because all three layers have been painted wet. This tight colouristic relationship fuses the form. The blue and ochre have been applied to the surface with a palette knife, while the yellow is purely characterized by the texture of the brush.

Because the pink bars react differently with each element of the composition they touch upon, the value and power of paint (left side) as opposed to line (right side) – concerning the ability to create form – is questioned. Heavy painting on the left domineers over other aspects of painting but only gains significance in relationship to those other aspects. To be sure, Lasker's heavily painted regions bear not even a distant relationship to the unbridled impasto of second-generation Expressionist painters. Lasker's work is characterized by a consistent calculation that denies rigidity, never sacrificing clarity for a deliberate clarity. Topographically, *Double Play* reads according to its literal elevation, the highly textured parts assuming a position of prominence spatially, the smoothly painted pink bars mediating the distance between the left form and the flat – almost cartographically 'drawn' – outline of the right form. This supposed ordering of elements in spatially sequential terms is undermined by the dictates that qualify form itself. Despite the overlaying aspects which guide the eye from left to right, no clear primacy of form emerges, leading us to the core question of what constitutes form. Is it (a particular combination of) line, texture, surface, shape or colour?

Our assessment of *Double Play* in terms of the primacy of form underlines Lasker's urge to establish the parameters of meaning for his application of paint. The pink bars, which as noted above mediate and connect the left and right sides of the painting, supply the first crucial evidence for how Lasker conceives of form. The second bar from the top is covered over by thick paint in two passages on the left side. Consequently, the pink bar is only partially revealed, protruding to the

left of the heavy tricoloured paint and noticeable in the small bay created between the two uppermost ends of the shape. If this second revealed pink part were to be transposed to the right-side shape, it would fulfil the role of the black line that is masked by the pink bar. In a similar fashion one could imaginarily trace through the end of the pink bar, which exceeds the outline of the left-side shape, and thus generate a boundary for the complimentary part of the right-side shape. This same phenomenon can be observed with the third pink bar, which is nearly completely covered over on the left side by the painted shape. Again, the single visible part could be transposed to the right-side shape in order to generate the outline of the complementary part that the bar masks. And this same transcriptive device is maintained with the fourth bar, which on the left side is preserved only by a small patch of surfacing pink.

This corresponding concordance between the left and right shapes begins to reveal an essential criterion for the establishment of form. The eventual definition of form could not be derived merely by comparing the various aspects of *Double Play*, for example, the pink bars to the right-side shape, or even perhaps the mauve background (which incidentally bears traces of the brush that created it) to the pink bars. None of these casual and numerous combinations would justify the density of Lasker's calculated exegesis of form, which can only be reasoned through comparing and comprehending the relationship between the left and right shapes.

In *Double Play* form is the synthetic unification and equating of the left and right shapes. Lasker reveals the entire complexity of form in a dualistic format, isolating separate aspects for their unequivocal definition and assignment of place. Thus, our understanding of form regards the two shapes as merely displaying different constituent elements of one single form.[7] Form is constituted through its likeness because any part of the left-side shape, even a small one, could not be considered as companion or equivalent to any part of the right-side shape. The two shapes are not interchangeable and only attain the status of form the moment we as spectators realize their necessary interconnection which pronounces them individually, yet together, as form. The left and right side *forms* are different yet are the same size and shape. This is a 'double play'!

The pink bars have the same shape but different sizes. They possess the same characteristics as the forms on the left and right sides but in other proportions, some elements repressed (texture), others obviated and simplified (line, shape and colour).

With *Double Play* Lasker demonstrates, through highly reflected employment of painterly methods, a 'self-analytical event' which defines

form. Paint in its various manifestations of colour, line, texture and shape is capable of constituting form when contextualized in such a way that the constituent elements compliment, communicate and support each other. The form on the left side becomes meaningful to us as spectators if we can experience the other part of it on the right side through different painterly means, both aspects enhanced through the homogeneous background and the pink bars. The arbitrariness of the painting in the left form (evidenced by the intuitive brushwork of the yellow lines) is posed against itself as an indulgent emotive expression, while the right form is subdued and restrained in a meticulous way. As the elements of form coalesce, offering the viewer the opportunity to experience the actuality of painting, we glimpse the rigorous and unique manifestation of a mind mediated through paint.

This occurrence of an experience assumes importance as truthful to its own objective – that of confining the experience and expression to paint alone. What the arrangement of form(s) may connote in the external or even internal world is not significant; the paramount goal for Lasker is the placement and execution of the brushstroke onto the linen as an unconditional authentic statement. The act of painting is dictated by this aspiration, contained within itself, confronting the question of how a human being can create a form without referring to external reality of visions, ideas (emotions) or history. As painting becomes a self-sufficient abstract language, a compounded abstraction of non-referential/non-representational elements, the importance of either establishing or possessing a criterion for continuation and evaluation becomes as important as the result itself. With *Double Play* the exegesis of this process – of understanding through revealing the development of form – dictates the result.

Instead of discoursing upon the expansive embattled terrain that painting today occupies (consequent to its disbelief in originality of thought and capitulation to cynicism) Lasker returns to a fundamental priority, the foundation of form. Form, the result of a mark or trace – an essential component for the 'image' – is a constant in painting which merits exclusive examination. It is enough to address its process of 'formation' before overstepping the actuality to discourse about how a painting can function as a thematically oriented issue-governed object. In *Double Play* form occurs as a created order of the real, one profound aspect of the painting. Analysis of form provides an occasion to regain truth in creation, an occasion to confront the principle of truth and its relationship to creativity.

The meaning of this endeavour can be retrieved through the preceding discussion concerning subjectivity and man's urge to reflect upon the reason for individual articulation. In today's context our equating of the Romantic transcendental subjective must concern itself with a definition of the real. For such a notion as autonomous subjectivity to gain currency in an objective forum, for the personal to transfer to the universal, a context for authenticity must be maintained. The 'hyperreality' that Lasker mentions precisely concerns this potential for a loss of context. The exploits of Reverend Moon do not affect an objective reality, in the authentic sense, because his goals are contained within the infrastructure of a subjective vision promoted through personal avaricious and wishful thinking about the real. Moon may be able to simulate the real by purchasing and constructing a newspaper page (which some may mistake for the real), but ultimately this ploy is merely a low order of mimesis. The advertisement is entirely dependent upon fabrication. It becomes impossible to connect the real to truth with today's highly mediated modes of construction and alteration. Before one can assess the content of an advertisement such as Moon's, one must first question the authenticity of the newspaper itself as a truthful unmediated source of information.

The erosion of the real, isolated here as a major issue confronting the painter in present-day society and an issue which jeopardizes the creation of meaning in art, has occupied the attention of all artists. Concerning the struggle to recuperate the real, Tom Wolfe notes a reversal in conception that has affected writers of fiction:

By the mid-1960's the conviction was not merely that the realistic novel was no longer possible but that American life itself no longer deserved the term *real*. American life was chaotic, fragmented, random, discontinuous; in a word, *absurd*. Writers . . . [held] long, phenomenological discussions in which they decided that the act of writing words on a page was the real thing and the so-called real world of America was the fiction, requiring the suspension of disbelief.[8]

This reduced summation of a profound shift in perception, a reorientation in the philosophical assessment of what comprises the pursuits of existence, underlines a basic inability of the individual to reconcile the creative gesture within a larger context. The fracturing of 'objective reality' not merely into various subjective realities but also into various illusory and real objective ones, repositions the individual (artist) within either a specific and selected reality (contextualized) or a random one (uncontextualized). In all cases, the imposition of reality can be regarded as an artificial necessity. Thus, the artist is confronted with two options:

Jonathan Lasker, *Main Event*, 1981, alkyd on canvas, 121.9 cm × 182.9 cm.
Collection Collins and Milazzo, New York.

Jonathan Lasker, *The Excessive Norm*, 1985, oil on canvas,
76.2 cm × 61.0 cm. Collection Sibylle Kaldewey, New York.

Jonathan Lasker, *Flower Bomb*, 1983, oil on canvas, 61.0 cm × 45.7 cm.
Private Collection, New York.

Jonathan Lasker, *Baroque Transparency*, 1988, oil on linen,
76.2 cm × 61.0 cm. Collection Bloom, Dekom and Hergott, Los Angeles.

either to address multiple realities, which today seems an inordinately complex project, or to isolate a single one and work within the expansive yet defined parameters of that reality – referring to others merely by implication. The latter selective and self-contextualizing option seems most viable and directly applies to Lasker, who has confined himself to traditional painting (both in his medium and his choice of paint) and refers only elliptically to subject matter outside his paintings. This method has been the exception in recent years.

In the painting of the 1980s two artists serve as examples paralleling this shortcoming, which Lasker supersedes. Continuing in his style of the 1960s, Georg Baselitz paints heavily impastoed 'Expressionistic' images of people, trees and other objects. The canvases hang inverted, upside down, as if to implicate through this alteration in format the terrible turbulence in contemporary painting and society. This ploy, which aspires to overturn convention and supposedly question the real, intimating that painting can no longer validly reflect reality, finally functions as odd gimmickry. Whether it is heavily painted or beautifully painted, whatever meaning a painting of a tree can have today, a tree is still a tree. Are we as viewers supposed to believe in the tree, regard the painting as powerful and pure, in this age where even the most common assurances (like newspapers) fall prey to fabrication? The accessible symbolism of Baselitz's work condemns painting to the recognizability of subject matter. This referentiality encouraged by Baselitz invokes an unmediated deluge of realities that overwhelm the autonomy of the painting, which can only retrieve meaning by being connected to other systems, other realities that are not made explicit by or in the painting.

A radically different approach to painting was taken by Robert Ryman, who stands at the conclusion of Formalism, having reduced his position to a conceptual purity. Ryman's recent work, like that of the late 1960s, is engaged with discovering how a painting is constructed and why each of its parts assumes a necessary appearance and function. Eliminating colour from painting, only employing tactilely manipulated white, Ryman questions the fundamentals of painting through a sustained programme of limited means. Any potential dialogue between painting and its self as an object becomes a monologue because the brushstroke is uncontextualized within the painting(s), becoming its own only motive. Ryman's work produces a non-analytical manifestation of form because the plane of the painting is the only form that exists. Any assurance of the real is bound to materiality which stands in advance of painting's generative primacy.

Lasker, who cannot be regarded as following a strictly formal (as initially defined by the Russian Formalists) strategy because his project departs from established facts of the painting, differentiates himself from artists like Ryman, Brice Marden and Robert Mangold. He notes how this generation of abstract painters undertook a conceptual tact in painting that was from the outset limited:

the last topic of discussion about the painted object was the object itself and its own existence in the world. After that I think that abstract painting had several historical options as how it could proceed. An artist could either work within a tradition as a painter . . . or could look at the discourse as not being finished yet and look at the painted object as still being a place for revolutionary practice.[9]

What project in painting could be more revolutionary than the regeneration of the real? Motivation for the act of painting must not be thematic (Baselitz) or formal (Ryman) or mythological (Twombly) but can only attain authenticity through the unmediated and unreferential subjective (Lasker), which ultimately becomes objective. Unlike novelists, who confront a disparity which Tom Wolfe characterizes as a critical dichotomy between life and the written word, Lasker as a painter must follow a trajectory that denies ulterior and extraneous motives. His paintings, despite suggestive titles like *Main Event*, *Idiot Savant*, *Baroque Transparency* and *Libidinous Prehistory*, call attention to the dialectic but must not be regarded as illustrative, decorative or possessing a 'kitsch element'.

The rapid evolution of painting in the twentieth century has by now exhausted through consumption its facility to connect directly with the wealth of other realities. Painting's ability to generate meaning through examination of its constituent components considered as elemental realities (late Modernism's high formalist solution) is rooted in medium manipulation and is thus finite. Options apparently excluded by time can only truthfully recur in a new and valid context. Regardless of whether painting has explored and invented all possible technical and formal elements, its rationale as a creative subjective endeavour can never be dismissed if cogently contextualized. And the meaning of the *contemporary* painting derives precisely from this notion of retrieval[10] – the artist's ability to deploy authentically the full range of either familiar or unfamiliar elements (line, gesture, colour, texture, etc.):

The only thing that distinguishes any art object from any other art object is that it has a very specific function that has not been sufficiently applied previously, or perhaps was never applied before. When I started making these paintings, I

sought to make them function in a way that abstract painting hadn't functioned in the past.[11]

In Lasker's work there is no concealed motive; the paintings contain (and construct) their context. The real – the reality of painting – is produced through the self-analytical event, which approaches truth through its internal reflexiveness, recollecting Heidegger's inexhaustible assertion about the coalescence of artistic elements in(to) their own beingness ('wie sie an ihnen Selbst sind'). The paint permits the genuine generation of form, becoming as expansive as subjective creation can be.

6

Susan Smith's Archaeology

YVE-ALAIN BOIS

While strolling through the exhibition entitled 'Seicento – le siècle de Caravage dans les collections françaises', held recently in Paris, I suddenly understood what deeply moved me in the work of Susan Smith. Not that her work had anything to do with Caravaggio or the Carracci or Guido Reni or many others, far lesser known, whose paintings filled the vast rooms of the Grand Palais. Nor that the pictures exhibited were remarkable in themselves or that the show's organizers had managed to convey a dramatically new point of view about the period considered; if anything, in fact, the show lacked both a real argument and a good number of works of quality; it consisted mainly in a presentation of what is part of any curator's job, the periodic disclosure of his or her collection's secret reserves to check if changes in taste or fashion might not prompt a reappraisal.

What then was the reason for the epiphany? – The lavish setting of the exhibition elaborated by Pier Luigi Pizzi, the famous designer of opera décor and *mise-en-scène*, with the much advertised sponsorship of Fiat (a rather new phenomenon in France). American museums have already accustomed us to vapid shows whose entire glitz comes from the wrapping created by a decorator – the ridiculous 'Treasure Houses of Britain' at the National Gallery was a case in point. But something quite different happened with Pizzi's fantasies. Not only is he credited for having played a role in the actual choice of the works exhibited, but his extraordinary architectural staging was intended as a faithful, much researched recontextualization. He not only conceived of the altars and frames in *trompe-l'œil* (false marble) for large pictures by Francesco Cairo, Fra Semplice da Verona, Mattia Preti, Ottavio Vannini and many others virtually unknown to me, and of setting up the series of *Muses* by Giovanni Baglione against a gorgeous lapis-lazuli wall speckled with chink-shaped applications of gold leaf. Pizzi went much further: he proposed the entire reconstitution, even if a schematic one, of a vanished

architectural frame for a famous aristocratic collection of seventeenth-century paintings. Indeed, Mansart's celebrated Italianizing creation for the picture gallery of Louis Phélypeaux de la Vrillière had been entirely replaced, in the eighteenth century, by a rocaille décor one can still see in the building today housing the headquarters of the Banque de France. But with the exception of the fresco on the vault, of which only a copy remains, the paintings are still extant, dispersed in various French museums, and the original disposition of those works, thanks to the patient and exacting inquiries of many scholars, was perfectly recoverable.

For quite some time now, art historians of various periods have stressed the fact that not only museums but also reproductions in books (the so-called 'Museum Without Walls' acclaimed by Malraux) have deprived works of art of a key element of their signification by scooping them out of their original loci – hence the somewhat dowdy period rooms which have been proposed as a meagre substitute by more than one museographer. The reproach here would be quite justified, for much as in the case of the *Abstrakte Kabinet* that Lissitzky was commissioned to build in Hannover in 1927–8 to house the Landesmuseum's very precocious collection of abstract art, Mansart's architecture had been designed to frame, literally to embed in the walls, a programmatic series of paintings which La Vrillière carefully commissioned from the artistic celebrities of his time, Poussin included – all in the same format as the first acquisition he had made for this shrine, a Guido Reni. A deliberate message was conveyed there (and the organizers of the show insist in the catalogue on the importance of this private space for the constitution of the very concept of 'Seicento'): that Italy had not collapsed after the prodigious boom of the Renaissance; that, in fact, significant ideas were more than ever coming from Rome. And it is the architectural signifier of this message that Pizzi spectacularly re-enacted before our eyes.

Now, Susan Smith's works are assemblages. She starts with a fragment (usually flat) of building material that she finds on the street or a demolition site (scraps of wallpaper, moulding, sections of an I-beam, etc.) and constructs around it a conglomerate of shaped canvases, each functioning like a brick in a complicated piece of masonry. Each canvas compounded in the assemblage is monochromatic, but its colour and texture are a response to the colour(s) and texture(s) of the found surface: the rule of the game is that no part of the assemblage should look foreign to the others once the work is finished.

One is entitled to ask what might be the connection between Pizzi's

glamorous jewel-casket, between the lustre of the décor provided for the 'Seicento' exhibition, and Susan Smith's 'object-pictures' of rather subdued if not delicate appearance? How could I perceive a link between these altogether small and shyly coloured works and the colossal scale and the gloss of Pizzi's reconstructions? Morphologically, nothing could be further apart from the decorator's frivolous, tongue-in-cheek jokes than Smith's patient craft, although it too relies a good deal on humour. But such a formal contrast, much too obvious, is without any heuristic value. Decisive to me, however, was another opposition, one in which Pizzi's work finds itself at one end of a spectrum and Smith's at the other, providing even, as it were, a critique of the stage designer's enterprise and an alternative reaction to a fundamental crisis in our culture. Both deal directly with the issue of context – Pizzi in adorning old paintings with all kinds of framing devices alluding to their original situation, Smith in endowing waste she collects in our urban environment with a new setting. Both strive to organize a dialogue between the sphere of art and the world at large; both propose an answer (the one almost the direct opposite of the other) to the question raised by the autonomization of art produced by, but also a condition of, the museum concept and the discourse of art history. Two issues are interrelated here. The first has to do with the very function of an art museum and with the stance modern art as a whole had to take *vis-à-vis* this late creation of mankind; the second with our relationship to the past in an epoch, termed 'Postmodernist', which is so prone to celebrate the 'death of history'.

It is by now a cliché to link the constitution of the art museum as a public space, of art history as a discipline, and of modernist art as a set of diversified practices united for more than a century in a common tendency towards critical reflexivity. To be sure, the birth of museums is antediluvian: the great specialist of the prehistoric era, André Leroi-Gourhan, recalls the excavation of a cave-age museum of sorts (not a collection of works of art, of course – the concept of art is much more recent – but of natural objects gathered for their 'beauty' and singularity), and countless testimonies speak of art collecting and display of riches in antiquity, their relationship to various cults, their importance in the economy of wars, etc.[1] But even if one leaves aside the issue of private versus public, all this has little to do with the art museum as we know it, where paintings are arranged both chronologically and nationally and where a linear (and hierarchic) 'evolution' of the arts is mapped for us in the enfilade of rooms we are urged to visit in a particular sequence. And it

is there indeed that the connection is most apparent between the teleological discourse of modernism, its claim to historical determinism in its ever-growing pursuit of the 'essence' of art, and the oriented space of the modern museum. It is not by chance, then, that most discussions concerning the origins of modernism (and the historicism of modernism) start with Manet, whose problematization of the relationship to the past made him, as Michel Foucault remarked twenty years ago, the first artist to paint for the museum.[2]

But things are not as simple as that. On the one hand, the urge to enter the museum, to produce works that should find their proper home there, precedes at least by a few decades Manet's enterprise. On the other hand, until well into this century, the museum had much less to do with the clear ordering planned by art historians for the Altes Museum in Berlin, for example – that model of modern museums – than with the paleontological tradition of the bric-à-brac display and of the *Wunderkammer*.[3] Let us briefly look at those two provisos.

In a lecture given for the inauguration of the Musée d'Orsay (which signals a certain return to the bric-à-brac museum), the revisionist art historian Francis Haskell dates the collusion between the production of art and the hegemony of the museum at least back to Géricault and Delacroix.[4] He notes that the *Radeau de la Méduse* was painted in 1818, right after the opening of the Musée du Luxembourg (the 'museum of living artists', as it was nicknamed); indeed, what private collection could have hosted this huge canvas whose morbid theme was 'unredeemed by religious, mythological or historical justifications', questions Haskell. And the same reasoning holds for Delacroix's *Massacre de Chio*. But it is when it comes to Courbet that this account is of a peculiar interest, as we shall see. The state had bought Courbet's *Après-dinée* in 1849, but instead of hanging it in the Musée du Luxembourg (which was conceived as an antechamber for the Louvre, whose gates were opened only for the dead), the Beaux-Arts administration had sent it to purgatory in the Lille Museum. According to Haskell, it was to avoid such a fate for his canvas that Courbet adopted a monumental scale in his *Enterrement à Ornans*: the work would go to the Musée du Luxembourg, and nowhere else.

As for the persistence of the bric-à-brac arrangement, countless complaints from artists could be filed. I choose here to quote a text by Paul Valéry, for its very date (1923) establishes that the phenomenon survived for many years the clear chronological and stylistic ordering advocated by art history: 'I enter a sculpture room where cold confusion reigns. I find myself in a tumult of congealed creatures, each of them

demanding, though not obtaining, the cancellation of all other works. And I cannot speak of the chaos of incommensurable scales, of the inexplicable mixture of dwarfs and giants, nor even of the shorthand account of the evolution offered to us by such a gathering of perfect and unfinished beings, of mutilated and restored creatures, of monsters and gentlemen.' True, Valéry's whining is that of a pre-modernist: he remains at the level of the things represented and does not see that the heterogeneity he is describing is entirely subsumed by the constitution of a perfectly homogeneous concept of sculpture. (By the same token, he would have liked to see restored, in painting, the separation of genres, which Manet – and this has much to do with the birth of modernism – had wanted to eradicate). But his complaint provides at least the evidence that the modern and historical presentation of public collections, which we have come to associate with the modernist sensibility as such, came very slowly to rule out the *Wunderkammer* store-room.

None of that fundamentally contradicts the view commonly held regarding the simultaneous rise of modernism and of the museum, but it puts it in a different light. If I insist on antedating the origin of this link, it is because Courbet's ventures give us another point of departure. It is unfortunate that, in his account, Haskell considered only the question of the size of his canvases, for this painter indeed laid bare one of the motives of that typical nineteenth-century phenomenon, which Haskell discusses later at some length, the artist's private museum (Thorwaldsen, Canova, Gustave Moreau, etc.). Everyone recalls the pavilion Courbet had built for himself to house his one-man show next to the Beaux-Arts section of the Exposition Universelle held in Paris in 1855. Eleven works by Courbet had been accepted by the exhibition committee, some of them important, but he was dissatisfied with the way in which they were to be displayed: not together, but dispersed in an undifferentiated mass of hundreds of paintings exactly as, in the next building, machines and machine-made products were exhibited, competing for the gold medal. 'I conquer freedom, I save the independence of art,' wrote Courbet to his friend Bruyas about his parallel show of some forty works, which he managed to install only six weeks after the inauguration of the fair and to maintain until it closed five months later. I have dealt elsewhere with this remarkable act of defiance in which I see one of the first 'avant-garde' performances and with the importance the previous Great Exhibition (that of the Crystal Palace in London) had had for Marx's discussion of the fetishistic character of the commodity.[5] To sum up in one sentence my sustained argument, I would say that Courbet demonstrated here that, if

he disliked the bric-à-brac of the grand show, it was not so much because of its lack of historicization (the Luxembourg was just as bad) but because he was afraid of seeing his works debased at the level of pure commodities, infinitely exchangeable, absolutely equalized by the law of the capitalist market. Not that his frustration at seeing his *Après-dinée* denied an eventual afterlife at the Louvre, where it could readily be compared to the production of the old masters, was minimal; but the instinct of self-preservation, for which the ideal museum was to represent a concealed heaven, had first to do with the threat represented by the very condition of modern life: that entropic undifferentiation of all things engendered by capitalist production and much denounced, in various modes, by Baudelaire, Flaubert and Marx.

Such was the museum, and although it did not cease to be maligned as a cemetery for art works, modern artists kept dreaming of it as their sole domain, as their source of education and the future home of their offspring (from Cézanne, who scorned himself for having wanted to burn the Louvre in his youth, to Matisse who thanked Gustave Moreau for having brought him back to it against the wishes of Bouguereau and his peers, or to Tatlin, Malevich and Rodchenko, preventing the 'moujiks', at the beginning of the October Revolution, from 'cutting boots for themselves from the Rembrandts of the Hermitage', as Felix Fénéon puts it in his interview with the great Russian collector, Ivan Morosov). There was the museum, and there was the world, that is, everything else. There is no need here to examine again the structure of exclusion of the museum, its final role in defining what is art and what is not (that is, what belongs only to the realm of the world). Duchamp's demonstrations suffice, for in pretending to show that even a urinal could be sanctified, he proved the exact contrary – that, as William Rubin was to admit in a memorable interview, 'the museum concept is not infinitely expandable', that by its very nature, in order to function as a framing institution, the modern museum had to eliminate whole chunks of reality (even of artistically intended reality).[6] Nobody understood better than Quatremère de Quincy, the reactionary advocate of late Neo-Classicism, the fragility and fraudulence of the decontextualization on which museological sanctification rests. Protesting against the savage pillage of antiquities organized by Bonaparte during his Italian campaigns (under the Directoire, prior to his coronation as emperor), Quatremère stressed that

the true museum of Rome, which I am talking about, is composed, it is true, of statues, colossi, temples, obelisks, triumphal columns, baths, circuses, amphitheatres, triumphal arches, tombs, stuccoes, frescoes, reliefs, inscriptions, frag-

ments of ornaments, building materials, pieces of furniture, implements, etc., but it is composed no less of the places, sites, mountains, quarries, antique routes, of the respective positions of ruined towns, of geographic connections, of the mutual relationships of all objects, of souvenirs, local traditions, of still extant uses, of parallels and comparisons which can only be drawn within the country itself.[7]

The petition he managed to circulate against Napoleonic plundering (signed by David among others), the triumphant arrival of the loot in Paris, celebrated with much pomp, the contrasting departure at dawn, after the collapse of the Empire, of these treasures returning to their original location – in these we have all the ingredients for an analysis of the repressed fact which lies at the origin of a great many museums, that they are the result of unpunished robbery. But Quatremère's stance involves more than moral indignation: his insistence on the site-specificity of works of art touches directly upon the hiatus I mentioned between the world and the museum, which is one of the essential conditions of modernity.

But what about our condition, the condition of our times which are termed 'Postmodern'? Could we say that the structure of opposition (world/museum) still holds true? Could we still state that 'the museum concept is not infinitely expandable'? On the contrary, everything points to a radical change of paradigm. If the production of the 1960s and 1970s was marked by a desire to test the limits of 'museability' (earthworks, conceptual art, etc.) and in a certain, but rather naive, sense to escape the modernist enterprise of autonomization of art since Courbet and Manet, anyone can notice a definite return to works easily digestible by the museum's voracious entrails. But if the phenomenon has often been linked to some sort of renewed submission on the part of artists to the diktats of the market, I feel that its cause rests on a deeper level of the current configuration of our *fin-de-siècle* culture: if works of art no longer attempt to outdo the museum, it is because it has become structurally impossible. And why so? Because the very opposition which ordained such a desire and continued, even if *a contrario*, to define what art was has collapsed. Because the dialectical pair museum/world has ceased to exist as such. Our world is one which has the potentiality of becoming, in its entirety, a museum; our Postmodern planet is gradually being gentrified, transformed into its own image, into a spectacle duplicating itself. And this process does not loosen the structure of opposition originated in the museum *per se*; on the contrary, it tightens

the effects of the exclusion: the dichotomy between clean facades and dreary back alleys becomes harsher than ever. Much has been written on our era as one of pure simulacra, but perhaps the readiness with which the art world swallowed this idea and immediately converted it as fuel for various 'new' brands (Neo-Geo and Cute Commodity being the latest trends) is nothing but the symptom of a refusal to see that the funerary economy of the museum is today going far beyond the embalming of art works and has already begun to congeal the totality of our surroundings.

This total museification renders obsolete Duchamp's astute argument, as well as Pizzi's dream of an expansion of the realm of the museum which would be limited to the sphere of art: the recontextualization of art is doomed to failure in its attempt to save the museum concept. To be sure, museums will continue to be erected, and at a growing pace. But in their race with the world, they will necessarily be outpaced. The creation of museums of artifacts, the enlargement of the concept of design, the elaboration of even more all-embracing period rooms – we shall have to look at a Mondrian while listening to Webern, seated in a Breuer armchair – all these new features of the entertainment department will only augment the pressure, not relieve it. Witness a recent inquiry in the *New York Times*, where architects, artists, fashion, interior and graphic designers, museum directors and other participants in the culture industry were asked to designate the future collectibles of the 1980s. The decade has not yet ended, and we were already provided with an inventory of the future museum of our times, from a Michael Jackson doll to Concorde souvenirs, from a 'Smoking Permitted' sign to a Robert Venturi chair, from a Ford Taurus to a Walkman.[8]

I have been gradually turning away, in this discussion, from the sphere of art. It is not out of some perverse desire to drown the reader with information but because I feel that Susan Smith's work is directly addressing the very issue which I am trying to elucidate. I could, of course, have written about her collages as abstract paintings reopening the Cubist exploration of tactility (a question much repressed in the standard histories of modern art), or as colour experiments in the tradition of Josef Albers's great teachings (indeed, many examples given in the first, luxurious edition of *Interaction of Color* were student responses to assigned tasks not dissimilar to Smith's endeavour: given a leaf of a certain colour, for example, find an accord which could match its intensity and value and erase its extraneousness without casting out its difference or, on the contrary, transfigure its banality). I could also have dealt with the peculiar way in which Smith's reappropriation of found

material, always of a geometrical shape, both suppresses the compositio-
nal arbitrariness denounced by the minimalists in the 1960s and presses
for a re-examination of their claim. I could have, in one sense, treated
these assemblages as art works pertaining to the modernist tradition and
examined them in formal or even in iconographic terms (for the
connotations of the incorporated found part, which always gives its title
to the work, invariably point to the urban cycle of decay and rejuve-
nation). But although such diverse qualities in part expand my pleasure in
front of these shaped, or rather built, canvases, it is my contention that
the signification of Smith's 'pictures' touches upon a much broader
feature of our contemporary experience – that her whole enterprise, as it
were, is that of a parable. Indeed, if any work can be termed 'Postmod-
ern', it is that of Susan Smith, precisely because it catalyses the crisis of
the modernist paradigm in bringing to the fore the collapse of the world/
museum opposition on which this paradigm rested.

Susan Smith's assemblages, as I have stated above, concern our relation-
ship to the past. But more than that: they are like an answer to the most
dominant brand of pictorial Postmodernism, the Neo-Expressionist
yuppie-punk wave which has been invading the galleries of our global
village for the past decade, the brand termed 'Neo-Conservative' (as
opposed to a 'Poststructuralist' type of Postmodernism) by Hal Foster
and the few critics who do not join the team of adulators.[9] As is well
known, the Neo-Conservative ideology of this type of Postmodernism is
marketed as a justifiable reaction against the dogmatist claims of
modernism, seemingly aligned, on this particular point, to the stance of
its 'progressive' counterpart. What the two Postmodernist positions
distinguished by Foster have in common is their claim that modernism
was living in a historicist terror, in the prison of a teleological conception
of history as progress of reason, in which each work was defined in
relationship with its predecessors and with its posterity. But where those
two positions differ is in the attitude which follows the claim. Against the
'Darwinism' of modernism, there is no other way, claims the Neo-
Conservative, than to take the 'cynical ideology of the traitor' – and those
are not my words but those of Achille Bonito Oliva, the author of various
books on the yuppie-punk wave which he baptized 'international trans-
avant-garde'.[10] For a traitor, nothing has any value if it is not for his own
direct profit. Against the naive political utopia of the historical avant-
garde movements, against the optimistic eschatology which was at the
core of their notion of history, Oliva and his peers construct an argument

on a fiction of apocalypse which is, *stricto sensu*, the exact counterpart of the teleology they pretend to eradicate. It goes like this: the world is going to die, hence we are freed from the burden of history, in other words, *après moi le déluge*. Being freed from the burden of history, we can return to history as a kind of entertainment, as a remote space of irresponsibility: everything has the same meaning for us. From the trash-can of history, says this theory, we could dig out any quote, any historical style. Denouncing the teleological historicism of modernism, the apologists of Neo-Conservative Postmodernism transform historical succession into simultaneity: they take the typical historicist point of view of a Leopold von Ranke (*alles gleich unmittelbar zu Gott*), that of a posthistorical God which could put everything in the same basket and would never have to take sides. Pretending to follow the path of Nietzsche, they become what he hated most and claim to hold a suprahistoric point of view. And it is not by chance that this Neo-Conservative Postmodernism coincides with a revisionist tendency in art history, which tries to deny that modern art ever existed, which affirms that Bouguereau and Manet lived in the same historical time or that the late de Chirico is not a negation of the early one.

It is against this rummaging through history, against this production of cynical stylistic pastiches that Susan Smith reacts. She too digs in the trash-can of history, but there is no indifference in the way she treats its vestiges and monumentalizes those pieces of refuse in establishing for them a new context that will reveal their origin without destroying their singularity. If she wants to reconstruct the past, it is to save it from the undifferentiation which is reflected upon its traces by their subsumption under the single category of 'pastness' (just as the Walkman and the Ford Taurus became members of a unique class, labelled 'The Eighties'). Against the current abuses of historical references, done in the name of the 'death of history' and as a refusal to address the collapse of the opposition museum/world (those abuses are yet another symptom of the deliberate repression of this phenomenon), Smith proposes the counterpractice of a guerilla archaeology.

I have mentioned Nietzsche, whom the Neo-Conservatives are so quick to reclaim as one of their forerunners. And I also borrowed the notion of 'abuse' from one of his most renowned pamphlets, the second of his *Untimely Meditations*, dated 1874: 'Vom Nutzen und Nachteil der Historie für das Leben'.[11] A detour via this text, at this juncture, seems to me more than appropriate, if only to show that far more than the

Susan Smith, *Blue Horizontal*, 1981, oil on canvas and found wood,
165.1 cm × 207.7 cm. Margarete Roeder Gallery, New York.

Susan Smith, *Grey with Metal and Silver*, 1985, oil on canvas with found metal,
130.7 cm × 146.7 cm. Margarete Roeder Gallery, New York.

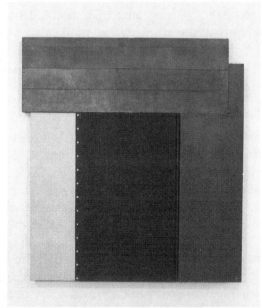

Susan Smith, *Green Metal with Red Orange*, 1987, oil on canvas with found metal, 135.9 cm × 126.4 cm. Margarete Roeder Gallery, New York.

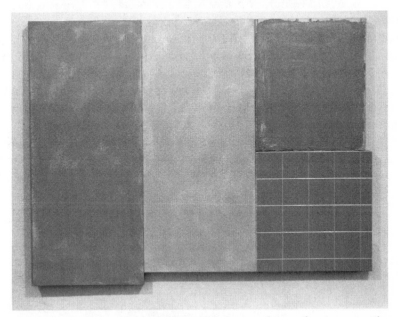

Susan Smith, *Green Grid with Blue and Orange*, 1986–7, oil on canvas with found masonite and plaster board, 100.4 cm × 133.4 cm. Margarete Roeder Gallery, New York.

Schnabels, Cucchis and Chias, Susan Smith could with some justice invoke the paternity of the great German thinker:

This meditation . . . is untimely, because I am here attempting to look afresh at something of which our time is rightly proud – its cultivation of history – as being injurious to it, a defect and a deficiency in it; because I believe, indeed, that we are all suffering from a consuming fever of history and ought at least to recognize that we are suffering from it.[12]

Thus runs the foreword of Nietzsche's essay. The timely untimeliness of the meditation has been most talked about, and even the sheer difference between our standpoint and Nietzsche's is sufficient to measure the resonance of his discourse: while the historicist century *par excellence*, the nineteenth, was not conscious of its illness, nothing would be more foreign to us than a claim of innocence in our 'cultivation of history', yet our pride is growing while masking our despair. Nietzsche's text was a diagnosis: it is not the consciousness of history that he wanted to denounce as the essential cause of the sickness of his time but the unconscious *excess* of this consciousness. Contrary to our Postmodern oracles, he did not envision the possibility of a posthistoric escape ('the unhistorical and the historical are necessary in equal measure for the health of an individual, of a people and of a culture'[13]) but wanted to advocate efficient uses of history. And in 1886, in the preface for the second volume of *Human, All too Human*, he wrote: 'what I had to say against the "historical sickness" I said as one who had slowly and toilsomely learned to recover from it and was in no way prepared to give up "history" thereafter because he had once suffered from it.'[14] Today, piercing the cloud of millenarianism which grows thicker and thicker, his untimely voice seems more timely than ever.

A brief reminder, thus, for those who, like me, are not philosophers: there are, for Nietzsche, three types of historical discourses, the 'monumental', the 'antiquarian' and the 'critical', each one becoming harmful once diverted from its function. I quote:

If the man who wants to do something great has need of the past at all, he appropriates it by means of monumental history; he, on the other hand, who likes to persist in the familiar and the revered of old, tends the past as an antiquarian historian; and he only who is oppressed by a present need, and who wants to throw off his burden at any cost, has need of critical history, that is to say a history that judges and condemns. Much mischief is caused through the thoughtless transplantation of these plants; the critic without need, the antiquarian without piety, the man who recognizes greatness but cannot himself do great things, all are such plants, estranged from their mother soil and degenerated into weeds.[15]

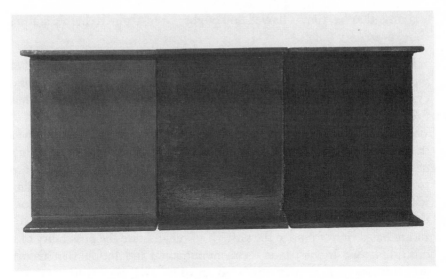

Susan Smith, *I Beam*, 1987, oil on canvas with found metal,
20.3 cm × 46.4 cm. Margarete Roeder Gallery, New York.

Nietzsche does not condemn any type of historical discourse in
particular, but its abuse. As Hayden White summed it up:

1. '*Monumentalism* is creative when it stresses the achievements of
great men, but destructive when it stresses the *differences* between past
and present or future greatness'[16] [I would add that it can yield to
discouragement in life or to academicism in art: Nietzsche gives as
example the fact that the great canons of the past, once monumenta-
lized, are being used to prevent the flourishing of a not-yet-monumen-
tal, new art];

2. *Antiquarian history* 'is creative when it reminds men that every
present human being is a resultant of things past, and destructive when
it makes of all present things *nothing* but the consequences of past
things'[17] [I would add: since 'it accords everything . . . equal import-
ance',[18] it is likely to yield to an ahistorical, suprahistorical point of
view, whose so-called 'wisdom' and 'neutrality' are to be despised as
fraudulent];

3. *Critical historiography* 'is creative when it acts in the service of
present needs and undermines the authority of the past and the future.
It is destructive when it reminds the present actor in the historical

drama that he, too, is flawed and ought not to aspire to heroic stature or revere *anything*.[19]

In sum, these modes of historical discourse, once in excess, can lead to pure cynicism and to the apocalyptic cult of death which lies behind cynicism. This is precisely what the young Nietzsche, whose vitalism has been stressed by many commentators, wanted to denounce with a vengeance. The only antidote which he could think of, at the time, was the nonhistorical and antihistorical power of art as an agent of forgetfulness, or in other words, the aestheticization of history. This did not satisfy him for too long, as we well know, and all his later texts, starting with the *Genealogy of Morals* (1887), elaborate on a proposition from the 'Uses and Abuses of History for Life' (that 'only he who constructs the future has a right to judge the past'[20]) to rehabilitate the possibility of a critical history. In these later texts, monumental and antiquarian history are transformed respectively into parody and the antihumanistic destruction of all continuities.[21] In this later version of critical history, now called genealogy, the issue is no longer to judge the past according to a sense of truth that our epoch could alone obtain, but to realize that our historical perspective is necessarily flawed by the fundamental injustice of our current will-to-know, itself a guise of our actual will-to-power. History does not have a meaning, a sense: behind the chaos of historical events, there is no essence, no Hegelian telos, no Darwinian nature; there is only a polyphony of conflicts. History cannot become a science: no less than any other human discourse or action, it is moved by conflicting wills-to-power. Hence this passage from the *Genealogy of Morals*:

There is no set of maxims more important for an historian than this: that the actual causes of a thing's origins and its eventual uses, the manner of its incorporation into a system of purposes, are worlds apart; that everything that exists, no matter what its origin, is periodically reinterpreted by those in power in terms of fresh *intentions*; that all processes in the organic world are processes of outstripping and overcoming, and that, in turn, all outstripping and overcoming means reinterpretation, rearrangement, in the course of which the earlier meaning and purpose are necessarily either obscured or lost.[22]

Although it is clear enough that contrary to the practice of the yuppie-punk artists – monumental history without passion, antiquarian history without piety, critical history without necessity – Smith's archaeology displays none of the *acedia*, or indolence of the heart, which characterized, for Walter Benjamin, any historicism;[23] although her recontextualization of fragments demonstrates that any reconstitution of the past is

indeed intentional, contrary to Pizzi's extravaganzas which are constructed upon the repression of this fact, I would like to take yet another detour in order to note the resonance of Nietzsche's text in terms of her problematics and for any discussion concerning the relationship of current art to that of the past and to the past 'as such'.

In fact, Nietzsche's essay was not without resonance in the field of art history itself. Although Nietzsche sent the 'Uses and Abuses of History for Life' to Jacob Burckhardt who answered half-heartedly, defending himself from the sin of teaching history for its own sake,[24] I believe that Aloïs Riegl was the first art historian to have tackled in any serious way the difficulties inherent to Nietzsche's diagnosis and even to have come up with the same conclusion, that of the *intentionality* of any historical construct. Burckhardt, in line with his master Ranke, did not sufficiently doubt the power of his discipline; he could not have asked himself, as Riegl did just before he died: 'But is the validity of the historical indeed already obsolete?'[25]

Riegl's anxious questioning came from the context of *fin-de-siècle* Vienna, whose culture had been a great consumer of Nietzsche's writings. And there is obviously today a strong sense of kinship between our time and the 'Last Days of Humanity', to use the title Karl Kraus gave to his most famous work: blockbuster exhibitions (MOMA, Beaubourg) and best-seller accounts (Carl Schorske's book, *Fin-de-siècle Vienna*, for example) remind us that our current millenarianism is a recurrent phenomenon. To be sure, the apparent causes of this millenarianism are different in the two cases – the death of the Habsburg Empire having little to do with our preoccupations – and the symptoms themselves seem quite different, even opposite: 'the last few years', writes Fredric Jameson, 'have been marked by an inverted millenarianism, in which premonitions of the future, catastrophic or redemptive, have been replaced by senses of the end of this or that (the end of ideology, art, or social class: the "crisis" of Leninism, social democracy, or the welfare state, etc., etc.): taken together, all of these perhaps constitute what is increasingly called Postmodernism.'[26] But if it would be wrong to assimilate our actual Postmodernist millenarianism with the 'Gay Apocalypse', Hermann Broch's famous phrase about *fin-de-siècle* Vienna, it might prove useful to dwell on what our Viennese predecessors had to say about their sense of doom. For they too spoke about the end of history; they too felt that their historicism had driven them to a radical impasse; they too were tempted to cynicism as the only viable solution to the mortal crisis of culture they were witnessing. Among the many writers witnessing this

cultural crisis, Riegl, as one of the founders of art history as a discipline (and one of the rare models given by Walter Benjamin for his conception of the 'materialist historian'), is perhaps the one whose insights are most revealing – reminding us, at the very least, that the field he helped define has not always been plagued by the academic purring in which so many of his successors indulge.

Riegl's question about the possible obsoleteness of the historical, quoted above, comes from a text entitled 'The Modern Cult of Monuments: Its Character and Its Origin', published in 1903, an essay which I can only read, metaphorically, as a theoretical account of the 'uses and abuses of history'. The status of this text is strange enough to be recalled: it is a report of the Committee for the Preservation of Historical Monuments of the Austro-Hungarian Empire, which Riegl was chairing. The task of this Committee, appointed by the government, was to provide a policy and a set of laws concerning the protection of monuments in the lands of the Empire, and Riegl's text was intended as a draft proposal. But it is much more than that, as Riegl could not refrain from transforming what would have been a dreary bureaucratic discussion into a passionate inquiry about the conflicts at work in our relationship to the past and, above all, about the historicity of a concept such as history.

It would be impossible to give full credit to Riegl's extraordinarily dense dialectical essay, where each line counts for a whole development (the title of the text already gives some hints of Riegl's exemplary economy of style: the 'modern cult of monuments' means that such a cult is modern, that is, historically determined; it also means that our relationship to the monuments of the past is less cultural than cultic). But it is at least worth referring to this text, for some of its insights are strikingly relevant today.

Confronted directly with the question, 'what should we do with our monuments?', a particularly burning one at the time (recall the quarrels following Viollet-le-Duc's earlier campaigns of restoration in France), Riegl first started by drawing up a typology of monuments. Broadly speaking, there are three types of monuments, corresponding to three different conceptions of commemoration, which appeared successively during three moments of human history. The most ancient type of monument is the *intentional* one, whose function was to commemorate a precise event, a family or a deceased hero. Monuments of this sort correspond to a mythical and patristic sense of history and were not always preserved after the disappearance of those who had erected

them. The second type of monument is the *nonintentional* one. It appears at the Renaissance, but in a hybrid manner, first because the men of the Renaissance had not yet entirely abandoned the mythical and patristic sense of history of antiquity (thus often transforming nonintentional monuments into intentional ones: this is Nietzsche's 'monumental history') and second because they had a tendency to think in terms of 'historic and artistic monuments'. The artistic value of a monument, however, is not a commemorative value but what Riegl called a 'present-day value' (it changes according to our *Kunstwollen*, the artistic 'will' which is specific to each epoch and which sets up standards according to which the artistic production of each epoch must be measured). In other words, Renaissance men were beginning to have a sense of history and indeed were the first to think of preserving monuments of the past, but like Winckelmann a few centuries later, they judged those monuments according to an aesthetic canon. The first era to recognize the commemorative value of the nonintentional monument as such was the nineteenth century, which can be termed the historical century, and it is not by chance, of course, that the practice of restoration develops fully at this time. The nonintentional monument thus becomes any historical trace that enables us to reconstruct the past. But this new historical interest – which corresponds to Nietzsche's antiquarian history – yields to a general historical relativism which in turn, at the beginning of the twentieth century, generates a third way to consider the monument: indifferently intentional or nonintentional, it is now respected for its age value. This age value is not related to the monument as it was in its original form (as was the issue for the historical value of the nonintentional monument) but to the quantity of time elapsed since its creation: the ruin of a medieval castle is the epitome of such a monument. This 'age value' is the most recent value attached to monuments and is also the most popular (there is no need to be an expert to be moved by its charm or to reflect on the 'necessary cycle of becoming and death', as Riegl puts it); its pretense to universality makes it often the worst enemy of the restorer.

These three types of monuments – or three types of commemorative values – are not mutually exclusive. For Riegl, on the contrary, they are related by a sort of evolutionist line: every intentional monument, referring to a precise event, can become nonintentional, referring then, as a document, to a period of history, and every nonintentional or historical monument can become an age-monument, referring to pastness in general.

From such a typology, Riegl elaborated an arcane and sometimes amusing casuistry developed to solve the conflicts occurring between different ways of looking at a monument, conflicts made all the more dramatic when policies of restoration are concerned (the proponents of age value, for example, want the effects of natural destruction to be given free course, which is unacceptable according to the two other concepts). But, as always, his analysis carried him much further than the simple requirement of defining a set of rules. For one thing, when Riegl wondered if the consideration of the historical value of a monument was not already anachronistic, he was actually wondering if his activity as an art historian would still have any meaning in the world to come. He had, after all, spent most of his life working in museums, that is, in institutions devoted to the cult of such a value. Since his foremost interest lay in the decorative arts of the past, Riegl was fully aware of the perversion of meaning which a work of art undergoes when it is decontextualized and trapped in a museum – he saw a conjunction of interest between the proponents of age value and modern artists in their opposition to what he called (he, too) the 'prisons of art'. In fact, and it is certainly a most paradoxical statement from a historian, Riegl was persuaded that the cult of 'historical value', because it was historically determined, was necessarily doomed to give way to a full domination of the cult of age value. This, I would argue, is the situation we may have reached today: the Neo-Conservative section of Postmodernism certainly makes use of the past indiscriminately, referring to it only for its pastness. Riegl's intuition is to have seen that this eclectic commemoration, having lost interest in the historical sense, properly speaking, was going to be enlarged, not diminished, by the technocratic development of modern Western civilization.

But Riegl also pointed to other conflicts facing the restorer, conflicts between the various commemorative values as a whole and what he called 'present-day' values. Those are of three sorts: there is first the current 'use value', for example, of a cathedral where mass is still performed; second, the 'novelty value' – that which prevents us from letting a beautiful building of the past crumble (by novelty value Riegl meant the sense of completeness and was referring to Viollet-le-Duc's aggressive restorations, although he elsewhere spoke of novelty in our modernist sense, when he attacked the historicist architectural styles of the nineteenth century as failing to address this issue). And finally, most important for us, there is the 'relative art value'. This depends entirely on our *Kunstwollen*, and here Riegl rejoins Nietzsche's plea for a critical

history: it is through our present *Kunstwollen* that we judge the past. In order to make his case clear, Riegl presents an example, that of a Botticelli painting with Baroque overpaintings: 'These overpaintings now possess for us an age value (additions by human hands assume over time the appearance of natural forces), even a historical value.' To remove them would undoubtedly go against those two values and yield to the present-day value of novelty understood as the stylistic and material integrity of the object. Yet

no one today would hesitate to remove the overpaintings so as to reveal the original Botticelli: this would be done not only out of art-historical consider-ations (in order to know a significant work in the evolution of the master and of fifteenth-century Italian painting), but also for artistic ones, because Botticelli's drawings and paintings are more congruent with our modern *Kunstwollen* than is Italian Baroque art.[27] [This was written in 1903.]

Just as Nietzsche stressed the actual intentions presiding over each new historical interpretation, Riegl, who certainly should not be character-ized as a positivist antiquarian, tells us that it is the present *Kunstwollen* which has the last word in our relationship to the past.[28] Although the relative art value, as a present-day value, is foreign to the concept of 'monument', we cannot but recognize its dominating power. Everything can be a monument, indeed, but not everything at the same degree at any moment of history. It is the consciousness that his discourse is historically determined which makes Riegl one of the founders of art history as a discipline; it is also this consciousness which makes this discourse such a useful tool today when we want to confront the apocalyptic defeatism of Postmodernism. It is this consciousness which made Walter Benjamin hail Riegl as one of his peers.[29] Indeed, this is what makes the annexation of Benjamin's discourse by the apologists of Neo-Conservative Postmod-ernism particularly repellent, since he defined the task of the critical (materialist) historian as an enterprise of salvation. Against the historicist conception of time as empty and homogeneous, against the antiquarian acedia, such a historian 'stops telling the sequence of events like the beads of a rosary. Instead, he grasps the constellation which his own era has formed with a definite earlier one', or again: 'he takes cognizance of it in order to blast a specific life out of the homogeneous course of history.'[30] This has nothing to do with the antiquarian recuperation of the past, whose indifferent accumulation of documents is a loss of memory: Benjamin's messianic concept of salvation involves the salvation of the present, not the recovery of the past at its expense. 'Only for a redeemed mankind has its past become citable in all its moments', writes Benja-

min.[31] Until this Day of Judgement, not everything will be quotable: not to be aware of this is to fall into the trap of Ranke's historicism which always empathizes with the victors. Nothing could be further from Benjamin's stance than the practice of the yuppie-punk painters: in their appropriation of the entire past as quotable, they indeed revert to Ranke's acedia which receives its economic justification in the commodification of everything, including the past, accomplished by capitalism. It is not by chance that they have elected Picabia as one of their heroes: this dandy advocated what he called an 'immobile indifference', another name for the 'ideology of the traitor', expounded by Bonito Oliva. Not only did it lead Picabia to reject his previous Dadaism and to become one of the most active defenders of the 'return to order', but his empathy for the victors ended up in anti-Semitic statements and glorification of the Vichy regime during the Second World War.[32] To quote everything or to quote only the authoritarian heroes of reaction is, ultimately, the same. Hence the urgent necessity of a critical history of quotation in art. For if one does not want to put everything in the same basket, a distinction must be elucidated between the art of quotation in the Renaissance, that of Manet and that of the Schnabels: this history could be understood as a chapter of political history. But it would also call for a new type of monumental history, for a new way to redeem the past.

Now, Smith also quotes (I have mentioned Cubism, Albers, Minimalism – we could also add Mondrian and his fascination, during his early career, with the accidental 'wallworks' constituted by blocks of interior decoration temporarily bared by the demolition of residential buildings, something which played a great part in Smith's earlier works). She also appropriates. I have mentioned the urban connotations of the found pieces which constitute the starting point of each of her shaped canvases. In her notes, she insists on the social history those finds carry with themselves; she points to the fact that they come from her daily environment, that of New York, and reveal a particular side of American vernacular culture in their dinginess ('plasterboard, wallpaper, galvanized metal, wood moulding'). At first, one could read her eagerness to redeem those pieces of scrap as trite nostalgia. There is perhaps an elegiac component in her art, but the task of mourning has been carried through, for her recoupments are polemical: the past she redeems is the negative mirror of our present. She does not recycle just any fragment of a ruined epoch; she does not deal with pastness as such; she deliberately chooses the alluvia produced by the general process of gentrification, by

the global museification ('ballast of places, people, things native or indigenous'). In doing so, she might seem only to help the process reach its perfection (there would be no remainder; everything would be reified; everything could become grist for the omnivorous mill of art). This is the risk of her enterprise, but this risk itself is a lesson, for there is very little chance of escape. The only way is tenuous, and it is what Smith demonstrates without bombast: to preserve all things from fetishist transfiguration into simulacra, into sheer signs of themselves, one has to strike the precise chord which resonates both with their history and with our present situation. In pointing to the visual (and social) fraudulence upon which the collapse of the opposition world/paradigm is based, in showing its repressed sides, Smith not only empathizes with the victims of this process, as Benjamin would say, but she shows that the décors of the Pizzis are nothing much more than a smokescreen (if the world, the context, is now so eager to enter the museum and the museum to absorb it, it is because both already speak the same language, because both function according to the same forgetfulness). The fact that this diagnostic of our times could be done in painting, could lead to the production of sensuous and even joyful works rather than brandished slogans, will undoubtedly be judged by some as naive or *dépassé*. I am not impressed by this political blackmail (the more naive of the two positions is not the most apparent one). In the modernist period, art could not escape the museum which had as one of its main purposes an entrenchment against the commodification of all things. Today, the museum itself has become a model for the world; it is impossible to run away from museological premises, for the museum is literally everywhere. But within this general confinement, one can still devise strategies of resistance: such to me is Susan Smith's archaeology.

7

Perverse Space

VICTOR BURGIN

Fifteen years ago, in her ground-breaking essay 'Visual Pleasure and Narrative Cinema', Laura Mulvey used Freud's paper on 'Fetishism' to analyse 'the voyeuristic-scopophilic look that is a crucial part of traditional filmic pleasure'.[1] Today, the influence of Mulvey's essay on the critical theory of the image has not diminished, nor has it evolved. Idealized, preserved in the form in which it first emerged, Mulvey's argument has itself been fetishized.[2] Fetishized, which is to say *reduced*. Mulvey broke the ground for a psychoanalytically informed theory of a certain type of image. Many of Mulvey's followers have since shifted the ground from psychoanalysis to sociology, while nevertheless retaining a psychoanalytic terminology. In the resulting confusion sexuality has been equated with gender, and gender has been collapsed into class. It has now become familiar to hear the authority of Mulvey's essay invoked to equate a putative 'masculine gaze' with 'objectification'. Here, in a caricature of the psychoanalytic theory on which Mulvey based her argument, 'scopophilia' is defined as a relation of domination-subordination between unproblematically constituted male and female subjects, and 'objectification' is named only in order to be denounced. In his preface to the 1970 edition of *Mythologies*, Roland Barthes wrote of, 'the necessary conjunction of these two enterprises: no denunciation without an appropriate method of detailed analysis, no semiology which cannot, in the last analysis, be acknowledged as *semioclasm*.' (London, 1972, p. 9) Mulvey's essay is exemplary in the way it holds these 'two enterprises' in balance. If I 'depart' from Mulvey's essay now, it is not in order to criticize it, I learned much from it and still agree with most of what she says; but I would like to travel further in the direction it first indicated, toward a psychoanalytic consideration of unconscious investments in looking. The route I have chosen is by way of a photograph by Helmut Newton, as Newton is a photographer whose work so conspicuously attracts denunciation and so clearly lends itself to Mulvey's analysis.

Newton's photograph

We know that Helmut Newton's photograph 'Self-portrait with wife June and models, Vogue studio, Paris 1981' had its immediate origin in a chance encounter.[3] In an interview with Newton, Carol Squiers asked: 'One of your self-portraits shows you wearing a trench coat with a nude model, and your wife sitting off to one side. Does your wife sit in on photo sessions?' Newton replied: 'Never. Ever. She had just come by for lunch that day.'[4] In describing Newton's picture I shall recapitulate a certain history of semiology, that most closely associated with Roland Barthes, which sets the stage for the introduction of the subject of representation into the critical theory of the image of the early 1970s. That is to say, I shall reconstruct the prehistory of Mulvey's introduction of psychoanalytic theory into a field of analysis dominated by linguistic models: models whose implicit spaces are classical, ordered according to binary logics – from the level of the phoneme to that of rhetoric – along the Cartesian co-ordinates of syntagm and paradigm. I shall begin with what we can actually see in this image. We see at the left the model's back and, in the centre of the frame, her frontal reflection in a mirror. Helmut Newton's reflection, similarly full length, fits the space beneath the model's reflected elbow. The photographer is wearing a raincoat, and his face is hidden as he bends over the viewfinder of his Rolleiflex camera. The photographer's wife, June, sits just to the right of the mirror, cross-legged in a director's chair. Her left elbow is propped on her left knee; her chin is propped on her left hand; her right hand makes a fist. These are the elements of the picture which are most likely to come immediately to our attention. In addition, reflected in the mirror, we can see a pair of legs with very high-heeled shoes, whose otherwise invisible owner we assume to be seated. We also see, behind the figure of June, an open door through which we glimpse an exterior space – a city street, or square, with automobiles. Finally, we may notice a number of subsidiary elements: at the centre, what appear to be items of clothing discarded on the floor; at the extreme right, other items of clothing on hangers; above the open door, the sign '*sortie*'; and so on.[5] This initial description concerns what is least likely to be contested about this image, what classic semiotics would call its 'denotations'.

We may now consider what this same early semiotics called the 'connotations' of the image, meanings which we may also take in 'at a glance' but which are more obviously derived from a broader cultural context beyond the frame of the image.[6] We may additionally consider the rhetorical forms in which the 'signifiers of connotation' are orga-

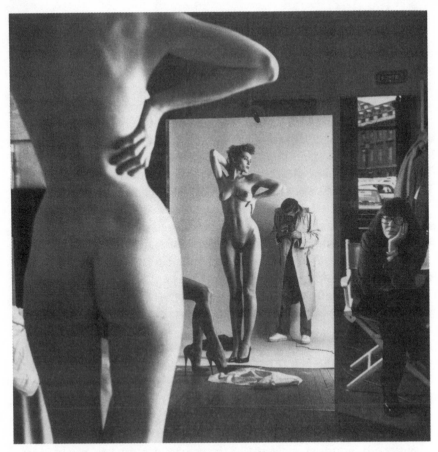

Helmut Newton, *Self-portrait with wife June and models, Vogue studio, Paris*, 1981.

nized. The image of the model reflected in the mirror is the very
iconogram of 'full frontal nudity': an expression, and an indeterminate
mental image, which entered popular memory in the 1960s from
discussions in the media about 'sexual freedom' in cinema and the
theatre. The model's pose is drawn from an equally familiar, and even
older, paradigm of 'pin-up' photographs. The cliché position of the
model's arms serves the anatomical function of lifting and levelling her
breasts, satisfying the otherwise contradictory demand of the 'pin-up'
that the woman's breasts should be both large and high. The lower part
of the model's body is similarly braced for display by means of the black
and shiny high-heeled shoes. These shoes exceed their anatomical
function of producing muscular tension in the model; they are drawn
from a conventional repertoire of 'erotic' items of dress. This reference is

emphasized by 'repetition' in the shoes on the disembodied legs which appear to the left of the main figure, where the evenly spaced 'side-elevation' depiction of the excessively elevated heels (another repetition) diagrams the primacy of erotic meaning over function (these shoes were not made for walking). The shoes encourage an understanding of the model as 'naked' rather than 'nude', which is to say they gesture toward scenarios of sexuality rather than of 'sublimation' (for example, the high-minded artist's 'disinterested' aesthetic contemplation of the female form). The sexual connotation is further anchored[7] by the apparently 'hastily discarded' garments at her feet.[8]

The figures of repetition in this photograph, and there are others, are articulated as subsidiary tropes within an overall structure of antithesis. The antithesis 'naked/clothed' divides the picture plane along its vertical axis. By contrast with the model, who thereby appears all the more naked, Newton is absurdly overdressed. The model's nakedness is, moreover, already amplified by being monumentally doubled and presented from both front and back. Newton's pole of the 'naked/clothed' antithesis is itself augmented by repetition in the jacketed and booted figure of June. There are further such rhetorical structures to be identified in this image. To enumerate them all would be tedious; it is enough to note that the apparent strength of many images derives from our 'intuitive' recognition of such structures. Perhaps one more is worthy of comment, if only in passing. The discarded garments in the mirror set up a subsidiary 'combined figure' of chiasmus ('mirroring') and antithesis about the axis established where the background paper meets the studio floor: a dark garment on a light ground, a light garment on a dark ground (the areas and shapes involved being roughly analogous). This reinforces my tendency, otherwise not strong, to read the two pairs of models' legs in terms of the opposition 'light/dark'; it encourages the idea that the woman I can only partially see may be black. Here, clearly, I am at the periphery of the range of meanings in respect of which I may reasonably expect to meet a consensus agreement. To return to things on which we are more likely to agree, I shall close my list of connotations and the forms of their organization by commenting on the raincoat which Newton wears. In a sexual context, and this image is indisputably sexual, the raincoat connotes those 'men in dirty raincoats' who in the popular imagination frequent the back rooms of 'sex shops'. In this same context, the raincoat is also the favoured dress of the male exhibitionist, the 'flasher'.

It is not normal for the photographer to exhibit himself, as Newton

does here. The mirror is there so the model can see *herself* and thus have some idea of the form in which her appearance will register on the film. Normally, the photographer would have his back to the mirror, remaining outside the space of the image. Here, however, Newton has colonized the desert island of back-drop paper that is usually the model's sovereign possession in the space of the studio. He has invaded the model's territory, the domain of the visible. From this position, he now receives the same look he gives. The raincoat is Newton's joke at his own expense, he exhibits himself to his wife, and to us, as a voyeur. In his interview with Carol Squiers Newton says, 'I am a voyeur! . . . If a photographer says he is not a voyeur, he is an idiot!' In *Three Essays on the Theory of Sexuality*, Freud remarks, 'Every active perversion is . . . accompanied by its passive counterpart: anyone who is an exhibitionist in his unconscious is at the same time a *voyeur*'. The photographer – a flasher, making an exposure – is here explicitly both voyeur *and* exhibitionist. His raincoat opens at the front to form a dark delta, from which has sprung this tensely erect and gleamingly naked form. The photographer has flashed his prick, and it turns out to be a woman. Where am I in all this? In the same place as Newton – caught looking. At this point in my description I have caught myself out in precisely the position of culpability to which Mulvey's paper allocates me – that of the voyeur certainly, but also that of the *fetishist*. The provision of a substitute penis for the one the woman 'lacks' is what motivates fetishism. The fetish allays the castration anxiety which results from the little boy's discovery that his mother, believed to lack nothing, has no penis. Mulvey writes:

The male unconscious has two avenues of escape from this castration anxiety: preoccupation with the re-enactment of the original trauma (investigating the woman, demystifying her mystery), . . . or else complete disavowal of castration by the substitution of a fetish object or turning the represented figure itself into a fetish . . . This second avenue, fetishistic scopophilia, builds up the physical beauty of the object, transforming it into something satisfying in itself.[9]

If it is clearly the 'second avenue' we are looking down in this picture, we must nevertheless acknowledge that it runs parallel with the 'first'. For who else wears a raincoat? A detective – like the one who, in all those old B-movies, investigates the dangerously mysterious young woman, following her, watching her until, inevitably, the *femme* proves *fatale*.

Caught looking, I (male spectator) must now suspect that I am only talking about this picture at such length in order to be allowed to *continue* looking. I remember one such instance of invested prevarication from my childhood. I was perhaps seven years old and accompanying my

mother on one of her periodic trips to visit my grandmother. The tramcar we rode stopped outside a music hall; it was here that we dismounted to continue on foot. On this occasion, the only one I remember, the theatre was advertising its two main current attractions. One was a strong-man and escape artist. The heavy chains and manacles of his trade were on public exhibition in front of the theatre, in a glass-topped display case. On the wall behind this manly apparatus, and also under glass, were photographs of the theatre's other main attraction – a strip-tease artist. I remember assuming an intense interest in the chains, regaling my mother with a barrage of questions and observations designed to keep her from moving on, while all the time sneaking furtive and guilty glances at the pictures of the half-naked woman. I could tell from my mother's terse replies that she knew what I was up to, and I allowed myself to be tugged away, the sudden inexplicable excitement of the moment giving way to a terrible shame. The structure of that recollected space now maps itself onto the space of Newton's picture. I become the diminutive figure of Helmut, myself as child. June's lips, which I now interpret as tense with disapproval, are about to speak the words which will drag me away . . . but from what? If I was seven years old, then the year was 1948, the same year Robert Doisneau made his photograph, 'Un Regard Oblique', which shows a middle-aged couple looking into the window of a picture dealer, the man's slyly insistent gaze on a painting of a semi-naked young woman. Whatever we may suppose to have been on the mind of Doisneau's 'dirty old man', it is unlikely to have been within the repertoire of my own childish imaginings. For psychoanalysis, however, *consciousness* is not at issue. There would be no objection in psychoanalytic theory to seeing this 'innocent' child of the latency period as caught on the same hook as Doisneau's adult; but neither is there any justification in psychoanalysis for reducing what is at stake here to a simple formula, whether it be the structure of fetishism or what-ever else. We cannot tell what is going on in the look simply by looking at it.

Newton has made an indiscernible movement of the tip of one finger. The shutter has opened and paused. In this pause the strobe has fired, sounding as if someone had clapped their hands together, once, very loud. The light has struck a square of emulsion. Out in the street a driver in a stationary car has perhaps glimpsed, illuminated in this flash of interior lightning, the figure of a naked woman. Perhaps not. In his book *Nadja*, André Breton confesses, 'I have always, beyond belief, hoped to meet, at night and in a woods, a beautiful naked woman or rather, since

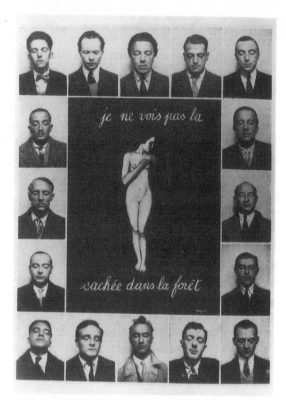

Page from *La Révolution Surréaliste*
(No. 12, 15 Dec. 1929)

such a wish once expressed means nothing, I regret, beyond belief, not having met her.' He then recalls the occasion when, 'in the side aisles of the "Electric Palace," a naked woman, . . . strolled, dead white, from row to row', an occurrence, however, he admits was quite unextraordinary, 'since this section of the "Electric" was the most commonplace sort of illicit sexual rendezvous.'[10] The final issue of *La Révolution Surréaliste* contains the well-known image in which passport-type photographs of the Surrealist group, each with his eyes closed, frame a painting by Magritte. The painting shows a full-length nude female figure in the place of the 'missing word' in the painted sentence, 'je ne vois pas la . . . cachée dans la forêt.'[11] In looking there is always something which is not seen, not because it is perceived as missing – as is the case in fetishism – but because it does not belong to the visible.

Optical space, psychical space

Ironically, the reduction of looking to the visible, and to the register 'objectification–exploitation', was inadvertently encouraged by the very 'return to Freud', initiated by Jacques Lacan, to which Mulvey's paper contributed. In his first seminar, Lacan had urged that we 'meditate on the science of optics'.[12] In an essay of 1987 I commented that it was precisely the model of the 'cone of vision', derived from Euclidean optics, which had provided the common metaphor through which emerging psychoanalytic theories of representation could be conflated with extant Marxian theories of ideology, eventually leading to the 'Foucauldianization' of psychoanalytic theory in much recent work on the image. In 1973, Roland Barthes had written, 'there will still be representation for so long as a subject (author, reader, spectator or voyeur) casts his gaze towards a horizon on which he cuts out the base of a triangle, his eye (or his mind) forming the apex'.[13] As I noted in my article: 'Barthes's optical triangle is . . . one-half of the diagram of the camera obscura – a metaphor not unfamiliar to students of Marx.' Furthermore, Laura Mulvey's essay was published in 1975, the same year as Michel Foucault's book *Discipline and Punish*.[14] As I further noted, 'Barthes's "eye at the apex" [the eye of Mulvey's male spectator] was therefore easily conflated with that of the jailor, actual or virtual, in the tower at the centre of the panopticon . . . [which] contributed to the survival of that strand of theory according to which ideology is an instrument of domination wielded by one section of a society and imposed upon another.'[15] I especially noted that what Barthes situates, indifferently, at the apex of his representational triangle is the subject's 'eye or his mind'. Here, I commented, 'Barthes conflates psychical space with the space of visual perception, which in turn is modelled on Euclid. But why should we suppose that the condensations and displacements of desire show any more regard for Euclidean geometry than they do for Aristotelian logic?'[16] The attraction of the cone of vision model for a critical theory of visual representations is the explicit place it allocates to the subject as an inherent part of the system of representation. The major disadvantage of the model is that it maintains the object as external to the subject, existing in a untroubled relation of 'outside' to the subject's 'inside'. As I observed, the predominance of the optical model has encouraged the confusion of real space with psychical space; the confusion of the psychoanalytic object with the real object.

I have noted that Mulvey's use of Freud's 1927 paper on 'Fetishism' has in turn been used to put a psychoanalytic frame around a non-psychoanalytic notion of 'objectification', one derived from a Marxian

idea of commodification – the woman packaged as object for sale. What has been repressed in the resulting version of 'scopophilia' is that which is most central to psychoanalysis: the unconscious, and therefore any acknowledgement of the active–passive duality of the drives to which Freud refers in his remark on the unconscious counterpart of exhibitionism. There is no objectification without identification. Otto Fenichel begins his paper of 1935, 'The Scoptophilic Instinct and Identification', by remarking on the ubiquity of references to the incorporative aspects of looking – for example folk-tales in which, 'the eye plays a double part. It is not only actively sadistic (the person gazing puts a spell on his victim) but also passively receptive (the person who looks is fascinated by that which he sees)'.[17] He adds to this observation a reference to a book by Géza Róheim on 'looking-glass magic'; the mirror, Fenichel observes, by confronting the subject with its own ego in external bodily form, obliterates 'the dividing-line between ego and non-ego'. We should remember that Lacan's paper on the mirror-stage, also invoked in Mulvey's paper, concerns a *dialectic* between alienation and identification, an identification not only with the ideal self, but also, by extension, with other beings of whom the reflected image is a simulacrum – as in the early phenomenon of transitivism. Fenichel writes: 'one looks at an object in order to *share in* its experience . . . Anyone who desires to witness the sexual activities of a man and woman really always desires to share their experience by a process of empathy, generally in a homosexual sense, i.e. *by empathy in the experience of the partner of the opposite sex*'[18] (my emphasis).

The object of 'objectification'

The concept of 'empathy' which Fenichel invokes here is not yet, in itself, psychoanalytic. To make psychoanalytic sense of the dialectic of objectification–identification to which he refers, we need a psychoanalytic definition of the object. In Freud's description, the 'object' is first the object of the *drive* – a drive whose 'source' is in a bodily excitation, whose 'aim' is to eliminate the consequent state of tension and whose 'object' is the more or less contingent agency by which the reduction of tension is achieved. In Freud's succinct definition: 'The object of an instinct is the thing in regard to which or through which the instinct is able to achieve its aim.'[19] The original object is not sexual, it is an object of the self-preservative instinct alone. The neonate must suckle in order to live. The source of the self-preservative drive here is hunger; the object is the milk, and the aim is ingestion. However, ingestion of milk and

excitation of the sensitive mucous membranes of the mouth are insepar-
able events. Fed to somatic satisfaction, and after the breast has been
removed, the infant may nevertheless continue to suck. Here the act of
sucking, functionally associated with the ingestion of food, becomes
enjoyed as 'sensual sucking', a pleasure in its own right. In this
description, sexuality emerges in a 'peeling away' from the self-preserva-
tive drive in the process known as 'anaclisis' or 'propping'.[20] In so far as
the somatic experience of satisfaction survives, it does so as a constel-
lation of visual, tactile, kinaesthetic, auditory and olfactory memory-
traces. This complex of mnemic elements now comes to play the part, in
respect of the sexual drive, that the milk played in regard to the self-
preservative drive. This is to say there has been a metonymical displace-
ment from 'milk' to 'breast' and a metaphorical shift from 'ingestion' to
'incorporation'. The object termed 'breast' here does not correspond to
the anatomical organ but is fantasmatic in nature and internal to the
subject; this is in no way to reduce its material significance. In his book,
The First Year of Life, René Spitz describes the primacy of the oral phase
in human development; he writes, 'all perception begins in the oral
cavity, which serves as the primeval bridge from inner reception to
external perception.'[21] In this context, Laplanche stresses that:

'The *object* . . . this breast is not only a symbol. There is a sort of coalescence of
the breast and the erogenous zone . . . the breast inhabits the lips or the buccal
cavity . . . Similarly the aim . . . undergoes a radical change. With the passage to
incorporation, suddenly something new emerges: the permutability of the aim;
we pass from 'ingest' not to 'incorporate' but to the couple 'incorporate/be-
incorporated' . . . in this movement of metaphorization of the aim, the subject
(the carrier of the action) suddenly (I do not say 'disappears', but) loses its place:
is it on the side this time of that which eats, or the side of that which is eaten?[22]

This ambivalence, then, marks sexuality from the very moment it
emerges *as such*, 'the moment when sexuality, disengaged from any
natural object, moves into the field of fantasy *and by that very fact
becomes sexuality*'[23] (my emphasis). We cannot therefore posit a simple
parallelism: on the one hand, need, directed toward an object; on the
other hand, desire, directed toward a fantasy object. As Laplanche and
Pontalis put it, fantasy, 'is not the object of desire but its setting. In
fantasy the subject does not pursue the object or its sign: he appears
caught up himself in the sequence of images'.[24] Thus Laplanche writes:

The signs accompanying satisfaction (the breast accompanying the offering of
nursing milk) will henceforth take on the value of a fixed arrangement, and it is
that arrangement, a fantasy as yet limited to several barely elaborated elements,

that will be repeated on the occasion of a subsequent appearance of need, . . . with the appearance of an internal excitation, the fantastic arrangement – of several representative elements linked together in a short scene, an extremely rudimentary scene, ultimately composed of partial (or 'component') objects and not whole objects: for example, a breast, a mouth, a movement of a mouth seizing a breast – will be revived.[25]

Thus, 'at the level of sexuality, . . . the object cannot be grasped separately from the fantasy within which it is inserted, the breast cannot be grasped outside of the process of incorporation–projection where it functions.'[26]

I have been speaking of infantile auto-erotism, in which polymorphous 'component instincts' (oral, anal, phallic) seek satisfaction on sites ('erotogenic zones') of a neonate body experienced only as a fragmentary constellation of such sites. In Freud's account of the subsequent development of sexuality, the passage from infantile auto-erotism to adult object-choice is described as routed by way of narcissism. The phase of 'narcissism', as the term suggests, coincides with the emergence of a sense of a coherent ego (a 'body-ego') through the agency of an internalized self-representation: the newly unified drive now takes as its object the child's own body *as a totality*. In adult 'object-choice' an analogously whole *other* person is taken as particular love-object, within the parameters of a general *type* of object-choice (heterosexual, homosexual; anaclitic, narcissistic). By this point, Freud seems to have offered contradictory descriptions of the object: on the one hand, initially, the object is that which is most contingent to the drive; on the other, later, it is that which 'exerts the sexual attraction'. As Laplanche comments: 'if the object is at the origin of sexual attraction, there is no place for thinking of it as contingent, but on the contrary that it is narrowly determined, even determining, for each of us.' In response, Laplanche proposes the notion of the *source-object* of the drive: 'The source being defined here as a point of excitation implanted in the organism as would be a foreign body.'[27] He sees the example of the internal breast as the prototype of such a source-object. By way of illustration, he suggests the analogy of the scientific experiment in which an electrode, implanted in the brain of an animal, is capable of being stimulated by a radio signal.[28]

I have not yet mentioned the place of vision in all this. In Freud's thought a wide range of distinct forms of behaviour are seen as deriving from a small number of component drives. The sexually invested drive to *see*, however, is not reduced to any such component instinct; it rather takes its own independent place alongside them. The physiological

activity of seeing clearly presents itself as self-preservative in function. The sexualization of vision therefore comes about in the same process of 'propping' of the libido on function as has already been described. Freud refers to looking as analogous to *touching*; Laplanche writes:

Imagine . . . the horns of a snail which would be moving with a sort of going-out and coming-in motion; in fact, precisely, the horns of the snail carry eyes. There we have the image of what Freud means in relating vision to exploratory groping (*tâtonnement*), and in comparing it to a collecting of samples (*prise d'échantillons*) in the exterior world. Thus the non-sexual activity of looking, in the movement of propping, becomes the drive to see in the moment when it becomes *representative*, that is to say the interiorization of a scene. I recall the primacy of vision in the theory of the dream, but equally in the theory of the unconscious, for that which Freud calls thing-presentations, the very substance of the unconscious, are for a large part conceived of on the model of visual representation.[29]

It has been observed that the scopic drive is the only drive which must keep its objects at a distance. This observation implies a definition of the object that is more bound to physical reality than psychoanalysis can ever afford to be. Certainly the look puts out its exploratory, or aggressive, 'shoots' (in Lacan's expression), but it equally clearly also takes in objects, from physical space into psychical space – just as surely as it projects unconscious objects into the real.

Enigmatic signifiers, perverse space

Freud describes infantile sexuality, the common basis of the sexuality of us all, as 'polymorphously perverse'. Formed in the paths of the vicissitudes of the drives, all human sexuality is deviant. Nothing about it belongs to anything that could be described as a 'natural' instinctual process. In the natural world instinctual behaviour is hereditary, predictable and invariant in any member of a given species. In the human animal what might once have been instinct now lives only in shifting networks of symbolic forms, from social laws to image systems: those we inhabit in our increasingly 'media-intensive' environment and those which inhabit us – in our memories, fantasies and unconscious formations. Human sexuality is not natural; it is cultural. Freud inherited comprehensive data on 'sexual perversions' from nineteenth-century sexologists, such as Krafft-Ebing and Havelock Ellis, who viewed the behaviours they catalogued as deviations from 'normal' sexuality. Freud however was struck by the ubiquity of such 'deviations' – whether in dramatically pronounced form or in the most subdued of ordinary 'foreplay'. It was Freud who remarked that that mingling of entrances to

the digestive tract we call 'kissing' is hardly the most direct route to reproductive genital union. In his 1905 *Three Essays on the Theory of Sexuality* he observed, 'the disposition to perversions is itself of no great rarity but must form a part of what passes as the normal constitution'. In opposition to the sexologists, who took socially accepted 'normal' sexuality as inherent to human nature, Freud stated that, 'from the point of view of psychoanalysis the exclusive sexual interest felt by men for women is also a problem that needs elucidating and is not a self-evident fact'. Sexuality in psychoanalysis is not to be reduced to the biological function of perpetuation of the species; as Laplanche emphasizes, 'the currency of physical reality is not in use in psychoanalysis which is simply not concerned with the domain of adaptation or biological life.'[30] If the word 'perversion' still has an air of disapprobation about it today, this is not the fault of psychoanalytic theory; it is due to the sense it takes in relation to social law, written or not. Considered in its relation to social law, we might ask whether fetishism should really be considered a perversion, at least in that most ubiquitous non-clinical form accurately described by Mulvey: that idealization of the woman in the phallocratic Imaginary which is precisely the inverted image of her denigration in the Symbolic.[31] The Symbolic, however, is not seamless. For the Symbolic to be seamless, repression would have to be totally effective. If repression were totally effective, we would have no return of the repressed, no symptom and no psychoanalytic theory. As an expression of the overvaluation of the phallic metaphor in patriarchy, the fetishistic component of Newton's photograph is perfectly normal – but only when we fetishize it, only when we isolate it from the space within which it is situated.

The space of Newton's photograph is not normal. The only clear thing about this picture is the familiar 'pin-up' pose of the model. According to the conventions of the genre we would expect to see *only* the model: isolated against the seamless background paper, cut off from any context by the frame of the image. Such a familiar space is alluded to in the rectangle of the mirror, which approximates the familiar 2:3 ratio of a 35 mm shot. But the isolating function of the framing edge has failed here, and it is precisely *this* function that a fetishistic relation to the image would demand. Elements which are normally excluded, including the photographer himself, have tumbled into the space framed by the mirror. This space is in turn set within a larger context of other elements which would normally be considered out of place. The resulting jumble is counterproductive to fetishism. Where fetishism demands coherence, for

this is its very founding principle, this image has a different productivity; it functions as a *mise-en-scène*, a staging, of the fundamental incoherence of sexuality: its heterogeneity, its lack of singularity, its lack of focus. Commenting on Freud's *Three Essays on the Theory of Sexuality*, Laplanche writes:

The whole point is to show that human beings have lost their instincts, especially their sexual instinct and, more specifically still, their instinct to reproduce . . . With its descriptions of the sexual aberrations or perversions, . . . the text is an eloquent argument in favour of the view that drives and forms of behaviour are plastic, mobile and interchangeable. Above all, it foregrounds their . . . vicariousness, the ability of one drive to take the place of another, and the possibility of a perverse drive taking the place of a nonperverse drive, or vice versa.[32]

In this photograph, as with the drives, there is much mobility: Helmut Newton stands in the model's space; June Newton occupies Helmut's place. Things are started – like the pair of disembodied legs – which are brought to no particular conclusion and are of indeterminate significance. The looks which are given by the protagonists neither meet nor converge, and they add up to nothing in particular. June is positioned as voyeur at a piece of sexual theatre; Helmut is both voyeur and exhibitionist; a familiar form of denunciation of this image would simply assume that the model is the victim of a sadistic attack, a casualty of an economy to which 'sexploitation' is central, but we might equally suspect a perverse component of exhibitionism in her being there to be looked at – an exhibitionism likely to provoke a mixture of desire, envy and hostility in male and female viewers alike. At first glance it might seem that the viewer of this image is invited to focus unswervingly on this central figure of the model, reduced to a visual cliché with no more ambiguity than a target in a shooting gallery. But the very banality of this central motif encourages the displacement of our attention elsewhere, but where? Nowhere in particular. In the space of events in which this vignette is situated nothing is fixed, everything is mobile, there is no particular aim; it is a perverse space.

For the human animal, sexuality is not an urge to be obeyed so much as it is an enigma to unravel. Jean Laplanche has identified the early and inescapable encounter of the subject with 'primal seduction', the term he gives to, 'that fundamental situation where the adult presents the infant with signifiers, non-verbal as well as verbal, and even behavioural, impregnated with unconscious sexual significations.'[33] It is these that Laplanche calls 'enigmatic signifiers': the child senses that such signifiers are addressed to it and yet has no means of understanding their meaning;

its attempts at mastery of the enigma, at symbolization, provoke anxiety and leave unconscious residues. Such estrangement in the libidinal relation with the object is an inescapable condition of entry into the adult world, and we may expect to find its trace in any subsequent relation with the object, even the most 'normal'. It is this trace of the encounter with the enigma of sexuality that is inscribed in Newton's picture. Reference to fetishism alone cannot explain why this picture looks the way it does. The concept of fetishism makes the whole question a purely genital matter. In a book on the erotic imagery of classical Greece and Rome, Catherine Johns remarks: 'The vulva is rarely seen: its situation makes it invisible in any normal position even to its owner'.[34] It is in this purely relative 'nothing to see' that the male fetishist sees the woman's sex only in terms of an absence, a 'lack'. All men are fetishists to some degree, but few of them are full-blown clinical fetishists. Most men appreciate the existential fact of feminine sexuality *as* a fact, albeit one which is not to be grasped quite as simply as their own. The Surrealists could not see what was 'hidden in the forest' until they closed their eyes in order to imagine it; even then they could not be sure, for there are other forests to negotiate, not least amongst these the 'forest of signs' which is the unconscious. Sooner or later, as in Newton's image, we open our eyes, come back to a tangible reality: here, that of the woman's body. That which is physical, that which reflects light – which has here left its trace on the photo-sensitive emulsion. But what the man behind the camera will never know is what her sexuality means to her, although a lifetime may be devoted to the inquiry. Perhaps this is the reason why, finally, Helmut Newton chooses to stage his perverse display under the gaze of his wife.

8

'Salle/Lemieux':
Elements of a Narrative

PAUL SMITH

> The paintings are dead in the sense that to intuit the meaning of
> something incompletely, but with an idea of what it might
> mean or involve to know completely, is a kind of premonition
> of death.[1]

To begin, I recall one very small but, for me, affectively satisfying
moment in the long and often tedious history of hermeneutics: E. D.
Hirsch recounts his teaching Donne's 'A Valediction Forbidding Mourn-
ing', and tells of 'the difficulty I had in convincing students that their
construction was wrong. They remained convinced that [the poem] was
being spoken by a dying man . . .'[2] My satisfaction comes in part from
seeing the impresario of shopping-mall literacy in present-day USA being
resisted by his students, of course. And Hirsch also unabashedly discloses
the relations of power that, it seems to me, normally subsist in the process
of establishing interpretations, and he thereby confirms that interpret-
ation is a way of making an imposition – on the text, on its students. At
the same time, the anecdote implicitly but unwittingly points me to a
question about the interpretation of individual texts: that is, what is the
status of the kind of knowledge to which Hirsch demands that his
students submit? What is the use of such a determinedly topical
knowledge about an isolated individual text? My reflex is to imagine that
there is very little use; at best that kind of knowledge of that kind of text,
imposed upon that text and on the reader, can only be the start of
something else, of some other or further process of understanding – but
never an end in itself.

In many respects it seems inevitable to me that one always think of
critical interpretation as an imposition, and that this would be true of
interpretation in relation to any text whatever, as much as to any painting,

old or new, Realist, Neo-Realist, abstract or whatever. But in the end, the imposition that interpretation might be is probably – and is probably often intended this way – much less an imposition upon any particular text than upon the cultural circumstances and contexts from which both the work and the interpretation arise. I assume here that any given painting will itself always to some non-trivial extent resist any given interpretation, since it is always wrapped in its own devices – devices that one might call, to begin an argument, defence mechanisms; and this fortification against interpretation has in recent years often come to be an end in itself and just as often lands up being dubbed 'Postmodernist'. But the cultural contexts into which one might 'fit' any defended piece of work are not themselves directly fortified by the picture's workings; rather the opposite – in defending itself the picture exposes the cultures from which it is produced and which will become the site of its consumption. So it is a specific kind of imposition that I will make here, primarily in relation to three recent American works, David Salle's *The Tulip Mania of Holland*, and two works by Annette Lemieux, *Homecoming* and *Courting Death* (all three works produced in 1985).

For me the interest of these pictures resides in what they might offer in the way of elements, or materials, within a narrative that I shall not be telling or fully elaborating here, but which I will content myself with trying to suggest or point to. This is, namely, a particular kind of narrative imposed on the cultural and social world, and part of my reason for not telling the story in full here is that I fear it will already be somewhat obvious or familiar. And yet the significance for me of these three artistic gestures is that they can subvent such a narrative as they themselves are surveyed and critiqued; it is the lines of this subvention that I want to sketch, in the belief that it does no harm – and may even be entertaining – to say over and over again that the narratives of the art institution (its texts, exhibition spaces, critical and journalistic discourse, its meanings, etc.) are never isolated from other narratives but are indeed part of them in overdetermined ways.

Together, then, the works I have chosen to look at here will serve as the raw data for a consideration and a somewhat sketchy telling or retelling of some strands of the cultural situation of America in the 1980s. My point of view or of enunciation is that of what I shall loosely call cultural studies, and my assumption will be that cultural studies is at its most telling when it can offer some at least partial review or rendering of a text as it is implicated into a social and cultural narrative, or when it can grasp the defences of the text itself as a narrative path leading to the open field

of the cultural. These three texts perhaps do not want or require my interpretation as such – but it is still an open question as to whether they want or require this kind of narrativization which they can be made to subvent. At any rate my position is that the art text inevitably opens out onto the wider semiotic environment in which it exists. It is not a relation of cause or effect that I assume, nor a relation of reflection, but rather that of an overdetermined implication, or of commensality and even commensurability.

The question of interpretation has of course been quite radically addressed by American art of the 1970s and 1980s, to the extent that in many respects the function of this address has in fact become to foreclose upon interpretation. That is, 'Postmodern' artists have often turned their work into something which some viewers complain is no more than a private affair: the viewer, armed initially with not much more than a traditional desire to comprehend, is not so much offered a hermeneutic puzzle to be solved but rather is confronted by a reified process of labour, whose meaning might not exist at all as an object to be deciphered for its statement, message or position but only as a set of relations (relations to what will be the question here). In other words, we as viewers have become familiar with the artistic gesture that offers itself *as such* and as little more. The work of art is still of course a commodity produced through semiosis – labour performed upon meanings – but this labour has been reduced to a minimal flourish whose significance resides not, in fact, in direct relation to graspable meanings but rather to deflected or disavowed meanings. In this sense the work must often be seen in its relation to the characteristic late-capitalist habits of adventurist ideology: cynicism, promiscuity, often secrecy, responsibility in only the tiniest degree, and so on. The viewer, disarmed by the defensive gestures of contemporary painting, will fundamentally have to judge not so much an image laden with meaning, but the signs and gestures of a work which is evasive, which strives to destroy its own relation to intrinsic meaning that we might have expected to find.

It would be comforting to be able to suggest that the viewer's place then becomes dependent upon some set of definable paradigms other than those by which we might 'normally' or 'traditionally' have stood before the work of art and attempted to grasp it. But these do not exist either, really: we are not helped much by the often repeated but ultimately dead-end claim that even in producing non-meaning, or resistance to meaning, an artist is still condemned to have created what Roland Barthes calls 'the very meaning of nonsense or non-meaning'.[3] So

we revert to narrative explanations as a way of grasping the status of the art work and its gesture as a socially symbolic act. And even those kinds of explanation will be various and variable – and undoubtedly partial – as they attempt to bespeak or illustrate a series or set of overlapping and overdetermined social constraints, reasons and responsibilities. For example, the works at issue here might readily become moments in a narrative of the evasion of responsibility in 1980s American culture or in a narrative of the massive extension of commodification in late capitalism. The narrative strand which I want to explore here is in fact neither of these, but another one (not unrelated): a narrative about, broadly speaking, gender.

Much of David Salle's work has extensively and even obsessively drawn upon what I will provisionally call emblems of male desire,[4] images which have, among their other effects, embroiled Salle in debates about pornography and made him the subject of various attacks and defences on that score. Although in part I will be forced to discuss the issue of pornography here, my aim is more to locate one of his pictures into a narrative frame, talking about the disposition of the gaze and of interpretation; about how Salle's defence against interpretation becomes a parable of fetishistic disavowal; and then to suggest how that disavowal is re-placed in the work of a woman artist, Annette Lemieux. The result, I hope, is the structure of a little tale, almost an allegorical one, in which a problem of masculinity is transformed and in which some small aspect of the history of the recent past might be contemplated.

One reason for choosing a picture by Salle to talk about in such a way, with such tendentiousness, is that his paintings could be said to emblematize a certain condition of interpretation in Postmodern art. This condition is that the painting should stand as a barrier to interpretation, should throw the reader away from the construction of readily graspable meanings, and my claim is that in this push Salle's paintings always send the viewer toward a process of contextualization or, as I will call it, a narrativization. Many of Salle's own interventions, his own comments about his work, which I take to be his own procedures of defending against interpretation or of setting up barriers to understanding, hint at how such barriers can be discursively erected and rationalized. In interviews Salle appears to give his authority to processes of anti-intentionalist reading when he makes comments such as the following:

I grew up with a very dubious relationship to aesthetic intentionality, which was highly stressed by the generation preceding mine . . . I was very interested in works where you had trouble figuring out what the intention of the artist was –

what it was that he was actually showing you, and what you had to make up to account for it . . . I would be hesitant to say what the real themes of my work are . . .[5]

Salle's paintings indeed set up interpretative traps for the viewer. Roland Barthes gives some clues, in his very rich essay on Cy Twombly, of how this kind of trap might operate for the viewer. Barthes notes how Twombly deploys titles and names as a kind of 'bait of meaning'. Titles are installed as an 'initiatory' device in Twombly's work. 'The title so to speak bars access to the painting.' Barthes begins, then, as do I, with a consideration of that little placard, 'this thin line of words that runs at the bottom of the work and on which the visitors of a museum first hurl themselves'.[6] Those words attached to Salle's painting, *The Tulip Mania of Holland*, act as a strong line of defence against interpretation. This tiny linguistic supplement does not seem to belong to this huge canvas, and yet, despite its tininess in relation to the visual work, it is entrusted with an extensive and paradigmatic function. It works, typed on a small card by the side of the painting, almost as a second canvas, as a kind of trap onto which the viewers hurl themselves, as they cannot immediately grasp the visual work and proceed instead to the wall to peer at the card – only to be thrown off again: no tulips and no Holland in this picture, no representation of anything that looks like Holland-icity, nothing explicitly about madness. The title, then, immediately offers itself as a semiotic lure – which is not to say that an inventive reader could not construe some relation between it and the visual work but that most readers will eventually have the good sense to recognize that they are being deliberately thrown off. The title disavows the painting, and vice versa.

The same process is perhaps what happens with the other piece of 'information' that goes with the title: the name of the artist himself. Either the name will have authority, or it will mean nothing very much to the viewer. Even when it has authority, it will perhaps still send the reader away from the painting again – perhaps into speculation about the gallery space (in this instance, the Carnegie Museum in Pittsburgh) and on into those loose and largely unknowable narratives of art stardom, art commodification, the politics of museums, and so on, that have in recent years become so much an unavoidable strand in our contemporary response to work in galleries.[7] In any case, both the title and the name authorize or even demand some conjecture on the part of the viewer but deliver little in return for that conjecture. Or perhaps the thought will strike us that we have got it the wrong way round and that the meaning which is central to this artifact is actually the evocative title itself, *The*

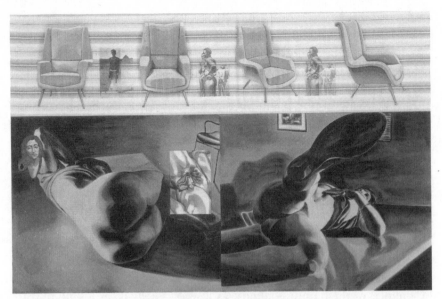

David Salle, *The Tulip Mania of Holland*, 1985, oil, acrylic and silkscreen on canvas and printed fabric, 335.9 cm × 518.8 cm. Carnegie Museum of Art, Pittsburgh.

Tulip Mania of Holland, and so it is the painting that is but a lure or a distraction from that. Or, of course, in the style of the good Postmodernist viewer, we might think it is both – the two processes of interpretation are put in play by the painter in order exactly to interrupt each other, producing that nullity in which we will begin to wonder: what is the point?

The wondering that one might undertake in front of Salle's painting is a little different from the kind of work that Barthes does with his Twomblys. Barthes implies that Twombly's use of this linguistic 'bait' is merely part of a process of seduction, a way of drawing the viewer into the puzzle of the picture. If the viewer takes the bait, he (I mean, he) is rewarded by the picture's transcendent effects. The picture has said no, but really means yes: persistence will be amply rewarded. Salle's is a very different kind of work: if Twombly, as Barthes says, is in the business of transforming dross into rarity and something sublime, the surface of Salle's painting offers no transcendence, is not seductive, remains dirty.[8]

As Salle's painting immediately and obviously denies such aesthetic gratification, we keep trying to discover the point, looking again at the painting and going through the steps of that ur-critical procedure of

description. To describe this picture to oneself, then. It is divided into three panels. There are two equal rectangles forming the bottom two-thirds of the work and one latitudinal rectangle set above them. The surface of the top part of the picture is of a cheap printed fabric, and images of four chairs are placed onto this fabric with three silkscreen images set between the chairs. At the furthest left the image is of a naked African woman; the middle and right-hand images are similar but with more figures. The bottom two rectangles most importantly include two different views of a white female life-model. The left-hand panel also contains two other major components of the composition: first, the seemingly disembodied head of a woman (though on closer inspection the body might be said to comprise the elongated staining of the canvas beneath her neck); second, an inset frame depicting male genitals. The two major blocks are both predominantly done in a grisaille wash; apart from the model's position in each, the panels differ also in that the left one depicts most of a chair, linking the frame with the chair images in the top panel, while the right-hand one shows the edge of a window frame.[9]

We know well enough by now that description is already interpretation; and thus, in my terms here, description is already an imposition on the way in which the picture is composed – but an imposition that will begin to push it into another realm, another area where a narrative can be formed around it. The composition of the painting, its collocation of its varying elements, is in this sense the site of a struggle between the text and the viewer, as the viewer tries to turn the composition to account, tries to make the imposition of an interpretative explanation. Why these elements? Why are they composed in this way?

Faced with the fact of the picture's composition, the reader then comes armed with the quintessential modernist injunction – only connect – as a warrant for an imposition but finds that the attempt to obey the injunction is thwarted by a Postmodernist picture such as this. That is, while the task of connection is certainly posed and proposed, it is also made too difficult (i.e. we are offered possible significance but with few clues), and the desire to connect becomes thwarted (i.e. we reach the conclusion that the composition is probably insignificant). And in a further step we might understand this probable insignificance of the painting as its possible significance, its commentary on both the objects it composes and on the viewer who tries to impose. Here the painting touches the logic of Postmodernism, opening out as it does onto such a limited logical circuitry and circuitousness.

But perhaps it is possible to turn that circuitousness to account by

recognizing that it is not simply a conceptual circuitousness but that it also has had to find its expression in the painting. Then we might notice a certain fluidity in the picture, as the chair in the top panel begins to move. That is, from left to right the chair is depicted in a small series of consecutive poses that sketch out a mobility, a small turn. This series might be seen as the beginning of a cartoon book, the construction of the illusion of movement from the flicked and riffled pages of a book of animation. This top frame then might be understood to recall the physical origins of the cinema, while in between the chairs we can see the black bodies which we might then grasp as a representation of an archetypal object of the movies: 'primitive' bodies.[10] At the same time, we are probably somewhat aware of the possible origin of these images – we have seen them many times, not so much in our anthropology or geography textbooks, but in the books and films that young boys were led to understand as 'documentary': the *National Geographic Magazine* spread or the obsessive television exploration of the 'dark continent'. Those representations of women's bodies constituted the sanctioned object of the western adolescent male gaze – for one of Salle's generation these black bodies were what the boy could see first, before the real thing, before the real white woman, before the onset of the complexities of a more 'civilized' heterosexuality.

What I call, then, the primary or primitive cinematic movement of Salle's painting is repeated in a supposedly more evolved, more sophisticated way in the bottom two sections. If the chairs in the top, primitive panel are cues to the chair in the bottom, sophisticated panel, the female bodies are arrayed in an analogous relationship. The di-splayed body of the white model constitutes of course both a 'pornographic' display and an 'artistic' display. This oscillation of a couple of paradigmatic girly poses into artistic studies of the nude, and the oscillation back again, is one more defence against meaning, defence against interpretation that the picture erects. That is, these two images are effectively offered as neither pornography nor art, and as both pornography and art. What is important about them is that, in their evacuation of a fixed meaning, the desire of both realms, or the negation of the intent of either gaze, comes to stand for the substance of the painting, comes to stand for what we can say about the painting as we look.

This oscillation, the setting up of an either/or, always resolves into a desire to have both, to fix the oscillation. Salle's desire to see everything at once is apparent in many of his other paintings, perhaps most overtly in the overlay of one image on top of others, as if it were possible not just to

see through a particular image to another but to hold both in a sort of suspension. In these superimposed or suspended 'see-through' images the structure of a fetishism is overt. Each of the images is both there and not there, as the eye is drawn from one to the other, often having to strain pruriently to make out the exact nature of the more skeletal images. The 'both at once' aspect of such paintings is a matter of quick succession, a little diachrony of the retina's attention and a narrative of fetishism. The painter's dream, however, is of a synchrony, a full presence of whatever it is that is desired in these pictures. The mark of the synchronic, then, always has to appear somewhere else in Salle's paintings, even if, as I have suggested, they are paintings 'about' movement of the eye or about moving pictures.

The mark of the synchronic is of course easy to locate. Many of Salle's canvases are marked by what, without wishing to press the pun too far, I would call studs: small objects, usually, which appear to be the utter foreground of the canvases and to be the fixed points around which the soft pictures beyond them are held in place. In some of his work these studs are actually three dimensional. In others they are *trompe-l'œil* effects in the sense that they overlay the perspectival arrangement of the painting's other fields. In many cases these studs can also be read as references to the various technologies of vision. At the same time they are objects of eroticism – sexual invitation and sexual target. In a sense they can be understood as *points de capiton*, holding the flux of the signifiers beneath them into a single moment, pinning the images, as it were, but still without fully endowing them with meaning. In other words, in order to see everything, and to see everything at once, you freeze-frame it, still permitting the impact of the swirling meanings but imposing the mark of a field of control over their movement.

What in fact is being both exhibited and controlled, avowed and disavowed, is, I suggest, the very imaginary of the pornographic scene. But Salle himself is very impatient about the pornography question and wants to deny that the images he proffers are pornographic. He claims that the 'original' pornographic images in effect become something different in the painting. 'One of the things that makes art worth looking at is its absolute specificity, its insistence that even if it kind of looks like pinstripes or pornography or comics, it's *not* that exactly . . . *Because they're arrived at in a completely different way*'.[11] A similar kind of claim is made by a female critic, Lisa Philips, when she defends Salle against the charge of pornography by suggesting that the images he uses 'fail to provoke arousal in the expected way'.[12] And yet this is as arguable as

Salle's own claims. Each of the images that might be called pornographic calls forth the ethos of its avatars, it seems to me. But, also, each such image is (literally in terms of Salle's working methods) drawn from a pre-existent image bank which is constituted by what might be called a vocabulary of forms. The image bank of the girly magazines' stills has perhaps by now given way to, or been confounded into, the image bank of the moving television advertisement. The swiftness and insistence of the thirty- or sixty-second television advertisement, for instance, will often depend for its pornographic effect of solicitation on exactly what it cannot show – that is, the detail of nudity or the specific detail of bodies engaged in sexual activity. What there is instead is a catalogue of poses and postures, signals to the spectator's eye that a prurient glance is required. The catalogue of televisual effects is perhaps preceded by the catalogue of girly magazine poses and effects, the signals of the pornographic as much as its enactment. Salle's paintings obviously work in close proximity to these catalogues and could even be said to record or register exactly the historical shift from the one to the other. While Philips seems to imagine that the pornographic depends on detail, on explicitness, Salle knows better. He knows that the pornographic is a matter of shape, posture, pose and, most of all, movement. He also knows that it has a history. He places the black women's images in a historically and spatially direct line to the white life-model, and we know that these Africans are there because they constitute the very type of the pornographic image that is not called pornographic; they are the models of disavowal, and to put them in the painting is to do ur-pornography.

So the painting's top section becomes the prehistory to what is shown below, becomes the painting's unconscious and its history – the top is, as it were, Muybridge to the Hitchcock of the bottom panel. The appearance in this painting of cinema as a cultural trope, or as a way of looking that is figured in these paintings, suggests the desire to give movement, or simply to figure movement, in the pornographic image. Salle is to some extent warranted when he claims that his paintings do not re-present their pornographic origins in the girly magazine; rather, this painting is in a sense an intermediary between the static fetishistic image of the men's magazine (the *Stag* end of the work) and the movement of actual cinema. It is never, of course, a question of bodies as such: these are emblems of a masculine and fetishistic desire and are only ever that; they are investigated for their point of insertion into an apparatus of movement rather than for their life or their potential life.

That point of insertion (or perhaps it is a question of multiple points of

insertion) constitutes the phrasing of a question. This is not a question about point of view, nor about perspective nor even colour. Rather, the point of insertion is a question of where the little boy (the producer-author of the pornographic imaginary) can comfortably seat himself. From which of these chairs can the insertion best be imagined or construed? This fantasy question is made explicit in what I will call the 'floating frame' of the lower left-hand panel: the male genitals there, almost in a kind of three-dimensional chiasmus with the female ones, make no actual contact but produce an imagined space or gap for insertion and penetration. (The reader's initial desire to 'only connect' is played on here.) Equally, the second of these floating images, the woman's head and deliquescent torso superimposed over the field of the nude model, becomes such a fantasized space through the opening in the woman's hair. This kind of feminine opening on the surface of the canvas has in fact been a topic in Salle's conversations with Schjeldahl – and it is here that we perhaps at last find some bit of the significance of the word 'Holland' in the title, as they discuss Jasper Johns's The Dutch Wives:

PS: What is a Dutch wife?
DS: It's a piece of wood with a hole in it used by sailors at sea as a surrogate for women. Hence those little drips on the painting, right below the circles. You could think of it as having set a coffee cup down on the surface of the painting, but you can also think of it another way.[13]

Hence too, perhaps, the elongated stain beneath the woman's head, the stain of the little boy producing.

The ostensible topic of the part of the conversation I have just quoted is the rather elevated notion of 'the painting as body analogy'. Salle explains that 'in painting there is the play on the tension of wanting to enter the pictorial space, penetrate the space'. The fetishizing oscillations of the painting are here located alongside the desire to act that lives in the male imaginary as the corollary to fetishism but always in tension with it: which will win out, the frustration or the rape?

This painting, then, is feasibly described as being about the pornography of looking and about the male desire that underpins what we might call a will to representation. The picture means very little to me beyond its presentation of this history, which it would be pointless to deny is also partly my own: a history of the white and heterosexual and boyish fantasy of the woman's body. The title acts in relation to this dream as a kind of tutelary or condensed fetish which admits the mania the painting depicts but displaces it both from the painting itself and from the white boy who produces it and throws it into the utter metaphoricity of

Holland (Holland's tulips are perhaps a less abstract metaphor in that they might traditionally refer to the female genitals, but none the less . . .). This history is bound up with the passage of the gaze from the static to the mobile, from photography to cinema, and it is a history which also travels – perhaps in the care of those deprived sailors at sea – from the first world to the third, from the sophistication of representation to the primitive object.

The sailors are not in the painting, of course – if they were, they would mark once and for all the motility of the desires that circulate there. I introduce them as a mere fictional device and in a tongue-in-cheek way. But they are intended here to speak as the mediation between each pair of points: still/motion picture, object/representation, primitiveness/sophistication, Africa/Holland. They mark the frustration of the male gaze as it travels from one point to another, the contradictory nature of the fetishizing gaze in this wavering motion, this flickering of desire that goes on there as a motor. The fetish object is defined in its always being simultaneously there and not there. The desire for the pornographic moving image (the film is better than the still photograph) is not for its explicitness or for its duration but for its flight from the history that the still still represents in a dangerous way, its ability to offer a mechanized commutation of the fetishizing gaze.

I do not really feel compelled to judge (or interpret) whether this picture of Salle's should be dignified by the idea that it constitutes an analysis and a critique of a particular apparatus and procedure of masculinity. Perhaps it is enough to suggest that it acts as both a process of disavowal and a sort of brazen admission of that disavowal – not quite an analysis of anything but a re-presentation of something. This is a painting, then, politically poised to resist condemnation or censure but at the same time allowing itself somewhat abjectly to be understood as guilty. It is a picture in crisis, or which represents a crisis or reflects upon a crisis.

Feminist artists and critics in the last two or three decades have, of course, spent considerable energy in what amounts to a critique of the male gaze and its institutionalized modes and have helped produce the crisis of disclosure and occultation that Salle's painting epitomizes, acts out or mechanizes. Such women artists as Kruger, Levine and Holzer are all crucial as proponents of the narrative whose edges I touch on here: the narrative whereby the masculinity – indeed, the masculinism – that pervades the painterly is thrown into crisis, where it learns to avow itself

and yet at the same time must hide itself in a wavering gaze and its companion, the desire to penetrate the field.

The Tulip Mania of Holland has an interesting correlate in a 1977 performance video by Ulrike Rosenbach, *Frauenkultur – Kontaktversuch*. Rosenbach's performance consists of rolling her body along the floor of a gallery space and thus passing by a series of fifty or sixty photographic prints projected one by one onto the gallery wall. The photos appear in sequence as the body rolling across the floor becomes more and more encumbered by the coax-cable which controls the projector. The images on the wall depict different women in a kind of 'evolutionary' process – the first, a 'primitive' image of a black female warrior in a jungle; the last, a 'sophisticated' contemporary white fashion model dressed in high-fetish clothing and posed distortedly. Rosenbach's performance cannot be dubbed an allegorical one. Its obviousness, its projection of a simple visual message, is considered sufficient to stand as a corrective to the logics and the histories of guilt and avowal, innocence and repression, that have attended the male construction of femininity; in the light of that rhetoric, that direct corrective, the audience's relation to the kind of attention that a painting like Salle's is predicated on is then forgotten. There is, then, a precise linearity in Rosenbach's performance which requests the patience of a linear attention (the trajectory across the gallery and across history takes almost thirty minutes). Rosenbach's performance de-eroticizes, de-masculinizes the narrative of the white boy producer and viewer and fetishist, largely by turning it towards this linear narrative, this straight-line history. Because the nature of this transition from the naked black body to the naked white body is overtly political rather than covertly fetishistic, it leads away from – and perhaps even is simply unaware of or ignores – the sophistication of the male gaze and its complex wavering processes.[14]

This kind of de-eroticization and the same kind of push towards the de-masculinization of the gaze can be imposed on Annette Lemieux's *Courting Death*. This is a still from a Hollywood movie (though I cannot identify the movie or the actress). Here the woman – masquerading, in the sense that she is all dressed up to be the object of the male gaze but does not hold that place as she should – turns a look of amusement or bemusement onto a skull before her. It could be suggested that she is looking not only at what I imagine to be a gendered skull (its size is a clue here) but also at a tradition in the way that Rosenbach's rolling body does. And, of course, she is also explicitly looking at (a) death – this is a quite solid *memento mori*. The standard feminist critiques of the male

gaze have stressed its ability to objectify women and thus in a sense kill them. This image represents a simple example of what feminists have called 'looking back', which has become a quite familiar strategy within contemporary feminist practice. In turning the look back onto the male subject, the woman escapes submission and discloses the deathly nature of the look in its origin.

For all the talk that one hears of how Postmodernist art work is 'deconstructionist', very little of that work actually carries out the

Annette Lemieux, *Courting Death*, 1985, colour print, 121.9 cm × 96.5 cm. Josh Baer Gallery, New York.

fundamentally deconstructionist process of simultaneous inversion and displacement of dominant concepts. But Lemieux's screenprint here comes close to a classic deconstructionist gesture, as it both inverts and displaces the ordinary or standard arrangement of the objectifying look. The woman in the picture is not the object of the gaze's probing (as she almost certainly would have been in the moving picture version of this image) but rather the origin of the look as it investigates in an amused manner the useless death's head in the foreground. Of necessity, the

male eyes remain blank and vacuous, leaving the woman the task of beginning to write. When the male/voice no longer dictates, the woman/secretary becomes the place from which both look and voice will emanate. Of course, the picture does this kind of deconstructive operation most specifically in relation to the painterly tradition (or at any rate to the tradition of the art world to which it belongs), and in that regard one can say that its function is to freeze the wandering gaze of the fetishist, reverse it and displace its meaning into another field, where the woman is no longer part of a 'painterly' investigation but an agent within the work. Moreover, the composition here is not used to fulfil a desire for insertion, for penetration of the space. Rather, what is set up is a relay of contemplation. The picture presents itself as the linear passage of the look, pulled together into an act of contemplation; that is, it throws off the fetishistic look and welcomes the construal of what we might call a thoughtful and contemplative look.

In this sense, I am trying to make the picture (imposing on it) stand against Salle's whole process of shuffling or commutating the gaze from one place to another and against his attempt to make connections solely by representing the desire for insertion into the space. I want this screenprint of Lemieux's to bespeak a return to the specificity of the look, a reinstatement of some lost ability to contemplate without wanting to see or say everything at once. At the same time – deconstructively, perhaps – my imposition depends exactly on a relation between Salle's and Lemieux's works here, a relation which is not exactly synchronic but which sets up the elements of some narrative.

Part of the narrative, 'Salle/Lemieux', is to be constructed, then, around the use of the look, constructed in a consideration of the *kind* of look or around what we might call the quality and kind of attention. In the Salle, the look is sadistic, cinematic, fetishistic in many ways and deceptive in others, displacing and deflecting the meaning of the look and the meaning of the object looked at. *Courting Death* contemplates, looks back at and also reconstructs the deathliness and emptiness of this sadistic and deceptive look. The male gaze is emptied, disclosed in its vacuity, by this looking. Lemieux's gesture then registers a crisis or a point of interruption; it is to this that Salle's work as a whole, it seems to me, responds – though equally, simultaneously, Lemieux's work responds to Salle (again, I do not wish to impose a cause/effect narrative here but rather a process of dialectical imbrication, of interruptions and of commensal, commensurate gestures).

This contrast which is not really a contrast is intended to subvent the

narrative I offer of the art-text in contemporary American culture. Perhaps, to be careful, I should say that the narrative is a conversational or dialogic one; or in a more dramatic vocabulary, it can be seen as a narrative of crisis and response, response and crisis. At any rate, I am reading here a certain kind of adventure: a picaresque movement from the anonymous commercial and pornographic image-bank of the woman's body, through the devices and apparatuses of the cultural gaze, meditated on and mediated by the personal adventurist gaze of the male, and from there to a re-placing of the woman's body and a work that tries to reconsider the power of the gaze. My narrative is, indeed, stereotypical or conventional enough in that it attempts to limn the course of a massive disruption (the dispersal of the field of meaning into the elements of a gaze) through to what might be thought of as its coming home, an attempt (mine or Lemieux's?) to 'reintegrate' the gaze.

In *Homecoming*, Lemieux's three frames are all part of the same narrative, part of the attempt to document and then reintegrate the dispersal of visual intelligence. If Salle's work is a labour on the fragments and abstractions of fetishistic guilt and exhibition, Lemieux's proceeds beyond the fragments and attempts to set the agenda for a 'different' gaze, a different process of erotic courtship. *Courting Death* can be understood as a reflection on or dialogue with the epigraph with which I opened this essay: 'The paintings are dead in the sense that to intuit the meaning of something incompletely, but with an idea of what it might mean or involve to know completely, is a kind of premonition of death.' In that epigraph Salle risks the emergence of Lemieux's (or at any rate, someone's) meditation on or interpretation of his own work's deliberate deathliness. Lemieux risks the death and nostalgia that is in the air where he is concerned or where he is a presence to be deconstructed. Lemieux's work stretches the fetishistic point of the structure of Salle's vision into a linear relay; in effect, she is denying the male's desired or putative ability to see everything at once. The thwarted process of seeing through one image to another is replaced by a linear drive, a narrativizing movement whereby a relay is established, and her frames bespeak connection.

But I am going too fast here. I feel as if my language is caught in the trap that my comparison of these two artists might always have entailed: ironically, the trap of trying to see two things at once. The juxtaposition of these two representatives of some small part of a cultural and artistic history loosens the tongue somewhat but lets the meaning slip away. It would be much better, perhaps, to concentrate, to tame the attention, to allow *Homecoming* to appear and to try to replicate what I think is its

gesture of using the space between work and spectator as the place where contemplation and meditation might be regenerated.

Homecoming consists of a large oil canvas, with two rectangular grounds, maroon on the outside and deep khaki-green on the inside; a large and almost lavender star sits in the middle. Attached to the outside of the canvas's upper right corner is a small framed photograph of a mother seated before a picture of her military son. A little distance away on the wall is a yet smaller frame enclosing a book jacket with a gold star at its centre. The motif of the star, appearing in each frame, is thus given a different context in each of the three frames. The stark presence and severity of the large abstract canvas is undermined or commented on by the intriguing detail of the two other, much smaller frames. The viewer's attention is drawn to the black and white photo of the wartime mother, and the significance of the star as a symbol of sacrificial motherhood in wartime emerges, casting the abstraction of the painted canvas in a different light and giving its central star shape some small point of historical reference.

The photograph of the mother here is perhaps relevant to what is by now a quite substantial feminist tradition of historical 'recovery': that is, it is a representation of a marginalized or repressed component of popular memory: the anonymous war mother awarded an official star for the loss of her son in battle – her narrative of heroism in sacrifice here stands *before* the dominant narratives of the fighting man. So *Homecoming* can be understood, on the one hand, as a deliberate reflection of the tradition of Abstract Expressionism and, on the other, as an attempt to *turn* it by the insertion into the composition of evocative rather than erotic emblems. The attempt is to root the abstraction of the large frame – and indeed the ensemble of the work – into what we might call an affective history, by means of the two small frames. The star as a quasi-imperialist symbol, the star that is a memory of school-days and the striving for reward, the star as a motif in the semiotics of abstraction: these three elements of the work's composition all resonate with each other, and their juxtaposition produces a kind of echoing relay of different memories, both individual and collective. This work is not exactly a critique of contemporary or historical ideologies or symbols; rather, it asks viewers to contemplate their own implication in the history of how all that comes about.

Thus, what becomes of prime importance here is the question of the composition, the collocation of these three images on the wall as they invite the movement not only of a gaze but of a historical contemplation.

Annette Lemieux, *Homecoming*, 1985, oil on canvas with framed photograph and framed book cover. 200.7 cm × 139.7 cm. Josh Baer Gallery.

Annette Lemieux, *Homecoming*, 1985 (Detail).

There are no self-sufficient and obstructive fragments here, no divisions which cannot be linked by the viewer into a kind of narrative. And the narratives that the work invokes internally, as it were, readily move out of the work itself into a consideration of other, 'larger' narratives: the 1980s move from Abstract Expressionism to an art that seeks once more a relation to history and the story of the feminist revisioning (as it is often called) of other histories. In this latter move *Homecoming* presents a feminist objection to a forgetting of history's impact. This is not the internalized narrative of someone's imaginary but a narrative of connection and affect in the world. In other words, this work goes 'beyond the fragments', as Victor Burgin puts it[15] and re-places a lost linearity, a lost narrativization. History, painting and viewer are all caught up in a relay that becomes a space for meditation, with the smaller pieces acting as a kind of memory to or for the large abstraction. There is, too, a reinvestment in the little placard at the side of the picture: instead of Salle's parrying and obstructive title, the word 'homecoming' joins the narrative and linear push of the work as a whole.

It is arguable that since the advent of Neo-Expressionism the task of the spectator in front of many works of art has been to consider not so much the image itself but the process of its construction. In front of such works the spectator has been asked primarily to consider the nature of a work's intervention into ongoing conversations about a supposed crisis of painting and representation. Alternatively, with other kinds of 'Postmodernist' or Post-Neo-Expressionist work, the spectator is subjected to a whole variety of discourses and codes whose aim is to recontextualize and refunction the artefacts and commodities of our consumer culture and which ask to be considered as critiques of the time and place in which we live. Whatever else one might want to say about those two pre-eminent kinds of contemporary art practice, it is largely the case that they have tried to eradicate the power of reference and affect – of expressivity even – from the art work. For many contemporaries, art's points of reference are still the self-reflexive languages and forms of art itself and/or the depredations of the increasingly complex culture of Postmodernism. In that context, to begin talking about affect, reference or expressivity – rather than about painterly self-referentiality or disembodied cultural signs – is not exactly fashionable right now: 'nostalgia', comes the cry, or 'revamped modernism'.

It is true that attachment to such terms might indeed simply be reactive – or even reactionary – in attempting to reinstate the time-honoured 'values' or the traditional aura of humanist art that are considered to

have become unavailable in the contemporary scene. Very often that nostalgic urge will have recourse to older codes and languages of art (as in Neo-Classicism or Photorealism) or will try to rehabilitate various forms of representational and narrative art practice. No doubt these are signs of the times in their way, designed to disavow the perceived decadence of Postmodernism. Lemieux, on the other hand, in the works I am considering here and also in much of her more recent production, seems both to accept and to use the available languages and forms of the Postmodern but at the same time tries to turn them beyond their interiority and self-referentiality and to make them more directly expressive. For her, the art forms and languages that have developed within those two main strands of the Postmodern are now available to be both deconstructed and refunctioned in their turn. Her remarkable work might at first blush look quintessentially Postmodernist – she seems to have used at some point or another just about every currently available art language or style, as she explores painting, sculpture, photography, photocollage, the written word and mixed media work. Often a given piece of hers will recall or allude to the style and look of some other contemporary artist: for example, her paintings can sometimes look like Ryman's, or LeWitt's or even Schnabel's; her sculpture might recall someone like Barry Flanagan, or sometimes Jeff Koons; her photos (especially ones like *Courting Death*) might owe a lot to Cindy Sherman and her photocollages to Barbara Kruger or perhaps Richard Prince. To some eyes, she might be running the risk of being taken for some kind of fashionable scavenger across the surface of the languages that are available to her.

Yet, finally, all those superficial similarities and points of reference are exceeded in Lemieux's work. Since the early 1980s she has been conducting a kind of battle against Neo-Expressionism and has begun a thorough traversal and critique of the modes of Postmodernist art. That is, her position in relation to much other contemporary work is perhaps best described as a need and desire to turn the spectator's attention away from where it is usually left – with the art work's process – and instead to draw it toward the actual image, its content and its historical ground in whatever context, code or language. For her there is no question of simply moving materials around in various combinations or modes in the kind of formal dance with which spectators are currently so familiar. Rather, her work is *conceptually* guided toward the actual ideas which can be attached to images and objects: it is an art of the signified rather than the signifier. In this sense, and in the context which she is continually re-elaborating, this strikes me as a profoundly political gesture, as a

contribution to our artistic and cultural narratives that forces a reconsideration of their loss, their depredations and their despair.

One way in which she effects this strategy is to produce works which repeat and elaborate a series of central motifs, shapes and images. Most of these are already culturally and historically laden – stars, crosses, flags, images of motherhood, evocations of war, and so on. Their already constructed significance would normally run the risk of being simply elided, considered old and hackneyed or straightforwardly critiqued in most contemporary art. Lemieux's aim, by contrast, is to reinstate those significances as proper components of the spectator's encounter with the image.

She exploits these images – sufficiently simple and abstract ones sometimes, as in the case of the stars here or the crosses elsewhere – in order to re-invoke the spectator's cultural and personal memories. These memories, or the process of their construction and interpretation, finally constitute the effect of her work. They have their roots in recognizable elements of our culture – as in *Homecoming* – but they are also unspecific enough to be broadly evocative for the spectator. They constitute in themselves an attempt to add something to, or to fill in, the abstract and formal icons which provide their frames or bases.

What is happening in *Homecoming*, I think, is that Lemieux is joining substantive images of the past and more abstract icons from the present without trying to attribute to them any transcendent symbolism. At the same time, she does seem to want to flirt with their nostalgic content, since it is in part through the presentation of a sense of something lost that the active tensions of her works can be elaborated. Between the vivacity of images that speak of something lost and the dryness of the codes of formalist art there lies the whole problematic – because political – question of how art comes to produce affect in and for its audience.

In the current context, such words as memory, affect and evocation can seem retrogressive, but these are the big signifiers that Lemieux's work invites the spectator to consider. As I suggested, her task is to reintroduce their significance into a tension with form – but without allowing the images she uses to fall into utter nostalgia or mawkishness. Predictably, though, Lemieux's work has produced accusations of nostalgia and sentimentality, as is demonstrated by one press reaction to her 1987 show at the Weinberg Gallery in Los Angeles. Her work was described as being endowed with a 'romantic sensibility' through which the topics of 'memory and loss [were] nowhere put to more than nostalgic use'.[16] Such a judgement both gets the point and misses it at the same

time. As is suggested by the title and the image of *Courting Death*, she is well aware of the possibility and danger – even the temptation – of the nostalgic. She courts it or, like the woman in her photograph, gazes enigmatically and teasingly at it – but her work does not in the end submit to the nostalgic, which is always kept in check by the severity of the abstract.

Victor Burgin has suggested that 'to move against fetishism in the visual arts is to move "beyond its fragments", beyond its divisions' and that among those divisions is that between 'the private and the social'.[17] Such a move is a risky one in that it can easily look like a moving back rather than a moving beyond. The reconsideration of the look, the taming of attention that anti-fetishism requires might be said to belong more properly to the modes of a traditional or modernist art – something like Twombly's perhaps where, in Barthes's terms, the spectator's contemplation and meditation are rewarded by the experience of rarity. Lemieux takes this risk but also draws attention to the nature of the risk. That is, the arrangement of the three frames in *Homecoming* acts as a reminder of the habitual divisions of contemporary art and its fetishistic character but at the same time requires a different act of attention – a linear and meditative attention – that pulls the frames together. Burgin has also suggested that the prevalent mode of contemporary art, and the consequence of its fetishizing tendencies, is a forgetting of history; Lemieux responds to this situation by a reinsertion of a piece of social history which, however slight a presence it might have, marks an attempt to blur the division between 'the private and the social'.

So Lemieux's work is in some sense 'about' bringing back the possibility of reverie and meditation to the spectator's experience of the art work. She attempts to tame the attention that has been scattered, deliberately thwarted and, indeed, denigrated in the era to which Salle's work properly belongs – an era of the forgetting of history, the deadening of attention, the confusion of the gaze and the celebration of the masturbatory comfort that the gaze takes in oscillation. Even if it might look like an almost modernist approach to the art object in Postmodernist form, its difference is that it does not just offer the reverie of meditation or the sublime experience of rarity emerging from dross but simultaneously shows, critiques and reconstructs the passage of the gaze, at the same time as provoking the spectator's necessarily continual implication in the particular histories and memories that can be read through images.

Of course, it is still possible that Lemieux's work could be understood

as another attempt to supply Postmodernist art with a sense of authenticity and relevance – an attempt that might itself be reactionary. Hal Foster has complained about that tendency in some other artists in a nicely turned passage where he claims that recent attempts to 'reinvest art and artists with aura and authenticity . . . attest only to the historical decay of these qualities' and that, in any case, this effort usually ends up producing only '*simulations* of authenticity and originality' which do nothing more than demonstrate exactly that loss of history in our culture for which they attempt to compensate.[18] But Lemieux's work is not so much concerned with the *ideological* work of returning those old qualities to art practice. Rather she seems more concerned with actually putting the history back in or with regenerating history bit by bit by means of a sustained insistence on her chosen motifs. It is in the space between the work and the spectator that such a task has to be carried out. One of the major efforts of Lemieux's work, then, is to help the spectator re-evaluate the power of the static image, its ability to make reference to our histories and its power to reinvoke our thought and our participation through small acts of attention and antifetishism.

In my descriptions of these works by Salle and Lemieux I have tried intermittently to locate the elements of the narratives to which I have been pointing, narratives of which the works are part, which they do not necessarily engage in willingly and which the artists themselves might well reject. But I want to stress in particular the way in which women's work and what in some mouths might be described as a feminine or feminist project have produced a certain kind of response or reaction to the work and workings of the male gaze. And it does not really matter to my narratives here that Lemieux might not be an overtly 'feminist' artist – in fact, it might rather help that she is not. Her work still helps suggest the structure of a little moral tale where . . .

9

Echo and Reflections

DAVID REASON

Hamish Fulton's text piece ROCK FALL ECHO DUST has haunted me since I first saw it, in a photograph of the words placed directly on the wall of a gallery in Philadelphia. Spare and monumental, simple and resonant, it seemed to offer a commanding presence in the room, yet was simultaneously reticent, self-effacing, unassertive. A work of poise which was neither strident nor dominating. Although the large letters painted flat against the wall possessed a clear sensuous quality, it was the Delphic enigma of the utterance it made public which clung like a burr to my mind. Here was a work which I could roll around in my head and my mouth for some time, and with relish. In this respect, and in the context of this present volume, the work announces what is for me a basic rule: to write only about an art which moves me. Only when I am engaged by the work, only when it challenges and shifts my understanding, can I write and speak with the focused tentativeness and the disciplined passion that I believe can best serve to establish a fruitful ground between my reader or listener and the work at issue.

In the best critical practice something of importance is at stake, and the question of what the critic is committed to is always in play. Too often, the critic's commitment is to attaining the position of superior judgement, of – through pronouncement and sentencing – putting artist and audience in their places and clanging shut the chance for debate. Hans Keller, toward the end of a lifetime of scrupulous writing and teaching about music, castigated critics as members of a 'phoney profession'. The esteem accorded them derived from it being their job 'to know better – not better than the reader in the first place, but better than someone else, than whom the reader also knows better as soon as he [or she] has read the critic.'[1] And who is this uninstructed 'someone else'? The artist. Keller is exaggerating, of course, but he exaggerates with the purpose of provoking his readers into recognition of the subordinate role that artistic creativity – and so the artists' point of view – plays in critics'

discourse. Whether smothering the artist with praise or finding faults (in the geological or the moral sense), self-indulgent criticism disqualifies both artist and reader from joining in the conversation, except she or he adopts the preening attitude of such criticism.

Anyone familiar with the development and variety of Fulton's work will find ROCK FALL ECHO DUST (p. xvi) an exceptional work. Fulton was a student of sculpture; the work that first brought him to public attention typically joined photographic images with texts; my chosen work, however, is composed of words only. There are several such text works that Fulton has made – more in recent years – and they comprise a telling extension of the artistic forms he has at hand. But this is not part of my reason for choosing this work on this occasion. To have chosen on that ground would have presumed of you, the readers, a degree of familiarity and knowledge of Fulton's work which I have no way of warranting, and so would have led here to my writing and argument depending upon assertions and judgements which, in all probability, my readers would have not been in a position to check out for themselves – at least not readily – and so I would be denying them (you) a chance of participating in the dialogue with the work and with me which I wish to promote. Inevitably, my writing speaks of and to particular and (more, or less) shared vocabularies of motivation, knowledge and judgement. None the less, my aspiration is to appeal not solely or so much to those who share my intellectual convictions as to those who are prepared to join me in an enthusiasm and attend wholeheartedly and wholemindedly to an experience which is as equally available to each of us as any experience ever can be. (The point is not that we each have the same or equivalent experience but that we can expressively share something of the experience that each of us has.)

What you see in this book is not a reproduction (image) of the work ROCK FALL ECHO DUST but the work itself. The opportunity which this provides for writer and reader to confront or face up to the demands of a commonly available work was an important consideration in my choice. On the one hand (so to speak) I have kept nothing up my sleeve: the work which I see is the work which you see, too, only providing that you have some minimal competence of sight. And so far as the sensuous qualities of this work are concerned, nothing vital or subtle (as too often both) has been lost in the printing, because the work is the page that has here been printed. However separated in time and space, you and I are effectively seeing this work together.[2]

Then what is the relationship between the 'version' of the work printed

here and that painted on the gallery wall in Philadelphia or – as also happens – elsewhere? I suggest that it is fruitful to think of them as distinct *performances* of the work ROCK FALL ECHO DUST, in much the same way as we would consider different performances of a piece of music,[3] performances of the same music even though they might sound different in important ways as a result of differences in performers, ensemble, conductor, the acoustics of the halls in which the performances take place, and so on. The existence of the 'one work' in these several ways incites us to discover and employ criteria of identity which suspend application of those more conventionally found in the visual arts, perhaps, but that is no minor part of the thrill of coming to terms with the work of an artist of integrity and innovation. There will be differences between seeing Fulton's work on a wall and seeing it on the page. For example, even if matters are so arranged that the lettering produces retinal images of the same size in each case, the sense of the manner and tone in which that lettering occupies the ambient space of the viewer will differ: in the book, the letter shapes inhabit a proximate space, they are to hand, and there is a space, and further surfaces, beyond the book; the viewer keeps her or his distance from the work: whereas on the wall, it cannot be handled or angled, it marks a boundary of vision. Do these differences signify? Undoubtedly; willy-nilly.[4] But it cannot be the *scale* of the work which signifies greatly: given that the work also exists on the page, the size of the lettering on the wall is unlikely to be designed to dominate and put the person looking at it in her or his place, although it is more likely to be of such a size that the text has a palpable presence in that space. Size as such seems relatively unimportant, except that the question is raised whether the work need be of any size at all. Could the work be dematerialized, perhaps, simply committed to memory, and still retain the forces of its being the work that it is?

Surprisingly, perhaps, for all its apparent insistence on using a minimum of material and emphasizing a conceptual play in the work, ROCK FALL ECHO DUST is a tangible piece whose physical presence provides for part of the pleasure it affords. Four words, alternately red and black, of four letters each, the square of letters so formed being underscored precisely by a sentence in red. This shape has economy, clarity, directness. Indeed, it so straightforwardly draws attention to its lack of excess, the absence of anything superfluous or frivolous, that we cannot escape the inference that everything that is there is part and parcel of the work, each noticeable aspect of the work contributes to the sense it might have. (And that includes the downward stroke of the initial letter

of ROCK, with its shy intimation of a graceful serif: in that single softening of an implacable geometry is stressed both the separateness of the letters as individual entities and their being related to each other in this common space. From the first, it is as though the dialectic of the one and the many is acknowledged.[5])

As I reflect on this arrangement of letters and colours, thoughts and memories begin to dart and buzz around me, like gnats in the tundra. 'Red' and 'black': two of the three colours known and distinguished in all cultures, the other being what has been commonly called 'white'. This might suggest a concern with universals of human existence, an interest in the forms of experience available to human beings independently of the specific culture in which they happen to find themselves.[6] It also recalls for me the confident colours and sober layout characteristic of the title pages of books published earlier this century, their slightly extravagant formality somehow in keeping with the welcome they extended on the threshold of the text; it was, I suppose, indicative for me of the respect which the author's prose was to show the reader. On a more playful note: did you too, I wonder, have one of those squares which held fifteen lettered tiles (so ensuring a 'mobile' space) which, by skilful (or lucky) manipulation could be rearranged to yield words and phrases? Could these words have arisen just like that, from a chanced upon permutation of letters? Do they perhaps have no significance beyond that of the man in the moon? (Or beyond their ability to lead to the posing of that question?)

How am I to read the text these letters and words propose? Each word names. ROCK, a thing, substantial, a substance of places and worlds. FALL, an action, happening to an object, or to something which, since falling is happening to it, is at that time like an object; at other times it might be like a person, maybe.[7] ECHO, an event and an action, a sign that something else happened, preceding it. The echo suggests a structure of space, for it indicates the presence of an aural mirror, a reflector of sounds. ECHO and FALL intimate time as the duration of events and processes; on the other hand, ROCK evokes a sense of vaster geological time-scales, ancient beyond the human span. DUST: what kind of thing is 'dust'?[8] Something both continuous and discontinuous (a layer of dust is a sheet of discrete particles), taking the form of other things, the objects it coats and shrouds, its own fine-grained form invisible to the naked eye, yet resisting our every attempt to make it shape up into anything other than a mound or heap or ridge of dust. Dust is the end of us: rock, plant or person, we eventually amount to this. Dust may be rock scaled down,

but it is also a reliable sign, for where there is dust, it is dry.[9] Each word of Fulton's text seems to enunciate a distinct modality of natural existence and to respond to and qualify the sense of another.

I hinted above that the form of arrangement of the letters might lead us to see the letters as letters, the words as words and the relations between letters and words as pleasing but, at root, arbitrary, a matter of how things happened to fall out, not of how they had to be. This applies also to the relations between the words themselves. It is as though there was the hint of a progressive syntax immanent in the text, an undulation or ripple of sense that propagates downwards but not upwards.[10]

ROCK	ROCK	ROCK	ROCK
	FALL	FALL	FALL
		ECHO	ECHO
			DUST

Laid out like this, the text accumulates line by line to form a skeletal narrative, an account that begins with the set scene, next identifies a condition of change or upset, continues with a consequence of that event and concludes with the closure of the event, the dust that was created by the falling rock or kicked up by a punchy echo finally settling. Is that what happened on Baffin Island in the summer of 1988? I do not know.[11] The moments of this possible story conform to the schema William Labov noted for oral narratives,[12] but that may largely be a product of my awareness of a wide variety of models which have been proposed for understanding narrative and cannot be taken to amount to a confirmation that this magic square of letters does, indeed, generate a narrative. Rather, such background helps to explain what it is about this text which lures me to give it a narrative reading. It could describe events which Fulton beheld. It could have been like that.

My inability to settle on privileging one reading rather than another (shapes, letters, words, story) is sustained by attending to the colour relationships the work draws. At first glance, the colours work to impede and dislocate the attempt to place the words in narrative sequence. They do more, however, for by so dramatically inviting us to group one thing with another in virtue of common colour, they equally serve to dislodge the primacy or givenness of other relationships which we might have thought to govern and ground the logic of this piece. Whereas ROCK aligns as part of speech and conceptually with DUST, and similarly FALL with ECHO, the colouring of the text relates FALL to DUST and ROCK to ECHO.[13] And now, as ECHO echoes the abrupt, almost crashing,

consonant of ROCK, the text is present to me as sound: the rumbling initial ROCK, the lingering FALL, ECHO opening into unbounded spaces, the decisive termination of DUST.

Fulton has made another work – BIRD ROCK – related to the same walk on Baffin Island.[14] It shows an isolated boulder lying on a wide plain flanked by mountains or high hills to both sides: just the place for echoes. The rock clearly has significance there *in its place*: its upper surface is coated with bird shit, indicating something of the length of time it has been used as a perch. Of course, boulders and stones have an honoured place in human social life: as one example among many, on the pilgrimage along the Tóchar Phádraig to Croagh Patrick in Ireland, each stone is named and has its story. Fulton's work continues, in a sense, that reflex of respect which has marked a Romantic sensibility. But as this image vividly shows, the rock is a feature of the landscape not only for humans. For the local birds (and so, in one way or another, for all the local wildlife) this rock has a significance beyond the aesthetic or symbolic.

BIRD ROCK: ROCK FALL ECHO DUST. If ROCK is this rock, maybe FALL is that waterfall? The ECHO the echo of a bird's cry and the DUST the dust at the camp site? Is this text work, then, an inventory of significant experiences: isolated, separated one from the other, adjacent only through Fulton's walking on Baffin Island for twelve-and-a-half days and juxtaposed in this work as a consequence of his sensibilities and dispositions?

Wherever I seem to have a foothold in some certainty of reference and relation, I soon find myself stumbling on shifting and uncertain terrain.[15] Yet this apparent uncertainty induces not anxiety but calm. The uncertainty comes about from my desire to determine what something means when there is, simply, whatever there is. Fulton walked in that place; it is the kind of place where one can walk, and for days on end. Of that much we can be sure.

Calmly and intricately, the work offers a promise of meaning which further thought shows to be a frustrating feint. There is nothing given beyond the page before you. Or rather, nothing beyond the page *and what it leads to* – to thoughts such as these I have been laying out, which track some of the ideas and responses which arise from me from meditation upon the work as it is before me. There are verbal upshots, paradoxes and handy aphorisms that I and you can cull from this congenial exericise. 'The word is not the thing, nor is the concept.' 'Things are what they are, and they are not that thing.' 'To experience

one's presence in the world with vividness and accuracy depends on, yet must transcend, language.' Plainly, the haunting quality of this work for me may amount to little more than a registration of the scent of mystical conundrums: an imitation of the enigmatic character of the world as it is is carried over into art as the avoidance of representation through the indulgence of paradox. 'As beautification requires shadows, so clarification requires "vagueness" – Art makes the sight of life bearable by laying over it the veil of unclear thinking', was once Nietzsche's opinion.[16] But it would be a fatal mistake – decidedly fatal – to confuse a refusal to moisten the stuff of the world with meaning (our meaning, making it glisten glamorously with an excess of our desire) with melting in the embrace of the tender mercies of irrationality or courting some self-styled Postmodernist phantasmagoria of hesitancy, diversity, fragmentation and counter-finality.

The traditions of the Western landscape arts come to this: all art is in limitation of nature. An image of nature has, like Narcissus's reflection, the status of something possessed and yet not possessed, of something seeming to snare what remains always elusive. The Greek myth entwines the fate of Narcissus with that of Echo. Echo loved Narcissus, but shy of imposing herself, she was reluctant to be the first to speak. One aspect of Echo is un-self-centredness, a willingness to allow the events and conditions of the world to make their impression. An echo is of course a kind of image (which motivates the pairing of the stories of Echo and Narcissus), but it is an acoustic image of a preceding sound, testimony to the actuality of that which went before. The echo repeats a part of what went before, and its potency (and poignancy) derives surely both from its invitation to recall the complete utterance and compare one with the other (in which it acts as a *fragment*) and from its simultaneous declaration that this earlier utterance has passed. Each echo tells a passing breath, so to speak, as Echo pined not for herself but for another. Indeed, Echo pined for the Otherness of an other, an other without whom she was incomplete and unconstituted. Unusually for the arts, the poetics of Echo seem to me more apt to Hamish Fulton's work than are the allegories of Narcissus's reflection.

Fulton's text work does not describe or convey nature or the experience of nature; nor does it deny that the world, the natural world, may be experienced. Indeed, his aim can be said to be precisely to know nature without being committed to knowing what it means. But to clarify these remarks we must consider the bottom line of the work, the statement of the ground upon which the work stands: A TWELVE AND A HALF

DAY WALK ON BAFFIN ISLAND ARCTIC CANADA SUMMER 1988. Suppose that we had no further information about Fulton's artistic practices or his work in general than that displayed in this text piece: what, then, could we make of this statement?

It plainly has a distinctive formal status in the work: it is written in smaller letters, although they are capital letters as is the larger text, and the line of text extends to the exact width of the rows of letters above it (and, of course, vice versa). Its dissimilarity gives it the status of a label or caption identifying where and when the phenomena listed above were perceived; but why then be so precise about the duration of the walk? Doubtless, because the walk itself is a phenomenal experience of a similar kind to these others noted above, and just as duration is an intrinsic aspect of their being, so is it for the walk itself. The duration of the walk takes the measure of the landscape (how hospitable or inhospitable it is to a passing human being, for example) and offers a gauge of the time it takes for the artist to slough off the chatter and babble of mundane life in an industrial society and to become immersed in the 'natural world' to the extent that knowledge-of gives way to knowing-how.[17] In the work, everything derives from what cannot be shown and shared – walking and camping in close relationship to a specific patch of the natural world. The work is made back home, in the studio, from notes made in the landscape.[18] It is the role of the final line of the text work to denote the walk, to attest to the actuality of the ground and condition of the work. It asserts that Hamish Fulton was there, experienced this and that, just like it says; this much time spent in this particular place. Like a haiku, the work coils back on itself, disconcerting and eventually annulling any literal meaning we may try to wring from it. Contemplating such work, I am persuaded metaphorically to re-enact Fulton's relationship with the landscape, for I can enter into the dialectic of this art and yet must come away from it with nothing, acquiring only the promise of an access route not to his but to my world.

'Urban living has always tended to produce a sentimental view of nature. Nature is thought of as a garden, or as a view framed by a window, or as an arena of freedom. Peasants, sailors, nomads known better. Nature is energy and struggle. *It is what exists without any promise.*'[19] John Berger has advanced this view recently, and with characteristic vigour. But it is misleading. On the one hand, it underplays the degree to which human activity (as well as the activity of other living things) affects and shapes even the remotest nature, bringing it even more securely into the ambit of legibility according to our intents and

interests.[20] Nature is, as it were, informed by human concerns, and both evolutionary pressures and the unceasing development of specific forms of human social organization have conspired to ensure that for us the environment (in every sense) is neither wholly transparent and intelligible nor utterly alien and capricious. Whether we would wish it or not, we have a pact with the natural world which is expressed in terms of aptness, fitness, possibility and surety: in short, it is only natural to look to the promises it seems nature might keep. On the other hand, however, Berger is correct: nature exists without promise. But if it exists without promise, it must also exist without threat or struggle or without energy, at least in the sense of the macho vim with which Berger invests that term. To exist without promise is to exist without hope, is just to exist. To conceive of nature in such bare terms – as we must – is extraordinarily difficult, and it is what Fulton's work strives for. His is a rare art which avoids both an accommodation to prevailing ideologies and (and this amounts to the same thing) to protest. If there is an accommodation in his work, it is with the natural world, not with the whims of historical sociality.

Berger develops his argument in an interesting and important direction. Acknowledging that different cultures – including the motley of cultures that comprise the strata of class societies – will respond differently to 'the beautiful in nature' because of their differing economic and geographical situations, he, none the less, believes it to be incontrovertible that 'there seem to be certain constants which all cultures have found "beautiful": among them – certain flowers, trees, forms of rock, birds, animals, the moon, running water . . .' He explains this in terms of an evolutionary possibility:

The evolution of natural forms and the evolution of human perception have coincided to produce the phenomenon of a potential recognition: what *is* and what we can see (and by seeing also feel) sometimes meet at a point of affirmation. This point, this coincidence, is two-faced: what has been seen is recognised and affirmed and, at the same time, the seer is affirmed by what he sees. For a brief moment one finds oneself – without the pretensions of a creator – in the position of God in the first chapter of Genesis . . . And he saw that *it was* good. The aesthetic emotion before nature derives, I believe, from this double affirmation.[21]

Again, I quibble, for Berger has once more compromised his own insight in a formulation which retains the separation of personal consciousness and nature. The aesthetic element in this moment of affirmation does not come with a recognition that we are separate from nature, in the sense that it is somehow something set over against us with

our human interests, as something alien and Other. Nor does it draw upon an uncritical fantasy that we may somehow overcome our alienation from nature and return to the natural state without residue, becoming 'as water in water'.²² Rather, it affirms an acceptance of the natural world as it were beyond good and evil, for its purposes and on its terms, not ours.²³ Aesthetic emotions or apprehensions, in this point of view, derive not from historically conditioned pleasures in the sensuous or practical qualities of nature but from a realization that everything that is is in its place. The figure who emerges from this perspective is that of the witness who refused to testify to anything beyond her or his standing as a witness. This is what ROCK FALL ECHO DUST accomplishes, a refusal of hierarchies of value through an ethical gesture which stifles any notion of nihilism.

To claim, in Rilke's forlorn phrase, that we are 'no longer at home in the world' is to clench in the fist of one's words the endemic and recurrently lamented estrangement of modern life. The powerlessness and inconsequentiality experienced in our everyday lives are not merely the consequence of a nineteenth-century rhetoric of alienation but form the foundation for that wish-full thinking that finds expression in the insistent utopian yearnings of politics and art. Modern societies pursue and are pursued by a way of life driven by a frenetic greed and ecological recklessness which conspicuously elude our rational control. Some political philosophers reckon ours to be a fundamentally new situation, requiring an unprecedented re-evaluation of our political thought and action. John Dunn, for one, argues passionately that we must reorientate our social life around values of prudence, humility and debate.²⁴ If art and its criticism cannot help to realize these aspirations, then they are trivial and sorry things indeed.

My understanding of the demands and responsibilities of criticism has developed from three domains of thought and experience. Initially, there was my dissatisfaction, genuine but inarticulate, with what I gained from consulting the various commentaries on art which was of concern and interest to me. These seemed on the whole to distance me from the work in question, to marginalize or disqualify my own experience in favour of an esoteric compendium of information which implicated whole networks of allusions and references, influences and correspondences. Little of this bore on my experience of the particular work. It tended rather to insist that I keep my mouth (and mind and heart) shut until I had a greater knowledge (of a certain kind). I was unable to accept such prohibitions and claims as either binding or authoritative. If art

could not speak through the particular encounter but required an education, then it was of little account in the general cause of emancipation, happiness and wisdom. Any exegetical or critical approach which excluded where I stood in meeting the work, therefore, excluded itself from my serious consideration.

Then there was the thrill of discovering the music criticism (he would not have called it such) of Hans Keller. It is only recently that I have come to appreciate the strenuous and liberating humility of his insistence that the only understanding of music which is of value arises through the practice of music itself. (And he was concerned to show how each significant musical work could generate its own protocols of intelligibility and interpretation: these are not merely brought to bear from outside the work itself.) Sound criticism does not exist as an activity parallel to or parasitic upon music; instead, music constitutes its own most vital critical tradition and commentary. The realization of this has seemed to acquire the status of a compositional principle with some contemporary musicians (in the case of the so-called 'poly-stylism' of the Soviet composer Alfred Schnittke, for instance), but it has always been so. Keller took this on board by elaborating a method of critical analysis (dubbed 'functional analysis') which demanded that he compose the analyses of particular works.[25] His method of commentary can only address works in their particularity and not as examples of more general trends, movements, etc. The critic is, in effect, put in the position of drawing attention to those things the artist might have been expected to do, given the general competence of members of her or his specific artistic culture, thereby throwing into relief what actually occurred. So the story is told, as Nietzsche wished it might be, from the artist's point of view.

Of course, the extension of institutionalized forms of art education enabled the critics' discourse – addressing as it does the condition of the market in art and the establishment of reputations – to itself become part of the context within which the individual artist struggles to formulate, understand and explain her or his own work to her or himself. Hence, there comes to be a double hermeneutic[26] of art which installs the critical discourse at the very origin of the subject it seeks to comprehend, with the consequence that it is made itself into the very material of art, and its discriminations and distinctions become incitements to subversion and transgression. As a result of observations such as these, I conceived criticism to include among its aims that of leading readers and viewers to comprehend something of the grounds of the creative process in such a way that they could appreciate what might be involved in making some

particular work. This necessarily entails 'putting people in touch with' their own (potential for) creativity: criticism becomes kin to therapy.

Lastly, I had become intrigued by a remark of Theodor Adorno, who had argued that in so far as the work of art concerned itself with artistic problems and did not attempt to express a political or social message directly, then it would inevitably propose a social theory.[27] This stimulating paradox engenders specific questions of land art; for example, what aesthetic sense did it make to connect the interpretation of this art to the generally developing social consciousness of environmental issues? In my critical writing I have attempted to spell out and take up some of the key issues raised by this problematic. For me, critical activity tries to illuminate the conditions of possibility of the making and the interpretation of art. It thus cannot but interrogate the prevailing concepts and situation of art and art criticism.

I write acutely conscious of the tension that can exist between words and work and of the absolute requirement that there is no suspicion that I desire the work be reduced to words, overwhelmed and traduced by my writing. Respect for the work demands that my utterance makes and marks an opening onto the work and onto the audience with whom it is shared. 'To write,' writes Maurice Blanchot, 'is to be absolutely distrustful of writing, while entrusting oneself to it entirely.'[28] A critical discourse which recognizes this is vulnerable without being hesitant or shy and tries to find a way with words that produces 'a saying which is always in the necessity of unsaying itself'.[29] In all criticism there is a tension between the desire to be educative and the urge to annul the self.

Criticism has sometimes been considered as an activity which seeks to identify processes which provide for the ability to refer to some 'this' as an art work. This view is, however, inadequate as it stands, since it presupposes that criticism itself is already in place and the art object is merely something sedimented, objectified, crystallized. Another persuasion urges that we regard the art object to be autonomous, self-sufficient. Two possibilities follow from this.

In the first, the art object is believed to express itself completely; it has no compelling need for interpretation; indeed, interpretation and commentary now becomes a kind of imposition on or violation of the art work. In this case, to what can criticism aspire? Surely, criticism can be seen only as a kind of tactical diversion whose goal is to exhaust words, for it is precisely the surfeit of words (of a pre-pared consciousness) which clouds our apprehension of the art object as the object which it is: this is a view which clearly corresponds to some understandings of Zen

precept and practice. It is a tactic which recognizes that we are always already in history, that we approach nothing with direct immediacy, but rather have to be brought to a condition in which we are, so to speak, on the other side of history.

The other possibility is that the art object is obscure and criticism is necessary to *bring the work home to us*, to connect art with history. The self-subsistent thing, apparently indifferent to our presence, practically or conceptually, appears as more than alien to us. Yet we cannot prohibit talk about art any more than we can (or would wish to) compel to silence those who habitually whistle under their breath: it is inhuman to silence speech, and doubly inhuman for anyone to silence in the name of art speech about art.

Is there any difference between the point of view of the artist and of the spectator? If there is, it does not lie simply in the 'fact' that the artist *makes* art while the spectator *uses* art, for the artist too uses art. On the one hand, the artist responds to the work of others, as stimulus, as galvanizer of new ideas, original possibilities, as something to be avoided, to be distanced from (the demands of that marketplace version of integrity – reputation – mop and mow in the wings here). On the other, she or he is also nourished by the talk about art, by the critical discourse of motives, means and meanings. Likewise, there is one kind of art which, by its conspicuous excellence of technique (what a freight of convention, of value and hermeneutic, is conveyed by that word 'technique'), inhibits the creativity of the spectator; and another kind of art which empowers and enables the audience by disclosing possibilities for creative expression which were, unnoticed, always already within reach. Thus, the artist can by example – which, like all actions, ripples out far beyond the achievement of its originating intention – deliver that same emancipatory jolt which the critic can bring to articulate consciousness.

It seems to me that the critical enterprise must adopt specific tactics of expression and analysis if it is to contribute anything to the causes of freedom and responsibility. Critical discourse must not vie with the work, nor must it strive to say everything that can be said. Leaving something noticeably unsaid leaves something for the reader to say and provides an itching occasion for 'going on'. Indeed, the critic should ensure that her or his writing breaks the usual expectations, the taken-for-granted cultural domain of reference and allusion, that would be ordinarily and unreflectingly established for the text. An unusual but productive novelty inhibits the 'completion' and valorization of the existing elite critical culture and gives permission where it is needed for

the timid reader to take up the matter at issue with whatever is felt to be relevantly to hand. (Of course, this must be done without trashing the cultural capital of the elite, which may well inform the inception and fate of the work of art.) Above all, perhaps, criticism should encourage the audience for the writing and the work to attend to the work slowly, allowing time and opportunity for preconceptions and hasty judgements to themselves be articulated and judged in the light of the work. The more immediate a perception appears to be, the more mediated it turns out to be on reflection. This is as true of the apprehension of the work of art as it is of the apprehension of nature.

I have heard it said that Hamish Fulton's work is not about landscape but rather about *clarity of mind*. There is truth in this. Fulton's work eschews any attempt to represent the land and instead represents (in that political sense of being charged with standing in the place of something or someone absent) the impossibility of representation of the experience of the landscape. And that insistence is the only way in which there can be the sort of truth-to-experience which is not content to delight narcissistically in an image of land but foregrounds land itself, as, indeed, the ground of the experience of land – of nature, generally, perhaps.

Three senses emerge in which it can be properly said that Fulton's art is a landscape art. Firstly, the landscape is itself the *condition* for that clarity of mind. Plainly, the exercise of walking and (if occasion demands and allows) camping in the landscape is a critical means of promoting and giving access to that clarity, but this is simply to confirm that experience and the specific tenors of consciousness are ringed by nature. Secondly, Fulton *values* that which is clearly seen; the landscape is revealed as the subject of an ethical relationship, a relationship which precedes all rational deliberation. I am reminded in this respect of the heroic philosophy of Levinas, who argues that we each have an ethical responsibility towards an Other, a responsibility which precedes and preforms any concrete activity on our part.[30] Landscape, in its guise of wilderness or nature, is such an intractable and obstinate Other. If I am to know the landscape, I must acknowledge from the outset that it will not be on my terms.

Finally, Fulton wants to be making *art*. That aspiration cannot be entertained, let alone realized, unless the aspirant is embedded with the discourses and practices of art, and to make art from the experience of landscape is inevitably to make an art which invokes its being taken up within a tradition of landscape art.

Some commentators have found Fulton's work 'cool'. Certainly, there

is a striking sense of self-effacement, of ego-less-ness, in the work, yet –
whether pieces are considered individually or all together – the work
clearly bears his 'signature'. It is *not* objective (in that curious sense of
existing independently of the specific consciousness of the individual who
brings it into being), yet neither is it *subjective*, primarily dependent on
the idiosyncrasies and whims of the individual constitution. Instead, it
reacquaints us with a ground of experience which *precedes* that dis-
tinction. Here we confront neither desire for the object (the 'landscape')
nor for the audience nor for the self (the much-vaunted 'ego'). Nor for the
work, which is notable not simply for its teeming invention and
inexhaustible precision but also for its scrupulous concern with the
material in hand: a page is given as much weight as a wall. This art makes
no concessions to narcissism. It is not so much cool as refreshing.

Here, for now, and with so much unsaid, my writing suspends itself.
There will be other occasions to elaborate and refine, question and refute,
what has been said and attempted. The last words (they could as well
have been the first) on this occasion are those of Hans Keller:

Fundamentally, the issue is as complex and as simple as that of *The Critique of
Pure Reason*: remove self-preoccupation and the only questions that remain are,
first, whom and/or what do I harm or hurt and, secondly, can it be shown to be
worth it? They are questions which, in their simplicity, go far beyond the
problem of criticism: they embrace the whole of active life of which criticism, all
criticism, is, in this respect, a focus.[31]

From World to Earth: Richard Deacon and the End of Nature

MICHAEL NEWMAN

If Richard Deacon's sculptures of the first half of the 1980s appear as humanist and, indeed, anthropocentric – their concern with organic form and an empathetic relation between object and viewer going somewhat against the grain of the 'appropriationist' paradigm of much Postmodernist art – I will argue in this essay that his work in the late 1980s may be understood as a move away from this residual anthropocentrism towards a post-humanism which is also a remembering, an anamnesis (un-forgetting), of the prehuman. Both phases, which, I shall suggest, are brought together in an important sculpture of 1989 entitled *Kiss and Tell*, have an ethical dimension: the first concerns the otherness of the other person metaphorically and negatively articulated in the withdrawal of the work from full perceptual and conceptual appropriation,[1] and the second, where the role of the metaphoric is diminished, articulates an ethic of the earth, that which pre-exists and supports the possibility of a human world. This is to imply a large claim: that in Deacon's work we see the traces of a post-Romantic understanding of 'nature' arising in the context of the danger of what has been called 'the end of nature'. To support this claim, it is necessary to recover the moment of negativity in work which appears affirmative and owes its market success at least in part to this appearance. If the moment of negativity in sculptures of the first phase is that of world-alienation, as the stimulus to the recovery of wholeness, of the identification of the ego with the object or non-ego, in an empathetic projection into organic form, that of the second phase departs from this idealist paradigm by an increased emphasis on what was already present, as a movement of withdrawal, in the first – the obdurate resistance to appropriation in order, paradoxically, to produce that which precedes the possibility of production. This can occur only as a trace, a memory of that which precedes the possibility of memory. It is as if what is mute is to be given voice to sing not a celebration or Orphic hymn but a lament.

I

Things.

When I say that word (do you hear?), there is a silence; the silence which surrounds things. All movement subsides and becomes contour, and out of past and future time something permanent is formed: space, the great calm of objects which know no urge.[2]

The piece of sculpture was a thing standing apart as the picture was apart, the easel-picture, but unlike the latter it did not even need a wall. Nor even a roof. It was something which could exist for its own sake alone, and it was well to give it absolutely the character of an object round which one could pass and which could be observed from all sides. And yet it must in some way be distinguishable from other things, ordinary things, which anyone may lay hold of. It must be made, by some means, untouchable, sacrosanct, separated from the influence of accident or time, in the midst of which it appears solitary and strange, like the face of some visionary. It must have its own assured place, uninflected by arbitrary considerations, and it must be made part of the calm permanence of space and its great laws. It must be fitted into the surrounding air as into a niche and thus be given security, a stability due to its simple existence and not to its significance.[3]

William Tucker opened his book *The Language of Sculpture*[4] with the second of these quotations, which is from the first part of Rilke's book on Rodin (1903);[5] the first quotation is from the second part (1907). Four of the chapters of Tucker's book were published as articles in *Studio International* in 1970, and others in 1972. The articles and the book grew out of a series of lectures which Tucker gave at St Martins School of Art in London, where Richard Deacon was a student from 1969 to 1972.

After a further period of study at the Royal College (1974–7), Deacon spent the year 1978–9 in the USA with his wife, the potter and artist Jacqui Poncelet, who had been awarded a Bicentennial Fellowship. He took with him a copy of Rilke's *Sonnets to Orpheus*. While in the United States, Deacon made a small group of ceramic pots, which have not so far been exhibited. One of them tapers from a broad shoulder down to a pointed 'base' and consequently has to be laid on its side. The exigencies of travel precluded making large sculptures, so Deacon made a series of drawings which he titled, after the fifth of Rilke's sonnets, *It's Orpheus When There's Singing*. He was concerned in these drawings to generate forms which signified – they were not to be abstract – but would not be read either as mimetic representations or as subjective expression. He developed a procedure which would create signifying forms somewhat independently of any preceding intention – so that he might be surprised himself at what emerged – but a procedure which would not, on the other

hand, be automatist in the Surrealist sense. Sticks of oil pastel and graphite were attached to string and used to generate curves. Figures in the drawings were brought out by partially erasing subsidiary curves, which none the less played a part in the emergence of the figures, since intersections of curves were frequently used as the centre for another curve. The effect of a palimpsest thus created gives a sense of the temporality of the disclosure of the figure.

These drawings should in no sense be taken as illustrations of Rilke's poems but rather as attempts to respond analogically to the conception of the object that the poems express. Deacon's response to Rilke was in part stimulated by Tucker's use of the Rodin book as a clue to a way of understanding the peculiar status of the modern sculpture as 'art-object (*Kunstding*)'. The meaning of Rilke for Deacon was mediated not only through Tucker but also through Heidegger, whom Deacon had been reading throughout the 1970s: in particular *Introduction to Metaphysics*, parts of *Being and Time* and, above all, the collection *Poetry, Language, Thought*[6] which contains the essay on Rilke, 'What Are Poets For?', as well as 'The Origin of the Work of Art', 'Building, Dwelling, Thinking' and 'The Thing' (in the latter essay, which has as its leitmotif the description of a jug, Heidegger asks 'What would a jug be that did not stand?' (p. 169) – a stimulus, perhaps, for the above-mentioned pot Deacon made). Taken together, Heidegger's essays amount to a meditation on what we could call, adapting Michael Fried, 'thing-hood',[7] in its relation to Being: Heidegger takes ontology, the being of the thing, rather than epistemology, how we know the object, as fundamental. Tucker's use of Rilke prepared the way for Deacon to find the link between Heidegger's thought and a possibility for his own practice – specifically for a way of understanding the relation between language and thing, which only fully emerged as a theme of his work in 1981.

In one of a series of articles published in *Studio International* between 1974 and 1975 Tucker wrote:

it is the central task of sculpture now *to represent space* . . . in the literal sense of *re-presenting* a particular spatial experience, using *present* space, with its given, known qualities as the medium . . . The represented space of the sculpture is thus both an interpretation of space in general, and simultaneously *space as an instrument of feeling*.[8]

This re-presentation of space has to do with the 'central paradox' of sculpture: 'that it is at once a thing in the world, with us, an object among objects – and yet privileged, set apart, withdrawn'. The autonomy of the sculpture is a condition, for Tucker, of its reflexive disclosure within

experience, as subject to gravity and revealed by light. What Tucker does not indicate here is that the 'present space' which is to be the medium for the experience of nearness and distance created by the illusory or metaphorical space invoked by the sculpture is not itself a timeless *a priori* but historically instituted. It is Heidegger who points out that the mathematization of space as a neutral continuum poses a threat to the 'place' of human dwelling. Such dwelling, according to Heidegger, can only occur within the horizon of finitude. Only within such a horizon can there be experiences of nearness and distance.[9]

The overcoming of this mathematization of space and its resultant loss of the experience of distance and nearness, which depends on the finite horizon of a world, is the topic of the essay in *Poetry, Language, Thought* simply entitled 'The Thing' (based on a lecture of 1950). Modern travel and the flow of information have resulted in the shrinking of distances in time and space (p. 165). 'The peak of this abolition of every possibility of remoteness is reached by television, which will soon pervade and dominate the whole machinery of communication . . . Yet the frantic abolition of all distances brings no nearness; for nearness does not consist in shortness of distance.' How can we come to know the nature of nearness? It cannot be encountered directly, but we can attend to what is near. Things are near to us. 'But what is a thing?', Heidegger asks (p. 166), and he goes on to consider the following example:

The jug is a thing. What is the jug? We say: a vessel, something of the kind that holds something else within it. The jug's holding is done by its base and sides. This container can again be held by the handle. As a vessel the jug is something self-sustained, something that stands on its own. This standing on its own characterizes the jug as something that is self-supporting or independent. (p. 166)

We can place the jug before us or represent it to ourselves in memory. But its thingly character does not consist in its being a represented object, in the 'over-againstness' of the object for a subject. Rather, it stands on its own as self-supporting. It stands alone as a vessel because it has been 'brought to a stand', in that it has been produced. It is no longer the 'object of a mere act of representation' but the result of a practice, a process of making which has set it up 'before and against us'. But we are still treating the apartness of the thing, its self-subsistence, as derivative, if not of representation in the Kantian sense at least of making. For Heidegger this means that the thing is still determined metaphysically, in relation to the subject, as formed matter. So Heidegger tries another approach: this time to the essence, the 'what-ness' of the thing. As a jug it is a vessel. The jug is not a vessel because it was made, but rather it was

made because it is this 'holding vessel': the idea or *eidos* of the vessel precedes its making. We have reached Plato but really have got no further in thinking the thing in its self-subsistence. Heidegger tells us that 'In the full nature of what stands forth, a twofold standing prevails' (p. 168). Firstly, that of stemming from somewhere, in the sense of having been made or being self-made. Secondly, 'standing forth has the sense of the made thing's standing forth into the unconcealedness of what is already present'. What Heidegger means by this is that the thing takes its place in a world, within a horizon, in which the process of presenc*ing* can occur.

The interplay between thing and horizon is mutual. Heidegger argues that science always encounters 'only what *its* kind of representation has admitted beforehand as an object possible for science' (p. 170). Science's knowledge, which is compelling in its own sphere, has 'annihilated things as things'. The essence of the thing as thing is that it creates its own standard of nearness and distance. The jug does this by pouring and withholding: this is the way it, in itself, calls to be understood rather than as shaped matter around an abstract void. 'To pour from the jug is to give . . . the jug's jug-character consists in the poured gift of the pouring out. Even the empty jug retains its nature by virtue of the poured gift . . .' (p. 172). 'Gift' is a privileged word in Heidegger. What is given is the jug itself: *es gibt*, it is there, and as such – as the event of its presencing – it is the gift of Being. Being is not, for Heidegger, some*thing* – that would be to model Being on beings (as in theology which understood God as a being) – but that which withdraws or conceals itself in the event of something coming into presence. The jug, with its holding and pouring, serves Heidegger as a metaphor for the gathering of the *logos* which, as poetic word, is the 'gift' of Being. The jug, in its self-subsistance, institutes the finite horizon within which things are disclosed *as* the things they are.

A jug-shape forms part of the first of Deacon's *Art for Other People* series, made in 1981 and at that time subtitled *The Singer*. It does not 'stand forth' on its own, since it is only half of the sculpture. The jug is of roughly hewn stone, rounded at the bottom and with the suggestion of a handle. From that side, the side of the 'handle', it resembles somewhat an inverted head. This sculpture was subtitled *The Singer*,[10] an allusion to Orpheus, whose head and lyre, after he had been dismembered by the Maenads, floated down the river Hebros, still singing and playing, enchanting wild beasts and inducing the trees and rocks to move from their places to follow the sound. 'Gesang ist Dasein', 'song is being', Rilke wrote in the third of the *Sonnets to Orpheus*. The pouring gift of the jug,

Richard Deacon, *Art for Other People No. 1*, 1982, stone and leather,
23 cm × 76.2 cm × 23 cm. Private Collection.

as thematized by Heidegger, is intimated by the other part of the
sculpture, the ribbed greenish-black leather sleeve, held open to the jug
by a wire loop, so that the jug appears about to pour its contents into the
mouth of the sleeve. This relation can be thought of as reversed. 'The first
work', Deacon said of this series in 1984, 'is in two parts, a jug and a
sleeve. The open sleeve is as much receiving as offering, and the jug is
either emptying or filling.'[11]

There are two aspects of this work which are quite alien to Heidegger.
The first is the sexual connotation of the two parts, intimating a
dependency of each on the other which contrasts with the self-subsistent
neutrality of Heidegger's jug. The second is revealed in the rest of
Deacon's statement:

The work that began the series was quite close in intention to the H.M.V. record
label [R.C.A. in USA], the dog and the record player. In that image it isn't quite
clear whether the dog is listening or whether he is actually speaking, barking into
the loudspeaker horn. It could be either since the horn is an amplifying and a
listening instrument.

The dog, of course, is traditionally a symbol of sexual licence. Shapes or contours suggesting abstracted male and female genitalia and other body parts, often in combination with forms which connote musical instruments, proliferate in Deacon's sculpture up to around the mid-1980s. Sexual fetishism is an aspect of his work, although not in an unreflective way: by 1983–4 he was making sculptures which thematized the problem of the penetrating and appropriating male gaze.[12]

It is also of interest here that Deacon refers to a slightly archaic image of technology. I would suggest that there is an analogy with the processes of making, or 'fabrication'[13] as he prefers to call them, which he employed in his sculpture from 1980: riveting, laminating or gluing and sewing to name the principal techniques. Rather than being the traditional sculptural methods, they are the techniques of workshop production – repetitive, but still involving the hand in the manipulation of a tool or material, by contrast with the now dominant automated production of the factory. (The jug of *The Singer* is the exception which proves the rule.) If the sculptures 'stand forth' as the gathering of a world, they also stress the other aspect of 'standing forth', their being made things. And they do so in a particular way that refers to repetitive, semi-skilled, alienated labour. In addition, the materials employed in the sculptures, rather than being 'raw' (e.g. clay, plaster), are already formed: sheet and corrugated steel, pre-cut strips of wood, leather, cloth and patterned linoleum. These are ways of incorporating negativity into the affirmative experience of aesthetic autonomy. Rilke and Heidegger's 'thing', the thing in its independence which is disclosed by the poetic word in saying and song, is pulled back into the problematic of modernism, whence the conception of the thing as autonomous or self-subsistent derives as an affirmative compensation for the alienation – or loss – of a substantive public world. Rather than being simply affirmative 'poetic objects', Deacon's sculptures incorporate an element of negativity into their very experience – into aesthetic experience. They are, in an important sense, about loss: the loss of 'world' in Deacon's work up to the late 1980s and the loss of 'earth', or nature, thereafter. But it would also be wrong to see the sculptures as purely negative or reactive: they are also instituting creations. The sculptures occupy an existing world – even if, for example in the museum, it is a 'worldless' world – while by their own evidence, in the phenomenological sense, they institute something different.

In an interview of 1982 Deacon said of the *Art for Other People* series that 'in part the reason why the sculptures I have been making recently all tip and roll has to do with that notion of wanting them to be ordinary like

everyday objects'.[14] This contact with the ground by means of a curved surface, to be found also in a number of the larger works, gives the impression that the sculpture is in the space but not quite of it. This contrasts with the homology of the rectilinear Minimalist object with the architecture of the gallery and suggests the independence of the sculpture from the space (which, in the modernist gallery, is 'a-topic' or placeless) but without returning to the framing device of the pedestal. Thus Deacon's sculptures are enabled both to assert their autonomy and, at the same time, to establish relationships with the way in which ordinary, everyday objects are encountered in the world (there is a tension involved in this dual role which is crucial to the meaning of the work, and to which I shall return). The initial intention was that the sculptures of the *Art for Other People* series would inhabit domestic environments, both resembling and being distinct from other objects in such situations, in the world but not quite of it. These works modestly take their place in an already existing world – they seem more effective in the private milieu of the home than in the public sphere of the gallery – yet at the same time they suggest other imaginative possibilities.

II

The problem I want to go on to consider – and here it becomes crucial to think what aesthetic autonomy means – is the kind of claim which the instituting creation of the work of art makes. Is it a truth claim? Or is the work of art as autonomous, as aesthetic, denied the possibility of making truth claims? Or does it make a truth claim about this very denial? This may be elucidated by a more detailed examination of the sculptures. I will focus on the two moments of the emergence of a distinctive sculptural language: first in some works of the early 1980s, and in the next section of this essay on those of the close of the decade. Two sculptures of 1980 and one from 1981 can be seen, in retrospect, as having established Deacon's distinctive language and its associated set of concerns.

One of the two untitled sculptures of 1980 which marked a breakthrough for Deacon is a large cone-shape made from steel sheet which is riveted and screwed together. The apertures at each end cut into the cone at an angle, both facing toward the same side. Both these apertures have a steel 'lip'. The one at the smaller end of the cone is parallel to the plane of the 'cut', and concrete is used to smooth the gradation toward the inside. The lip at the larger end twists from facing outwards at the extreme end, where it is attached by strips of steel to the inside of the

aperture, and inwards at the end more towards the centre of the sculpture, where it is attached to the outside. About half way along the aperture, this 'lip' changes from being as if opened out from the inside to suggest a direction inwards from the outside.

Clearly, what is at issue in the perceptual experience of this structure is the relation between inside and outside. The visual access to the inside, the penetrability of the sculpture, changes as the viewer circumambulates the sculpture: from one side access is completely blocked by the curved surface. As the viewer walks around the smaller end of the cone, an oblong aperture appears which gives some visual access to a dark interior but does not really invite the physical self-projection to the inside, which is the case as the larger aperture opens out. We could say that there is a disjunction between space and distance: imaginative projection overrides spatial location, running from the extremes of total exclusion to the invitation of the viewer's desire to be enclosed.

Despite this aspect of invitation, there is something rather uncomfortable about the work which prevents one from feeling too much at home with it. The material surface, though inflected by the mottled finish of the steel, is cold. The large curved lip has a sharp edge. And the process of production is mechanical and repetitive, rather than involving the immediacy and variations of touch. It might not be going too far to say that, while on the one hand bodily self-projection is invited, on the other it is alienated. Something similar could be said of the imagistic aspect of the work: on the one hand, intimations of the body and, on the other, these are abstracted and emerge from a mechanical form, like the hull of a ship or aircraft.

Deacon's sculpture incorporates aspects of the Minimal 'specific object': identity of surface and structure, *Gestalt* wholeness rather than compositional part-to-part relations and seriality – one thing after another – which appears in Deacon's work in the process of production rather than in the repetition of elements. While Minimalism posed a challenge to the traditional distinction of sculpture as a genre, it did so purely on the level of phenomenological experience, of perceptual consciousness, so its potential for critique remained limited and was only subsequently developed by Conceptual art which focused on context, institution and language.[15] Minimalism incorporated negation into the affirmative experience of autonomous art by making the object anti-empathetic – through rectilinearity, factory finish and a unity of accretion rather than composition. Aesthetic experience is reconstituted as alienated experience.[16] The problem with this approach lay in the possibility

of inversion: alienated experience can be rendered aesthetic (as has been demonstrated in the Neo-Minimalism of the late 1980s), thus affirming alienation rather than negating the 'affirmative culture' of autonomous art. The homogeneity of the Minimalist object leaves no alternative.

Deacon's work marks a return from 'specific object'[17] to sculpture, which had in any case occurred in the assimilation of Minimalism into the modernist tradition. He returns to sculpture, however, in a way which incorporates contradiction into the experience of the work. William Tucker had provided a suggestion of how this might be achieved in his work *Tunnel* (1972–5), which was shown in 1975 in the exhibition he curated, 'The Condition of Sculpture' at the Hayward Gallery. While preserving the coextensiveness of surface and structure from Judd's work, Tucker reintroduced representation into the actual spatial experience of the work – a disjunction between geometrical and represented space, and a consequent shift from the technological to the metaphorical. One effect of this was to break the homology of the rectilinear Minimalist sculpture and the 'white cube' of the modernist gallery[18] – *Tunnel* is a curved enclosure within a rectilinear space – but without returning sculpture to the autonomy of the pedestal. The reintroduction of the curve mitigates the absolute alienation of Minimalism, its hard, inhuman geometry, production-line repetitiveness and factory finish, allowing bodily identification and a re-establishment of links with the sculptural tradition of figuration. Deacon, however, preserves enough of the 'alienation effect' of Minimalism to prevent his work being in any simple way either affirmatively traditionalist or autonomous, while distancing himself from Minimalism's systematizing, anti-humanist implications. It would not be going too far, I think, to suggest that Deacon's work involves a retrieval of a certain vitalist aesthetic, while at the same time bearing witness – through the process of production and its formal involution – to aesthetic alienation.

This vitalist aesthetic, deriving from German Idealism and Romanticism, enters Deacon's work through his attempt to find a sculptural analogy to Rilke's poetry, particularly the *Sonnets to Orpheus*, in the drawings of 1979, *It's Orpheus When There's Singing*. The relation to drawing, and to the poetic image, is clear in another untitled work of 1980 made from laminated wood. Not only is it more open in form as a 'drawing in space'; it also has the effect of opening. It is somewhat like a flower, and the tear-shape at the back could be read as the abstracted form of a female sex. The invitation of the organic shape to *Einfühlung*, feeling of oneness or empathy,[19] is more obvious than in the other

Richard Deacon, *Untitled*, 1980, laminated wood with rivets.
Saatchi Collection, London.

untitled sculpture of 1980, while it similarly involves repetition, both formally and in the evident process of production of gluing.

While Deacon was interested in the relation between language and process or object – from the point of view primarily of description – since his student days,[20] the first work, apart from the Orpheus drawings, to employ language in the title as an integral element in the work – as poetic disclosure – is the sculpture of 1981 entitled *If the Shoe Fits*. Here the corrugated and sheet steel structure has connotations of clothing, perhaps a slipper, a musical instrument and a dwelling. This much is evident even without knowing the title. What work does the title do? It alludes both to the adoption of a social role or mask and to the fairy tale of Cinderella – the prince will marry whomsoever the glass slipper fits. The fragility and delicacy of such a slipper is belied by the toughness of the steel – more shanty town Old Mother Hubbard than potential prince's bride. Moreover, the implication of comfort, of being at home, is undercut by the multiplicity – beyond any structural necessity – of sharp-pointed screws pointing up and outwards through the steel sheet which forms the upper surface. The homeliness of the title is contradicted by the material and the somewhat threatening, even aggressive and at the very least uncomfortable screws and sharp edges. The sculpture invites, and at

Richard Deacon, *If the Shoe Fits*, 1981, galvanized, corrugated and sheet steel,
305 cm × 152 cm × 152 cm. Saatchi Collection, London.

the same time resists, both the narrative familiarity prompted by the title
and aesthetic appropriation for simply pleasurable consumption. It is
unheimlich – familiar and unfamiliar, homely and unhomely.

<div align="center">III</div>

We are now in a position to appreciate the distinctiveness of Deacon's
approach to sculpture in the early 1980s. The notion of sculpture implicit
in these works is mediated first through Minimalism and then through
poetry. Minimalism, as theorized by Judd in 'Specific Objects' – in the
notion of 'three-dimensional work' which was 'neither painting nor
sculpture' – freed the three-dimensional object from its identity as
sculpture.[21] We could say that not only was the Minimal object 'neither
painting nor sculpture'; neither was it sculpture nor ready-made, as well
as being, in a certain sense, both. Minimalism problematized autonomy –
not least by denying its consolations – without attempting to do away
with it or transgress it. If anything, the dependence of art on autonomy

was foregrounded by works like Andre's brick *Equivalents* (1966), which simply would not appear as art outside the gallery. Duchamp had demonstrated that the concept of the art work was paradigmatic rather than essentialist and, thus, intrinsically historical, changeable and determinate. Judd applied the lesson in the attempt to formulate a new object-type which required both a new practice and an accompanying theorization – new objects along with a new concept of an object – although this historicality was at the same time negated through the legitimation of Minimalist practice, by Judd and others, by means of a concept of experience as a timeless *a priori*[22] – hence the subsequent development of Land Art towards reference to structures built by prehistoric or 'native' cultures, such as stone circles and the Nazca lines.[23] It is notable that both Judd, and later Tucker, consider the Duchampian ready-made in terms of aesthetic experience rather than as a challenge to the institution of aesthetic autonomy.[24] None the less, autonomy was shown by Minimalism to be determinate through the introduction of the alienated and alienating factory mode of production into the autonomous sphere of aesthetic consolation.

While a student at the Royal College during 1974–7,[25] Deacon attended philosophy courses at University College London, including seminars on aesthetics by Richard Wollheim in 1975 and on Kant's *Critique of Pure Reason* during 1975–6, when he also read Strawson's book *The Bounds of Sense*[26] and Gilbert Ryle's *The Concept of Mind*. For an artist to study philosophy was not unusual in the mid-1970s in the context of Conceptual Art (although Deacon's interests, and the influence of Tucker and Yehuda Safran, drew him to the German phenomenological and hermeneutic tradition). Through his study of the mediating role of categories in our knowledge of the world in Kant, Deacon was well placed to understand the implications of Judd's practice and writing as having formulated a distinctive concept of an (art) object. Deacon's writings while at the Royal College show two interests which came to inform his sculpture: in the process and psychology of perception; and in language which was then a particular concern of British Conceptual Art. While at that time other artists, such as the Art & Language group, typically borrowed their vocabulary from the analytical philosophy of language and logic, however, Deacon's interests tended toward poetry, metaphor and the world-disclosive possibilities of language.

Before drawing on Heidegger, Deacon came to explore this theme as a response to the problem posed by Wittgenstein's notes on the ambiguous 'duck-rabbit' figure in *Philosophical Investigations*, which is taken up by

Wollheim in the discussion of 'seeing-as'.[27] The problem posed for Wittgenstein by the ambiguous figure is how to account for the change in the figure: on the side of the subject (perception) or of the object (the thing itself changes). Wittgenstein goes on to draw an analogy between 'seeing an aspect' and 'experiencing the meaning of a word'.[28] According to Wittgenstein's later philosophy, a language is a form of life, and to live in a language is to learn to behave in certain ways – to use sentences with the intention of having them understood and thereby achieving certain ends, e.g. getting someone to do what you want them to do. But what, we may ask, would be the case if one wished to create a language or to encounter a new language of which no one yet knows the rules? That is just the situation of modern art, in which the works which are valued most highly are those which institute a new rule or otherwise present a new concept of an (art) object. The paradox of modern art is that once the 'rule' or language game is learnable, it no longer functions as an act of instituting, of free autonomous creation, and consequently needs to be superseded. This is precisely the paradox of the confirmation of the work of genius by succession in Kant's *Critique of Aesthetic Judgment*, where the instituting work is confirmed *as* instituting by a successor which breaks the rules that the predecessor had established, keeping alive, as it were, the very possibility of free creation which the predecessor exemplifies.[29]

In modernist art the '*as*', the horizon which is to disclose the work as the thing that it is, has itself to be instituted.[30] This is a burden which, as Kant realized, can never be borne by the single work in itself – there has to be some way, supplementary to the work itself, of distinguishing it from 'original nonsense', of confirming it as a work which matters 'for us'.[31] Works made in series since Monet can be understood as an attempt to resolve this problem internally on the side of production – establishing the rules internally to the series, while at the same time keeping them open through variation. The problem of the 'as' is raised in Deacon's unpublished Royal College essays, where he makes the distinction, drawing on Wollheim, between 'looking for' and 'looking at', concluding in his essay 'Observations on a Painting by Poussin' that 'pure "looking at" remains a possibility only conceivable within and against the illustrative mode'.[32]

This point is exactly parallel to that which Heidegger makes in *Being and Time*: that the 'presence at hand' of an object for a contemplative subject is a derivative – and not, as the metaphysical tradition would have it, foundational – mode of engagement with the world. 'Presence at hand'

derives from a defective instance of 'readiness to hand', or the practical engagement of the *Dasein* (being-there: the being 'thrown' into an already given world which at the same time involves a projecting of possibilities into the future) with the implements and objects of its world; this is the force of the famous example of the hammer, which is only apprehended as a thing, 'present' to the contemplative gaze, when, broken, it no longer functions, or is no longer 'ready to hand'.[33]

Where does art fit into Heidegger's schema? If art is in Wittgensteinian terms a 'form of life' or 'language game', it is a mode of 'readiness to hand'. Would this provide an adequate theorization of modernist art? If we followed this line, we would need to understand autonomous modernist art either in terms of its social function, in which case the work of art would tend to reproduce and thus affirm the pre-existing 'language game' in which it functioned, or else as a 'defective' mode, in which case, as an affirmative, autonomous presentation of the non-functional, it would reflect on the defectiveness of the world of the 'ready to hand', of technology and means – end functionalism.

Whereas for Heidegger in *Being and Time*, 'presence at hand' is a defective mode of 'readiness to hand' – which is to say that the particular 'world' into which the *Dasein* is 'thrown' is prior to the universality of theory, an inversion of the metaphysical hierarchy – we might want to say that the autonomous presence insisted on by modernist art is an indication of a defect in the pragmatic world. Put in the terms of Frankfurt School critical theory, the defect in the already existing world would be its domination by instrumental reason where everything is merely a means to an end, which in turn becomes a means, and which cannot generate a substantive good or value as an irreducible end. Art becomes an end in itself because of the lack of substantive ends, or forms of life understood as valuable in themselves, in the social public sphere. Art as an end in itself is a response to an intolerable 'form of life' or 'language game', the 'presence at hand' of the autonomous work of art is a negation of the instrumentality of the 'ready to hand' which is understood as inherently defective. However, as art becomes autonomous, the affirmative presence of the particular and the unique is driven into a sphere where it cannot make a truth claim, where the force of its instituting is limited in so far as the work is taken as 'aesthetic'.

Heidegger's 'turn' after *Being and Time* was prompted, at least in part, by his realization of what 'world' had become, which he named the *Gestell* (perhaps best translated as 'set-up') of technology, where 'nature' and human beings themselves become a resource for total domination.[34]

The 'world' into which a human being had been 'thrown' could, as such a *Gestell*, only be overcome in a new foundation. Heidegger turns to art as a model of foundation. If art is to be understood in such a way, it must first be freed from the subjectivist categories of aesthetics: if we only encounter our subjective projection of form, we can never transcend what we ourselves already are and the governing categories of the instrumental world-view; and if art is understood as autonomously external to the practical world, or as an island within it, art would not make a substantive and effective foundational claim. So in 'The Origin of the Work of Art' Heidegger takes the 'great art' of the Greek temple, considered as a model for substantive foundation, as the gathering of a community and projection of its world which also preceded the beginning of the tradition of Western metaphysics.

There is a deep problem with Heidegger's account, however, which is indicated by the way in which he goes on to discuss van Gogh's painting of the *Old Shoes* as if it were not a painting at least in part about the fate of painting, a modernist work, but a revelation, rather, of the thingly character of the thing, and ultimately of the nature of truth.[35] Heidegger's concern in both cases is with the work of art as the foundation of the horizon of a world wherein each entity becomes what it is. This amounts to a regression behind the already instituted, inauthentic world of *Being and Time* to the instituting of 'world' in the first place. In Wittgensteinian terms, this approach focuses on the 'as' in 'seeing-as'. If the instituting of the horizon wherein entities become what they are is to be a *new* instituting, an innovation, it cannot derive solely from an already existing world, not even as a negation of it, since this would mean that the possibility of the new world would already be contained *in nuce* in the old and so would not be really new – not a creation. Hence, there must be something other than 'world' which is involved in the instituting. This is why the 'ready to hand' world can no longer be taken as foundational.

This 'other' Heidegger names 'earth'. Truth – the institution of the 'as' structure, the horizon for the disclosure of entities – prior to correspondence happens in and as the 'strife' of world and earth. Earth cannot be objectified; it is always opaque to and withdraws from objectification – but is a necessary condition of possibility for objectification to take place – for the place of objectification to be inaugurated. This is somewhat like the role of the idea of nature in Kant's *Critique of Aesthetic Judgment*, which 'gives the rule to genius' yet is itself, as a whole, opaque to the categorical determination of the understanding. Heidegger's conception of truth as a 'sending' or 'giving' by Being does have deeply problematic

consequences for both rationality and moral responsibility and, argu-ably, renders historical process resistant to rational inquiry. But it is, none the less, an attempt to find an answer to an important question, which is also raised by Kant in the third *Critique* and by modern art generally: how can we elucidate the conditions for innovation as substantive foundation in a way which is not an anthropocentric repetition of mastery over the particular – its determination by the concept, the universal, the will? 'Earth' indicates an extra-human, pre-worldly and unappropriatable yet immanent co-principle of foundation. That the essay concludes with the fragment of a poem by Hölderlin indicates the path Heidegger's thought will take: the principle of 'earth' in the foundational origin of the work of art – that which enabled the 'great art' of the Greek temple to be an origin – will be absorbed into poetic language where 'Being and Saying' belong together: language gives the names which determine the as-structure. The work of art, for Heidegger, is not simply historical, in the sense of determined or enclosed by history as the work's 'context', but the very foundation of historicity as such: 'Whenever art happens – that is, whenever there is a beginning – a thrust enters history, history either begins or starts over again.' And: 'Art is history in the essential sense that it grounds history.' Because, 'Art lets truth originate'. (*Poetry, Language, Thought*, p. 77)

This claim might plausibly apply to the Greek temple but not to the van Gogh painting, made in an epoch in which art practice is socially marginalized.[36] Can aesthetic autonomy be overcome in this affirmative way by a regression to an emphatic conception of art before aesthetics? Or does this move remain voluntarist despite any purported critique of the will? The historical determinations of the autonomy of the aesthetic cannot – and I follow Adorno in this – be overcome either philosophi-cally (which is one reason why Heidegger's writing ceases to be conceptual philosophy and becomes a form of poetic utterance) or 'internally' by the art work itself.[37]

What Deacon takes over from Heidegger, and a reading of Rilke informed by Heidegger, is the conception of disclosure and the role of language in it. What he adds – this is foreign to Heidegger – is a negating moment in the disclosure. For art to make a claim about truth – as it does for Heidegger – it would have to cease to be autonomous modernist art, which is what Heidegger suggests in his discussion of the *Old Shoes* in 'The Origin of the Work of Art'. The point of the sentimental and quite inappropriate evocation of the peasant woman trudging in the fields is to give the painting the role of reflexively disclosing a world and thus letting

truth happen as disclosedness or unconcealedness through the establish-
ment of a horizon. What Heidegger neglects to consider are the
conditions which prevent this truth claim from having an extra-aesthetic
force – from being a *truth* claim rather than one of beauty or subjective
expression. Van Gogh's practice was indeed foundational, but in a way
which was compelled by history to remain 'internal' to modernist
painting rather than as the historical founding of the collective world of a
people, like the Greek temple.

If Deacon's sculpture makes a truth claim which concerns, as in
Heidegger, the prior disclosure of a world in which (derivative) claims
concerning truth as correspondence (representation) can occur, in so far
as this claim is made from within autonomous art, it can only be made
negatively. We cannot see the sculptures as if they were not art (which is
why it is appropriate to call them 'sculptures' rather than 'three-
dimensional work' or 'Greek temples') because it is not up to them
whether they are art or not. The non-aesthetic is incorporated by Deacon
into the work of art as that which makes it a *work*: as the process of
fabrication applied to pre-formed, manufactured materials. That which
makes it a work of *art*, however, prevents the truth claim, which I want to
say that it makes, from reaching its destination as a claim of *truth* rather
than as a socially marginalized aesthetic experience. The internal con-
tradiction arises because that which makes the sculpture a work is the
same as that which prevents its claim being the general one of truth: the
world of social labour, to which the manufactured materials and
repetitive fabrication process which constitute the work allude, negates it
as the instituting creation of the possibility of truth in so far as it remains
confined to the specialized sphere of the aesthetic. By incorporating this
process the work makes a truth claim about its own negation, the denial
of its foundational possibility by the very history of alienation which the
work seeks to overcome in its instituting historicity. And at the same time
the work negates, as a unique work of art, the repetitive process and the
repetition of social reproduction which constitutes it.

While Deacon drew on Heidegger, whom he read alongside Rilke, for a
strong account of the disclosive possibilities of art, the internal con-
tradiction which gives his work from 1980 its tension is distinct from
Heidegger's overtly affirmative and lyrical later writing and derives
rather from the incorporation of alienation into autonomous aesthetic
experience by the Minimalist 'specific object'. Around 1986–7 a change
began to occur in Deacon's work, which developed a possibility in the
earlier work but in a somewhat different direction. It could be conceived

in Heideggerian terms as a shift of emphasis from world to earth or, in terms of their negativity, from world-alienation to earth-alienation.

IV

We never thought that we had wrecked nature. Deep down, we never really thought we could: it was too big and too old; its forces – the wind, the rain, the sun – were too strong, too elemental.

Bill McKibbern, *The End of Nature*

In January 1990 a book devised by Deacon was published in Oslo on the occasion of his exhibition at the Kunstnernes Hus, Oslo, Norway. Its title *ATLAS: Gondwanaland and Laurasia*, refers to the two land masses which divided to form the five continents. In the first half of the book, 'Gondwanaland', drawings of empty boundaries face photographs of land and waterscapes, each framed with a black border. In the second half, 'and Laurasia', drawings, most of which mark mass and shape within contours, face colour Xeroxes of photographs of surfaces which fill the whole page. In the first part, we observe and define at a distance; in the second part, the horizon disappears as we are brought close to what we see. Each group of drawings can be seen as dealing with one of two aspects of the series of wall-relief sculptures *Like the Back of My Hand* (1986–7): boundary and incident. The book is prefaced with a letter, written during the year in which that series began, in which Deacon writes of his intention to make a book called *Gondwanaland* and describes his fascination with the paleogeographical concept of the primal land masses, 'a deduction, an extrapolation backwards from the facts, from the evidence in the here and now'. He finds the notion that the earth 'could be a *different* place . . . both fantastic and compelling.' He goes on to remember a map he had drawn in his childhood:

As a boy, always aware both of the possibility of imminent cataclysmic disaster and of the desire to leave, I used to keep ready to hand under the bed a small case. Amongst the things it contained – false documents, money, food, whistle, knife, string, etc. – was a map. It was a map I had drawn. The map had no relation to where I was; self-evidently I knew where I was but would be going somewhere else, to a place I did not know. In such a place a map is useful. The map as I remember had a shape – as if it were the map of an island – with a few geographical features. Shape is the outside edge, boundary, extremity, limit. It is other. By contrast a street plan for example has no shape separate from the sheet on which it is printed. There is an implied continuity between the map and the place in which one stands. Somehow, therefore, in order for my map to represent

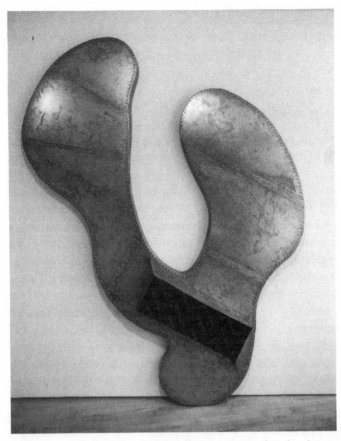

Richard Deacon, *Like the Back of My Hand No. 6*, 1987, phosphor bronze sheet,
sponge and cloth, 260 cm × 160 cm × 30 cm. Saatchi Collection, London.

another place in the intended sense, there was a necessity for it to have a shape or
boundary. The contour of the interior, however, is always more difficult.

The wall reliefs of the series *Like the Back of My Hand* have a shape – a
curvilinear boundary, somewhat reminiscent of the forms of biomorphic
Surrealism – which gives the effect of an island seen from above. Within
the boundary there is contour, elevation and incident created through the
incorporation of found fabrics, leather and other materials, including
wave-patterned foam rubber framed in a projecting 'box' in *No. 6*
(1987). Often there is a contrast between the curvilinear boundary and
contours and the rectilinear geometry according to which these materials
are inset, rather like a road or airport runway in a landscape as seen from
above. As is the case in the freestanding sculptures, what is at issue is the

way in which we, as viewers, may – or may not – inhabit the work. There is a play of nearness and distance, of the remote and the tactile, of familiar and unfamiliar, of pattern and plan. The two aspects which are separated in the book are combined in the reliefs. The sculpture confronts the viewer, evoking the desire for presence, yet it also withdraws into the distance, becomes a picture rather than a thing. The distinction which is implied, and to which I will return, is between a territory which we view from outside and above, from an ideal or meta-physical perspective (a plan), and a terrain which we might inhabit and within which we orient ourselves in terms of its internal details and markers.

Like the Back of My Hand introduced a new principle of form into Deacon's sculpture, which was realized, in effect, simply by moving the relief away from the wall: that of the disjunction between a two-dimensional plane and a three-dimensional mass. In *Turning a Blind Eye Again* (1988) a plane – a sheet of steel – bisects the two halves of the sculpture. *Skirt* (1989) is a good example: the semi-circular shape made from repeated units of sheet steel, which billows out like the skirt of a hovercraft, is not the plan of the section; the shape is built off the plan, exceeding it. Stopping the curve at the section makes the form appear incomplete, as if related to an invisible wall. In *Distance No Object II* (1989), a copper-surfaced ear-shaped ring of fibreglass is attached to the 'back' of a structure reminiscent of the reliefs which mirror the same contour in shiny, hard-edged steel. The new organizational principles evident in these works are disjunction, doubling and incompleteness. This contrasts with the predominance of 'fulfilled' shapes in the earlier work, where pleasure is frequently obtained in the completion of a curving movement (which becomes increasingly introverted and 'knot-ted' in the second half of the 1980s), even if full, emphatic satisfaction is restrained by the austerity and connotations of materials and process. The effect is to create a disjunction between the plane and the three-dimensional form. What is the meaning of this disjunction? One way to interpret it is to suggest that the plane serves as an analogue to the plan, which anticipates the projection of the predicted from the already known, while the three-dimensional form adds a degree of contingency unpredictable from the plan. In effect, the synthesis of form and material achieved through the process of fabrication in the earlier work is taken apart.

Certain works suggest that a shift is also occurring in the process of making: *Three Works* (1989) imply a compression in the bounded yellow foam rubber and convey the effect of geological formations. The dry

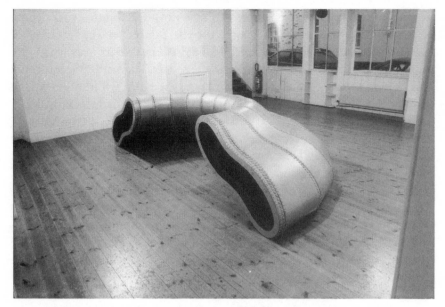

Richard Deacon, *Skirt*, 1989, galvanized steel, 79 cm × 354 cm × 183 cm.
Marian Goodman Gallery, New York, and Lisson Gallery, London.

elegance and transparency of the early work has been replaced by a
certain obdurate lumpiness, as in *Seal* (1989), where two similar grey
plastic-covered oblongs are joined together with aluminium strips. I
would not wish to generalize this too far: *Mammoth* (1989) combines
features of both phases – metal fabrication with asymmetries which make
the perceptual experience unpredictable – as do other works of the
period. But such a work highlights the changes visible elsewhere: in
process, from light-industrial, artisanal fabrication to layering and
accretion which have quasi-natural, geological connotations (e.g. of
sedimentation and layering of strata[38]), and in form, from wholeness to
disjunction and conjunction, and from curvilinear geometries which
were structurally transparent, whether in terms of surface or line, to pod
and lump-like exteriors. This last feature is present in *Cover* (1990), the
rippled, projecting or 'pointing' contour of which is based on one of the
drawings from the 'Laurasia' section of *Atlas*. Square panels of copper
beaten out from inside are attached to a hidden frame, their joins forming
a rectilinear grid which contrasts the irregular and asymmetrical contour.
The contact of the object with the floor is mediated by a copper lip which
goes round the base like a thin roll, preventing the effect of the shape
coming up from underneath the ground; the overall effect is like a cup

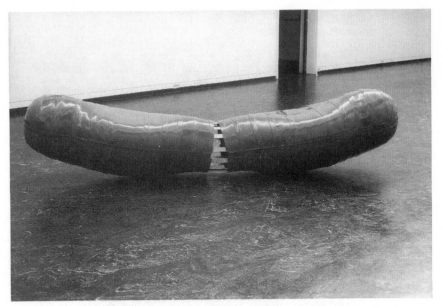

Richard Deacon, *Seal*, 1989, welded PVC and aluminium
74 cm × 240 cm × 84 cm. Private Collection, London.

turned upside down, where, as the title implies, there might be something concealed underneath. This serves to emphasize the impression of stubborn exteriority, where the bloated shape contrasts with the crisp contour and clean relation with the ground. Three of the works shown in New York in April 1990 had titles which are both verbs and nouns: *Cover, Skirt* and *Coat* (transparent, welded PVC, 1990).[39] These titles suggest a combination of thing and activity, which in their brevity contrast with the earlier use of colloquial phrases as titles, but may be related to Heidegger's conception of 'the thing' discussed above. A number of the sculptures of this period seem to suggest a quasi-natural process of becoming, congealing or accreting into form in a way distinct from the viewer's projective, form-giving or inferring activity; the difference is signalled in the disjunction of three-dimensional object and plane/plan in the later works.

Kiss and Tell (1989, p. xiv) may now be appreciated as a key work which recalls the themes and procedures of the earlier body of work, while developing those of the new. The title, a colloquial saying which may indicate a metaphorical dimension to the object, recalls the titles of the mid-1980s. The combination of a 'telescope' form with an 'ear'-shape attached to the side continues the themes of hearing and looking, and

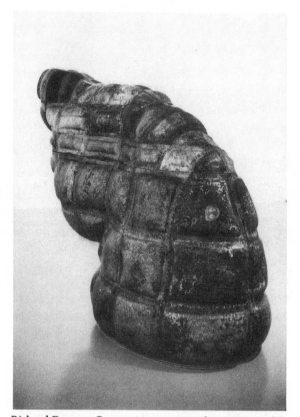

Richard Deacon, *Cover*, 1990, copper, aluminium, m.d.f.,
185 cm × 335 cm × 120 cm. Marian Goodman Gallery, New York.

nearness and distance, from the earlier work – the ear suggests the
soundbox of a musical instrument, recalling the 'Orphic' trope. And the
laminate used to produce the hollow 'telescope' together with the
stapling of thin wood squares of the 'ear', which is a form of the
'stitching' of one thing to another (which gives the effect of a cladding,
unlike the copper panels of *Cover*), are related to the earlier processes of
fabrication. However, *Kiss and Tell* also incorporates the distinct
structural features and concerns of the body of work developing toward
the end of the decade. The 'telescope'-shape is made from thick, rigid
disks of wood, suggesting accretion rather than the tensile dynamic of the
earlier curved laminate forms. Rather than being open, involving the
transition between interior and exterior, and inviting the self-projection
of the viewer to the interior, the 'ear' of *Kiss and Tell* is obdurately closed,
more like a pod, a skin over a hollow but inaccessible interior –

suggestive, to refer to the title, of secrecy. And although the two parts are reminiscent of the two parts of *Art for Other People No. 1 (The Singer)*, the yoking together of the disparate shapes, the 'ear'/'pod' projecting from the side of the 'telescope' by means of a metal link, tends to emphasize their disjunction.

The changes in form and material production parallel a change in the relationship of the object to the viewer from the works which precede the series *Like the Back of My Hand*. The most obvious formal shift is from open to closed volumes and from lucid structuration to a more obdurate, stubborn and polymorphous shape achieved through the joining of plates (*Struck Dumb*) or the layering of material (*Seal*). Like much of the earlier work, however, these shapes are still hollow: the difference is that whereas the earlier sculptures characteristically invited the perceptual self-projection of the viewer to the inside, these objects resist entry. This may be seen as the result of an increased emphasis on a feature which was already present in the earlier work, where this 'otherness', resulting from the aspect of sheer materiality, served as a counterweight to the tendency of the viewer to appropriate the work through the empathetic projection of self into the structure and the incorporation of the structure as a 'mental' idea. The materiality resists perceptual appropriation while the structure allows and, indeed, invites it. This appropriation is possible in so far as the work is habitable as a way of being in and seeing the world. As habitable, the sculpture takes on a mediating role between viewer and world, as if the accustomed categories with which perception is synthe-sized were replaced by new and different ones. In poetic metaphor the category becomes a name which discloses rather than subsumes the world and unites rather than divides viewer and object: hence the governing metaphor for the experience of the sculpture in Deacon's work of the early 1980s is the Orphic 'song' whereby the perceiving subject and thing resonate together.

In the sculpture from the late 1980s the object exists alongside the viewer rather than being a habitable and mediating structure. The effect is more impersonal, as if the sculpture were almost indifferent to the existence of the perceiver (which may be the result of Deacon's increasing construction of large-scale works where production is delegated to fabricators, a move from artisanal hand-work production to engineering, just as the disjunction between plan and shape may follow from the resultant reliance on working diagrams). Furthermore, the closed, lumpy shapes are less identifiable with parts of the body than was the case with the characteristic forms of the earlier sculptures, tending to imply,

rather, a whole body in themselves and a body which, rather than being human or from the human world of instruments, is vegetal or geological.

How are we to draw together these developments in Deacon's work and interpret them?

It is possible, I think, to understand the change as being from the human-centred (whether rational geometry or organic, empathetic life) to the non- or pre-human, from production, identification, metaphoricity and language to formation and deformation. This is different from the *anti*-humanism of some art practice (including Minimalism) and theory (Althusserian and Lacanian) of the 1960s and 1970s, which could be understood as a sceptical obverse to the late Romanticism of Abstract Expressionism and Existentialism respectively. Rather, Deacon's 1989–90 work is concerned with the conditions of possibility for there to be a humanism or anti-humanism at all. What is at stake for us today is the very possibility of what Heidegger in 'The Origin of the Work of Art' called 'earth' and Kant and the Romantics 'nature'. We may anticipate the devastation of the earth by ecological disaster, as we once did by nuclear devastation, but in terms of our sense of place – of our place *within* it – it has already been devastated.

Hannah Arendt writes in her book *The Human Condition*, published in 1958:

As a matter of fact, the discovery of the earth, the mapping of her lands and the charting of her waters, took many centuries and has only now begun to come to an end. Only now has man taken full possession of his mortal dwelling place and gathered the infinite horizons, which were temptingly and forbiddingly open to all previous ages, into a globe whose majestic outlines and detailed surface he knows as he knows the lines in the palm of his hand. Precisely when the immensity of available space on earth was discovered, the famous shrinkage of the globe began, until eventually in our world (which, though the result of the modern age, is by no means identical with the modern age's world) each man is as much an inhabitant of the earth as he is an inhabitant of his country. Men now live in an earth-wide continuous whole where even the notion of distance, still inherent in the most perfect unbroken contiguity of parts, has yielded before the onslaught of speed. Speed has conquered space; and through this conquering process finds its limit at the unconquerable boundary of the simultaneous presence of one body at two difference places, it has made distance meaningless, for no significant part of a human life – years, months, or even weeks – is any longer necessary to reach any point on the earth.[40]

'World' – as the world which tradition bestows – is lost in the Cartesian withdrawal into subjectivity, destroyed by the violent doubt invoked by the 'evil demon'. In the return from the subjective Archimedian point of

the 'I think', 'world' is transformed into the knowable mathematics of spatial extension, into raw material to be exploited. (This is why Heidegger seeks to retrieve 'world' through a critique of Cartesian subjectivity.) Arendt distinguishes 'world alienation' from the transformation which she associates with the event of Galileo's invention of the telescope:

... the astounding human capacity to think in terms of the universe while remaining on the earth, and the perhaps even more astounding human ability to use cosmic laws as guiding principles for terrestrial action. . . . In the experiment man realized his newly won freedom from the shackles of earth-bound experience; instead of observing natural phenomena as they were given to him, he placed nature under the conditions of his own mind, that is, under conditions won from a universal, astrophysical viewpoint, a cosmic standpoint outside nature itself.[41]

Whereas 'world alienation', according to Arendt, involves subjecting the phenomenal world to the Platonic idealization of geometry, which remains analogically related to it, in 'earth alienation' geometry – which still implies a world, albeit an ideal one – is subjected to algebra, to the primacy of process, opening the way to the Newtonian unification of astronomy and physics into a single science, Einstein's relativity theory, and the current project of the unification of the physical and the life sciences. Bill McKibbern has drawn attention to the consequence of 'earth alienation': that, within the space of a lifetime, 'we are at the end of nature'.[42] We tend to believe that nature 'takes for ever. It moves with infinite slowness through the many periods of its history whose names we can dimly recall from school – the Devonian, the Triassic, the Cretatious, the Pleistocene . . . the message is: Nothing happens quickly. Change takes unimaginable – 'geological' – time. But '[t]his idea about time is essentially mistaken.'[43] With the 'greenhouse effect' of the release of carbon dioxide and methane into the upper atmosphere, which traps the infra-red rays of the sun and which has been caused by human activities (the burning of fossil fuels, intensive farming, the burning of the rain forests), nature, through climatic change, is being drastically altered on a global scale.

'Earth', now in the process of *total* transformation through climatic change as a by-product of human activity, is no longer other to 'world', perhaps as a result of that very conflictual relation of 'strife' which Heidegger evokes in 'The Origin of the Work of Art', and as a consequence, the meaning of indeterminacy, of instituting creation in art has changed. Not even the dispensations of Being sent in the poetic word

can save us. While the poetic word discloses 'world', language, as utterance, itself rests on a pre-significative ground – of heat and cold, of plate tectonics, sedimentation and erosion, of the flows of winds and oceans, of germination and decay – which has a history which begins before 'our' history, and may continue beyond it.[44] As we have seen, Deacon's sculpture *Kiss and Tell*, as well as combining the techniques, draws together the themes of the two bodies of his work: firstly, the relation between seeing, which distances and separates things from each other and the human being from things, fixing contours, and hearing, where 'inside' and 'outside' are indistinguishable, which unifies and, secondly, the stratified rings of the 'telescope', a specular technology which is contrasted by the geological or biological process of formation suggested by the tactile oozings of red-brown glue. The 'ear' is closed as if deaf to the viewer. If poetry and song recall the beginning, the instauration of 'world', the miraculous possibility of signification out of the abyss of indeterminacy, then Deacon's turn, in works which can less and less be thought of as poetic or metaphorical or even as 'his' works and which intimate not so much the social negation of fulfilment and happiness as the negation of humanity as such, is to a memory of the beginning before the beginning. The necessity of Deacon's turn from the earlier anthropomorphic aesthetic is linked to the relation between anthropocentrism and the *hubris* of technology, but it does not involve a return to an anti-industrial Romanticism. Rather, the sculptures made since the late 1980s continue to imply an acknowledgement of human finitude and, in addition, the way in which the possibility of being human remains dependent on the processes of nature which are at once obdurately and magnificently other and yet precarious, vulnerable to a domination which threatens to recoil on humanity itself. If these sculptures make a claim on us, it is one in which both truth and the ethical are entwined: our obligation to the earth.

References

Introduction

1 Norman Bryson, ed., *Calligram – Essays in New Art History from France* (Cambridge, 1988), p. xv.
2 Richard Wollheim, *Painting as an Art* (London, 1987), p. 9.

1 *Marcelin Pleynet, Art and Literature:* Robert Motherwell's '*Riverrun*'

1 See Marcelin Pleynet, trans. Mary Ann Caws, *Robert Motherwell* (Paris, 1989), pp. 19ff. The quotations by Motherwell used in this essay can mainly be found in this source.

2 *Wystan Curnow, The Shining Cuckoo*

1 The Auckland City Art Gallery declined an invitation to purchase this work. A market for art in New Zealand barely existed at this time. In 1970, at the age of 51, McCahon took a brave step in committing himself to painting full-time. He had previously worked as a curator at the Auckland City Art Gallery and as a teacher of painting at the Elam School of Fine Art also in Auckland.
2 This is, for example, the third essay devoted to *The Shining Cuckoo*. The others are: John Caselberg, 'Colin McCahon's Panels, *The Song of the Shining Cuckoo*', *Islands*, 18 (1977); Sarah Knox, 'Paint by Numbers: the Mediation of McCahon', in *NowSeeHear*, eds, Ian Wedde and Gregory Burke, Victoria University Press, 1990. See also, Gordon Brown, *Colin McCahon, Artist*, Reed, 1984. A more global view of McCahon is taken by: Bernice Murphy, 'Colin McCahon, Resistant Regionalist or International Modernist?', *Art and Australia*, 27 (Spring 1989); Tony Green, 'McCahon and the Modern', in *Gates and Journeys*, exh. cat., Auckland City Art Gallery, 1989; Stuart Morgan, 'A Leap of Faith', *Artforum* (October 1986); and Wystan Curnow, 'Thinking About Colin McCahon and Barnett Newman', *Art New Zealand*, 8 (1977–8).
3 Paul Brach, 'John Walker's Multivalent Monolith', *Art in America* (Summer 1983). See also Caroline Collier, 'Romancing the Shape, Progress to Oceania', *Studio International*, 1008 (1985).
4 'It is certainly important for me to *believe* that one can produce a major statement . . . from a culturally isolated geographical location like Australia or New Zealand. And to me McCahon provides a superior role model to any of his Australian peers'; from 'Imants Tillers in Wellington', *Art New Zealand*, 55 (1989), 55. 'Australian visual art has produced no comparable artist in the twentieth century . . .', Bernice Murphy,

'Colin McCahon'. 'Do younger artists see McCahon as a validation of changing priorities as they distance themselves from the art of the 80s?' from 'The 80s. From Leantime to Dreamtime', *Tension* (January 1990), 80.

5 Imants Tillers, 'In Perpetual Mourning', *ZG/Art & Text*, (Summer 1984).

6 McCahon's 1990 ICA show was prompted in part by the Tillers/McCahons in Tillers's exhibition there two years before.

7 'Imants Tillers in Wellington', p. 54.

8 Ibid.

9 'The Life-Motif – interview with Imants Tillers by Jennifer Slayter', in *Imants Tillers*, ICA (London), 1988, and 'Imants Tillers in Wellington', 52.

10 Thomas McEvilley, 'The Case of Julian Schnabel', in *Julian Schnabel, Paintings 1975– 1987*, exh. cat., Whitechapel Gallery, 1987, p. 19. Schnabel has recently taken an interest in McCahon's work; works like *Ignatius of Loyola and Pope Pius IX* (1987) suggest grounds for 'dialogue'. McEvilley discusses Schnabel's growing use of Christian iconography and, more recently, of text, in the 1980s. In light of the fact that McCahon used both from the 1950s on, the following remarks are worth noting: 'Modernist art for at least a generation has lacked overt Christian imagery. Around mid-century there was a general assumption . . . that this subject matter could not be painted anymore.' (p. 18) And, in connection with Tillers's use of these features of McCahon, also these remarks: 'Christian iconography has not yet been reduced by Post-Modern quotational parody; it is in a sense still too hot to handle in that way. In Schnabel's work Christian imagery . . . seems to appear not with ironic distance so much as with a sense of personal continuity.' More instances of border effects?

11 *The Shining Cuckoo*'s immediate neighbours in Tillers's *oeuvre* include a tile version of Sigmar Polke's painting (on a blanket), *Carl André in Delft* (1969) which endorses the German artist's parody, as well as *Metal Rug* (1987), which by contrast identifies his own practice with that of the American artist. André, according to Tillers, led him to adopt canvasboards as the material support for his paintings. These vitreous enamel tiles were all 'spin-offs' from his work on a commission for a ceiling for the Australian Federation Pavilion, a Bicentennial project. The colour spectrum, which appears on the ceiling, derives from the first panel of Arakawa's four-panel work, *Topological Bathing or Blank Lines* (1979–81).

12 Concerning the C and D series, McCahon wrote that they were 'bits of a place I love, painted in memory of a friend who now – in spirit – has walked this same beach'; catalogue note to the exhibition, Peter McLeavey Gallery, November 1973. The friend referred to was James K. Baxter, an accomplished poet and radical Catholic who established New Zealand's best known commune at Jerusalem on the banks of the Wanganui River. He died of a heart attack in October 1972; in the months prior to his painting these series McCahon had been designing stage sets for memorial productions of four of the poet's plays. The deaths in May 1973 of another poet and early supporter, Charles Brasch, and in August of his own mother meant that death must have been close to his thoughts at the time. See Brown, *Colin McCahon, Artist*, p. 179.

13 Yve-Alain Bois, 'Painting: The Task of Mourning', in *Endgame, Reference and Simulation in Recent Painting and Sculpture*, ICA (Boston), 1986, p. 5.

14 Max Kozloff, 'Painting and Anti-Painting: A Family Quarrel', *Artforum* (September 1975).

15 Colin McCahon, in *Colin McCahon, A Survey*, exh. cat., Auckland City Art Gallery, 1972, p. 28.

16 Ibid., p. 38.

17 Jean-François Lyotard, 'The Sublime and the Avant-Garde', *Artforum*, April 1984. This sentence and the quoted material in the remainder of the paragraph are from the same source.

18 See Lawrence Alloway, 'Residual Sign Systems in Abstract Expressionism', *Artforum*, (November 1973), 38.

19 'Imants Tillers in Wellington', p. 53.

20 Mark Rosenthal, *Anselm Kiefer*, exh. cat., Philadelphia Museum of Art and The Art Institute of Chicago, 1987, p. 32.

21 Jacques Derrida, 'The Parergon' (trans. Craig Owens), *October*, 9 (1979), 24.

22 See Laurence Simmons, 'The Enunciation of the Annunciation', in *NowSeeHear*, eds, Ian Wedde and Gregory Burke, Victoria University Press, 1990, pp. 179ff for a discussion of the parergon in relation to some earlier McCahon paintings.

23 Clement Greenberg, 'Modernist Painting', in *The New Art*, ed. Gregory Battcock, Dutton, 1973, p. 68. See also Stephen Melville, 'On Modernism', in his *Philosophy Beside Itself*, University of Minnesota Press, 1986, pp. 3–33, and David Carroll, *Paraesthetics*, London, 1987, pp. 134–54.

24 See Tillers's *The Shining Cuckoo*; its 240 tiles are numbered 13563 to 13803, each being, like each of the canvasboards which make up a Tillers painting, a numbered 'page' in what he calls his *Book of Power*. As to Kiefer, who has made books since 1969, he says, 'they are my first choice'. Rosenthal shows that the breakthrough in his painting resulted from the application of the 'mixed media' approach of his artist's books to the canvas. The role of the book is a clear indication of the conceptual roots of both painters' work.

25 The 'page' as a division in a work occurs also in McCahon's *Is There Anything . . .* (1982), where a vertical dotted line divides one area of text from another. A similar line bisects *The Lark's Song*, where it also represents the ascent of the lark and cuts through the text. This work was painted on two doors which were then hinged together or 'bound'.

26 Newman's *Stations of the Cross* (1958–66) and Rothko's Chapel canvases (1966–8) are relevant to a discussion of *The Shining Cuckoo*, not just for their use of the Christian text but also for what is made of the cut of the page. Newman's work has been installed in the circular tower gallery of the National Gallery in Washington, Rothko's in the hexagonal Chapel in Houston – at one stage Rothko had thought of numbering the locations of the fourteen canvases on the exterior of the building. These arrangements resist the narrative progression the works, nevertheless, invite and indicate the mixed feeling both artists had about using the effect of a literary medium.

27 McCahon's numbering here is playful. The 1 is painted on the selvage line, perhaps because it is itself like a line; the 2 is aligned immediately to the right of the selvage; there is no number 3, and 4 occupies the same position as 2, except the corner has been painted grey, as is the equivalent corner of the fifth canvas with the 5 painted over it. The right-hand corner is all sunshine but so over-coded we barely know what to do with it.

28 From a note included in the exhibition.

29 *Colin McCahon, A Survey*, p. 36.

30 There are published translations by Hotere and McCahon in *Islands*, 18 (1977), pp. 402–3. I would like to thank Jeny Curnow for her assistance with the Maori text, and my colleagues Tony Green and Jonathan Lamb for their comments on other parts of this essay.

31 This suggestion is from Ron Brownson who proposes also that we may think of the 'sectioning' as 'an analogue to the actual sound of the pipiwharauroa, with its sense of being both close and far away from the call which is made from the bird at *rest*.' (letter to the author, 3–9–90).

3 Stephen Bann and William Allen, Jannis Kounellis and the Question of High Art

1 Quoted in Stephen Bann, *The True Vine: On Visual Representation and the Western Tradition* (New York, 1989), p. 244.
2 Cf. Erwin Panofsky, *Meaning in the Visual Arts* (Harmondsworth, 1970), p. 66.
3 Illustrated in *Artstudio*, No. 13 (Summer 1989), p. 87.
4 Cf. Svetlana Alpers, *The Art of Describing* (London, 1983), p. 236.
5 The symbolism of Klein's impressive *Triptych* of 1960 (Louisiana Museum, Denmark) appears, however, to have been more specific. Of the three canvases hung together, the left-hand one is painted red, representing the Holy Spirit, the right-hand one blue, representing the Son; the central panel, covered in gold leaf, with burnt areas, is identified with God the Father.
6 Cf. Hubert Damisch, ' "Equals Infinity" ', *20th Century Studies*, No. 15/16 (December 1976), p. 67.
7 Cf. Hubert Damisch, *Théorie du nuage* (Paris, 1972), pp. 263–4.
8 Cf. Marcelin Pleynet, *Giotto* (Paris, 1985), p. 88.
9 Cf. Julia Kristeva, in Norman Bryson, ed., *Calligram* (New York, 1988), p. 37.
10 Thomas McEvilley, in *Jannis Kounellis* catalogue, Museum of Contemporary Art, Chicago (1987), p. 101.
11 *Jannis Kounellis*, exhibition catalogue, Whitechapel Gallery (London, 1981), pp. 81–2.
12 Ibid., p. 85.
13 Jacqueline Burckhardt, ed., *Ein Gesprach – Una discussione* (Zurich, 1986), pp. 54–7. I have used the English translation of these relevant extracts published in *Galeries Magazine* in 1989; a French translation of the whole discussion is also available: *Batissons une cathédrale – Entretien* (Paris, 1986).
14 Cf. Bann, *The True Vine*, p. 198–201.
15 *Apollinaire on Art*, ed. Leroy C. Breunig (New York, 1972), p. 279.
16 Cf. Harold Rosenberg, *The Anxious Object* (Chicago, 1982), p. 103.
17 Cf. Julia Kristeva, *Histoires d'amour* (Paris, 1983), pp. 101–17.
18 Julia Kristeva, 'Jackson Pollock's Milky Way: 1912–1956', *Journal of Philosophy and the Visual Arts*, 1989, p. 39.
19 McEvilley, in *Jannis Kounellis* exh. cat., p. 40.
20 Kristeva, 'Jackson Pollock's Milky Way', p. 39.
21 McEvilley, in *Jannis Kounellis* exh. cat., p. 88.
22 Ibid.
23 Cf. Roland Barthes, *La chambre claire* (Paris, 1980), p. 129.
24 Burckhardt, ed., *Ein Gesprach*.
25 Cf. Bann, *The True Vine*, p. 193.

4 David Carrier, David Reed: An Abstract Painter in the Age of 'Postmodernism'

1 The best-known recent painter's account of this problem, Frank Stella's *Working Space* (Cambridge, Mass., and London, 1986) is fatally flawed by a narrow formal approach to old master art. It is strange that Stella claims an interest in Sydney Freedberg's *Circa 1600* (Cambridge, Mass., 1983), since his account involves a total misreading, albeit a strong 'misreading' (in Harold Bloom's sense of that word), of Freedberg's book. Since Stella's art of the 1980s involves a literal or sculptural use of space it is hard to understand the connection he would have us find between his reliefs and Caravaggio's paintings.
2 See Roger Fry, 'Some Questions in Esthetics', reprinted in his *Transformations: Critical and Speculative Essays on Art* (Garden City, NY, 1956), pp. 23–6, and his

Cézanne: A Study of His Development (Chicago and London, 1989). His account in 'Some Questions' of a painting no longer attributed to Poussin is discussed in my *Artwriting* (Amherst, 1987), pp. 27–9, where that work is reproduced.

3 Clement Greenberg, *Art and Culture: Critical Essays* (Boston, 1961), pp. 137–8. I refer to Ruskin's notion, developed throughout the early parts of *Modern Painters* (London, 1897), that an artist ought to represent nature rather than mere things of her or his own creation because what God created is more majestic than anything a mere mortal can imagine.

4 Clement Greenberg, 'Modernist Painting', reprinted in *The New Art*, ed. G. Battcock (New York, 1966), p. 109.

5 For a highly interesting discussion of this problem, see Richard Shiff, *Cézanne and the End of Impressionism* (Chicago and London, 1984), chs. 10 and 12.

6 See Arthur Danto, *The Philosophical Disenfranchisement of Art* (New York, 1986), ch. 3. One obvious target of his account is Fredric Jameson's Marxist interpretations.

7 Greenberg, *Art and Culture*, p. 218.

8 See my 'Le opere d'arte false nell'era della riproduzione meccanica', *Museo dei Musei* (Florence, 1988), 29–34; 'Baudrillard as Philosopher: or, the End of Abstract Painting', *Arts*, (September 1988), 52–60; and 'Art Criticism and its Beguiling Fictions', *Art International*, 9 (1989), 36–41.

9 My earlier, no longer adequate, account of David Reed's work is 'Artiface and Artificiality: David Reed's Recent Painting', *Arts* (January 1986), 30–3. See also Tiffany Bell, 'David Reed: Baroque Expansions', *Art in America* (February 1987), 126–9.

10 One good review, with a promising title, is Michael Kimmelman, 'New from David Reed, a Modern Traditionalist', *The New York Times* (27 October 1989), p. C31.

11 I will not give a bibliography of the now large journalistic literature on Reed. The best (though very brief) account is Joseph Masheck, *Point 1. Art Visuals/Visual Arts* (New York, 1984), p. 116. Much has been said in the journalistic literature about his alleged relationship to Lichtenstein, a pseudo-morphism; a more revealing parallel would be to note the connection between such recent Reeds as *No. 268* or *No. 254* and Hans Hofmann's 'push pull' paintings.

12 S. J. Freedberg, *Andrea del Sarto* (Cambridge, Mass., 1963), pp. 79–80.

13 See Stephen Bann, 'Adriatics – à propos of Brice Marden', *20th Century Studies. Visual Poetics*, 15/16 (December 1976), 116–29 and his 'Abstract Art – a Language?', in *Towards a New Art: Essays on the Background to Abstract Art 1910–20* (London, 1980), pp. 125–45.

14 I quote from Adrian Stokes, *Colour and Form*, reprinted in his *Critical Writings* (London, 1978), vol. II, p. 60. When first Reed and I met, Stokes was the first art writer we discussed. It is true that Reed's taste (and mine) and – in many ways – his view of colour differ drastically from Stokes's. But Stokes has written one of the few serious discussions of colour.

15 Leo Steinberg discusses a related del Sarto, the *Tallard Madonna*, in his 'The Sexuality of Christ in Renaissance Art and in Modern Oblivion', *October*, 25 (Summer 1983).

16 Mary D. Garrard, *Artemisia Gentileschi. The Image of the Female Hero in Italian Baroque Art* (Princeton, 1989), pp. 328, 336. She goes on to offer a highly imaginative reading of the scene: 'Artemisia's Judiths, poised between the death blow they have delivered the patriarch and their potential capture by his lieutenants, . . . embody the only kind of heroism realistically available to women in a patriarchal world.'

17 See John T. Spike, *A Taste for Angels: Neapolitan Painting in North America 1650–1750* (New Haven, 1987), pp. 93–6.

18 Ann T. Lurie, *Bernardo Cavallino of Naples. 1616–1656* (Cleveland and Ft Worth, 1984), cat. no. 216.

19 Stephen Koch, 'Caravaggio and the Unseen', *Antaeus* (ed. D. Halpern), 54 (Spring 1985), 103–4. See also my 'The Transfiguration of the Commonplace: Caravaggio and his Interpreters', *Word & Image*, vol. III, no. 1 (1987), 41–73.

20 Sir Denis Mahon, *The Age of Correggio and the Carracci: Emilian Painting of the Sixteenth and Seventeenth Centuries* (Washington, DC, 1986), cat. no. 469.

21 Here I borrow from Leo Bersani and Ulysse Dutoit, *The Forms of Violence: Narrative in Assyrian Art and Modern Culture* (New York, 1985), which has much to say about what I am calling implicit narratives. My 'Gavin Hamilton's *Oath of Brutus* and David's *Oath of the Horatii*. The Revisionist Interpretation of Neo-Classical Art', *The Monist*, vol. 71, no. 2 (April 1988), 197–213, offers one application of these ideas.

22 See my *Principles of Art History Writing* (University Park and London, 1991).

23 In a short television lecture filmed at the Max Protetch Gallery, New York, during Reed's November 1989 exhibition, Arthur Danto made this point, drawing attention to the crucial relationship between Reed's brushstrokes and the drapery in Baroque art.

24 This reflection, hard to see in most full-scale photographs, is captured clearly in a detail in Mina Gregori et al., *The Age of Caravaggio* (New York, 1985), p. 240.

25 For a detailed reproduction, see ibid., p. 245. This observation has not been recorded in the art historical literature.

26 'Narrative effects are circulated when their product, the told, can be detached from the telling.' Sande Cohen, *Historical Culture: On the Recoding of an Academic Discipline* (Berkeley, Los Angeles, London, 1986), p. 323.

27 See Gould, *Correggio*, pp. 78, 80 and Alberto Bevilacqua, *L'opera completa del Correggio* (Milan, 1970), pp. 112–13.

28 Geraldine D. Wind, 'The Benedictine Program of S. Giovanni Evangelista in Parma', *Art Bulletin*, 65 (1976), 521–7. Thanks to Virginia Budney for this reference.

29 Leo Steinberg, 'Observations in the Cerasi Chapel', *Art Bulletin*, 49 (1959), 183, 187. The suggestion that these Correggios are site-specific works is not, to my knowledge, developed in the earlier literature. See S. J. Freedberg, *Painting in Italy 1500 to 1600* (Harmondsworth, 1971), p. 289; also Hubert Damisch, *Théorie du/nuage/pour une histoire de la peinture* (Paris, 1972), pp. 11–31; Rudolf Wittkower, *Art and Architecture in Italy 1600 to 1750* (Harmondsworth, 1973), p. 161; Eugenio Riccomini, 'The Frescoes of Correggio and Parmigianino: From Beauty to Elegance' in Mahon, ed., *The Age of Correggio and the Carracci*, pp. 16–18; Anthony Blunt, 'Illusionistic Decoration in Central Italian Painting of the Renaissance', *Journal of the Royal Society of Art*, (April 1959), 309–26; and Marie Christine Gluton, *Trompe-l'oeil et décor plafonnant dans les églises romaines de l'âge baroque* (Rome, 1965). This conception of painting is developed in Leo Steinberg's 'Leonardo's Last Supper', *Art Quarterly*, vol. 36, no. 4 (1973), esp. pp. 368–70.For a discussion, see my 'Panofsky, Leo Steinberg, David Carrier. The Problem of Objectivity in Art History', *The Journal of Aesthetics and Art Criticism*, vol. 47, no. 4 (1989), 333–47.

30 Leo Steinberg, *Other Criteria*, 82.

31 See Douglas Crimp, 'On the Museum's Ruins', in *The Anti-Aesthetic: Essays on Postmodern Culture*, ed. H. Foster (Port Townsend, WA, 1983), p. 44. Where Greenberg's formalist theory relies upon the identification of continuities between the old masters and the modernists, the crucial point here is that these changes in the relation of the work of art to the spectator are discontinuous. That does not, of course, show that Steinberg is committed to the chiliastic claims of the Postmodernists.

32 See my *Principles*, chs. 1–4.

33 Fry, 'Some Questions in Esthetics', p. 30, my italics.

34 Greenberg, *Art and Culture*, p. 130, my italics.

35 The movement I here describe from the would-be objectivity of formalism to the

obvious subjectivity involved in identifying implicit narratives appears, in an instructive way, in Barthes' development from his early semiotic theorizing, which treated image interpretation as a kind of science, to his contrast in his book on photography between the studium and punctum, which involves an open recognition of his own subjectivity. 'A photograph's punctum is that accident which pricks me (but also bruises me, is poignant to me.)'; see Roland Barthes, *Camera Lucida. Reflections on Photography*, trans. R. Howard (New York, 1981), p. 27. Barthes' 'punctum' might be described as a way of identifying what I call an implicit narrative.

36 Greenberg, *Art and Culture*, p. 137.

37 'David Reed. Interview with Jonathan Seliger', *Journal of Contemporary Art*, vol. 1, no. 1 (Spring 1988), p. 74. This essay owes much to my discussions over the past few years with David Reed and to our visits together to museums and art galleries. It is dedicated to Paul Barolsky, a student of Freedberg, whose *Walter Pater's Renaissance* (University Park and London, 1987), an important model of innovative art history, moves forward by asking that we take a new look at the past. In an odd way, which I discovered only when this essay was completed, Reed's and Barolsky's concerns are connected. Discussing his wish to be a painter making works 'meant to be lived with in relaxed and intimate moments', Reed has said: 'I want to be a bedroom painter.' (Seliger interview, p. 74). In an earlier book Barolsky writes: 'It is indeed surprising that . . . the most recent books on the social history of Renaissance art have scarcely mentioned the function of nuptial art.' Paul Barolsky, *Infinite Jest. Wit and Humor in Italian Renaissance Art* (Columbia and London, 1978), p. 210.

5 *Rainer Crone and David Moos, Romance of the Real: Jonathan Lasker's Double-Play*

1 'A Spiritual Revolution Is Needed', *Za Rubezhom*, 17–23 November 1989, as quoted in a translated transcript of the original interview 'Rev. Moon Breaks Silence, Gives First Interview In 13 Years, To Soviet Newspaper', *International Herald Tribune*, 14 December 1989, p. 11.

2 V. Iordanski, quoted from the preface to the interview, 'A Spiritual Revolution is Needed', ibid., p. 11.

3 Jonathan Lasker, *Cultural Promiscuity* (a conversation with Collins and Milazzo and thirteen studies) (Rome, June 1989), unpaginated.

4 Ibid.

5 Descending from Aristotelian poetics, truth in a mimetic mode could never be fulfilled because the work of art was precisely a reproduction and not the 'real' object or vision it emulated. Poesis, on the other hand, circumvented this shortcoming by formulating its objective as anterior to any observed or ideal vision.

6 Novalis, *Schriften. Die Werke Friedrich von Hardenbergs*, vol. 2, ed. Paul Kluckhohn and Richard Samuel (Stuttgart, 1960), p. 647, no. 473.

7 In this context, the apparent fact that each shape is broken into two parts (the large part and the smaller 'island' at the level of the fourth pink bar) divided by the mauve background, does not imply a multiplication of form. We refer to one shape on each side because neither the smaller nor larger parts taken individually would supply different or additional information.

8 Tom Wolfe, 'Stalking the Billion-Footed Beast: A Literary Manifesto for the New Social Novel', *Harper's Magazine* (November 1989), p. 49.

9 Lasker, *Cultural Promiscuity*, n.p.

10 Lasker stands as a paramount example of an artist who confronts seemingly 'traditional' issues, but stemming from his creative mode, the concerns of past eras are transmuted into the contemporary. By contemporary we do not merely refer to a present or current historical moment (today) but rather build into the meaning of this

notion an ability to retrieve essences from past histories (in this case theoretical) and revivify them in a befitting current context. The five electric orange upholstered stainless steel chairs on which the three of us usually sat together in the studio, while looking at and discussing Lasker's paintings, recalled a specific flavour and aura of furniture design that originated in the 1950s. But these contemporary chairs are not relics or antiques, nor are they authentic; but are rather contemporary and suitable in themselves as chairs of the 1980s.

11 Lasker, *Cultural Promiscuity*, n.p.

6 *Yve-Alain Bois, Susan Smith's Archaeology*

1 See Louis Marin, 'Fragments d'histoires des musées', *Cahiers du Musée National d'Art Moderne*, No. 17/18, 8–17.

2 Cf. Michel Foucault, 'La bibliothèque fantastique' (1967), trans. as 'Fantasia of the Library', in *Language, Counter-Memory, Practice* (Ithaca, 1977). This essay is discussed in Eugenio Donato, 'The Museum's Furnace: Notes Toward a Contextual Reading of *Bouvard and Pécuchet*', in *Textual Strategies: Perspectives in Post-Structuralist Criticism*, ed. Josué Harari (Ithaca, 1979), and in Douglas Crimp, 'On the Museum's Ruins', *October*, No. 13 (Summer 1980), 41–57.

3 On the Altes Museum, designed by Schinkel according to a programme shaped by the German art historian Carl Friedrich von Rumohr, cf. Douglas Crimp, 'The End of Art and the Origin of the Museum', *Art Journal*, (Winter 1987), 261–6.

4 Published as 'The Artist and the Museum', in *New York Review of Books*, Vol. 34, No. 19 (3 December 1987), 38–42.

5 See my 'Painting: The Task of Mourning', in *Endgame* (Boston, 1986), pp. 29–49; reprinted in Yve-Alain Bois, *Painting as Model* (Cambridge, 1991).

6 Lawrence Alloway and John Coplans, 'Talking with William Rubin; "The Museum Concept is not Infinitely Expandable",' *Artforum*, (October 1974), 51–7. In this interview, Rubin declared: 'Perhaps the dividing line will be seen as between those works which essentially continue an easel painting concept that grew up associated with bourgeois, democratic life and was involved with the development of private collections as well as the museum concept – between this and, let us say, Earthworks, Conceptual Works and related endeavours, which want another environment (or should want it) and, perhaps, another public' (p. 52).

7 Quatremère de Quincy, *Lettres sur le préjudice qu'occasionneraient aux Arts & à la Science le déplacement des monuments de l'art de l'Italie, le démembrement de ses écoles et la spoliation de ses collections, galeries, musées, etc.* (Paris, 1796), repr. (Paris, 1989), p. 102.

8 Patricia Leigh Brown, 'Collecting the Eighties: Stash the Swatch; Keep the Kettle', *The New York Times* (15 December 1988), Section C (Home).

9 'In American cultural politics today there are at least two positions on postmodernism now in place . . . One aligned with a neoconservative politics, the other derived from poststructuralist theory. Neoconservative postmodernism is the more familiar of the two: defined mostly in terms of style, it depends on modernism, which, reduced to its worst formalist image, is countered with a return to narrative, ornament and the figure. This position is often one of reaction, but in more ways than the stylistic – for also proclaimed is the return to history (the humanist tradition) and the return of the subject (the artist/architect as *auteur*). Poststructuralist postmodernism, on the other hand . . . is profoundly antihumanist: rather than a return to representation, it launches a critique in which representation is shown to be more constitutive of reality than transparent to it.' Hal Foster, '(Post)Modern Polemics', in *Recodings – Art,*

Spectacle, Cultural Politics (Port Townsend, WA, 1985), p. 121. Needless to say, Neo-Geo and Cute Commodity, while not sharing with the Neo-Expressionist trend the return to the figure, to pathos, to handicraft, etc., partake of the same enterprise of dehistoricization: what Schnabel did with Caravaggio and Kokoschka, what Clemente did with Chagall, Salle with Picabia, etc., Taaffe does with Newman or Op Art, Jeff Koons and Haim Steinbach with Duchamp, etc.

10 Cf. Achille Bonito Oliva, 'A proposito di transavanguardia', *Alfabeta*, No. 35 (April 1982). This text constitutes an answer to Jean-François Lyotard's 'Intervention italienne', which appeared in the January issue of the same journal (No. 32) and in the French journal *Critique*, No. 419 (April 1982), then in English as a postface to Jean-François Lyotard, *The Postmodern Condition: A Report on Knowledge* (Minneapolis, 1984).

11 Until recently, Nietzsche's essay was entitled in English: 'The Uses and Abuses of History for Life'. 'Disadvantages' has now been substituted for 'Abuses', but although this correction is adequate I will retain the symmetry and dissymmetry of the old translation: the rhetoric of the prefix is more complex than those who coined the term 'Postmodernism' might want us to believe. On the one hand 'abuse' is opposed to 'use' as the bad to the good, on the other 'abuse' contains 'use' as one of its parts: nothing could be more symptomatic of the crisis I am trying to explore than the aporetic character of this morphologico-semantic structure.

12 Friedrich Nietzsche, 'On the uses and disadvantages of history for life', in *Untimely Meditations*, trans. R. J. Hollingdale (Cambridge, 1983), p. 60.

13 Ibid., p. 63.

14 Friedrich Nietzsche, *Human, All too Human*, trans. R. J. Hollingdale (Cambridge, 1986), p. 209.

15 Nietzsche, *Untimely Meditations*, p. 72.

16 Hayden White, *Metahistory – The Historical Imagination in Nineteenth-Century Europe* (Baltimore, 1973), p. 351.

17 Ibid.

18 Nietzsche, *Untimely Meditations*, p. 74.

19 White, *Metahistory*, p. 351.

20 Nietzsche, *Untimely Meditations*, p. 94.

21 On this question, cf. Michel Foucault, 'Nietzsche, la généalogie, l'histoire', in *Hommage à Jean Hyppolite* (Paris, 1971), esp. pp. 167–72.

22 Friedrich Nietzsche, *Genealogy of Morals*, trans. Francis Golffing (New York, 1956), p. 209.

23 Cf. Walter Benjamin, 'Theses on the Philosophy of History', in his *Illuminations* (New York, 1969), p. 256.

24 Cf. his letter to Nietzsche dated 25 February 1874, quoted in the 'Introduction' written by J. P. Stern for the edition of the *Untimely Meditations* from which I am quoting, p. xxi.

25 Aloïs Riegl, 'Der Moderne Denkmalskultus, sein Wesen und seine Entstehung' (1903), in *Gesammelte Aufsätze*, ed. Karl. M. Swoboda (Augsburg–Vienna, 1928), p. 167. This text has been translated by Kurt Forster as 'The Modern Cult of Monuments: Its Character and Its Origin', *Oppositions*, 25 (Autumn 1982). Although Forster's translation is accurate, his rendition of this sentence ('But have we actually transcended the validity of historical value', p. 34) obliterates, it seems to me, the acuity of Riegl's interrogation.

26 Fredric Jameson, 'Postmodernism, or The Cultural Logic of Late Capitalism', *New Left Review*, 146 (July–August 1984), 53. For a critique of Jameson's article, cf. Mike Davis, 'Urban Renaissance and the Spirit of Postmodernism', *New Left Review*, 151 (May–June 1985), 106–13. For an excellent inquiry about the various modes of the

current millenarianism, cf. the first issue of *Copyright* (Autumn 1987), entitled 'Fin de Siècle 2000'.

27 Riegl, 'The Modern Cult of Monuments', p. 49.

28 On Riegl and positivism, cf. 'Naturwerk und Kunstwerk' (1901), reprinted in Riegl, *Gesammelte Aufsätze*, pp. 59–60 and passim. Certainly Riegl's idea of positivism is utterly idiosyncratic, for while he often defines himself as a positivist, he is particularly ironic against those who content themselves with the mere registration of fact. Read, for example, this extraordinary statement from 'Late Roman or Oriental' (1902): 'I do not share the view that a knowledge of monuments alone already constitutes the alpha and omega of art-historical knowledge. The well-known, dubious, and loud-mouthed argument, "What, you don't know that? Then you don't know anything at all!" may have had a certain validity in the period of materialistic reaction to Hegelian overestimation of conceptual categories [this refers to the work of Gottfried Semper]. In the future we will have to ask ourselves in regard to every single reported fact, what the knowledge of this fact is actually worth. Even the historical is not an absolute category, and for the scholar, not only knowing per se, but also the knowing-how-to-ignore certain facts at the right moment may well have its advantage' in *German Essays on Art History*, ed. Gert Schiff, trans Peter Wortsman (New York), p. 190. In his neo-Kantian reading of the concept of *Kunstwollen*, Erwin Panofsky defended Riegl against his self-inflicted characterization as a 'positivist' by trying to show that he owes the method of his research to transcendental idealism (cf. 'The Concept of Artistic Volition' (1920), tr. by Kenneth Northcott and Joel Snyder, *Critical Inquiry* (Autumn 1981). But Riegl's gentle rebuttal of Hegel's 'overestimation of conceptual categories' should not mask his indebtedness to Hegel's dialectics, particularly noticeable in *Spätromische Kunstindustrie*. This obviously sets him apart from Nietzsche, or rather exacerbates a tension in his late writings between two different conceptions of history.

For Riegl's stance against antiquarianism, cf. notably the introduction of *Spätromische Kunstindustrie* (1901), 2nd edn (Vienna, 1927), pp. 4–6; in the mediocre translation by Rolf Winkes entitled *Late Roman Art* (Rome, 1985), pp. 6–7: there Riegl makes it clear that his interest in late antiquity stems from issues revived by contemporary art practice. Cf. also 'Naturwerk und Kunstwerk', pp. 53–6.

29 Benjamin's longest passage on Riegl can be found in *Strenge Kunstwissenschaft* (1932), whose two versions are excellently translated in English by Tom Levin along with a careful account of Benjamin's debt to Riegl in *October*, No. 47 (Winter 1988). It is not by chance, Benjamin had noted, that Riegl chose to work on the then despised collective art of late Roman antiquity. He saw the dissolution of the figure/ground opposition in this art as corresponding to the struggle of early Christianity against the classical lore of the 'right of the strongest' and to its democratic ideal (cf. *Historische Grammatik der bildenden Kunsten*, K. Swoboda and O. Pächt eds. (Graz, 1966), p. 38 and esp. p. 102: 'The clear detachment of motifs on a neutral ground was . . . a fundamental principle of antique art, so to speak the embodiment of the right of the strongest. But it happens that in early Christian-late Roman art the ground is elaborated in a configuration of its own, to the point where we wonder where is the ground and where are the motifs . . . Within the coloristic harmony, there is no stronger person to be served by a weaker person as a foil; the eye observes only a multiplicitous whole out of which no dominant figure emerges.' Written a few years before *Spätromische Kunstindustrie*, this manuscript was published only posthumously). The same 'democratic impulse' is behind Riegl's *Dutch Group Portrait*, his last great book, published in 1902.

30 Benjamin, 'Theses on the Philosophy of History', p. 263.

31 Ibid., p. 254

32 Cf. Yve-Alain Bois, 'Francis Picabia: From Dada to Pétain', *October*, 30 (Autumn 1984), 121–7.

7 *Victor Burgin, Perverse Space*

1 Laura Mulvey, 'Visual Pleasure and Narrative Cinema', *Screen*, Vol. 16, No. 3, (Autumn 1975); reprinted in her *Visual and Other Pleasures* (London, 1989).

2 I am speaking particularly of writing about 'static' visual representations – photographs, and so on. Mulvey's essay provoked a more nuanced debate among film theorists, but in terms very different from those of this essay.

3 'Self-portrait with wife June and models, Vogue studio, Paris 1981', in Helmut Newton, *Portraits* (New York, 1987), plate 14.

4 Ibid., p. 14. Is the similarity of this image to *Las Meninas* by Velázquez also due to chance? Commenting on one of his own dreams, Freud remarks that the dream was 'in the nature of a phantasy' which 'was like the facade of an Italian church in having no organic relation with the structure lying behind it. But it differed from those facades in being distorted and full of gaps, and in the fact that portions of the interior construction had forced their way through it at many points'; Sigmund Freud, *The Interpretation of Dreams* (1900), in *The Standard Edition of the Complete Psychological Works of Sigmund Freud*, Vol. IV (London, 1958), p. 211. In his essay of 1908, 'Creative Writers and Daydreaming', Freud describes the production of works of literature, and by implication other forms of art, in analogous terms: the foundation of the work is in unconscious materials; in an opportunistic relation to the conscious plan of the artist, they enter the surface structure by means of the primary processes. As Sarah Kofman observes, 'For inspiration, a concept belonging to the theological ideology of art, Freud substitutes the working concept of the primary process. The artist is closer to the neurotic . . . and the child than to the "great man".' See Sarah Kofman, *The Childhood of Art* (New York, 1988), p. 49. Artistic activity in the adult, then, is made from the same stuff as phantasy and has its childhood equivalent in play. The child in play is serious. In Kofman's description, 'the artist plays with forms and selects, among the preconscious processes, the structures which, in relation to his psyche and its conflicts, are perceived as the most significant.' (Ibid., p. 113.) The word 'selects' here might encourage an overestimation of the role of self-conscious deliberation. In an essay on Freud's aesthetics to which Kofman refers, Ernst Gombrich gives this gloss of Freud's model of the joke: 'Take the famous answer to the question: "Is life worth living?" – "It depends on the liver". It is easy to see what Freud calls the preconscious ideas which rise to the surface in this answer – ideas, that is, which are not unconscious in the sense of being totally repressed and therefore inaccessible to us but available to our conscious mind; in this case the joy in lots of alcohol which the liver should tolerate and the even more forbidden joy in the aggressive thought that there are lives not worth living. Respectability has imposed a taboo on both these ideas, and to express them too boldly might cause embarrassment. But in the churning vortex of the primary process, the two meanings of 'liver' came accidentally into contact and fused. A new structure is created and in this form the ideas cause pleasure and laughter.' See E. H. Gombrich, 'Freud's aesthetics' (1966), in *Reflections on the History of Art* (Oxford, 1987), pp. 230–1. The import of the collision of signifiers must be recognized, 'selected', in order to be given form in a work of art. As such works are produced at the 'interface' of primary and secondary processes, however, it is never clear to what extent such recognition and selection is conscious.

5 I am aware that we do not *see* that the photographer is Helmut Newton, we must choose to believe what the caption tells us; we do not *see* that the camera is a Rolleiflex, this must be added from a store of specialist knowledge; and so on. But scepticism must

end somewhere; after all, we do not *see* that the 'people' in this image are not, in fact, wax figures.

6 In the setting of psychoanalytic theory, 'topographically', such connotations belong to the preconscious; to the extent that they are commonly available, we might therefore speak of a 'popular preconscious'.

7 In his classic paper, 'Rhetoric of the Image', trans. Stephen Heath, in *Image Music Text* (London, 1977), pp. 32–51, Barthes spoke of the 'anchorage' of the connotations of the image by means of the written text. It can easily be demonstrated, however, that an image may anchor the connotations of a text or the connotations of another image (or another signifier within the same image). It should also be obvious that a 'text' may anchor another text.

8 CS: 'When you photographed yourself nude in 1976, your clothes were very neatly folded on a chair in the picture. But when you photograph women who are nude, their clothes are scattered everywhere . . .'
HN: 'I'm quite a tidy person. I would hate to live in disorder . . . But this is interesting – I create that disorder – I want the model to take all her clothes off and just dump them. (Newton talking to Carol Squiers, in *Portraits*)

9 Mulvey, 'Visual Pleasure and Narrative Cinema', pp. 13–14.

10 André Breton, *Nadja* (New York, 1960), p. 39.

11 *La Révolution Surréaliste*, No. 12 (15 December 1929), p. 73. In the very first issue of the journal a similar arrangement of portrait photographs, a Surrealist guard of honour to which in this case Freud has been conscripted, surround the picture of the Anarchist assassin Germaine Berton.

12 Jacques Lacan, *Le Séminaire, livre I: Les écrits techniques de Freud* (Paris, 1975), p. 90.

13 Roland Barthes, 'Diderot, Brecht, Eisenstein', in *Image Music Text*, trans. Stephen Heath (London, 1977), p. 69.

14 Michel Foucault, *Surveiller et punir: Naissance de la prison* (Paris, 1975); *Discipline and Punish: The Birth of the Prison* (London, 1977).

15 Victor Burgin, 'Geometry and Abjection', *AA Files – Annals of the Architectural Association School of Architecture*, No. 15 (Summer 1987; 1988), p. 35; reprinted in *Thresholds: Psychoanalysis and Culture*, ed. J. Donald (London, 1990); *Abjection, Melancholia and Love: The Work of Julia Kristeva*, Andrew Benjamin and John Fletcher, eds. (London, 1989).

16 Ibid., p. 38.

17 Otto Fenichel, 'The Scoptophilic Instinct and Identification', in H. Fenichel and D. Rapaport, eds, *The Collected Papers of Otto Fenichel* (New York, 1953), p. 375.

18 Ibid., p. 377.

19 Sigmund Freud, 'Instincts and their Vicissitudes' (1915), in *The Standard Edition of the Complete Psychological Works of Sigmund Freud*, Vol. XIV (London, 1955–74), p. 122.

20 This account contradicts the hypothesis that the infant initially exists in an 'objectless state' of auto-erotism. As Laplanche and Pontalis write: 'the self-preservative instincts have a relationship to the object from the start; consequently, in so far as sexuality functions in anaclisis with these instincts, it too must be said to have a relationship to objects; only after detaching itself does sexuality become auto-erotic.' See J. Laplanche and J.-B. Pontalis, *The Language of Psycho-analysis* (London, 1973), p. 31.

21 René A. Spitz, *The First Year of Life* (New York, 1965), p. 62.

22 Jean Laplanche, *La sublimation* (Paris, 1980), p. 62.

23 J. Laplanche and J.-B. Pontalis, 'Fantasy and the Origins of Sexuality', in V. Burgin, J. Donald and C. Kaplan, eds, *Formations of Fantasy* (London and New York, 1986), p. 25.

24 Ibid., p. 26.

25 Jean Laplanche, 'The Ego and the Vital Order', in his *Life and Death in Psychoanalysis* (Baltimore, 1976), p. 60.

26 Laplanche, *La sublimation*, p. 66. This account of the emergence of sexuality as inseparable from the emergence of fantasy works against the prevailing understanding of the fetishistic relation to an object as 'frozen', motionless.

27 Ibid., p. 65.

28 I understand this idea much as I understand Barthes's notion of the punctum; see, 'Diderot, Barthes, *Vertigo*', in my *The End of Art Theory: Criticism and Postmodernity* (London, 1986); also in, V. Burgin, J. Donald and C. Kaplan, eds, *Formations of Fantasy* (London, 1986).

29 Laplanche, *La sublimation*, pp. 102–3.

30 Jean Laplanche, *New Foundations for Psychoanalysis* (Oxford and Cambridge, MA, 1989), p. 23.

31 Freud explicitly noted that the clinical fetishists he encountered in his practice did not come to him because of their fetishism. They were content to be fetishists. Freud assumes this is to be explained by the ease with which the fetishist may obtain his object, but surely we can think of other perversions which are equally 'facile' but which engender shame and the wish to be cured.

32 Laplanche, *New Foundations for Psychoanalysis*, pp. 29–30.

33 Jean Laplanche, *Nouveaux fondements pour la psychanalyse* (Paris, 1987), p. 125. My translation differs from *New Foundations for Psychoanalysis* (Oxford and Cambridge, MA, 1989), p. 126.

34 Catherine Johns, *Sex or Symbol* (London, 1982), p. 72.

8 *Paul Smith, 'Salle/Lemieux': Elements of a Narrative*

1 David Salle, 'The Paintings are Dead', in *Blasted Allegories*, ed. Brian Wallis (Cambridge, Mass., 1987), p. 325.

2 E. D. Hirsch, *Validity in Interpretation* (New Haven, 1967), p. 73.

3 Roland Barthes, 'The Wisdom of Art', in *Calligram: Essays in New Art History from France*, ed. Norman Bryson (Cambridge, 1988), p. 171.

4 Carter Ratcliff, 'David Salle and the New York School', in *Salle* exh. cat., Rotterdam (26 February–17 April, 1983). Cf. Ratcliff's description of these images as 'emblems of desire'. Of course, they are primarily emblems of a desire that is constructed as *masculine*. One might want to add that they are, at that, emblems of heterosexual masculine desire, although I do not discount the possibility that, in relation to the cultural imperatives and narratives of women's bodies, the homosexual male imaginary is subject to some of the same formations as the heterosexual.

5 These quotations are taken from Peter Schjeldahl, *Salle* (New York, 1987).

6 Barthes, 'The Wisdom of Art', pp. 172–3.

7 David Carrier's impressive book, *Artwriting* (Amherst, 1987), underscores many of these relations while at the same time showing their relatively inchoate and unstable nature. Carrier's readings of how 'artwriting' is implicated with the market are sound and powerful – though his deeply rationalist habits of mind prevent him from engaging the more political consequences of his insights.

8 Barthes's essay on Twombly is, of course, a *tour de force*. It is interesting to note, however, how it is shot through with its own kind of disavowal and, indeed, its own kind of conservatism. That is, the essay disguises its rather traditional claims for the sublime effects of Twombly's work by a detour into Zen.

9 Some of the same images appear again in Salle's 1986 *Dusting Powders*, and the same kind of grisaille nudes are a common feature of his work in the mid-1980s. In a couple

of other pictures I have seen what I call the *National Geographic* images foregrounded (*Plastered Again* and *Din*, both 1984).

10 I mean here to allude to Jean Louis Schefer's magnificent work on figuration and the appearance of 'enigmatic' or 'primitive' bodies in both cinema and art practice. Unfortunately, consideration of the pornographic, or of the relation of gendered desire to figuration, is a gap in Schefer's work. A selection of Schefer's work, which I edit and translate, is forthcoming from Cambridge University Press, 1991.

11 Schjeldahl, *Salle*, p. 72.

12 Lisa Philips, 'His Equivocal Touch in the Vicinity of History', in *Salle* exh. cat., ICA, University of Pennsylvania (9 October–30 November 1986), p. 26.

13 Schjeldahl, *Salle*, p. 73.

14 A short account of Rosenbach's performance is contained in A. A. Bronson and Peggy Gale, eds, *Performance by Artists* (Toronto, 1979), p. 144.

15 Victor Burgin, *The End of Art Theory: Criticism and Postmodernity* (Atlantic Highlands, NJ, 1986), p. 108.

16 Knight, 'A Deathly State of Nostalgic Ennui'.

17 Burgin, *The End of Art Theory*, p. 108.

18 Hal Foster, *Recodings* (Port Townsend, WA, 1985), pp. 75–6.

9 David Reason: Echo and Reflections

1 Hans Keller, *Criticism* (London, 1987), p. 30. This is an appropriate point at which to express my thanks to Thomas A. Clark, from whose conversation I have profited immeasurably in preparing this essay.

2 Much of my writing about art has appeared as essays in catalogues accompanying exhibitions of work for the same reason, that is, so that my words cannot outdo the presence of the work nor silence the general reader by excluding her or him from the outset from the presence of the work to which my text relates. Of course, I refer to works which are not immediately available to the reader – indeed, it is a favourite methodological tactic of mine to ensure that my text includes at least one item which would normally be excluded from a consideration of the work on show and in question – but I do this to subvert the authority of the tacit boundaries of discourse that we find in place – thereby, I hope, exciting the interest of the reader to explore further my allusions and references and giving permission (if permission is needed) to bring to bear whatever in her or his own experience and understanding develops the understanding of the work and its place in the reader's own life concerns.

3 The parallels between music and Fulton's text works can be taken further. In the case of music, the sensuous qualities of the aural (pitch, intensity, duration, timbre) are used to articulate the musical content, which is not then wholly structural in character. Similarly, with a text piece the sensuous qualities of the visual (size, shape, colour) are used to articulate something which is not itself visual but which is articulable through that medium (and the appropriate sensibility). The text piece is not an image (although each painted letter could be said to be a kind of image of itself), nor does the word refer as such, even though the interpretation of the work depends upon the words' ability to refer. In such ways the visual image does the work of a musical performance.

4 Fulton tells me that when this work was presented at The Clocktower Gallery, New York, the letters of ROCK were 31½ inches high. At that size, the word HALF struck him with such vividness that it seemed the most important word of the piece.

5 The corresponding letters of the final line (in the words ARCTIC and SUMMER) have the same form, but not the same effect. This is perhaps explained by their size (much smaller), position (*in* words) and placing (in a final line with a clear denotative intent). They could be considered to lend a muted seasoning of destabilization to any reading

which overemphasizes a given and unqualified unitary quality of these shapes as *letters*, none the less.

6 The 'background' colour to Fulton's wall works is not white as such but a colour which can be more accurately designated as pale cream, or light biscuit, or off-white. 'Red' and 'black' are mutually changed, visually, when painted on this colour compared with their effect when painted on a white background.

7 'Fall' is also an American and Middle English term for a season of the year, which is otherwise called in English 'autumn'. This sense is not in play here, since the walk from which the work arises took place in the summer.

8 A concern with the small things of the natural world is often taken to be a token of the Romantic disposition. This is no part of Fulton's work, which tries to present matters as they stand. Compare Ruskin: 'The higher the mind, it may be taken as a universal rule, the less it will scorn that which appears to be small or unimportant; and the rank of painter may always be determined by observing how he uses, and with what respect he views the minutiae of nature . . . he who cannot make a bank sublime will make a mountain ridiculous.' John Ruskin, *Modern Painters* (London, 1904), Vol. I, p. 343.

9 'Dust' also makes a surface like a palimpsest. It bears the marks and traces of passing activity and may even retain the footprints of spiders.

10 I am reminded of materials that physicists call 'anisotropic', that is, materials whose properties are sensitive to matters of direction. But I resist introducing this term into the main text, partly because it requires an exposition out of proportion to its usefulness here, partly because I suspect that I am more delighted at the opportunity to play on 'tropic', 'tropism' and 'trope' than I am in genuinely furthering my understanding of Fulton's work itself. Although such word-play can be pressed into insightful service, there is nothing deep at stake here, only a half-resisted temptation to self-indulgence.

11 One afternoon the sun melted ice at the top of a cliff which released some rocks. They fell: the crash echoed and was followed by a large cloud of dust which lingered after the avalanche and echoes had finished. The dust drifted on a slight breeze – unusually, for Baffin Island is normally quite a windy place. This is the event, as Fulton told it, which led to the text work, and it clearly identifies key elements of the Baffin Island landscape unmentioned in the text: sun and wind. A subtle power (equivalent to that of the enigma of things as they are) is generated in the refusal to disclose this event as the 'original' event – it is an originating event, perhaps, but there is always more than this implicated both in 'nature' and 'work' – and in withholding from such a story the status of 'description' or 'solution (to a riddle)'.

12 Initial condition: complicating action: outcome: resolution: coda. See William Labov, 'The Transformation of Experience in Narrative Syntax', in his *Language in the Inner City: Studies in the Black English Vernacular*, (Oxford, 1972), pp. 354–96. In the case of the skeletal narrative of *ROCK FALL ECHO DUST*, the functions of resolution and coda are both carried by the one final full reading.

13 And the latter two to the final line of the piece, which is also printed in red.

14 See *Hamish Fulton: Selected Walks: 1969–89*, exh. cat., Albright-Knox Museum (Buffalo, 1990).

15 Fulton's practice seems at first glance related to Hegel's discussion of 'daubed' images, which rest on intention for their understanding: in view of the notorious inscrutability of intentions and the absence of appropriately informing conventions, this amounts in effect to its contrary. Here is Hegel: 'Any poor figure is adequate provided only it reminds one of the subject it is intended to signify. For this reason piety is also satisfied with poor images and will always worship Christ, Mary or any Saint in the merest daub.' G. W. F. Hegel, *Lectures on Aesthetics*, Part III, Sec. 2, Ch. 2, quoted by E. H. Gombrich, 'The Edge of Delusion', a review of David Freedberg, *The Power of Images*

(Chicago, 1989), in *New York Review of Books*, 15 February 1990. Thus, the concept of the work escapes technical domination but in a manner very different to that in which Fulton achieves a similar end. It is more illuminating to reflect upon Levinas's discussion of the relationship between object, image and art, in which each thing 'is what it is and is a stranger to itself, and there is a relationship between these two moments . . . We will say the thing is itself and is its image. And that this relationship between the thing and its image is resemblance.' Emmanuel Levinas, 'Reality and its Shadow' (1948), in Sean Hand, ed., *The Levinas Reader* (Oxford, 1989), p. 135. Unfortunately, I do not have the space to develop that argument here.

16 Friedrich Nietzsche, *Human, all Too Human*, trans. R. J. Hollingdale (Cambridge 1986), p. 82, s. 152.

17 This way of putting the matter clearly invites comparison with meditational doctrines and practices, such as those which are popularly associated with Zen Buddhism. 'Be without thoughts – this is the secret of meditation' it says in the text called *Zazengi*; see Edward Conze, *Buddhist Scriptures* (1959; Harmondsworth, 1984), p. 138. And in the case of Fulton's work there is methodological warrant for citing such resonances in the light of the profound influence of Japanese culture and thought on the generation of artists and intellectuals who grew up through the widening cultural horizons of the 1960s. This cultural yeast came via John Cage and D. T. Suzuki, or in the wake of a greater ease and cheapness of travel (if you did not own a bike, you could always hitch), it was directly confronted in the course of visiting Asia and the Far East. Similarly, the political and cultural revival among American Indians and the corresponding, but relatively delayed, reconstruction of views of the life-world of Australian Aboriginal peoples were of greater inspiration to many British artists of that time than were the traditions and practices of Western 'high art'. The possibilities of informed spontaneity and of an art that engaged with the fundamental issues of human life (mortality, responsibility and respect, healing and nature) were embraced within an idiom which rehabilitated peoples hitherto marginalized and disqualified by mainstream industrial-scientific culture. For some this furnished the trappings of a nostalgic and false utopianism, but it confirmed Fulton in a principled rejection of what came to be regarded as inhibiting, oppressive and inhumane materialistic values.

Consider this: writing of the considerations which informed his selection of material for an anthology of writings of and about contemporary indigenous peoples, Roger Moody tells us: 'I earmarked for inclusion a statement by the Aboriginal community of Welatye Therre (Alice Springs), just before learning that one of the families involved in this occupation of a sacred site lost some of its members in a grievous fire. Aboriginal customary law demands that no material, printed or photographic, be circulated which might identify, or 'image', the dead, for a year after the tragedy . . . not only was the particular piece pulled out, but I destroyed all photographs and references to members of the Welatye Therre occupation and asked others to do likewise'; Roger Moody, ed., *The Indigenous Voice: Volume 1 – Visions and Realities* (London, New Jersey and Copenhagen, 1988), p. xv. Such active respect is entirely of a piece not only with the ethics of Fulton's vision and practice but with its aesthetics, too.

18 Generally, Fulton takes nothing from and leaves nothing in the landscapes which he visits, apart from the photographs and notes brought home and the campfire ashes left behind (in, of course, those places where it is appropriate to light a fire and in which it is possible to leave the ashes in such a way as to cause no great harm to the environment).

19 John Berger, 'The White Bird', in *The White Bird: Writings by John Berger*, ed. Lloyd Spencer (London, 1988), p. 7 [my emphasis].

20 Nature is best conceived of as *second nature*, which Hegel considered to be a nature created and transformed by human interest but which can be used in an extended sense

that allows the participation of other natural agents. See Alfred Schmidt, *The Concept of Nature in Marx* (1962; London, 1971).

21 Berger, 'The White Bird', p. 8 [emphasis in the original].

22 This is Georges Bataille's telling characterization of 'animal consciousness'. Quoted in Gaston Bachelard, *Water and Dreams: An Essay on the Imagination of Matter* (1942), trans. E. R. Farrell (Dallas, 1983).

23 The conviction that there are viable concepts of interests and rights which apply to the things of the natural world is regularly expressed in the cosmologies of non-industrial peoples and is a commonplace of radical environmentalist thought. Such views have come under often sensitive scrutiny by professional philosophers and legal theorists in recent years. A useful account of the development of these ideas from an influential and sympathetic, but not uncritical, commentator can be found in Roderick Frazier Nash, *The Rights of Nature: A History of Environmental Ethics* (Madison, Wisc, and London, 1989).

24 John Dunn 'Reconceiving the Content and Character of Modern Political Community', in *Interpreting Political Responsibility: Essays 1981–87* (Cambridge, forthcoming). Of course, cultures throughout history have flattered themselves that on their actions depended the fate of the world: the mortal urgency of this discussion derives from observing that in our case it is so.

25 Functional analysis is described in a fashion accessible to the non-musician in 'Part III: Music Criticism' of Keller, *Criticism*.

26 This useful term was coined by Anthony Giddens. See his *The Constitution of Society* (Cambridge, 1988).

27 This contention he develops at length in Theodor W. Adorno, *Aesthetic Theory* (2nd edn, 1972), trans. C. Lenhardt, ed. G. Adorno and R. Tiedemann (London, 1984).

28 Maurice Blanchot, *The Writing of the Disaster*, trans. A. Smock (London, 1986).

29 Emmanuel Levinas, *Ethics and Infinity: Conversations with Philippe Nemo*, trans. R. A. Cohen (Pittsburgh, Duquesne University Press, 1985), p. 107.

30 Levinas 'Reality and its Shadow'.

31 Keller, *Criticism*, p. 164.

10 *Michael Newman, From World to Earth: Richard Deacon and the End of Nature*

1 For a discussion of this question and other works by Deacon, see my essay 'The Face of Things', in *Richard Deacon: Sculpture 1980–84*, exh. cat. Edinburgh, The Fruitmarket Gallery, 1984 and Lyon/Villeurbanne, Le Nouveau Musée (1985).

2 Rainer Maria Rilke, *Where Silence Reigns: Selected Prose by Rainer Maria Rilke*, trans. G. Craig Houston (New York, 1978), p. 132.

3 Ibid., p. 94.

4 William Tucker, *The Language of Sculpture* (London, 1974).

5 I have used the translation from *Where Silence Reigns* in preference to that in Tucker, *The Language of Sculpture*.

6 Martin Heidegger, *Poetry, Language, Thought*, trans. and intro. Albert Hofstadter (New York, 1971).

7 See Michael Fried, 'Art and Objecthood', *Artforum* (June 1967), reprinted in *Minimal Art: A Critical Anthology*, ed. Gregory Battcock (New York, 1968), pp. 116–47.

8 William Tucker, 'What Sculpture Is', pts. 1–8, *Studio International* (Dec 1974–May/June 1975).

9 Cf. Martin Heidegger, *Being and Time*, trans. John Macquarrie and Edward Robinson (Oxford, 1962), Division One, III, 'The Worldhood of the World', esp. sects. 22–4 on spatiality.

10 In a recent catalogue reference to *Art for Other People No. 1* this subtitle is no longer given.

11 *Sculpture: Kevin Atherton, Richard Deacon, Shirazeh Houshiary*, exh. cat., Greater London Arts, Bexley (1984).

12 The most obvious examples being *Two Can Play* (1983) and *The Eye Has It* (1984). See Newman, 'The Face of Things' for a discussion of the theme of vision in Deacon's sculpture.

13 The term is drawn from the discussion of *homo faber* in Hannah Arendt, *The Human Condition* (Chicago, 1958), which Deacon had read. For an excellent discussion of this, and of the *Art for Other People* series as a whole, see Lynne Cooke, 'Richard Deacon: Object Lessons', in *Richard Deacon*, exh. cat., London, Whitechapel Art Gallery, 1988–9.

14 'Richard Deacon Talking to Caryn Faure Walker', *Aspects* (Winter 1982).

15 For a further discussion of Deacon's work in relation to Minimalism, see Newman 'The Face of Things', and for the relation between Minimalism and Conceptual Art, see also my 'Revising Modernism, Representing Postmodernism' in *Postmodernism*, ed. Lisa Appignanesi (London, 1989).

16 For an important critique along these lines of Donald Judd's work, and by implication Minimalism in general, see Karl Beveridge and Ian Burn, 'Don Judd', *The Fox*, No. 2 (1975).

17 The term is from Donald Judd's important article, in effect the manifesto of Minimalism, 'Specific Objects', *Arts Yearbook 8*, 1965, reprinted in *Donald Judd: Complete Writings 1959–1975* (Halifax and New York, 1975), pp. 181–9.

18 Cf. Brian O'Doherty, *Inside the White Cube: The Ideology of the Gallery Space* (San Francisco, 1986).

19 Cf. Yehuda Safran, '"The Object is the Poetics": Empathy and Embodiment', *AND Journal of Art* (Winter 1983/4).

20 See Richard Deacon, *Stuff Box Object* [1971/2] (Cardiff, 1984), which documents, with photographs and text, a project of his final year as a B.A. student at Saint Martins School of Art and was submitted with his application for admission to the M.A. course in the Department of Environmental Media at the Royal College of Art. It reflects an interest in process and performance art. In the preface to the publication Deacon writes, 'This is an edited version of the original, which itself was derived in the main from letters that I wrote to my mother. Many of the themes which appear in the writing, such as that of transformation and substitution; of the links between name and the named; of relations between plans, actions, material and meaning; of covering and uncovering; of repetition and innovation, have continued to preoccupy me. Thus, although the reference is oblique, the text serves as an introduction to and a partial commentary on the sculpture that I make now.' Among the actions performed are building a box, entering it and lying in a foetal position, carpeting it, nailing twigs to the other sides, placing a mannikin inside and removing it, nailing wire netting to the outside, cementing the top, laboriously plastering the exterior, and finally removing and storing the accretions to the box.

21 Judd, 'Specific Objects', p. 181.

22 In the transcendental-phenomenological tradition of Kant, Husserl and a certain reading of Maurice Merleau-Ponty, *The Phenomenology of Perception*, trans. Colin Smith (London, 1962).

23 See Lucy R. Lippard, *Overlay: Contemporary Art and the Art of Prehistory* (New York, 1983).

24 Tucker writes, 'The *Bottle Rack* and the other pieces I mentioned are inspired: they do not work simply on their incongruity, as useful objects in an art context; in fact their detachment from the original context, except with the show shovel, makes them

virtually unrecognizable *except as sculpture* . . .'; *The Language of Sculpture*, p. 120, his emphasis. And for Judd the important thing is that 'Duchamp's ready-mades and other Dada objects are also seen at once and not part by part'; 'Specific Objects', p. 183.

25 Where he was taught by Yehuda Safran who has an interest in Husserlian phenomenology; see Safran, ' "The Object is the Poetics" '.

26 A title which Deacon applied to a sculpture of 1987.

27 Richard Wollheim, *Art and Its Objects* (Harmondsworth, 1970), sects. 11–14.

28 Ludwig Wittgenstein, *Philosophical Investigations*, trans. G. E. M. Anscombe (Oxford, 1963), p. 214.

29 Immanuel Kant, *Critique of Aesthetic Judgment*. See sects. 46–50 on genius.

30 For discussion of the 'existential-hermeneutical "as" ' see Heidegger, *Being and Time*, pp. 200–1, 265–6.

31 See Kant, *Critique of Aesthetic Judgment*, sect. 46.

32 The essay was written in 1977, and the Poussin painting discussed by Deacon is *Landscape with a Man Killed by a Snake*, c. 1648, National Gallery, London. For a further discussion of this essay, see Newman, 'The Face of Things'.

33 See Heidegger, *Being and Time*, sect. 16.

34 See Martin Heidegger, *The Question Concerning Technology and Other Essays*, trans. William Lovitt (New York, 1977).

35 Heidegger, *Poetry, Language, Thought*, pp. 32–7. For an excellent discussion of this problem in 'The Origin of the Work of Art', on which I have drawn, see Jay M. Bernstein, 'Aesthetic Alienation: Heidegger, Adorno, and Truth at the End of Art', in *Life After Postmodernism: Essays on Value and Culture*, ed. John Fekete (London, 1988), pp. 86–119.

36 Cf. Bernstein, 'Aesthetic Alienation'.

37 See Theodor W. Adorno, *Aesthetic Theory*, trans. C. Lenhardt (London, 1984).

38 Which were of interest to Robert Smithson in the late 1960s and early 1970s; see his *Writings: Essays with Illustrations*, ed. Nancy Holt (New York, 1979).

39 The exhibition was at the Marian Goodman Gallery.

40 Hannah Arendt, *The Human Condition* (Chicago, 1958), p. 250.

41 Ibid., pp. 264–5.

42 Bill McKibbern, *The End of Nature* (London, 1990), p. 7.

43 Ibid., p. 3.

44 As a student, Deacon read Rachel Carson's book *Silent Spring* (1962; Harmondsworth, 1972), which has had a profound influence on the development of ecological thinking.

Select Bibliography

The bibliography consists chiefly of the main works which are cited in the foregoing essays but has been supplemented with a number of other texts which seem to relate in a significant way to the contemporary practice of art criticism.

Abrioux, Yves, *Ian Hamilton Finlay: A Visual Primer*, Edinburgh, Reaktion Books, 1985
Adorno, Theodor W., *Prisms*, trans. Samuel and Shierry Weber, London, Spearman, 1967
——, *Aesthetic Theory*, trans. C. Lenhardt, ed. G. Adorno and R. Tiedemann, London, Routledge, 2nd edition, 1972, reprinted 1984
Alpers, Svetlana, *The Art of Describing: Dutch Art in the Seventeenth Century*, London, Murray, 1983
Apollinaire on Art, ed. Leroy C. Breunig, New York, Viking, 1972
Bachelard, Gaston, *Water and Dreams: An Essay on the Imagination of Matter*, trans. E. R. Farrell, Dallas, Pegasus Foundation, 1983
Balzac, Honoré de, *Gillette or the Unknown Masterpiece*, trans., with an essay, Anthony Rudolf, London, Menard, 1988
Bann, Stephen, 'Adriatics – à propos of Brice Marden', *20th Century Studies. Visual Poetics*, 15/16 (December 1976), 116–29
——, 'Abstract Art – A Language?', in *Towards a New Art – Essays on the Background to Abstract Art 1910–20*, London, Tate Gallery, 1980, pp. 125–45
——, *The True Vine: On Visual Representation and the Western Tradition*, New York, Cambridge University Press, 1989
Barthes, Roland, *Image Music Text*, trans. Stephen Heath, London, Fontana, 1977 (selected essays)
——, *L'obvie et l'obtus: Essais critiques III*, Paris, Seuil, 1982
——, *Camera Lucida: Reflections on Photography*, trans. Richard Howard, London, Cape, 1982
Baudelaire, Charles, *Selected Writings on Art and Artists*, trans. P. E. Charvet, Cambridge, Cambridge University Press, 1981
Benjamin, Walter, *Illuminations*, trans. H. Zohn, New York, Schocken Books, 1969
Berger, John, *The White Bird*, ed. Lloyd Spencer, London, Hogarth, 1988
Bois, Yve-Alain, 'Francis Picabia: From Dada to Pétain', *October*, 30 (Autumn 1984), 121–7
——, 'A Picturesque Stroll around *Clara-Clara*', in *October – The First Decade*, ed. Annette Michelson et al., Cambridge, Mass., and London, MIT Press, 1987, pp. 342–72
Bryson, Norman, ed., *Calligram: Essays in New Art History from France*, New York, Cambridge University Press, 1988 (contains essays in translation by Barthes, Serres, Marin, Kristeva, Bonnefoy, Baudrillard, etc.)

——, *Looking at the Overlooked: Four Essays on Still Life Paintings*, London, Reaktion Books, 1990

Burgin, Victor, *The End of Art Theory: Criticism and Postmodernity*, London, Macmillan, and Atlantic Highlands, NJ, Humanities Press International, 1986

——, 'Geometry and Abjection', *AA Files – Annals of the Architectural Association School of Architecture*, 15 (Summer 1987)

Carrier, David, *Artwriting*, Amherst, University of Massachusetts Press, 1987

——, 'Art Criticism and its Beguiling Fictions', *Art International*, 9 (1989), 36–41

——, *True Fictions: The Stories of Classical Art History*, University Park and London, 1991

Carroll, David, *Paraesthetics*, London, Methuen, 1987

Clark, Thomas A., 'An Order Made: Hamish Fulton's Canadian Walks', *Northward Journal*, 47 (1989), 4–26

Crimp, Douglas, 'The End of Art and the Origin of the Museum', *Art Journal*, (Winter 1987), 261–6

Curnow, Wystan, 'Thinking About Colin McCahon and Barnett Newman', *Art New Zealand*, 8 (1977–8)

Damisch, Hubert, *Théorie du/nuage/pour une histoire de la peinture*, Paris, Seuil, 1972

——, '"Equals Infinity"' (trans. R. H. Olorenshaw), *20th Century Studies*, 15/16 (December 1976), 56–81

——, *Fenêtre jaune cadmium ou les dessous de la peinture*, Paris, Seuil, 1984

——, *L'Origine de la perspective*, Paris, Flammarion, 1987

Derrida, Jacques, *The Truth in Painting*, trans. Geoff Bennington and Ian McLeod, Chicago and London, University of Chicago Press, 1987

Didi-Huberman, Georges, 'The Art of Not Describing: Vermeer – the Detail and the Patch' (trans. Anthony Cheal Pugh), *History of Human Sciences*, Vol. 2, No. 2 (June 1989), 135–69

——, *Devant l'image*, Paris, Minuit, 1990

——, *Fra Angelico: Dissemblance et Figuration*, Paris, Flammarion, 1990

Fried, Michael, 'Art and Objecthood', repr. in Gregory Battcock, ed., *Minimal Art: A Critical Anthology*, New York, Dutton, 1986

——, *Absorption and Theatricality: Painting and Beholder in the Age of Diderot*, Berkeley, University of California Press, 1980

——, *Realism, Writing, Disfiguration: On Thomas Eakins and Stephen Crane*, Chicago and London, University of Chicago Press, 1987

Fry, Roger, *Cézanne: A Study of his Development*, new edn, Chicago and London, University of Chicago Press, 1989

Gadamer, Hans-Georg, *Truth and Method*, trans. W. Glen-Doepel, London, Sheed and Ward, 1975

——, *The Relevance of the Beautiful and Other Essays*, trans. Nicholas Walker, Cambridge, Cambridge University Press, 1986

Greenberg, Clement, *Art and Culture: Critical Essays*, London, Thames & Hudson, 1973

Hirsch, E. D., *Validity in Interpretation*, New Haven, Yale University Press, 1967

Judd, Donald, *Complete Writings 1959–1975*, Halifax, Press of the Nova Scotia College of Art and Design, and New York, New York University Press, 1975

Keller, Hans, *Criticism*, London, Faber, 1987

Kirkeby, Per, *Selected Essays from Bravura*, Eindhoven, Van Abbe Museum, 1982

Kounellis, Jannis, *Odyssée Lagunaire: Ecrits et entretiens 1966–1989*, Paris, Daniel Lelong, 1990

Kristeva, Julia, *Desire in Language*, trans. Thomas Gora et al., New York, Columbia University Press, 1980

——, 'Jackson Pollock's Milky Way: 1912–1956', *Journal of Philosophy and the Visual Arts*, (1989), 35–9

Levinas, Emmanuel, *Ethics and Infinity: Conversations with Philippe Nemo*, trans. R. A. Cohen, Pittsburgh, Duquesne University Press, 1985

Lippard, Lucy R., *Overlay: Contemporary Art and the Art of Prehistory*, New York, Pantheon Books, 1983

Lyotard, Jean-François, 'The Sublime and the Avant-Garde', *Artforum*, (September 1975)

——, *The Postmodern Condition: A Report on Knowledge*, trans. Geoff Bennington and Brian Massumi, Minneapolis, University of Minnesota Press, 1984

Mulvey, Laura, *Visual and Other Pleasures*, London, Macmillan, 1989

Newman, Michael, 'The Face of Things', in *Richard Deacon – Sculpture 1980–1984*, exh. cat., Fruitmarket Gallery, Edinburgh, 1984, pp. 33–45

——, 'Revising Modernism, Representing Postmodernism', in Lisa Appignanesi, ed., *Postmodernism*, London, Free Association Books, 1989

Nietzsche, Friedrich, *Untimely Meditations*, trans. R. J. Hollingdale, Cambridge, Cambridge University Press, 1983

——, *Human, All too Human*, trans. R. J. Hollingdale, Cambridge, Cambridge University Press, 1986

O'Doherty, Brian, *Inside the White Cube: The Ideology of the Gallery Space*, San Francisco, The Lapis Press, 1986

Panofsky, Erwin, *Meaning in the Visual Arts*, Harmondsworth, Penguin, 1970

Pater, Walter, *The Renaissance*, Library Edition, volume I, London, Macmillan, 1910

Pleynet, Marcelin, *Painting and System*, trans. Sima N. Godfrey, Chicago, University of Chicago Press, 1984

——, *Giotto*, Paris, Hazan, 1985

——, *Robert Motherwell*, trans. Mary Ann Caws, Paris, Daniel Papierski, 1989

——, *Les Modernes et la Tradition*, Paris, Gallimard, 1990

Ratcliff, Carter, 'David Salle and the New York School', in *Salle*, exh. cat., Rotterdam, Museum Boymans-van Beuningen, 1983

Reason, David, et al., *The Unpainted Landscape*, London, Coracle Press, 1987

Riegl, Alois, 'The Modern Cult of Monuments: Its Character and Its Origin' (trans. Kurt W. Forster), *Oppositions*, 25 (Autumn 1982), 21–52

Rilke, Rainer Maria, *Rodin and Other Prose Pieces*, trans. G. Craig Houston, intro. by William Tucker, London and New York, Quartet, 1986

Rosenberg, Harold, *The Tradition of the New*, new edn, Chicago, University of Chicago Press, 1982

——, *The Anxious Object*, new edn, Chicago, University of Chicago Press, 1982

Ruskin, John, *Modern Painters* (Vols I–V of Library Edition), London, George Allen, 1903–5

Safran, Yehuda, ' "The Object is the Poetics": Empathy and Embodiment', *AND Journal of Art*, (Winter 1983–4)

Serres, Michel, *Les cinq sens: Philosophie des corps mêlés I*, Paris, Grasset, 1985

——, *Statues: Le second livre des fondations*, Paris, Bourin, 1987

Shiff, Richard, *Cézanne and the End of Impressionism*, Chicago and London, University of Chicago Press, 1984

——, 'On Criticism Handling History', *History of Human Sciences*, Vol. 2, No. 1 (April 1989), 63–87

Smithson, Robert, *Writings: Essays with Illustrations*, ed. Nancy Holt, New York, New York University Press, 1979

Stella, Frank, *Working Space*, Cambridge, Mass., and London, 1986

Stokes, Adrian, *Critical Writings*, 3 vols, London, Thames and Hudson, 1978

Wollheim, Richard, *Art and its Objects*, Harmondsworth, Penguin, 1970

——, *Painting as an Art*, London, Thames and Hudson, 1987

Index